INSIDE

HAUTE COUTURE

INSIDE

HAUTE COUTURE

BEHIND THE SCENES
AT THE PARIS ATELIERS

DÉSIRÉE SADEK ▪ GUILLAUME DE LAUBIER

ABRAMS ▪
NEW YORK

Contents

Behind the Scenes

Attending an haute couture runway show in Paris is a privilege granted to only a few hundred people throughout the world. In this book, we wanted to expand those limits—by inviting you behind the scenes of the shows, which are usually closed to the public, and into the very fashion houses where the exceptional clothing is made and refined until those magic moments when the one-of-a-kind garments are presented onstage.

We introduce you to the artists themselves and bring you into secret spaces still filled with the creative energy of legendary designers such as Gabrielle "Coco" Chanel, Christian Dior, and Yves Saint Laurent. You'll watch Stéphane Rolland, Elie Saab, and Franck Sorbier at work. You'll see the final adjustments being made in Jean Paul Gaultier's atelier and follow the last-minute runway preparations at Ralph & Russo, Alexandre Vauthier, and Alexis Mabille.

A moment on the steps of a mythical staircase, a pose in an authentically restored Parisian landmark, a fitting in an haute couturier's private dressing room. . . . The camera captures a drawing here, a chalk mark there, fabrics flowing, fingers embroidering, and needles sewing. And everywhere, the concentration of the artisans is razor sharp.

Each haute couture creation starts with a designer's intuition, evolves through sketches and patterns, passes through multiple pairs of scissors, is adjusted with a pincushion's worth of pins, and then is made real by dedicated seamstresses at work for hours. Cinderella's fairy godmother notwithstanding, a classic isn't invented at the snap of a finger!

Providing both a showcase for craft and a laboratory for creativity, haute couture allows many vital trades to live on and thrive: hand-sewing and tailoring, embroidery, haberdashery, millinery, feathering, production of hat blocks and mannequins, and the like. (And these specialties, in turn, continue to reflect the excellence of French haute couture.) All this precise, detail-oriented work results in unique pieces that maybe only a few in the world can afford to own but that the rest of us can appreciate, especially since these originals bring the avant-garde to the fore and quite often herald advances in the prêt-à-porter (ready-to-wear) fashion most of us buy and enjoy.

Remember, *haute couture* is an exclusive French honor, a term protected and defined by decree and criteria set in 1945. Every year, a commission composed of professionals, the Chambre Syndicale de la Haute Couture, establishes a list of fashion houses authorized to use the designation—a list that must be validated by the Ministère de l'Economie, de l'Industrie et du Numérique (see page 204). The selection is governed by strict rules: pieces must be unique and custom-made entirely by hand in the company studios (or ateliers); a house's Parisian workshop must have at least twenty full-time employees; and two collections with at least twenty-five designs each, for daytime and evening wear, must be presented annually in Paris, one in January and one in July.

The Chambre Syndicale de la Haute Couture belongs to the Fédération Française de la Couture, du Prêt-à-Porter des Couturiers et des Créateurs

de Mode (the French Federation of Fashion and of Ready-to-Wear Couturiers and Fashion Designers), founded in 1973. It brings together fashion-design companies that hold the prized status—a very exclusive club with, as of July 2015, thirteen permanent members, seven corresponding members, and eleven invited members. (The latter two categories allow non-French fashion houses access to this highly selective family. See page 204 for more information on these designations.) The ten fashion companies described in this book are all members—a representative selection of the diversity of talents that continue to thrive in this competitive arena.

Haute couture's label of excellence is hugely prestigious and this kind of savoire faire is still the pride of France, as it has been since the seventeenth century, when the fashion, arts, architecture, and music of Louis XIV's court at Versailles were the envy of all Europe. Ladies of high society traveled to Paris to buy their clothing and accessories at Le Grand Mogol on the rue du Faubourg Saint-Honoré, opened in 1770 by the intrepid milliner and dressmaker to Queen Marie Antoinette, Rose Bertin.

While Bertin can be considered the precursor of Parisian haute couture, Louis-Hippolyte Leroy carried on the tradition during the First French Empire. A purveyor for Emperor Napoleon and his wife Josephine, he became the first star fashion designer, making custom dresses only for clients who came in person to his atelier on rue de Richelieu in Paris.

And yet, 2,400 tailors were tallied at the time in the city, already the capital of fashion. A young designer, originally from England, Charles Frederick Worth, invented the runway show, using live models known as *sosies* (look-alikes), and sold his "collections" at Bon Marché, the department store of the period that inspired Émile Zola's novel *Au Bonheur des Dames*. In 1868, he founded the Chambre Syndicale de la Confection et de la Couture pour Dames et Filletes—very good reason to grant him the title of father of haute couture.

Starting in 1914, the list of fashion talents began growing still longer: Paul Poiret, Jacques Worth (grandson of Charles), Jean Patou, Gabrielle Chanel, Elsa Schiaparelli, Cristóbal Balenciaga, and Christian Dior. Together, these great talents forged the golden age of French couture. In the 1960s, Yves Saint Laurent, Pierre Cardin, André Courrèges, and Emanuel Ungaro kept that flame burning.

Ever since, even though fashion has become international, Paris retains the title as its capital. For this, we can thank especially the designers represented in this book. They continue to ensure the success of Paris Fashion Week, the only city that hosts runway shows carrying the haute couture label twice a year.

Before each show, however, come weeks of madness, when every artisan is on hand to get the garments out of the designers' atelier and onto the stage, where the dream of haute couture comes alive. Let the show begin!

—*Désirée Sadek*

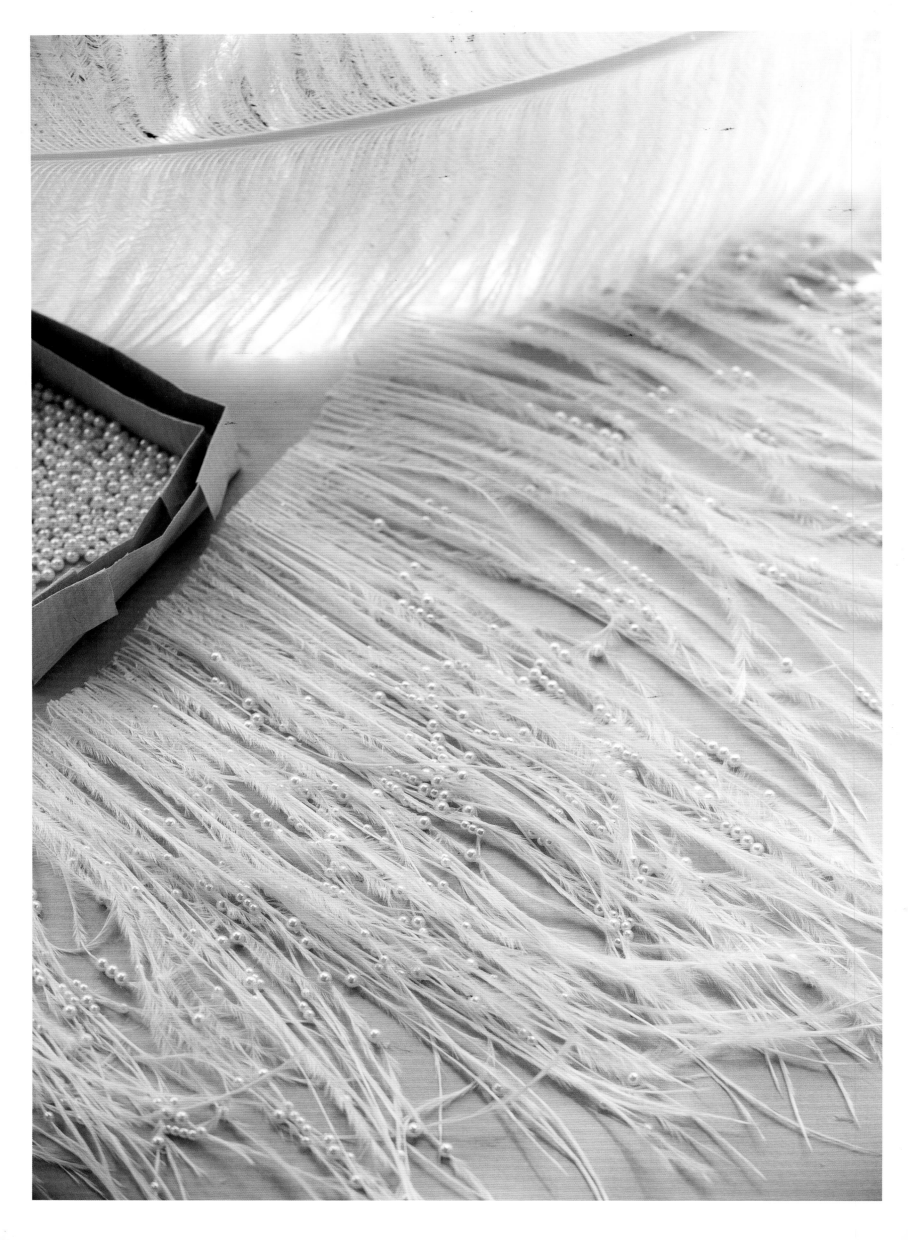

Vain trifles as they seem, clothes have, they say, more important offices than merely to keep us warm. They change our view of the world and the world's view of us.

VIRGINIA WOOLF
Orlando, 1928

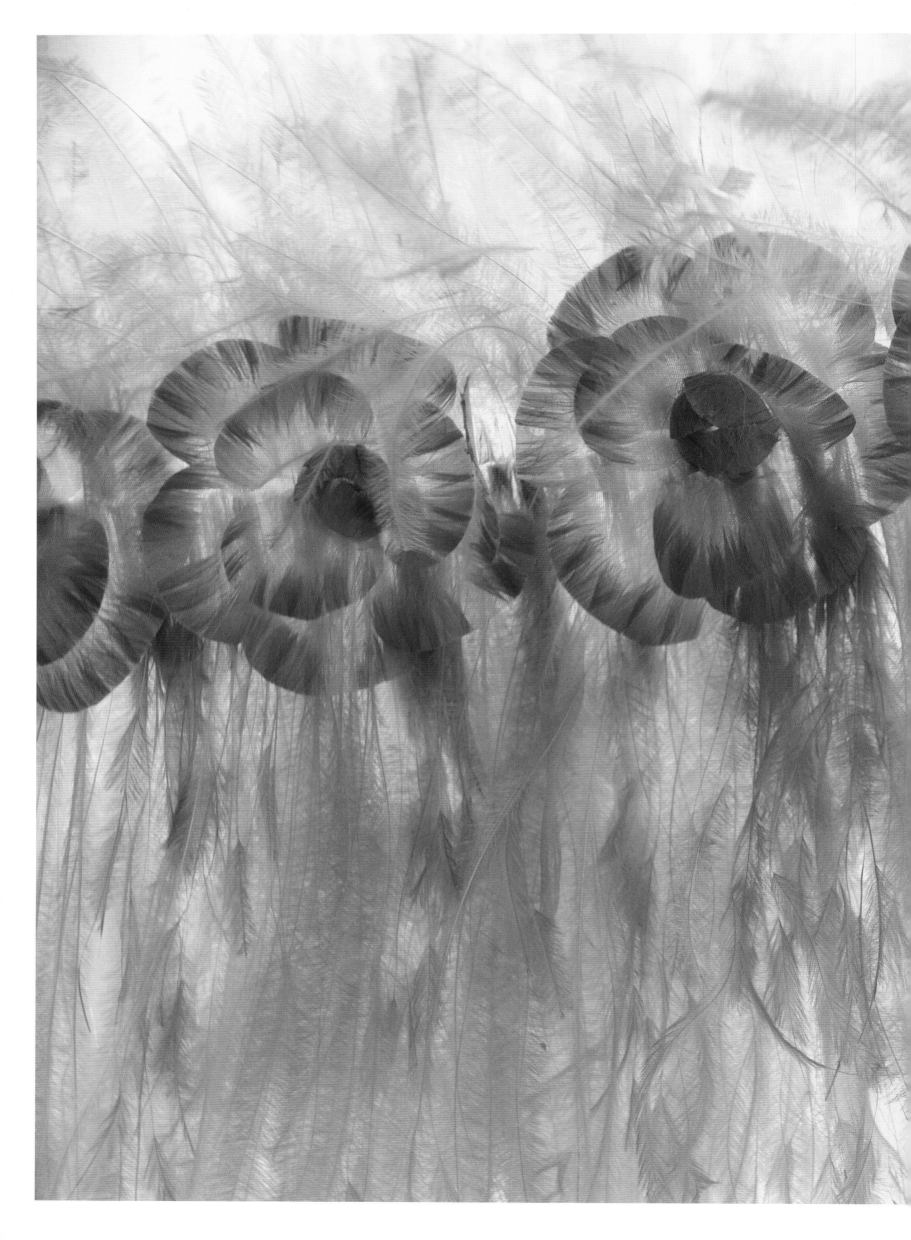

CHANEL

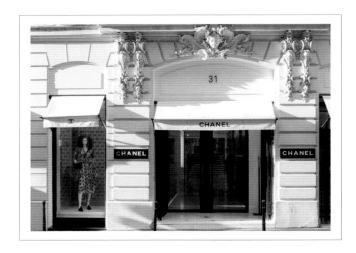

Chanel
31, RUE CAMBON

It was at 21, rue Cambon, in Paris's first arrondissement that, in 1910, Gabrielle "Coco" Chanel opened her first boutique, Chanel Modes. This was a hat store, and the lease stated that no clothes were to be sold there. After opening a shop in Deauville in 1913 and a fashion house in Biarritz in 1914, the woman nicknamed "Mademoiselle" moved her Paris fashion house to 31, rue Cambon, in 1918. Then she expanded into the adjacent buildings, numbers 27, 25, and 23, for her apartment, ateliers, and offices.

But how did Gabrielle Chanel get here? She was born in Saumur in the Maine-et-Loire department of western France on August 19, 1883. When she was twelve, her mother died, and her father sent her to a convent orphanage in Aubazine, where she learned to sew. For eight years, she wore a uniform. It is said that this smock is what would inspire her most famous design, the "little black dress."

By age twenty, Gabrielle already had style; she worked as a seamstress and sang in a cabaret. The military officers in the audience called her "Coco"—a stage name she kept for her entire career. Étienne Balsan, a wealthy textile heir, was quickly captivated by her and, in addition to financing her millinery, introduced her to the habits and secrets of high society.

Gabrielle began an affair with one of Balsan's friends, the great love of her life, Arthur Edward "Boy" Capel, who next supported her business ventures as they evolved from hats to clothes and built up a wealthy clientele. She was soon able to reimburse both Balsan and Capel for their investments in her, and she acquired financial independence.

In 1919, a tragedy occurred that would forever leave its mark on her: Boy died in a car accident. But, as she had earlier in her life, Coco was able to transform difficulties into creative strength. To overcome her grief, she created an "ode" of a sort to her perished lover: a perfume called N°5. (Later, Marilyn Monroe, another lonesome beauty, was said to wear nothing but a few drops of N°5 to bed. And, thus, a myth was born.) The perfume would become legendary.

"A woman who is unloved is lost. Unloved, she might as well die,"[1] Coco Chanel said at age seventy-six. And throughout her life, she did, in fact, find inspiration in the men she loved. Buttons and ganse cord tell of her time with Balsan. Her affair with Grand Duke Dmitri Pavlovich gave her the opportunity in 1920 to incorporate Russian fashion into her collections. Her love for the Duke of Westminster and their travels to Scotland would give rise to her Chanel tweed suits in 1928.

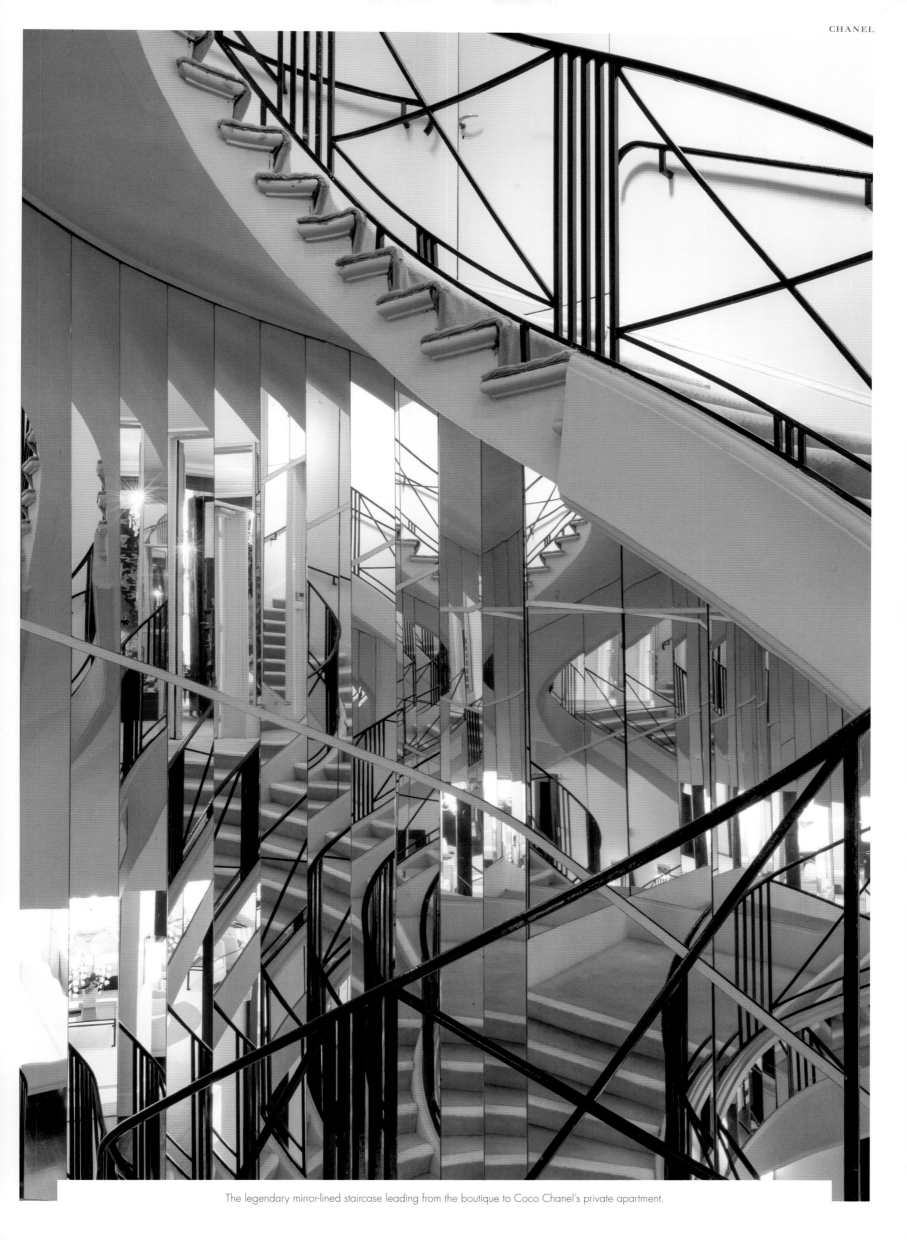

The legendary mirror-lined staircase leading from the boutique to Coco Chanel's private apartment.

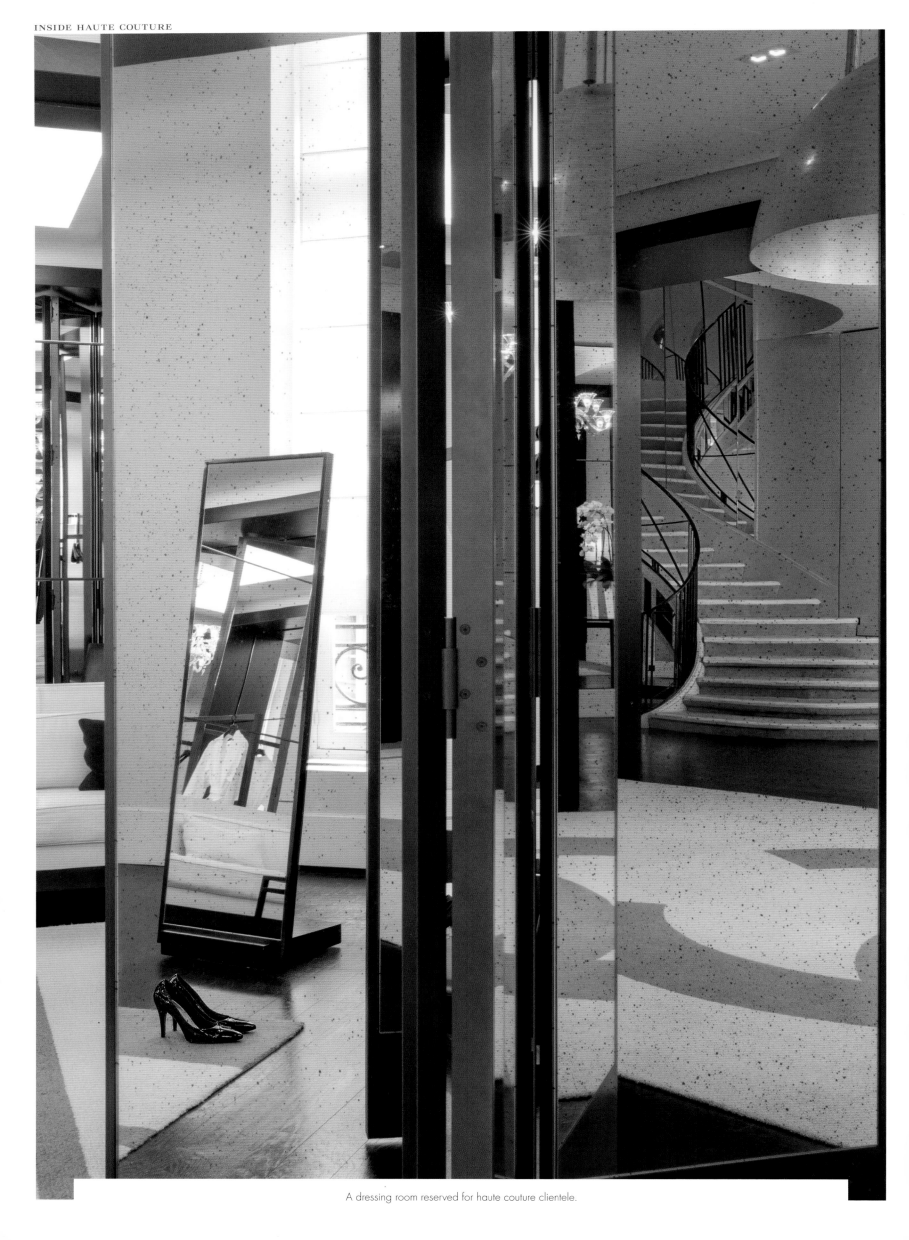

A dressing room reserved for haute couture clientele.

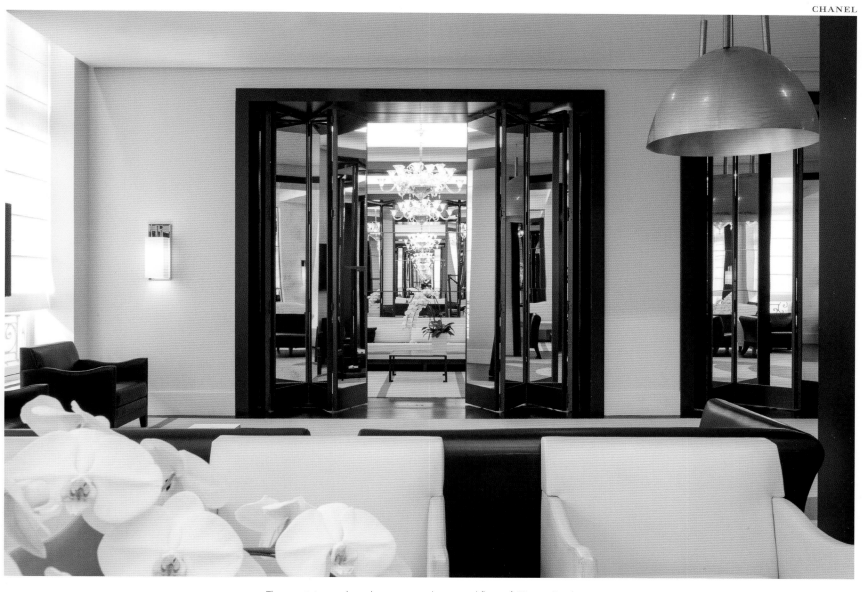

The prestigious *salons de couture* on the second floor of 31, rue Cambon.

But the Chanel spirit cannot be reduced simply to Gabrielle's sentimental journeys: Mademoiselle made life into fashion and made fashion style. Going against the tenor of her times, she broke taboos, emancipating women's clothing by replacing corseted outfits with comfortable suits and loose-fitting dresses. She even shortened skirts and defied feminine norms by establishing a more androgynous look: pants and short hair. Cardigans and costume jewelry enlivened her collections. The camellia, her favorite flower, became the fashion house's symbol, and pearls, which she wore for every occasion, her talisman.

The year 1926 was a good one for Gabrielle Chanel, and she dared to introduce the "little black dress." Simple and modern, in a color until then considered only for mourning, the garment caused an uproar. In *Vogue*'s October 1 issue it was dubbed "Chanel's Ford," referring to the car's popularity and accessibility. But it soon became the staple of every runway show. Thus, a style was born, and the foundations of the brand were in place.

Having little fondness for management, however, in 1954, Mademoiselle decided to sell her business to an early business partner, Pierre Wertheimer, but continued to be its director. The perfumes and couture were brought together under the name Chanel S.A.

On January 10, 1971, at age eighty-seven, Coco Chanel died alone in the apartment she had been living in for twenty years at the Ritz, the renowned luxury hotel in Paris. Her final collection, presented the following day, was unanimously praised.

After her death, the House of Chanel was something of an orphan for more than ten years. Philippe Guibourgé launched the firm's first prêt-à-porter line in 1978, but he lacked the visionary spirit needed to succeed Mademoiselle, who, in sixty years of business, had continually reinvented fashion.

In 1983, the firm's artistic director, Karl Lagerfeld, was given the delicate mission of rebranding the interlaced Cs. He would do more than that, though. He revived Coco Chanel's innovative spirit and provided the extravagance to match her style. He showcased his own creativity, all while unearthing the most inventive ideas Mademoiselle had in her closet.

As Chanel's creative director, Lagerfeld continues to have carte blanche. "I can do what I want, I can take every risk, I have total freedom,"[2] he likes to say. And he ingeniously uses that freedom to produce contemporary heirs to styles designed long ago by Coco Chanel herself. In 2005, fifty years after the birth of the iconic, rectangular, 2.55 flap handbag (the name refers to the date of its creation, February 1955)—with its quilted-leather exterior, double gold chains, and "Mademoiselle lock" with Chanel logo—Lagerfeld re-launched it and, since then, has reinterpreted the bag every season, adding different colors, materials, and sizes to the line.

Today, after more than one hundred years, Chanel reigns over haute couture, fragrances, beauty products, and jewelry. True to itself, forever innovative, it is the ambassador of elegance *à la française.*

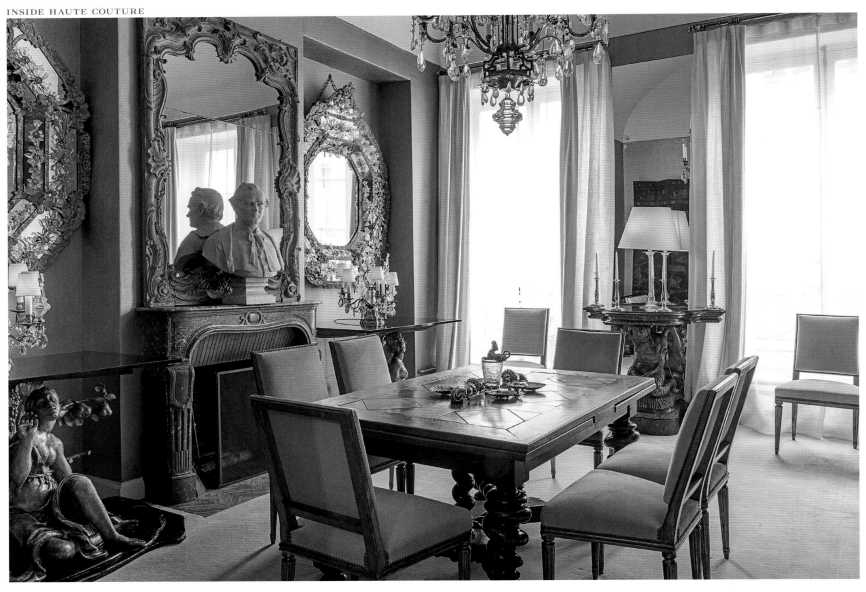

The fashion house's signature double Cs can be seen in the wrought iron chandeliers in Chanel's apartment.

INSIDE COCO CHANEL'S APARTMENT

Every morning, the same routine: Gabrielle "Coco" Chanel leaves the Hôtel Ritz, where she sleeps, right across the street from her workplace at 31, rue Cambon. A valet from the luxury hotel notifies her assistants of her imminent arrival, so that the premises can be spritzed with N°5. After entering the ground-floor boutique and climbing the legendary staircase walled with mirrors, "Mademoiselle" arrives at what she considers her true "home": a lavish, baroque-inspired apartment displaying everything she loves together in one place, its opulence strongly contrasting with the austerity of the atelier's second-floor rooms.

One can almost imagine her picking up a volume by Shakespeare, Voltaire, or Brontë, then stretching out to read on the suede sofa with its quilted cushions—the ones that will inspire an endlessly copied handbag. She glances at a lamp made of quartz and semiprecious stones and smiles at the double Cs interlaced in its cast iron. The monogram will become the signature of the couture house. The scent of N°5 also lightly wafts over her "pet" lion statues, her birdcage, and her beloved camellias. As in a treasure hunt, the apartment slowly reveals myriad objects symbolic of the Chanel style.

On a coffee table, two small vermeil boxes, a gift from the Duke of Westminster, store her ubiquitous cigarettes. The boxes are ruby red on the outside, gold within. Real luxury isn't flaunted; it's as subtle as the details of a Chanel jacket. To this day, white flowers without scent are replaced twice a week to grace the premises, much like the eternal spirit of Mademoiselle herself.

In 2013, the Ministry of Culture declared Chanel's apartment a historical monument.

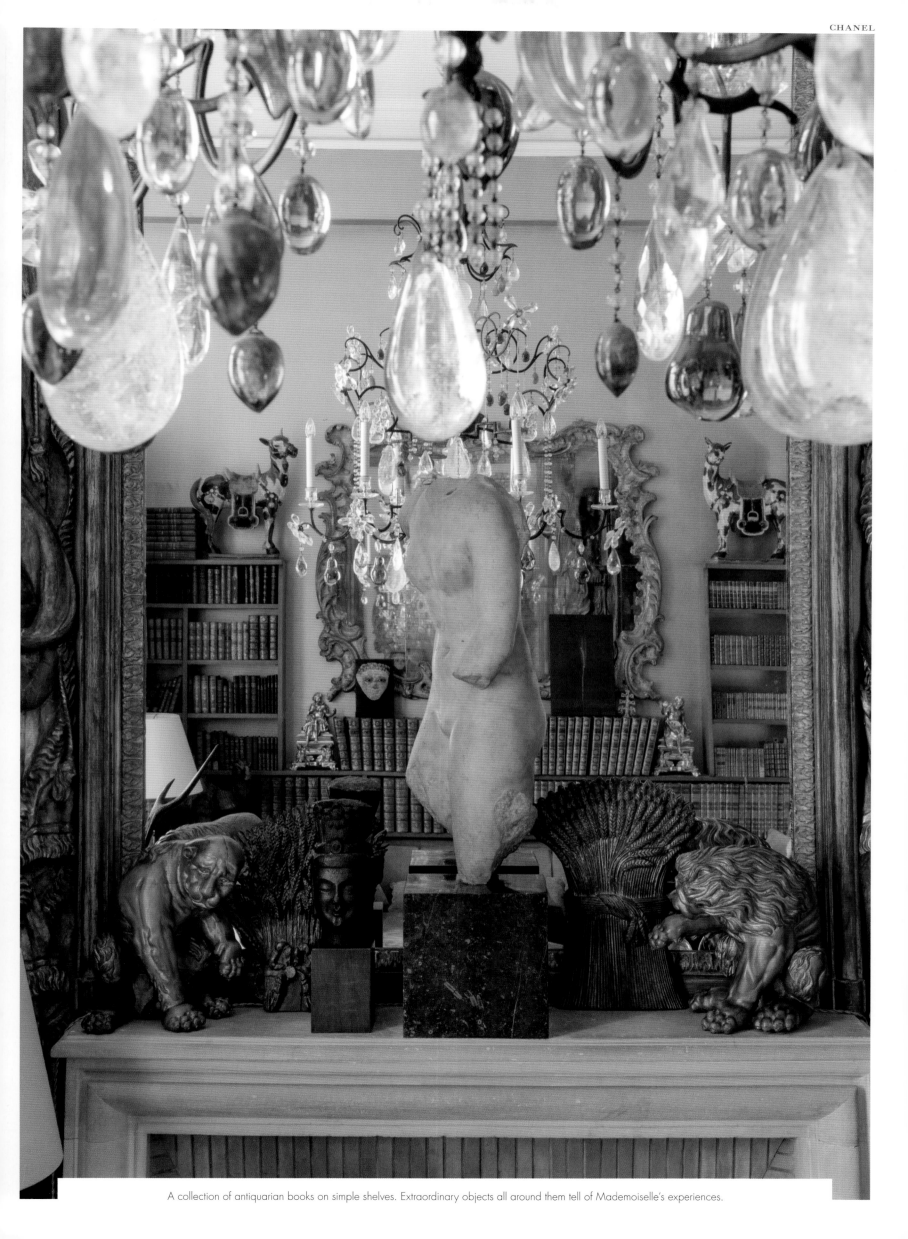

A collection of antiquarian books on simple shelves. Extraordinary objects all around them tell of Mademoiselle's experiences.

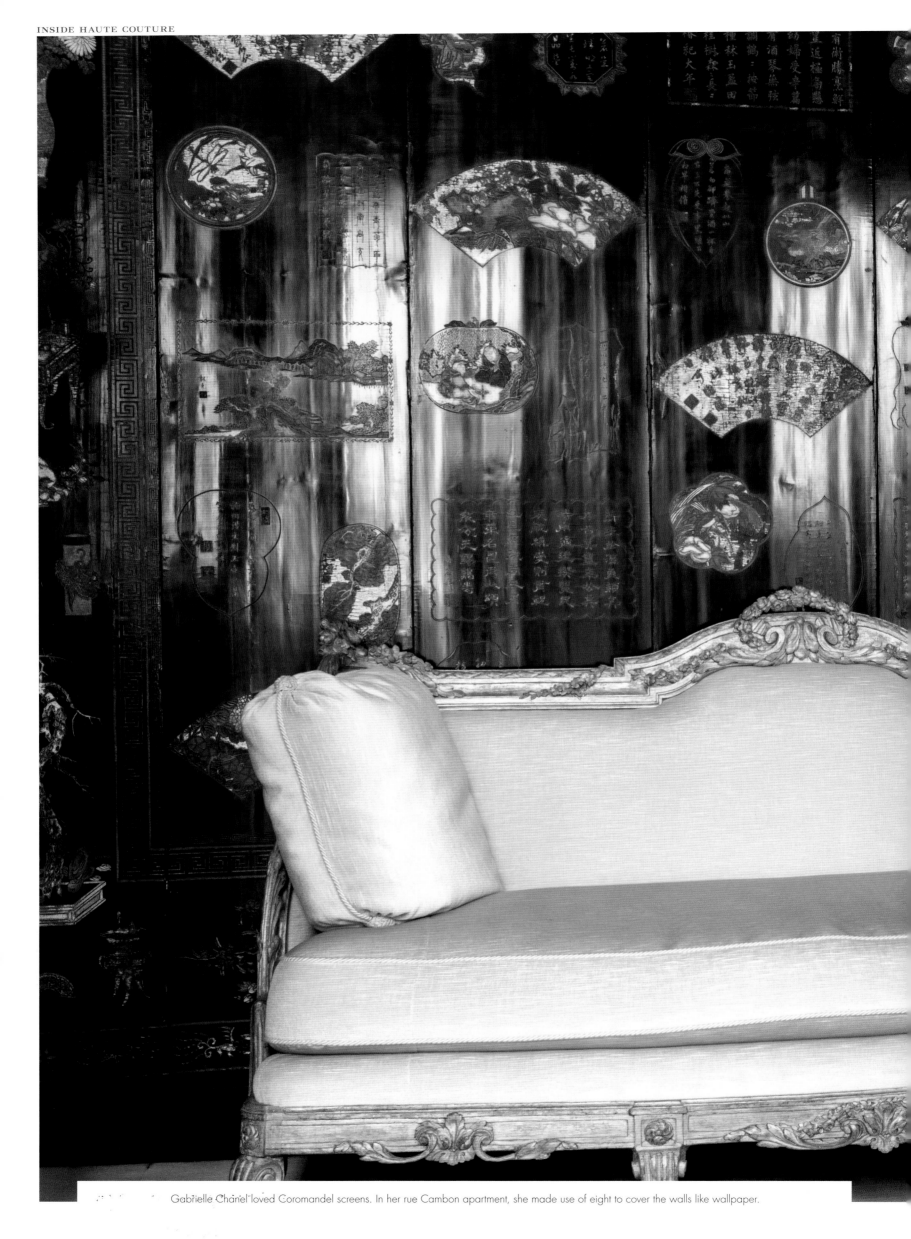

Gabrielle Chanel loved Coromandel screens. In her rue Cambon apartment, she made use of eight to cover the walls like wallpaper.

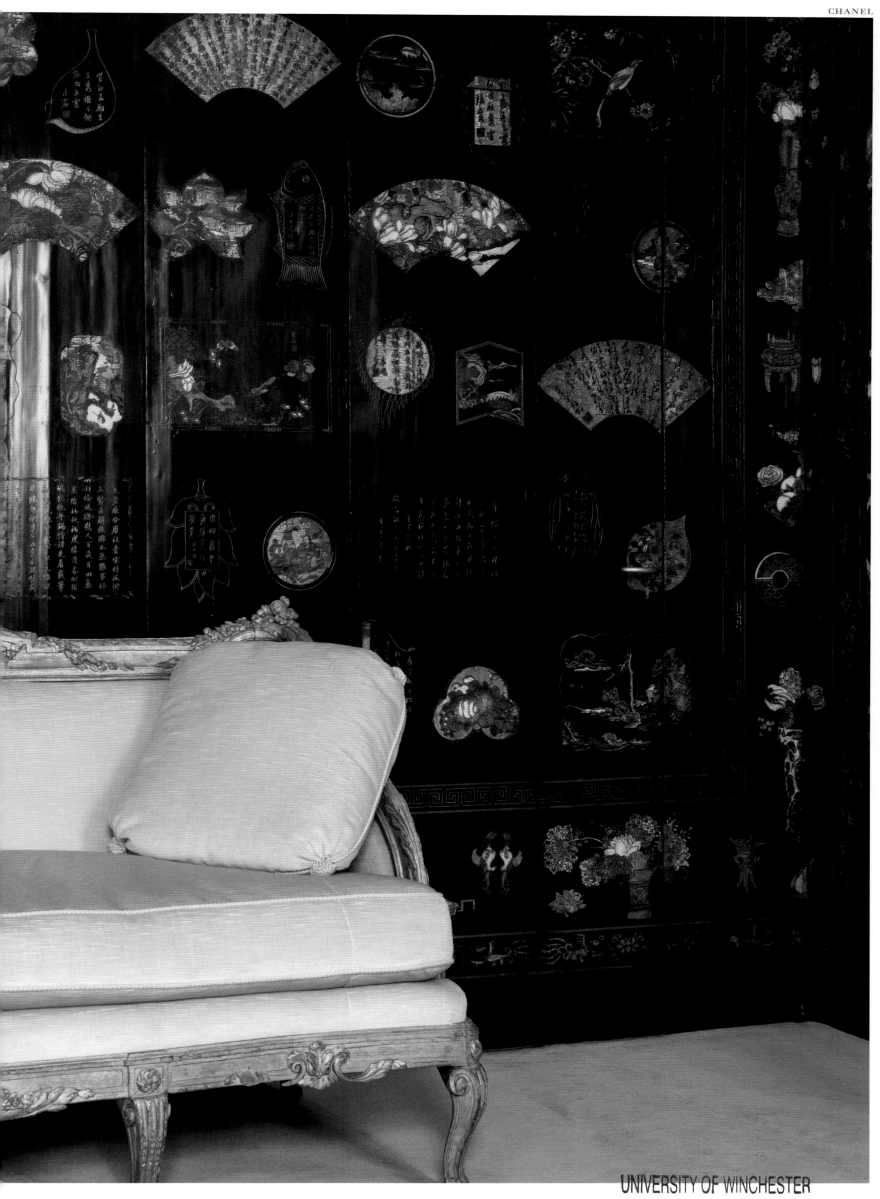

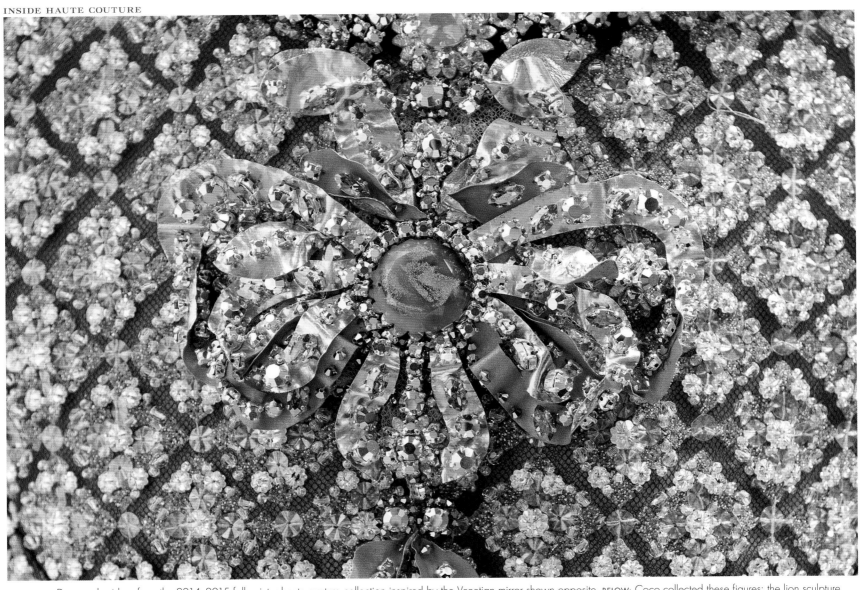

ABOVE: Dress embroidery from the 2014–2015 fall–winter haute couture collection inspired by the Venetian mirror shown opposite. BELOW: Coco collected these figures; the lion sculpture was reproduced at sixty feet (eighteen meters) in length and placed within the Grand Palais for the 2010–2011 fall–winter Chanel runway show.

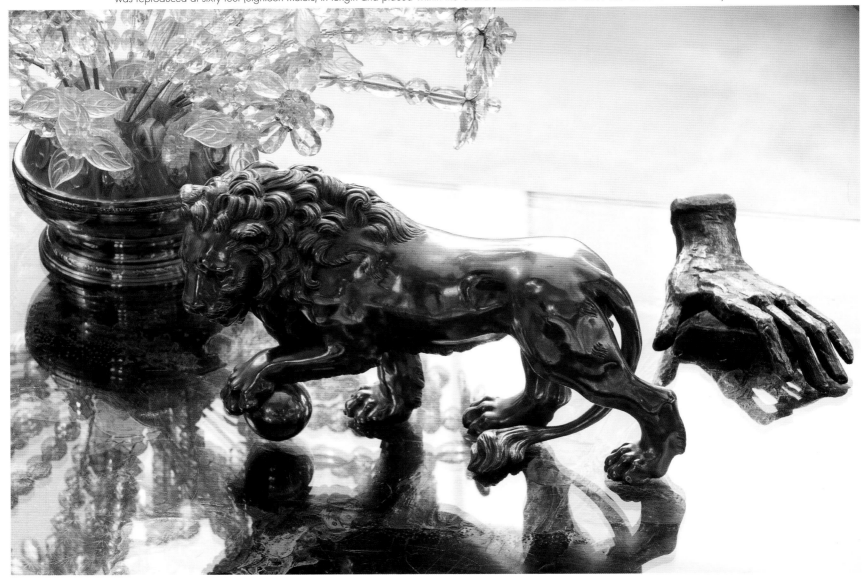

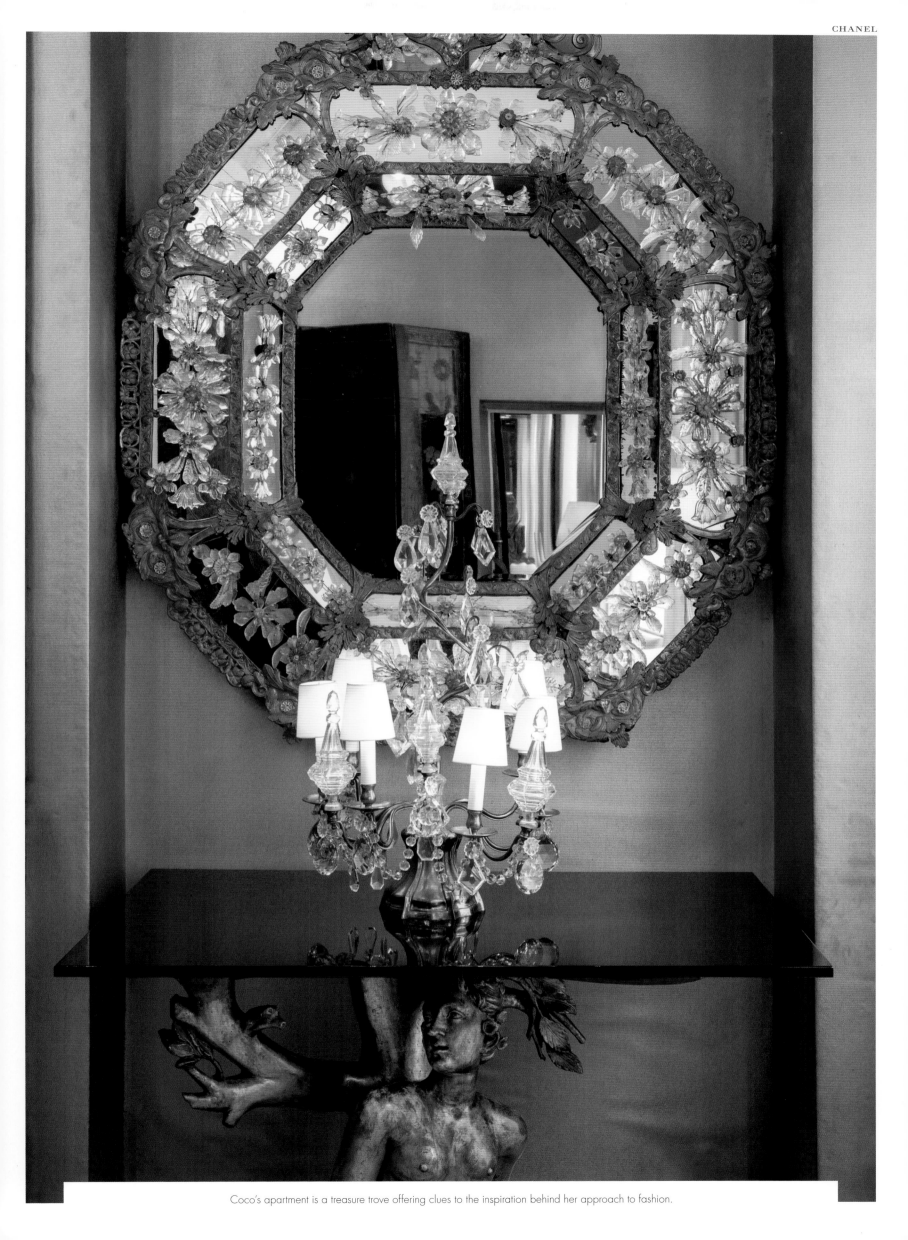

Coco's apartment is a treasure trove offering clues to the inspiration behind her approach to fashion.

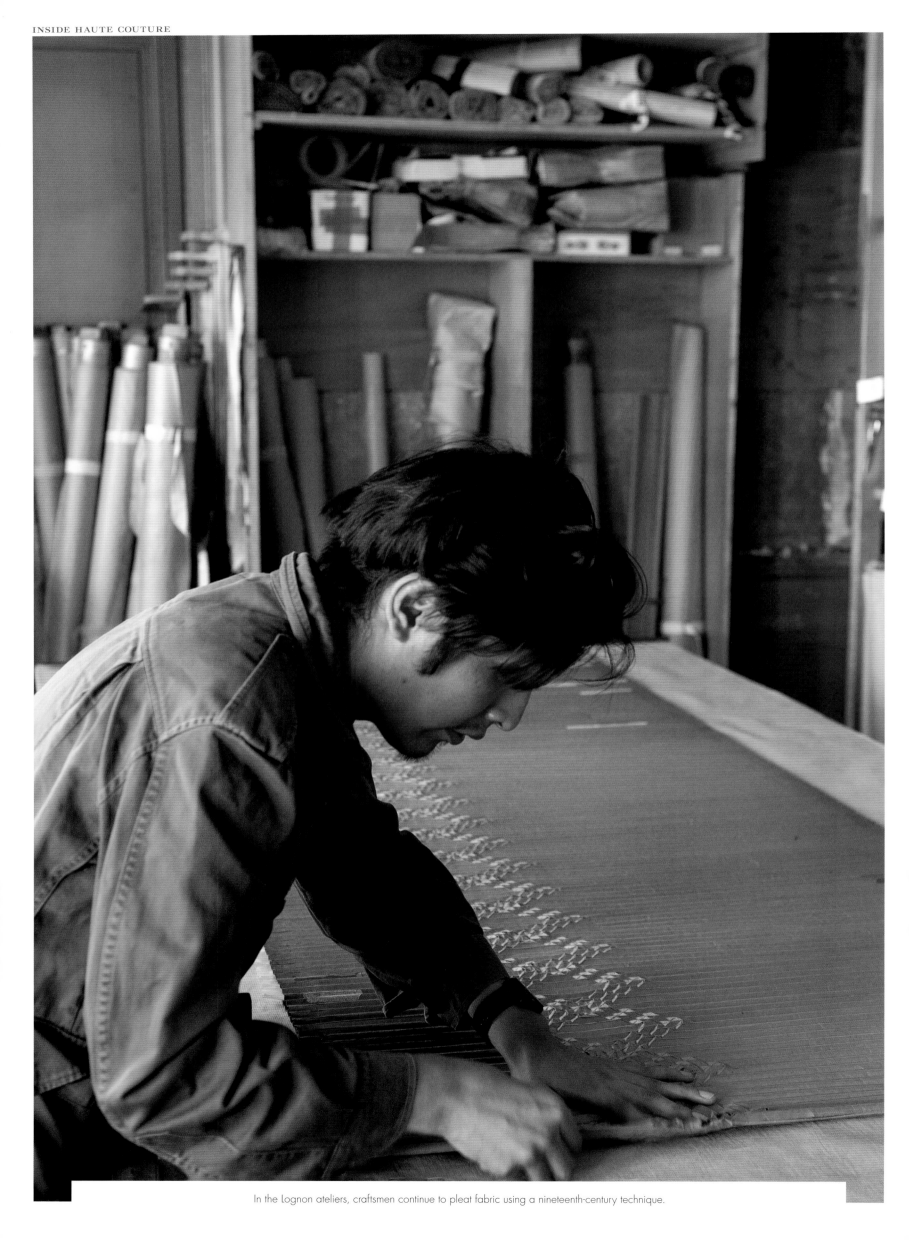

In the Lognon ateliers, craftsmen continue to pleat fabric using a nineteenth-century technique.

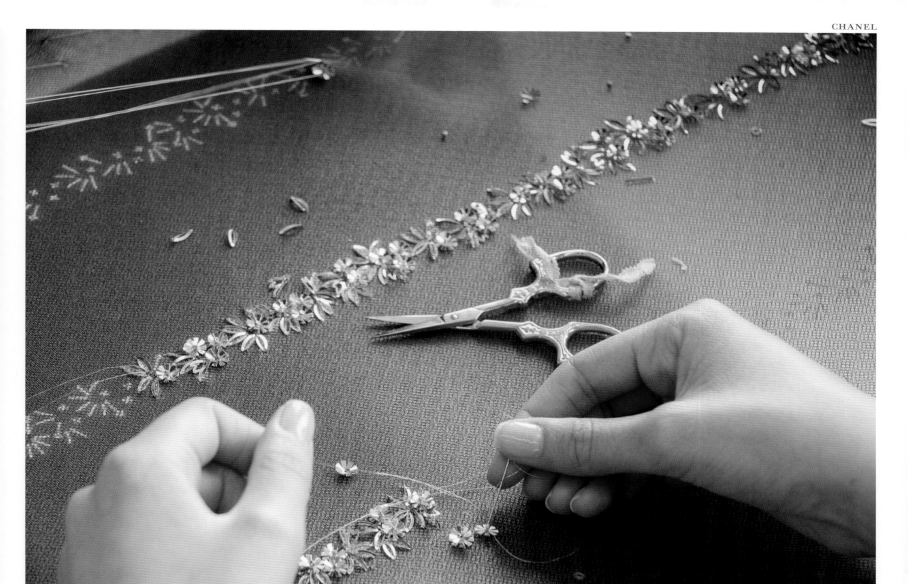

ABOVE: The Lesage archives conserve more than seventy thousand examples of embroidery art, a century and a half of expertise.
BELOW: Examples of pleating from the Lognan workshops.

INSIDE THE ATELIERS

Paraffection is the "affectionate" name the House of Chanel gave to its subsidiary established in 1997 to preserve the crafts of fashion.

Today, deep inside the great house, one finds many independent specialist workshops—Desrues jewelry, Maison Michel hats, Maison Lesage embroidery, Massaro shoes, Goossens haute couture costume jewelry, Maison Lemarié feather pieces, Lognon pleating, and Guillet fabric floral arrangements—multiple perfectly mastered crafts under one roof.

Goossens designed Coco's costume jewelry; the shoemaker Massaro, the famous beige flats with black satin toes. They all contributed to the label's myth and image, and these Chanel partners are equally precious for their history and contemporary contributions.

Their acquisition by Chanel keeps these workshops fresh by asking them to continually diversify and design new product lines. Although the companies are, for the most part, based in Chanel's offices in Pantin in the northeastern suburbs of Paris, they can also sell their wares to other great couture houses.

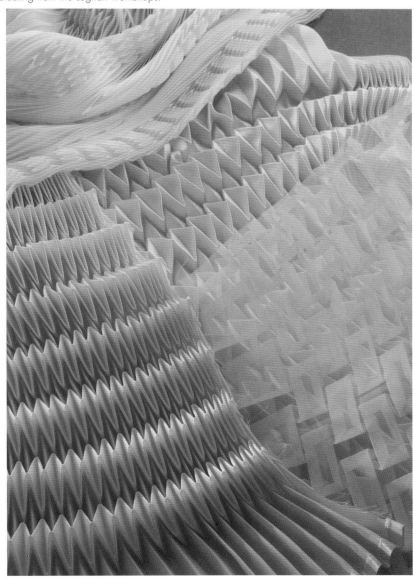

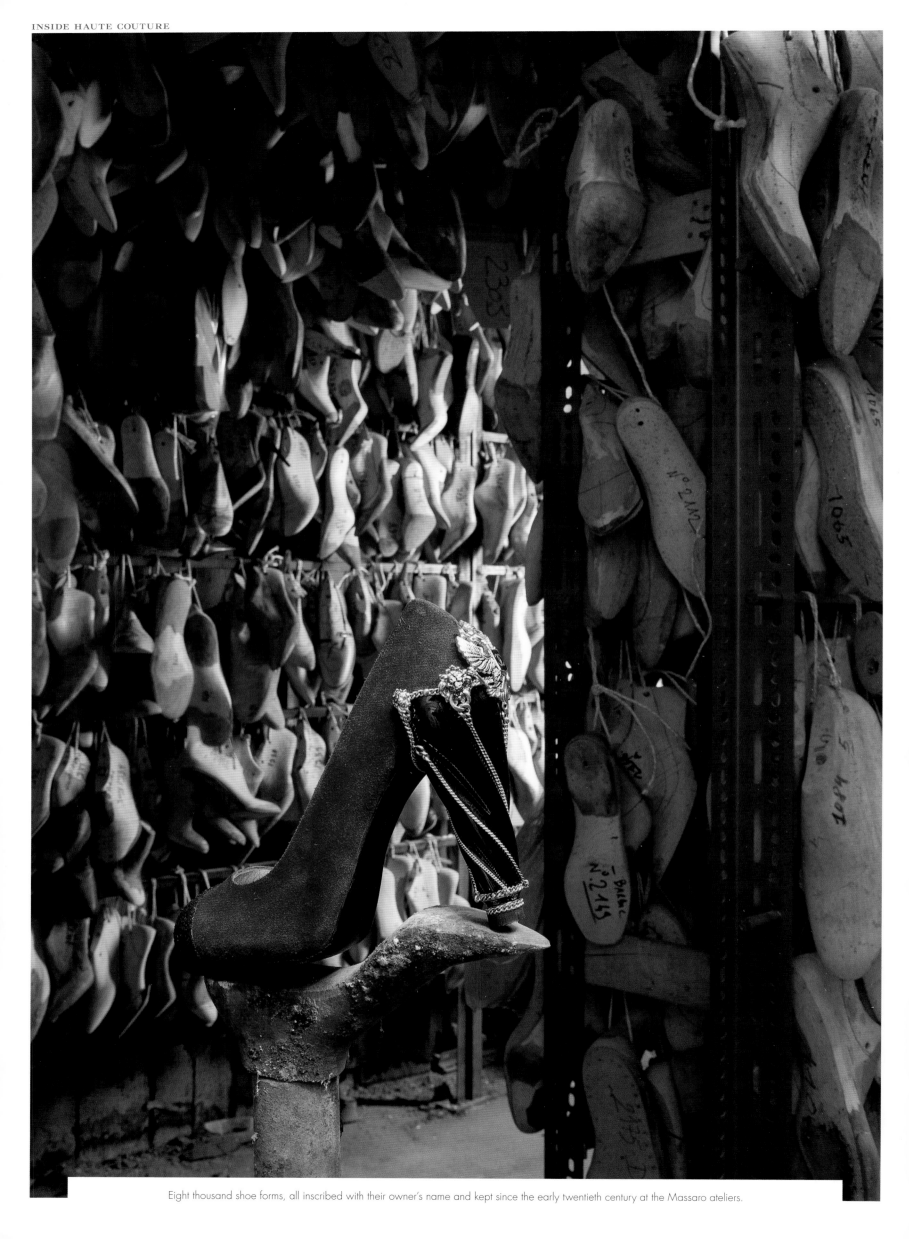

Eight thousand shoe forms, all inscribed with their owner's name and kept since the early twentieth century at the Massaro ateliers.

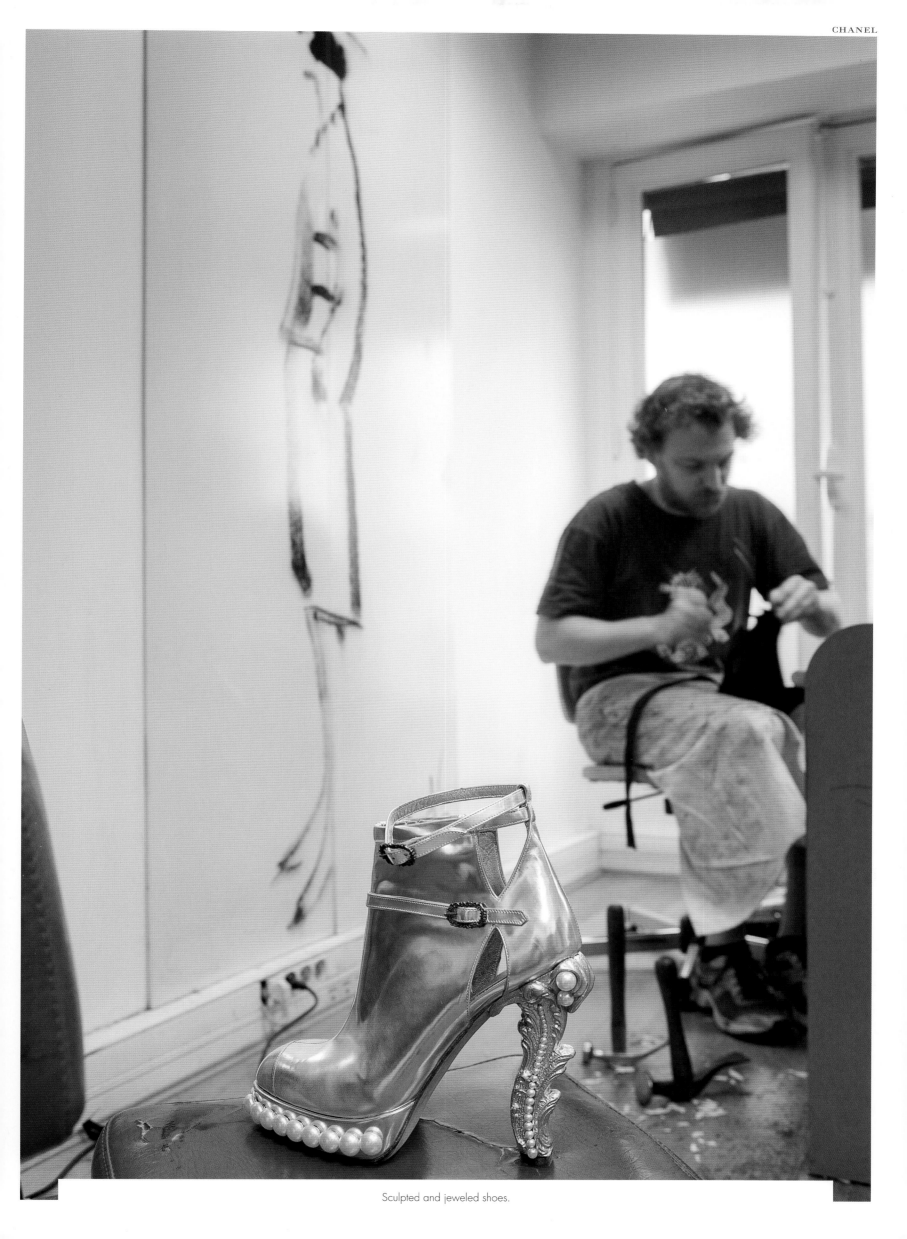

Sculpted and jeweled shoes.

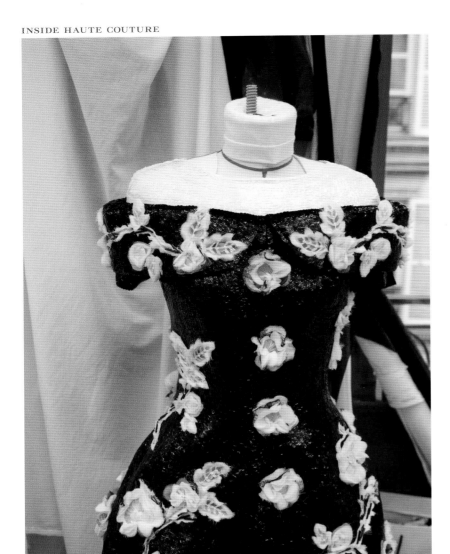

The Chanel ateliers on the fourth floor of 31, rue Cambon. TOP LEFT: Chanel's 2013 spring–summer haute couture collection presents floral motifs of the 1930s from the archives of the Victoria and Albert Museum in London.

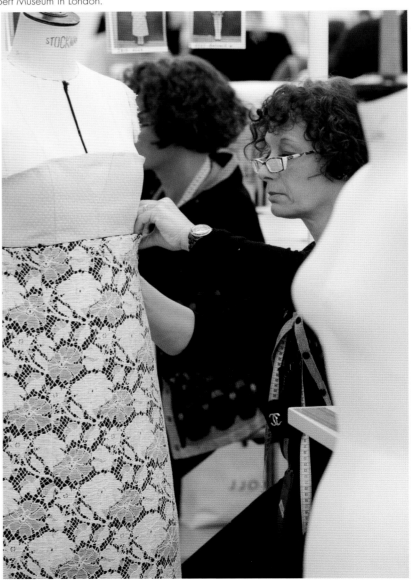

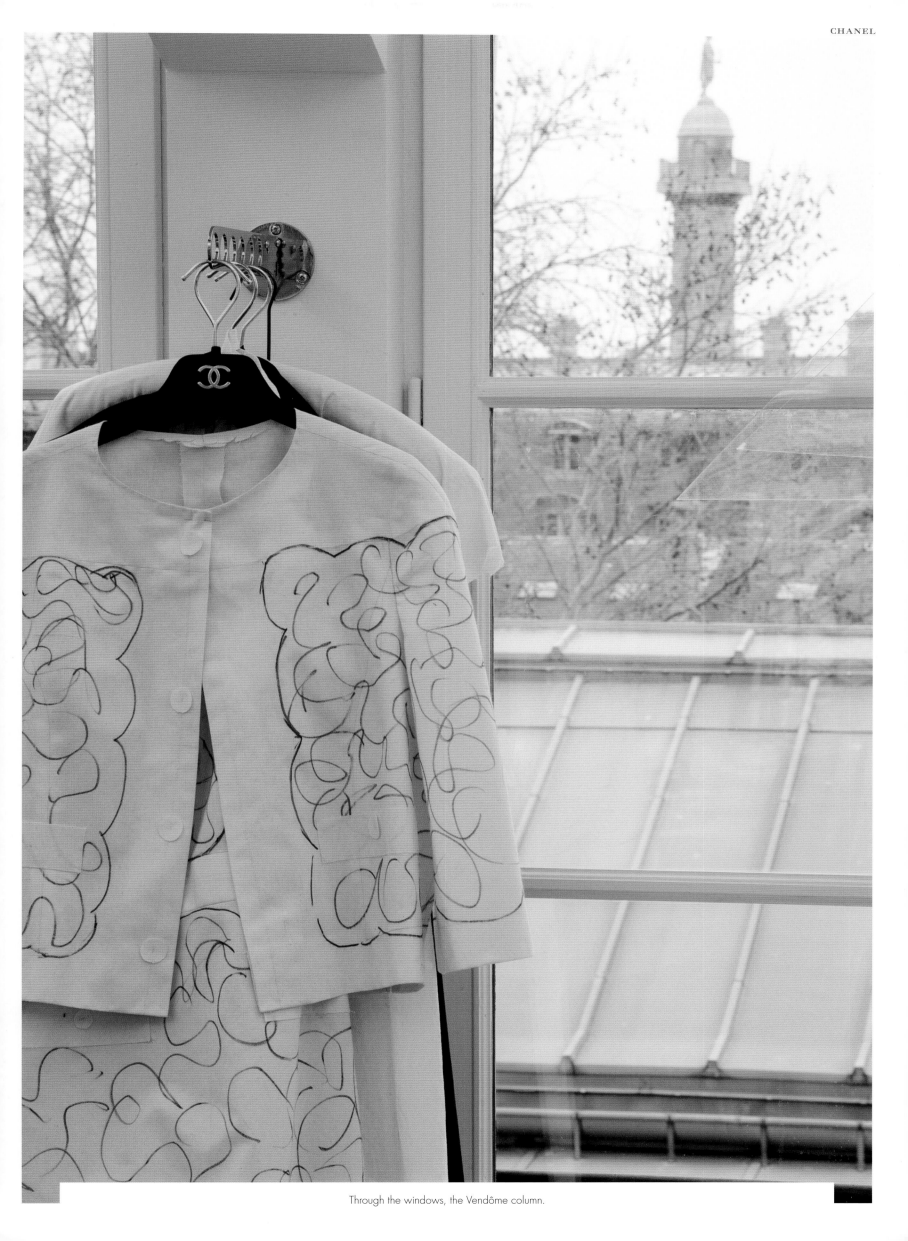

Through the windows, the Vendôme column.

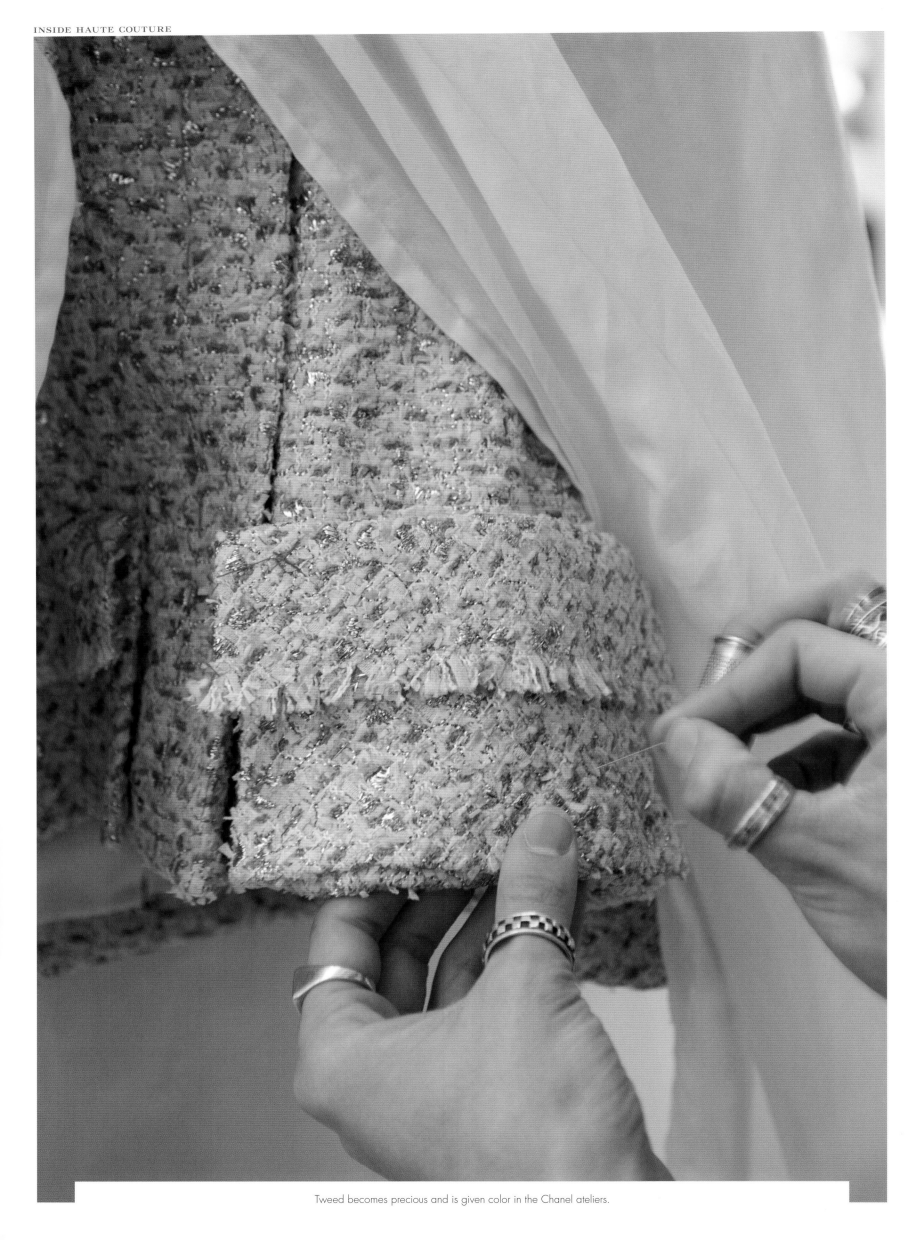

Tweed becomes precious and is given color in the Chanel ateliers.

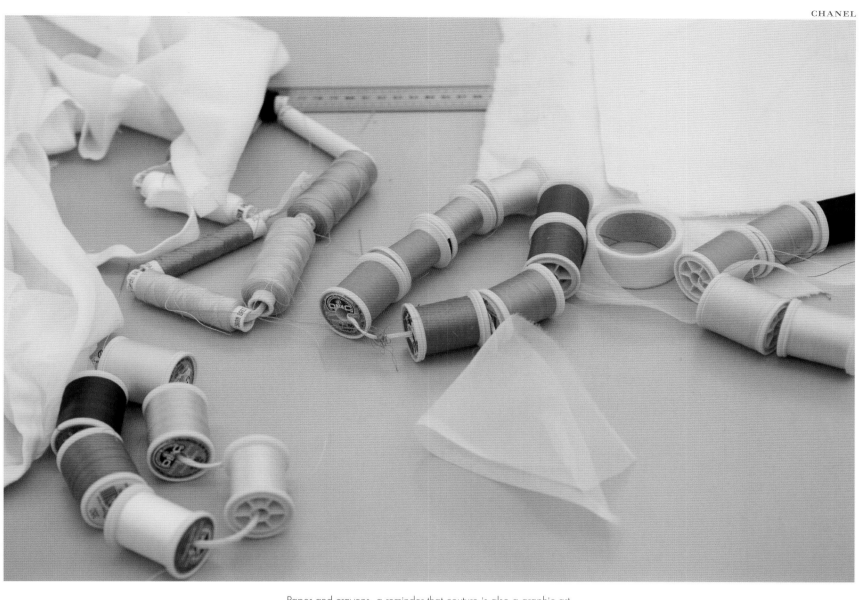

Paper and crayons, a reminder that couture is also a graphic art.

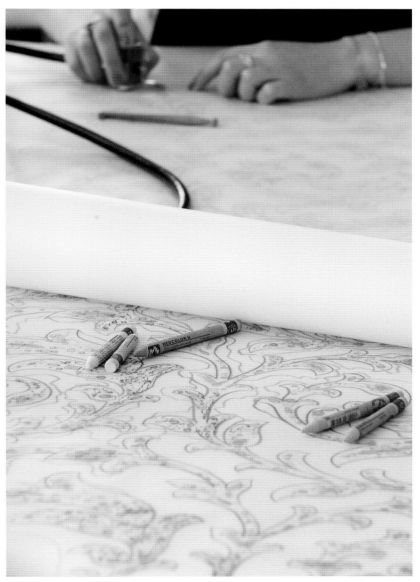

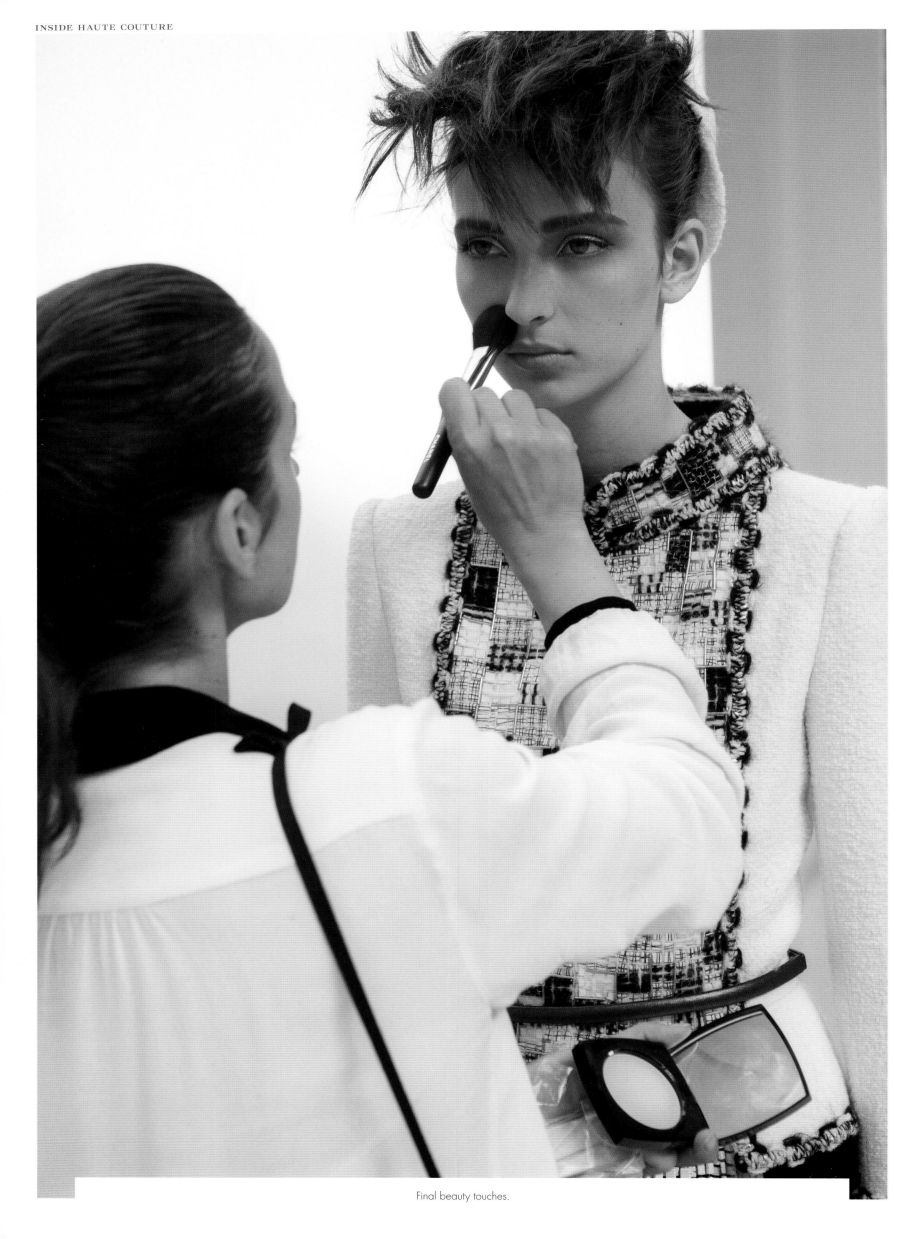

Final beauty touches.

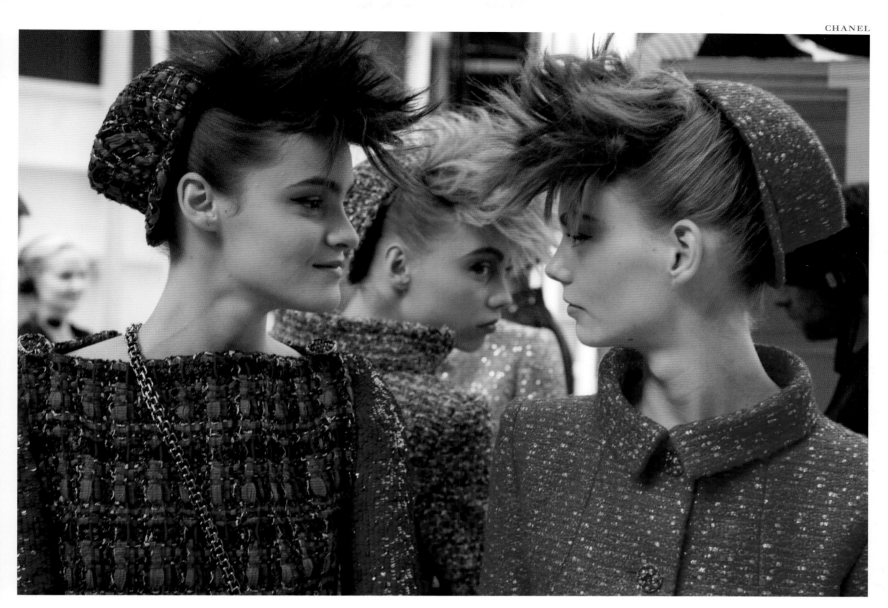

The lineup just before the start of the fall–winter 2014–2015 runway show.

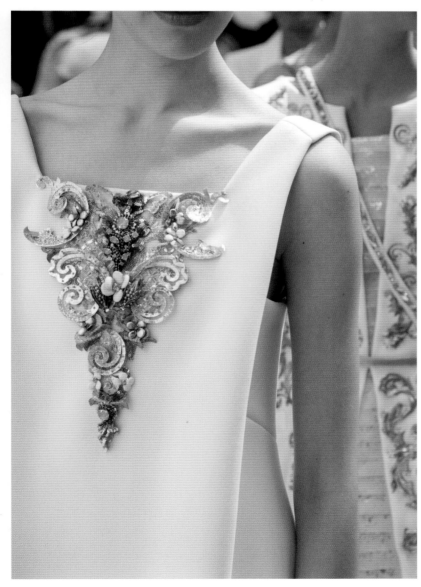

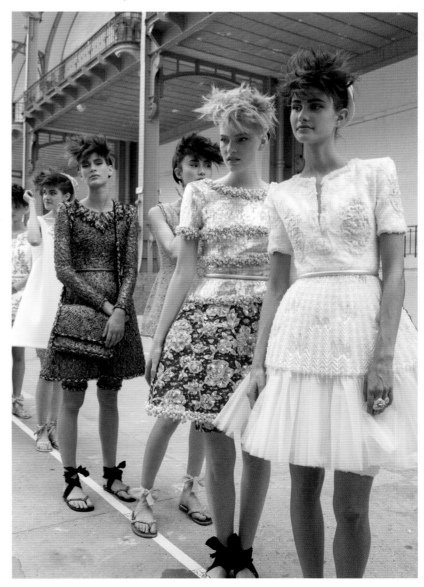

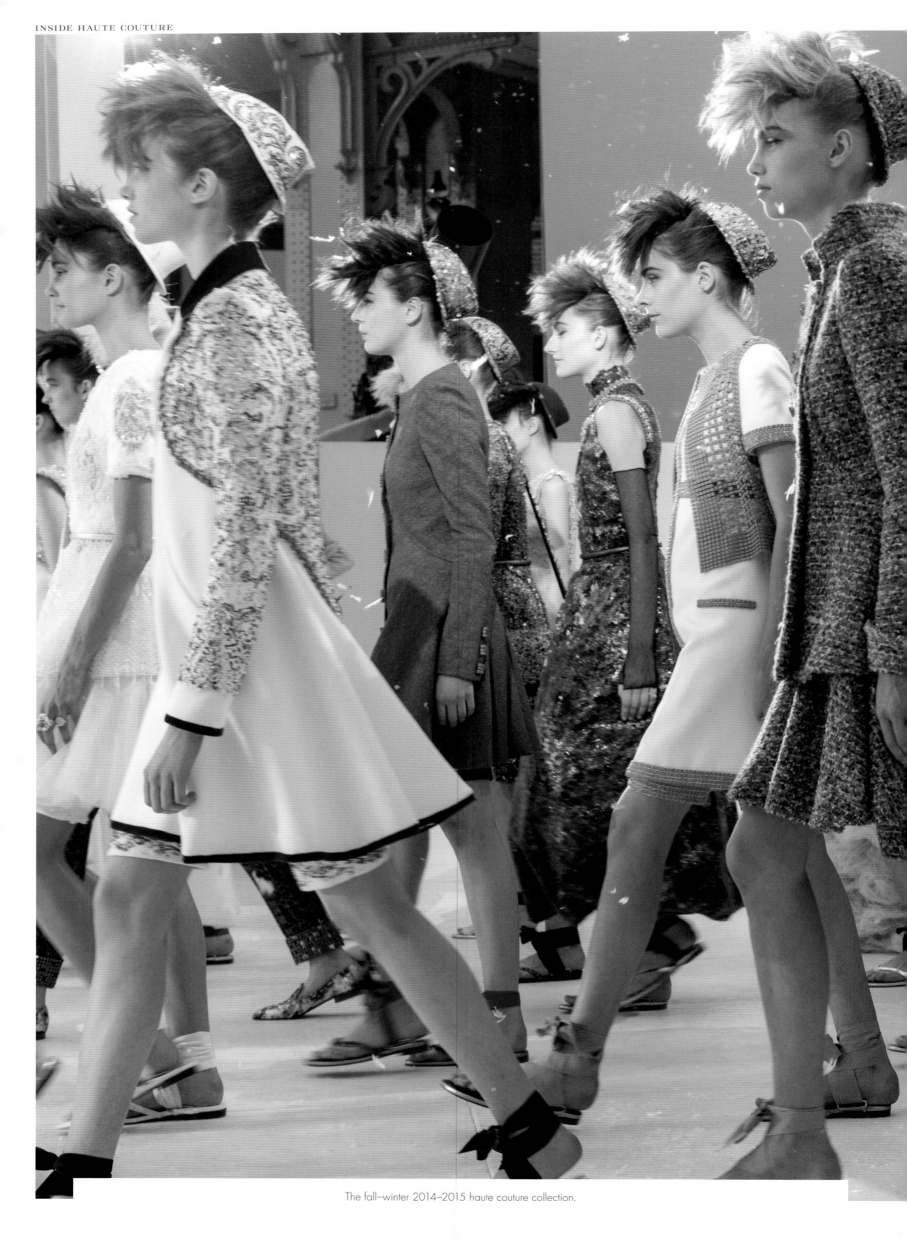

The fall–winter 2014–2015 haute couture collection.

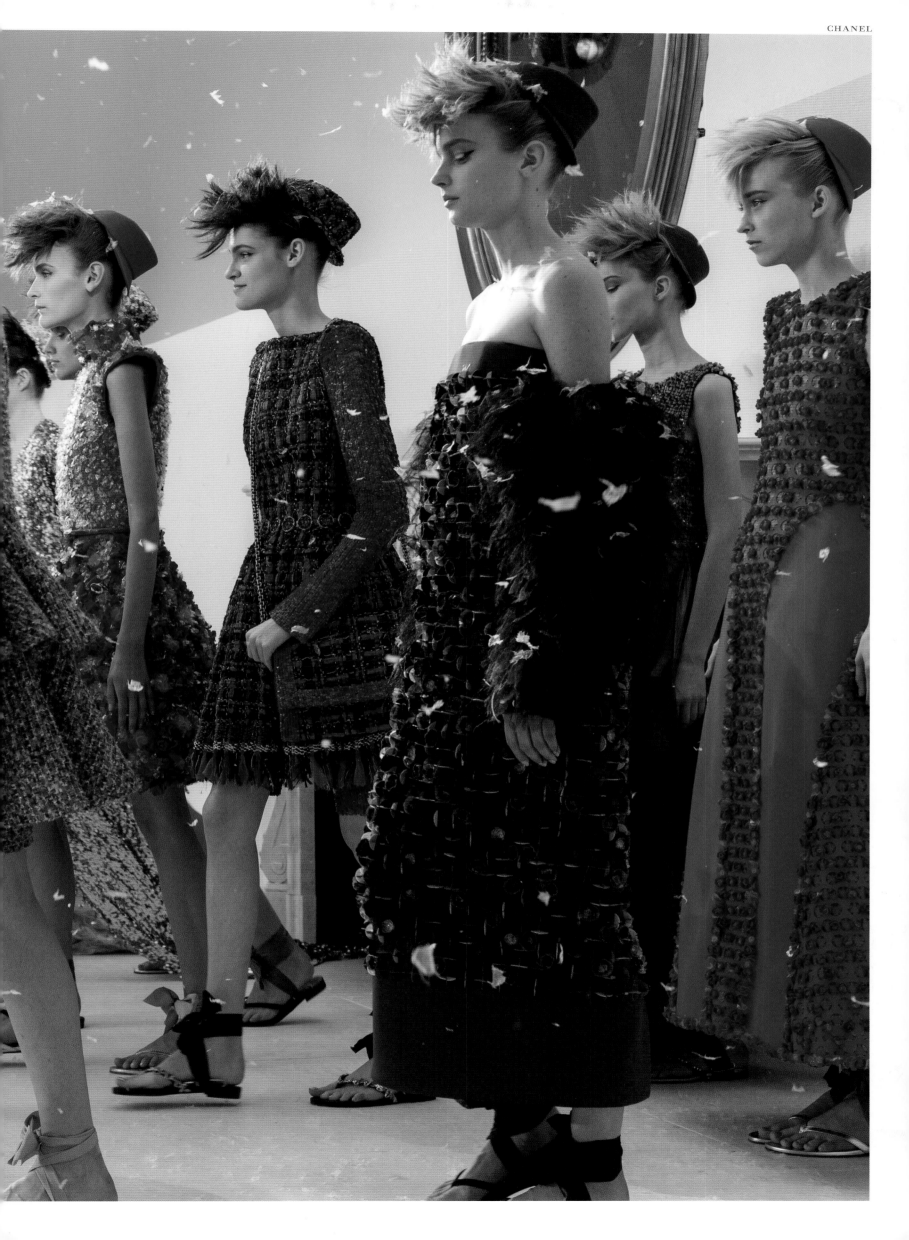

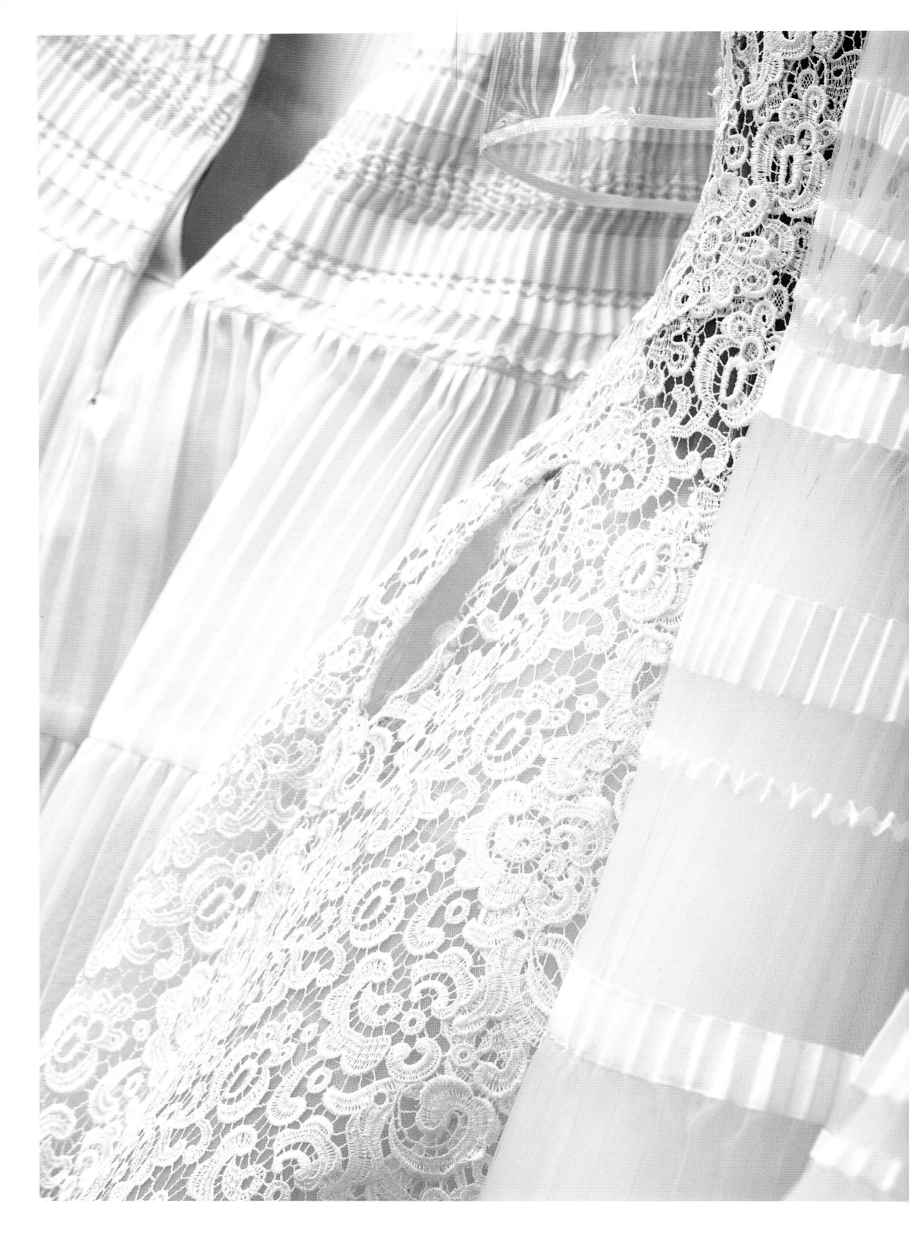

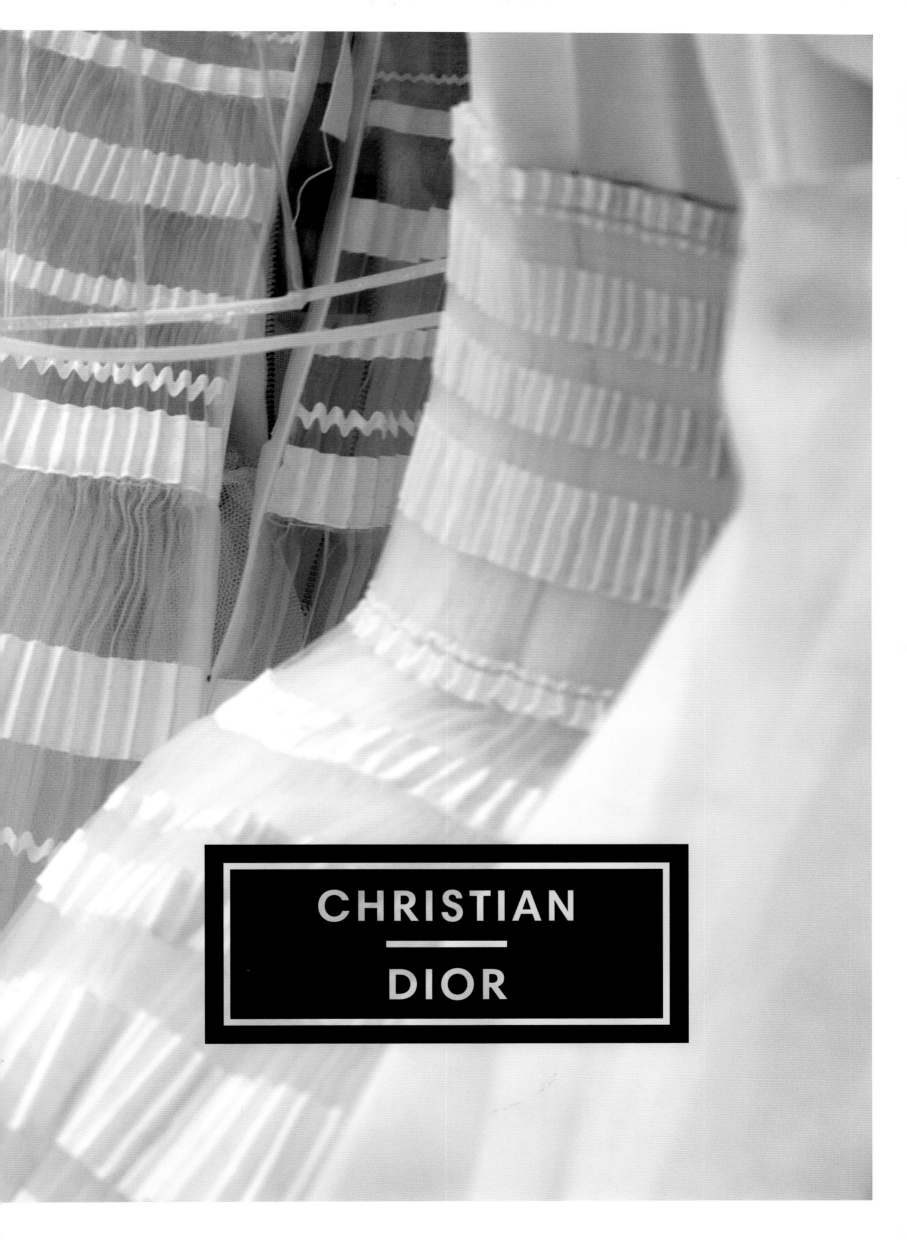

Christian Dior

30, AVENUE MONTAIGNE

It was in Paris's prestigious eighth arrondisse-ment and textile center that, in 1946, French entrepreneur Marcel Boussac, the "king of cot-ton," invested sixty million francs in Christian Dior's house of haute couture. A bold choice for the textile manufacturer. While three yards were once enough to make a dress, a Dior dress required twenty!

Challenging Gabrielle "Coco" Chanel's war-time, practical fashions, Dior brought back a fuller but corseted style he deemed feminine, glamorous, and opulent. He wanted to create "flower-women, with soft shoulders, full busts, and tiny waists."[1] And following the hardships of the Occupation, Frenchwomen went mad for the dream he provided them: insecurity and anxiety replaced by elegance and luxury!

Dior's first runway show on February 12, 1947, shattered the mores of wartime fashion and introduced the ultra-feminine "New Look" (so named by Carmel Snow, editor-in-chief at *Harper's Bazaar*) in women's wear. Cinched waist, full skirt, rounded shoulders—this avant-garde trio was revolutionary! It drastically con-trasted with the 1940s silhouette, which favored straight skirts and square shoulders. Ninety models presented two principle lines: "Corolle," inspired by flower forms, and "En huit," which had an angelic aspect. A signature of this first collection was the iconic Bar suit, consisting of a long, flowing skirt and basque jacket. In the Dior ateliers, the head *tailleur* was a certain Pierre Cardin, now a famous designer in his own right.

The new trend of more lavish garments soon spread around the world. At the same time, Dior audaciously launched a fragrance, Miss Dior, with distinctive floral and woodsy notes; the fashion designer was convinced that perfume was a dress's final touch. The scent would be fol-lowed by Diorama in 1948, Eau Fraîche in 1953 (the first unisex fragrance), Diorissimo in 1956, Eau Sauvage, a men's cologne, in 1966, and oth-ers, the long list crowned in 1999 by the iconic J'adore, a refined and sensual perfume with gen-erous bouquet that is always a top seller in France.

As early as 1948, Dior, the great visionary that he was, decided to conquer the United States as well as Paris. He launched Christian Dior Inc. on the corner of Fifth Avenue and Fifty-Seventh Street, where prêt-à-porter clothing and acces-sories could be purchased. Avidly courted by the American press, he was the first fashion designer to make the cover of *TIME* magazine, on March 4, 1957. Hollywood celebrities, including Olivia de Havilland, Rita Hayworth, Ava Gardner, Marilyn Monroe, Lauren Bacall, and Elizabeth Taylor were mad for his designs, and Marlene

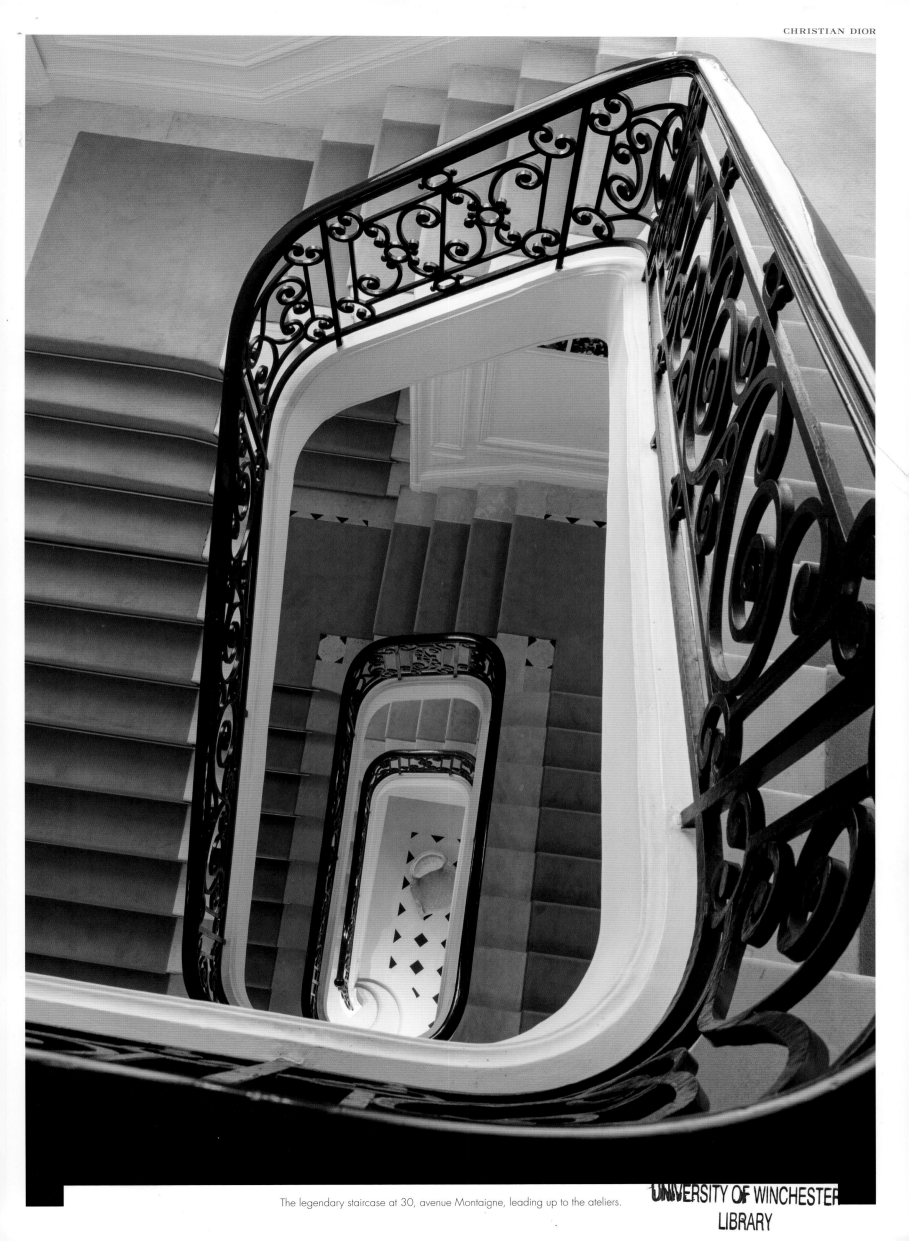

The legendary staircase at 30, avenue Montaigne, leading up to the ateliers.

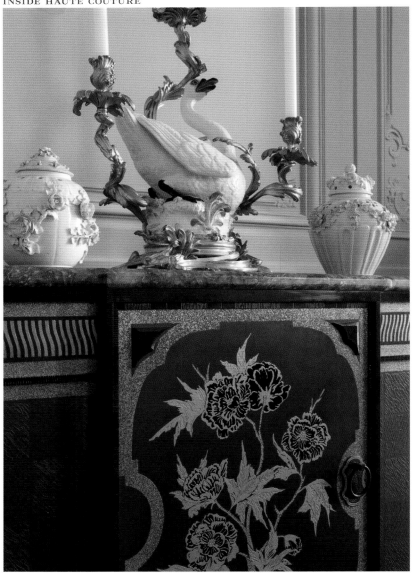

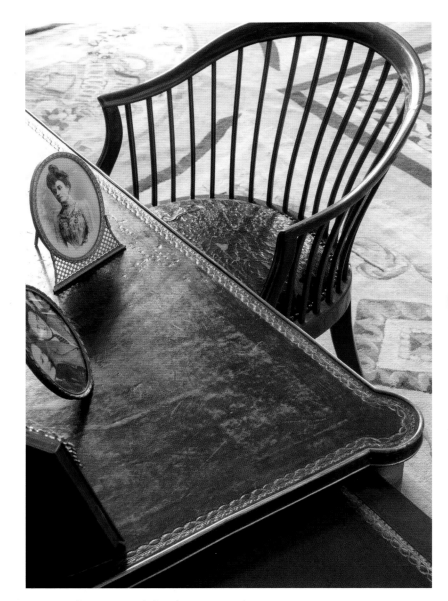

ABOVE LEFT: A straw marquetry secretary with chinoiserie. **ABOVE RIGHT:** Christian Dior's desk in the Louis XVI style.

Dietrich refused to star in a film unless Dior created her costume: "No Dior, no Dietrich!"

A self-taught businessman, Dior laid the foundations of a true empire by introducing a distribution-and-licensing policy. Wholesale manufacturers of thousands of articles bearing his name paid him royalties. Fully aware of the impact of communications, he also opened public-relations offices throughout the world, which helped secure his fame.

A genius of fashion, in ten years Christian Dior expanded his business into fifteen countries, with seventy-six thousand employees. In 1957, his house was responsible for more than half the exports of French couture.

Ever since the first runway show, Dior's every collection has been an event. Announcing the end of the New Look in 1953, Dior launched his "H" line (for *haricot vert*, or string bean), signaling an end to the curves of his past dresses. This leaner look, however, didn't stop the New Look from being reinterpreted by every Dior designer to come after Christian: Marc Bohan in 1987, John Galliano in 1997, and Raf Simons, who went back to the fundamentals in 2012.

Ten years after his first show, Dior had sold more than one hundred thousand patterns! Exhausted, the relentless worker retired in 1956 to his Château de la Colle Noire to write his memoirs. He died of a heart attack in 1957 at the age of fifty-two. He had just presented his last collection, "Fuseau," which he designed with his first assistant, Yves Saint Laurent. His friends described Christian Dior as a generous man, funny, enjoying life, but he remained discreet and we know little about his private life.

From 1996 to 2011, John Galliano lent an ultra-sophisticated style to the House of Dior, featuring brightly colored elegance and rich references to fashion history, resulting in visual fireworks at the runway shows.

Galliano's polar opposite, Raf Simons, creative director of Jil Sander women's and men's prêt-à-porter, was asked to head Dior in 2012, and his work shines with a minimalist Belgian esthetic. Born in Neerpelt in 1968, he studied industrial and furniture design in Genk. Each of his collections proves his compatibility with the avenue Montaigne company, easily reviving the brand's identity while also introducing his own distinctive style.

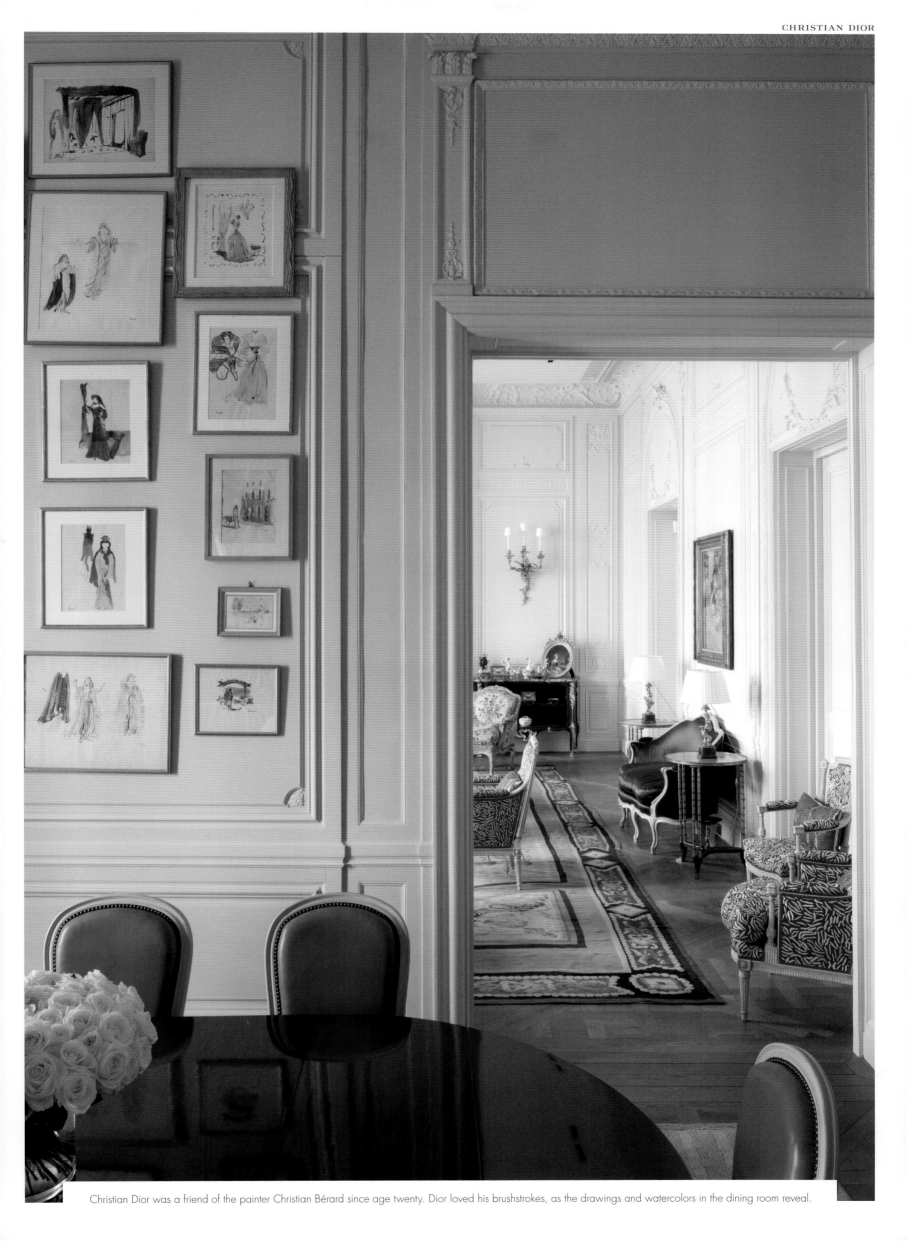

Christian Dior was a friend of the painter Christian Bérard since age twenty. Dior loved his brushstrokes, as the drawings and watercolors in the dining room reveal.

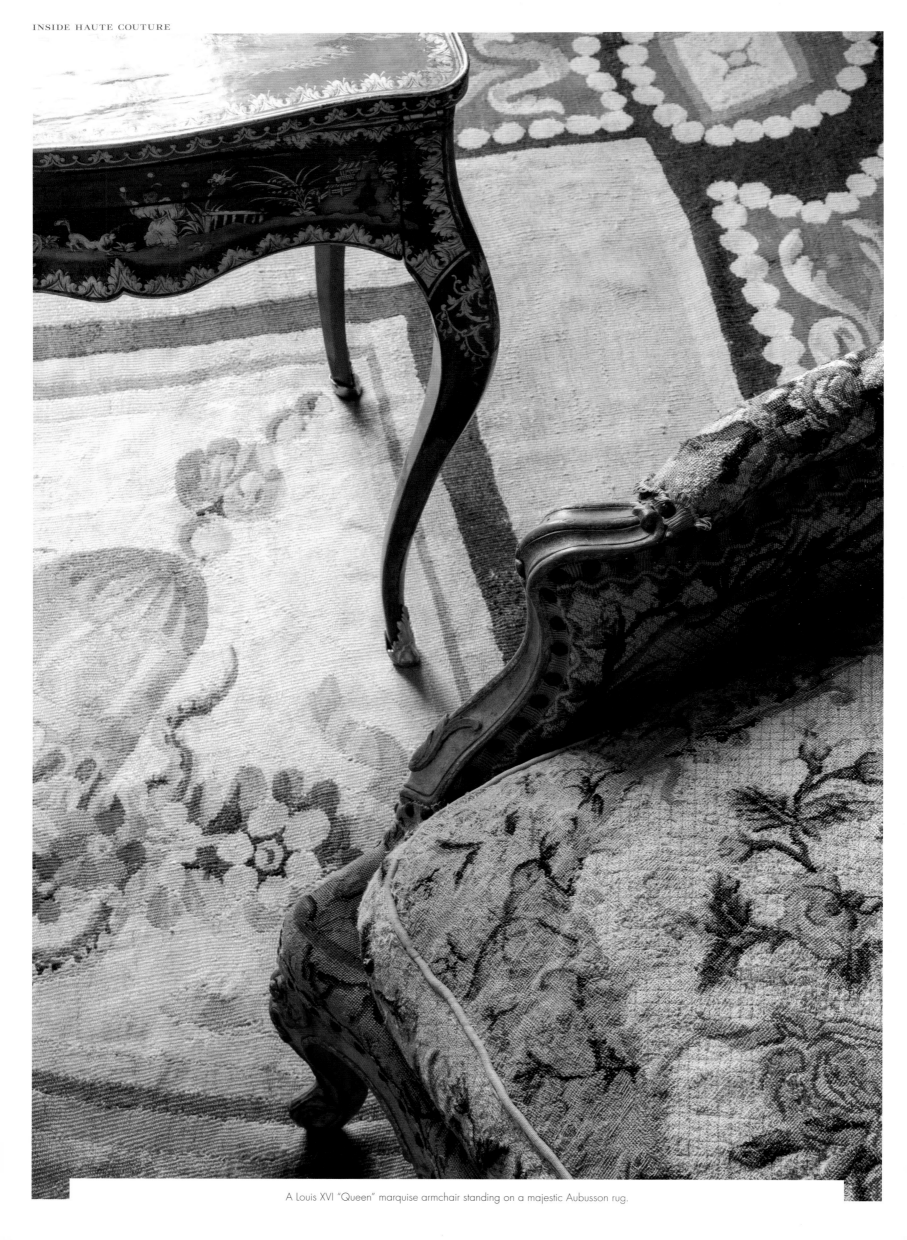

A Louis XVI "Queen" marquise armchair standing on a majestic Aubusson rug.

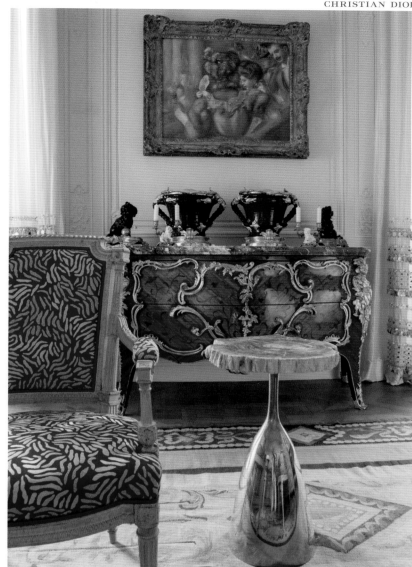

ABOVE LEFT: *La Portrait de Jeune Femme à la Robe Bleue*, attributed to Jean-François Garneray. ABOVE RIGHT: Auguste Renoir's *La Loge au Théâtre des Variétés*.
BELOW: Family photographs on a Louis XV desk.

IN CHRISTIAN DIOR'S APARTMENT

Long ago, charmed by the compact but elegant proportions of two small adjacent town houses on avenue Montaigne, numbers 28 and 30, Christian Dior resolved to one day locate his fashion house in them. Years later, in 1946, as fate or luck would have it, the designer was looking for a location when the town house at 30 avenue Montaigne became available. There, interior designer Victor Grandpierre re-created the neoclassical atmosphere of Dior's childhood paradise, ending up with a twentieth-century version of Louis XVI style. The fashion designer would write of the result in his memoirs, saying that the space was "simple without being dry, and especially so classic and Parisian, that this style could not in any way divert or distract one's eye from the collection."

Until 1957, models in haute couture dresses would, one by one, descend the town house's steep staircase during Dior's legendary runway shows. This staircase also led to the ateliers.

To pay homage to its founder, the House of Dior has restored this inspiring space and conserved the objects and works of art Christian Dior loved. All the elements of Dior's spirit are still there: a Toulouse-Lautrec painting and another by Auguste Renoir; a Claude Lalanne "Ginkgo" leaf table; mother-of-pearl-encrusted curtains reminiscent of his Granville childhood; a magnificent floral motif Aubusson rug; a bergère armchair dear to Marie Antoinette; *La Portrait de Jeune Femme à la Robe Bleue*, attributed to Jean-François Garneray; and, above all, the Louis XV desk on which stand photographs of happy family times in the Granville garden.

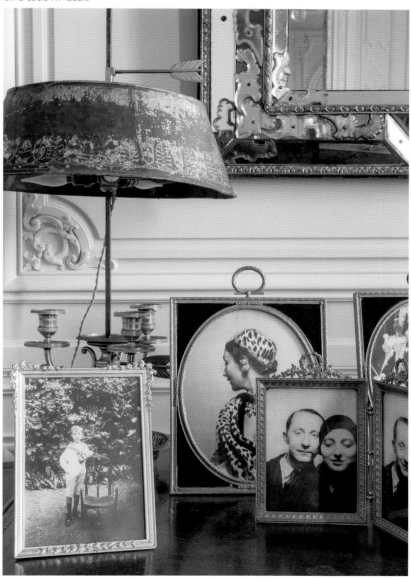

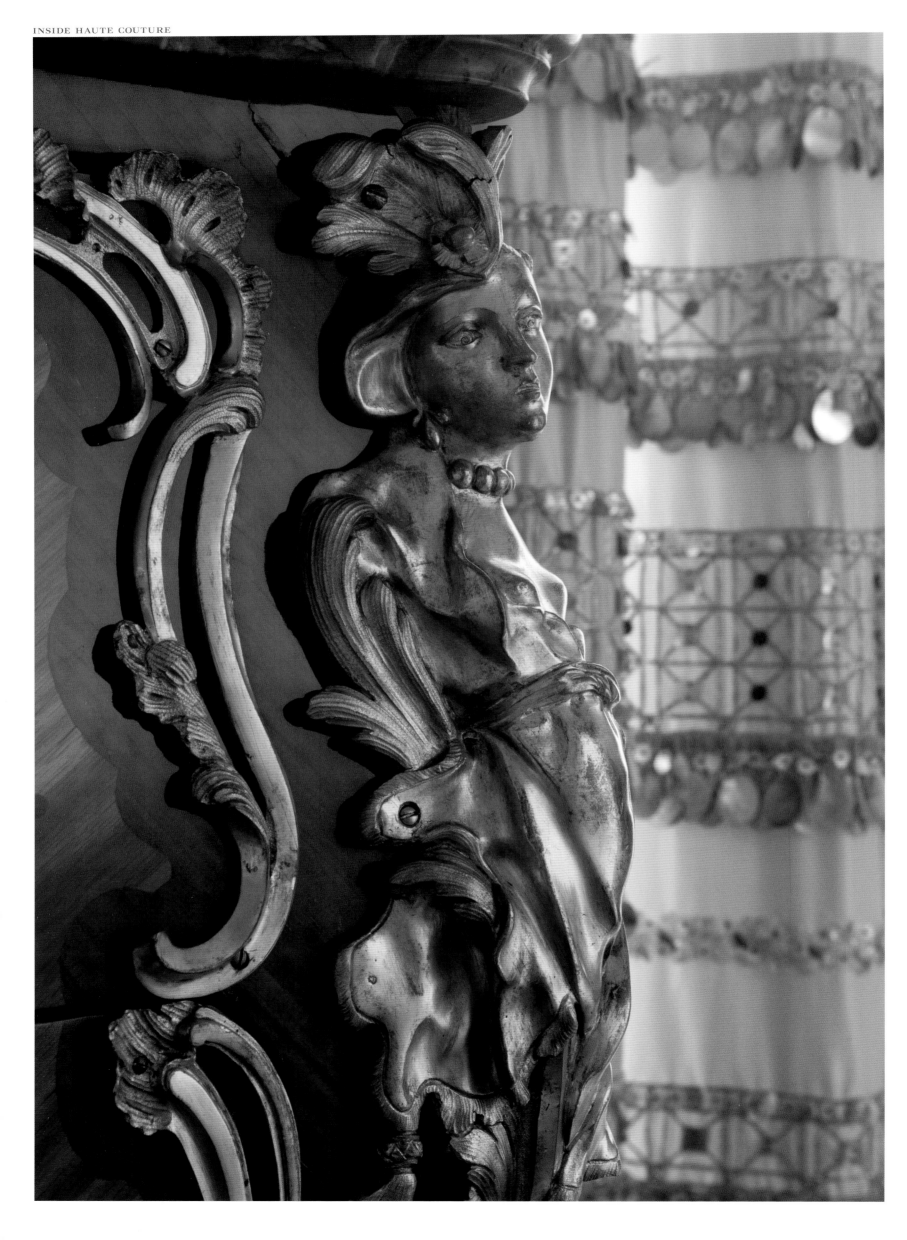

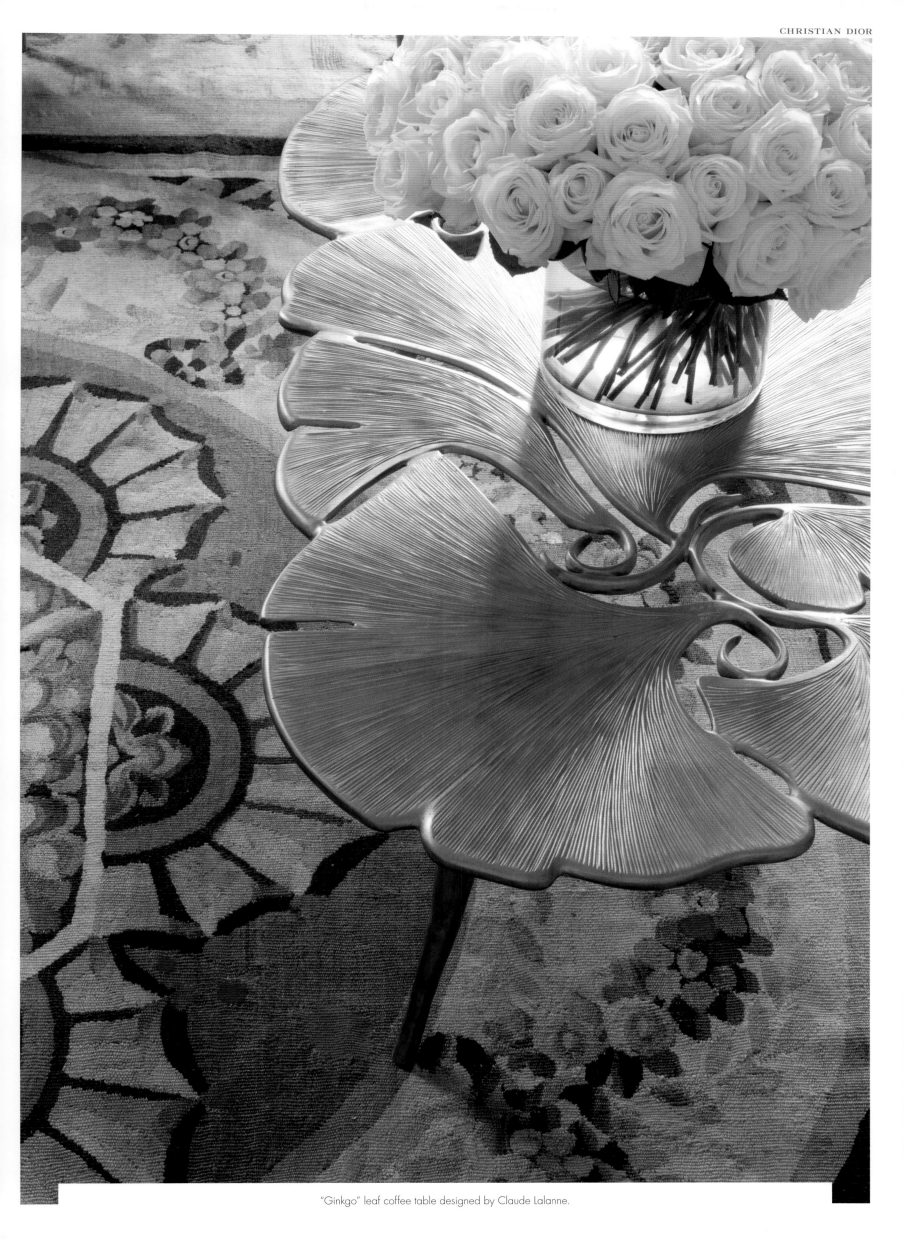

"Ginkgo" leaf coffee table designed by Claude Lalanne.

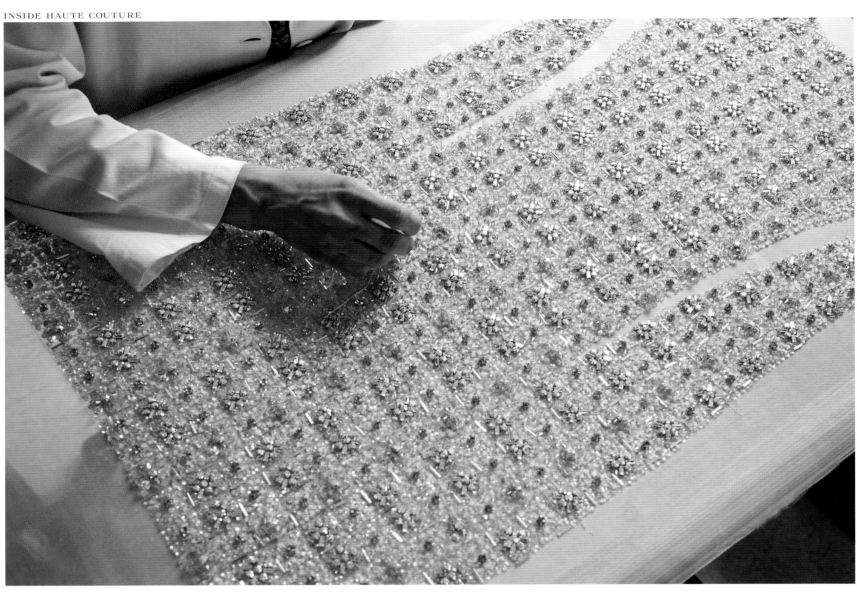

Delicate details produced by the Vermont embroidery atelier, acquired by Dior.

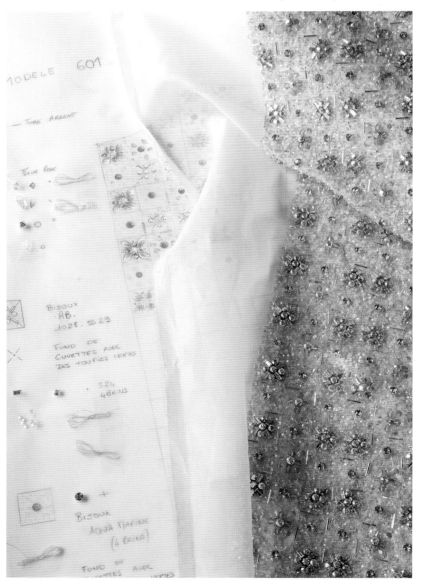

INSIDE THE ATELIERS

At 30, avenue Montaigne, Christian Dior started with three ateliers, a tiny design studio, a showroom, a changing room, a management office, and six small fitting rooms. Today, this address still anchors the House of Dior, its expansion into multiple buildings and addresses over the years revealing the growing influence of Dior's empire.

From 1947 to the present day, seamstresses in the House of Dior have continued to work their perfection, creating extraordinary collections. (This haute couture is first expressed in white muslin before being made in fabric that will give life to the dress's architecture.)

The Ateliers Broderies Vermont, acquired by Dior, make the embroidery for the collection, combining thread, cabochons, beads, sequins, and crystals to richly enhance the haute couture.

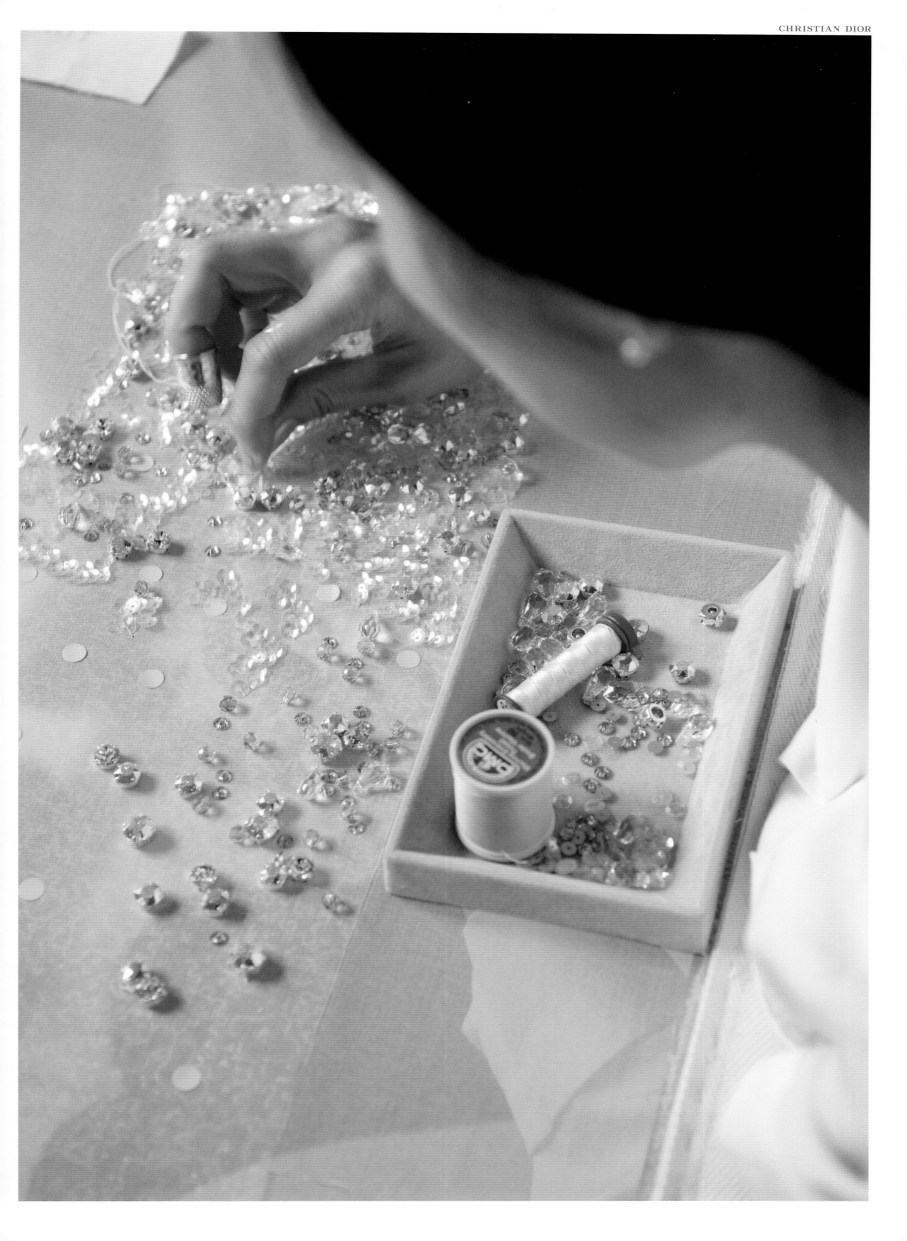

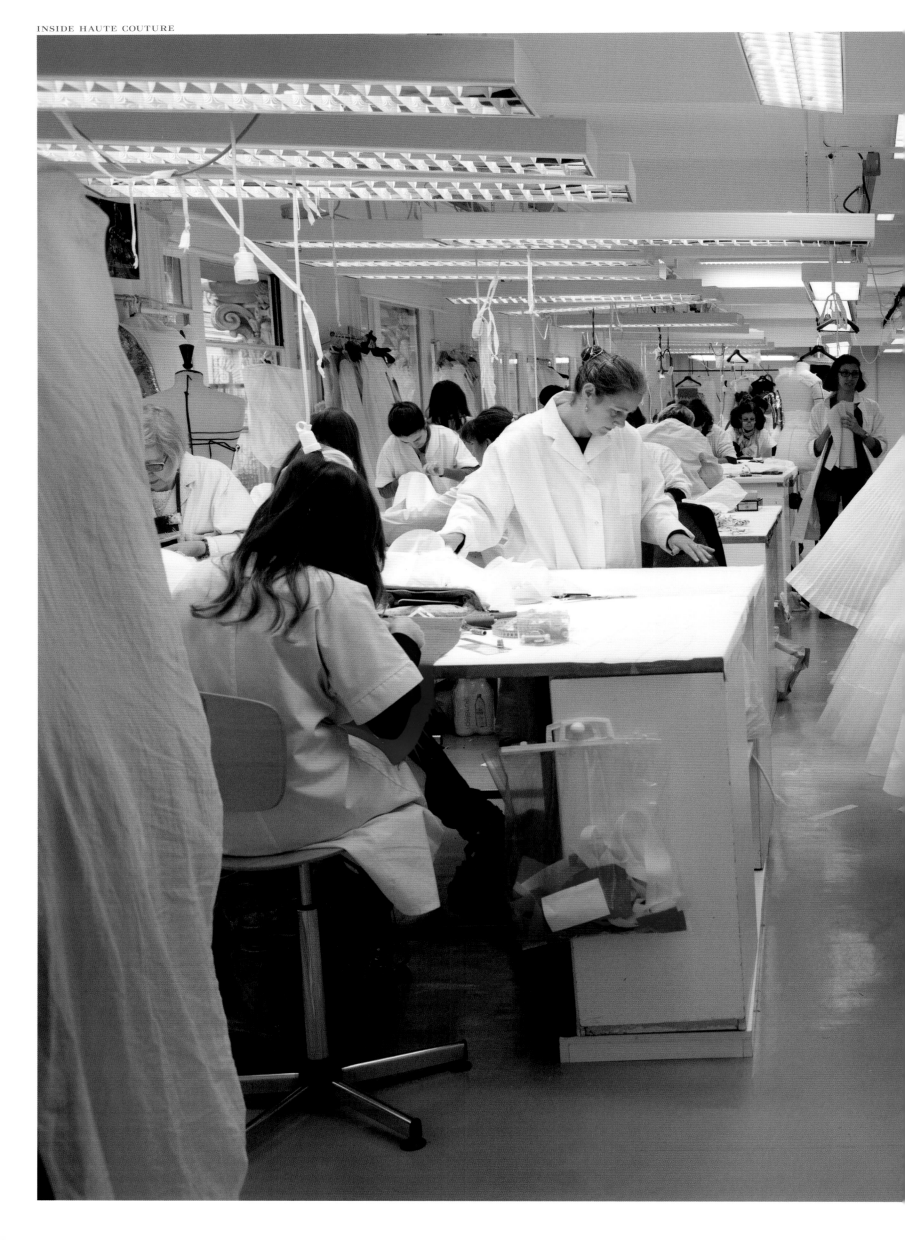

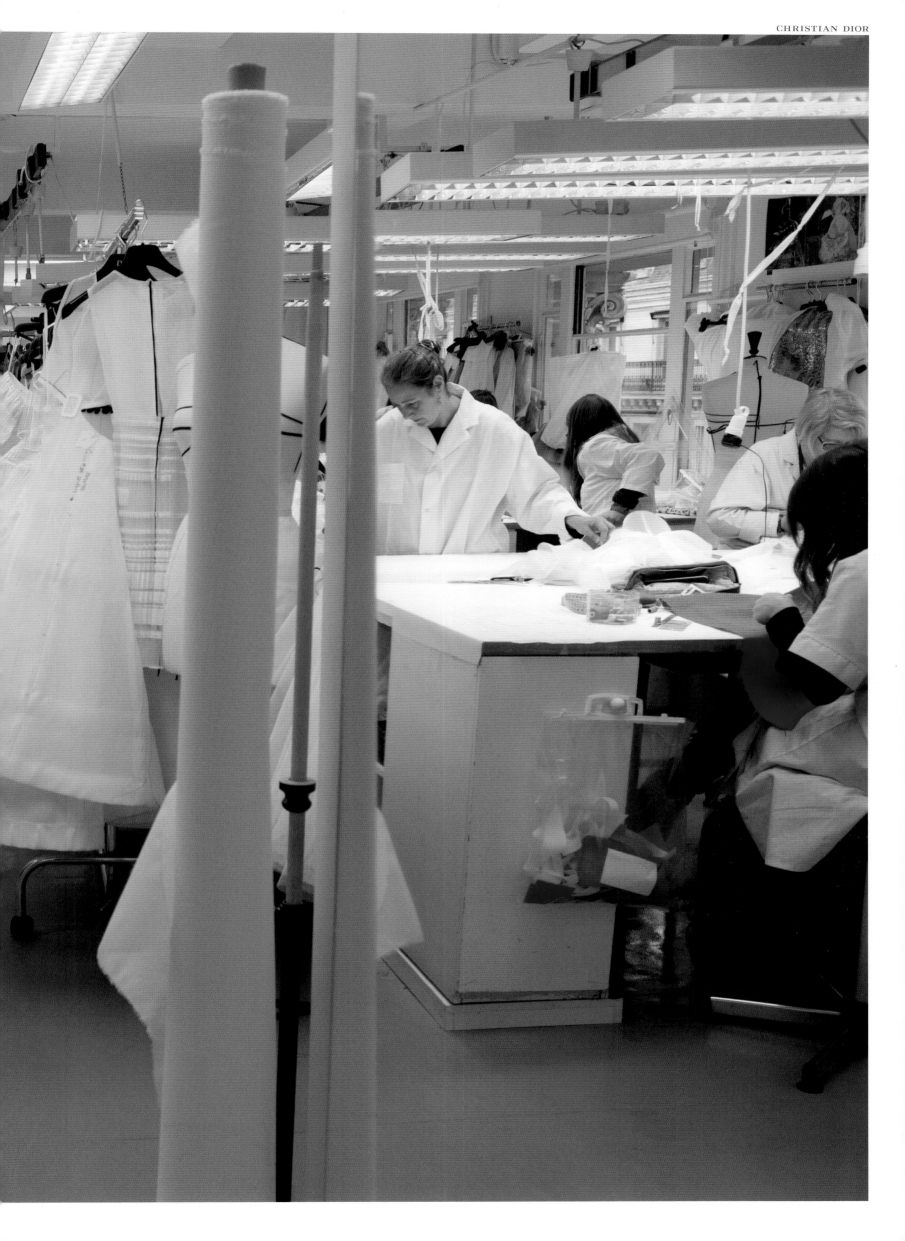

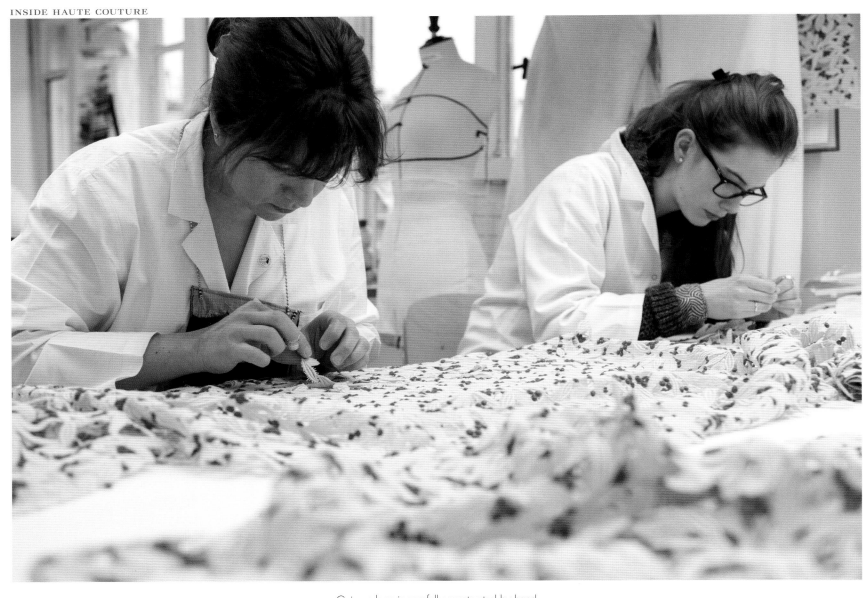

Guipure lace is carefully constructed by hand.

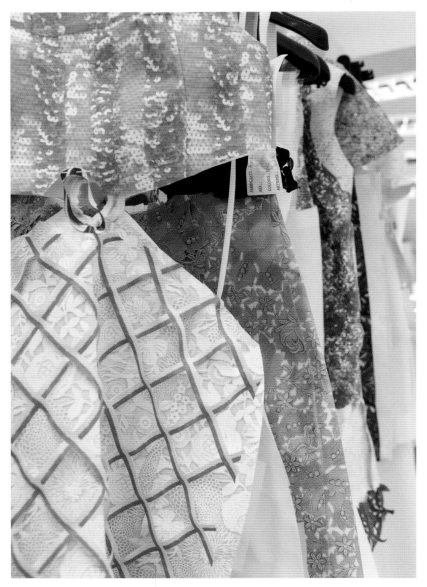

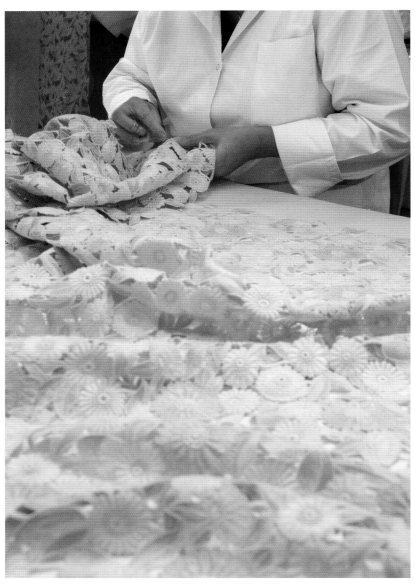

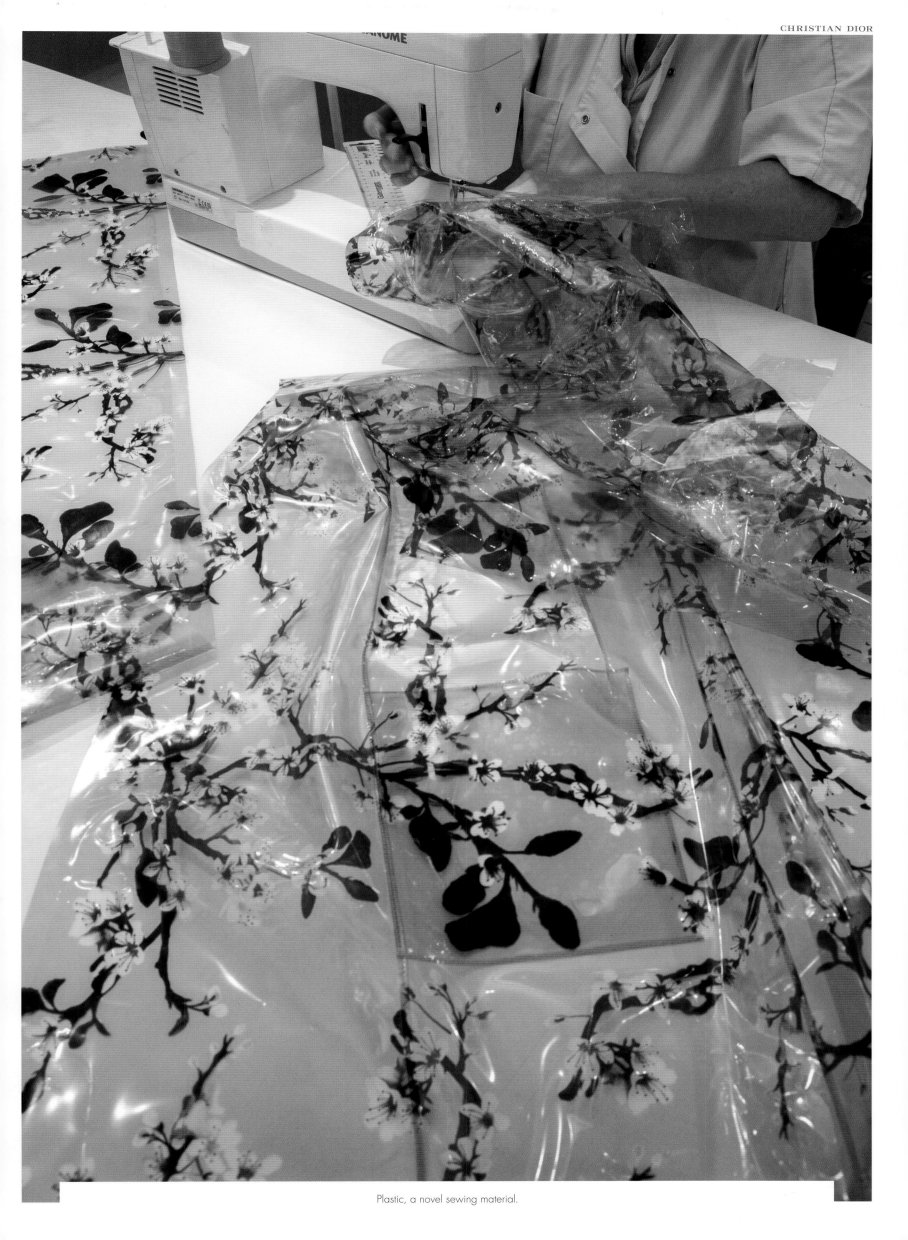

Plastic, a novel sewing material.

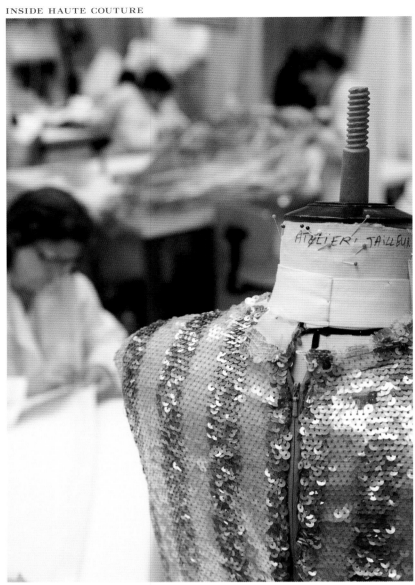

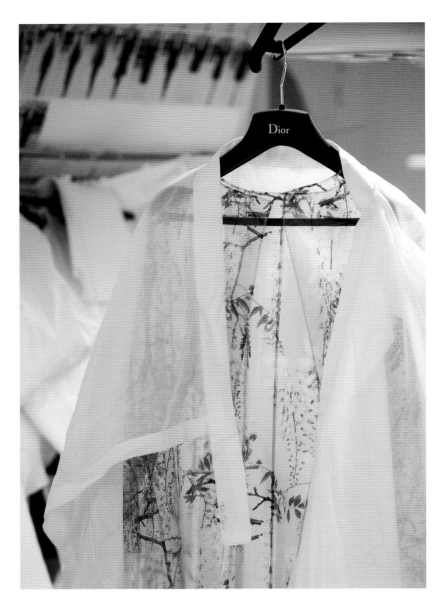

The *flou* (draping) atelier, where garments of crepe de chine, mousseline, lace, and other fragile or flowing fabrics are created.

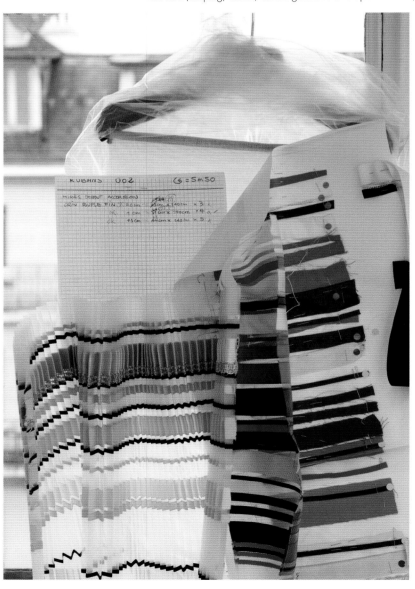

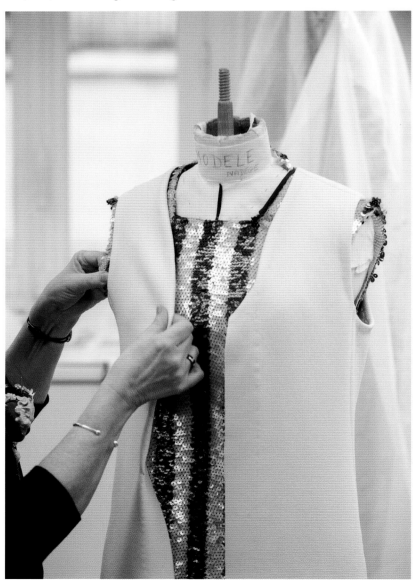

The *tailleur* (fitted) atelier, where architectural rigor reigns and the tailoring of structured fabrics takes place.

The same dress is indecent ten years before its time; daring one year before its time; chic in its time.

JAMES LAVER

Costume and Fashion: A Concise History, Thames & Hudson, 1990

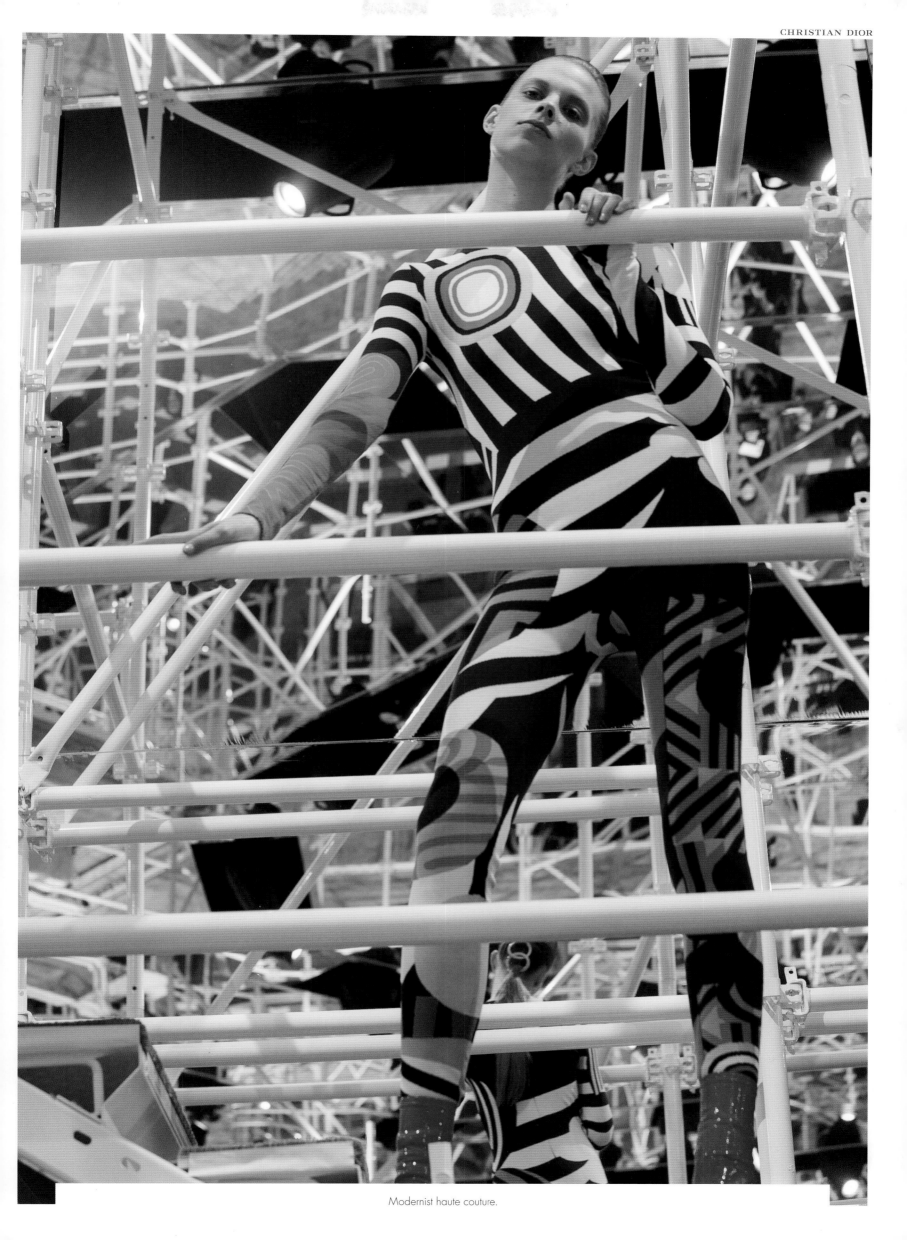

Modernist haute couture.

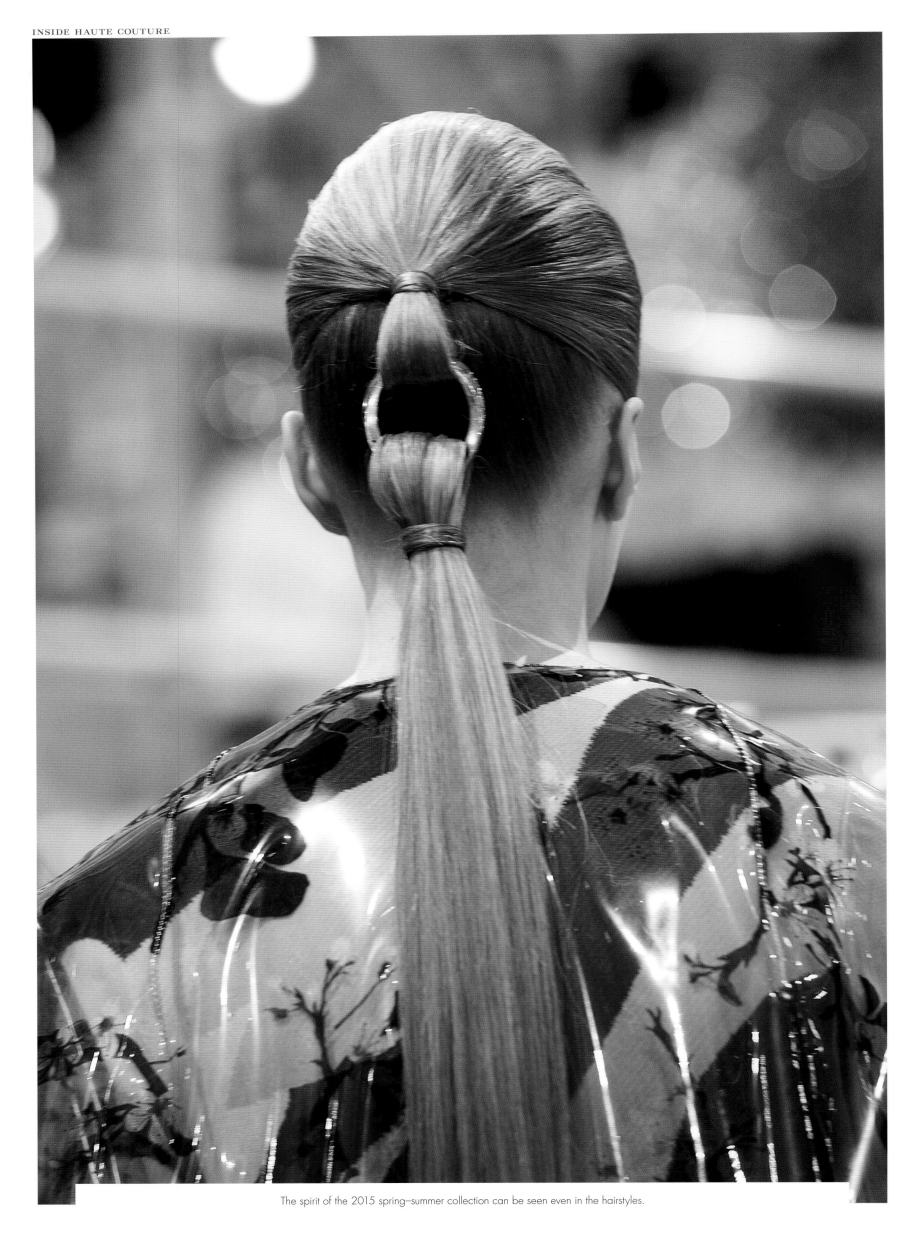

The spirit of the 2015 spring–summer collection can be seen even in the hairstyles.

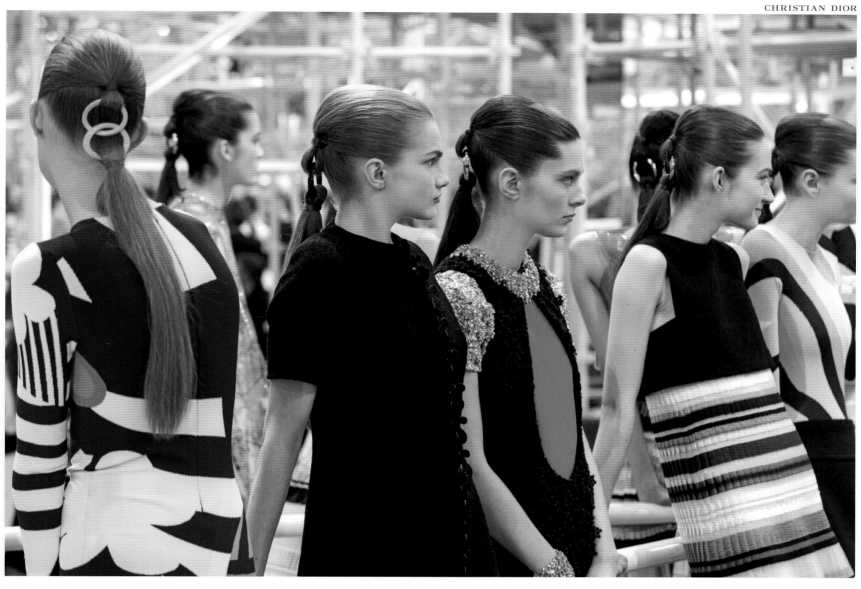

Beautiful creativity, from head to toe.

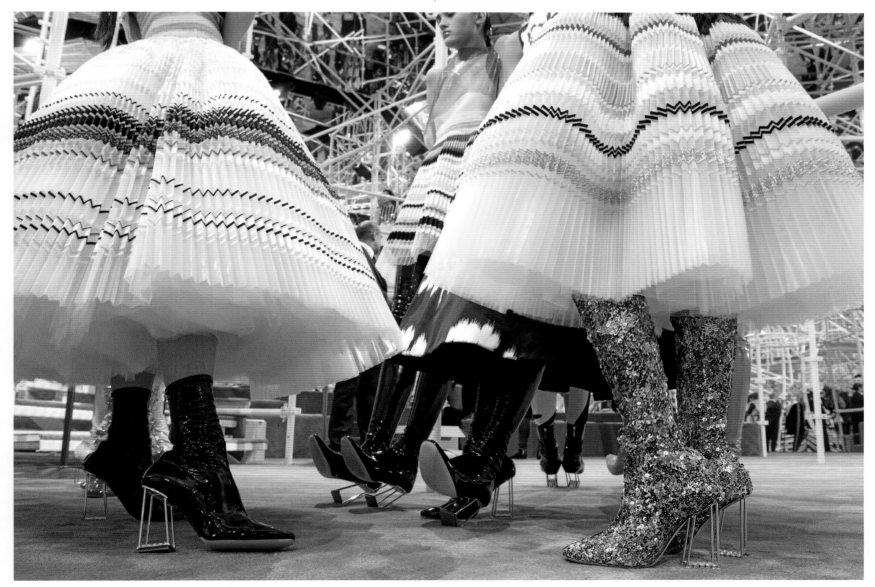

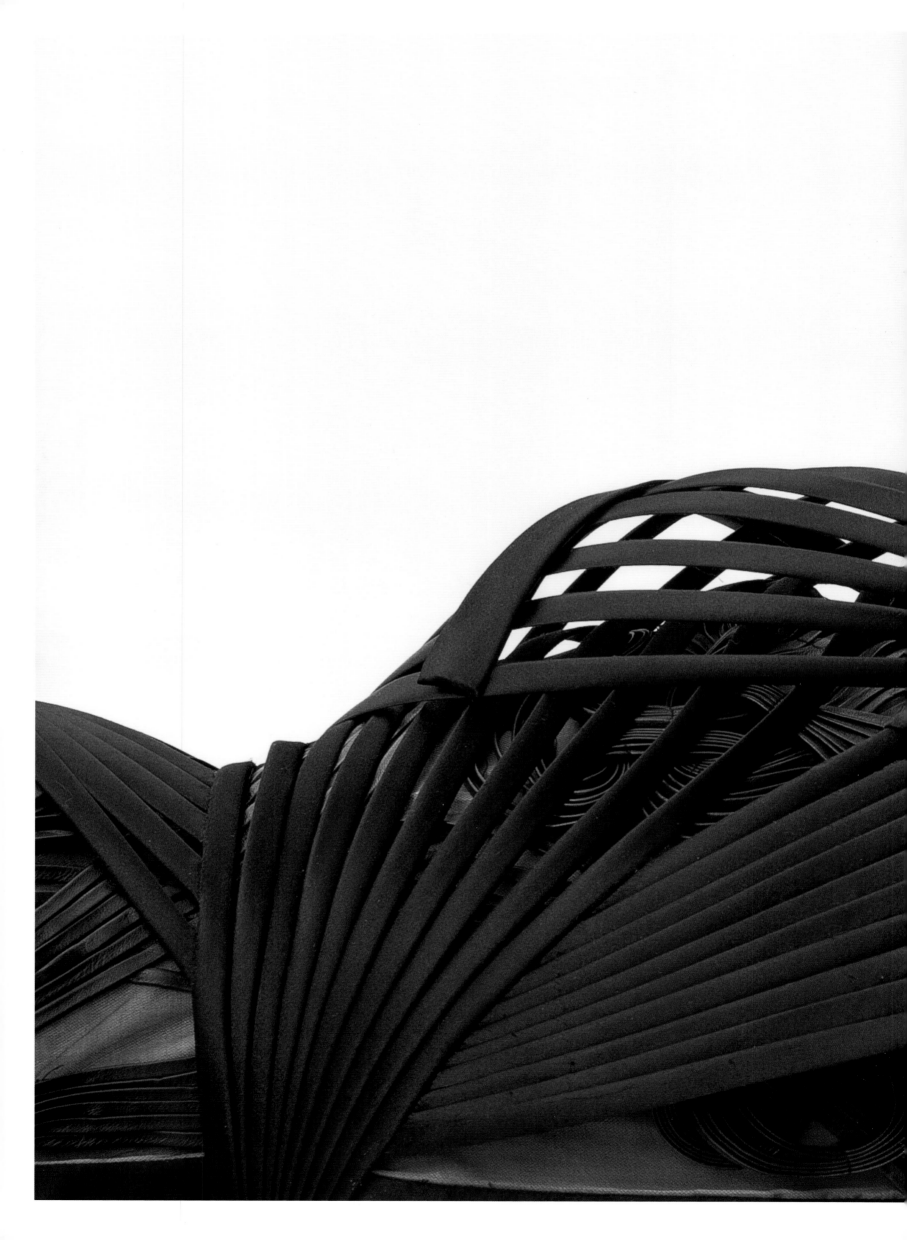

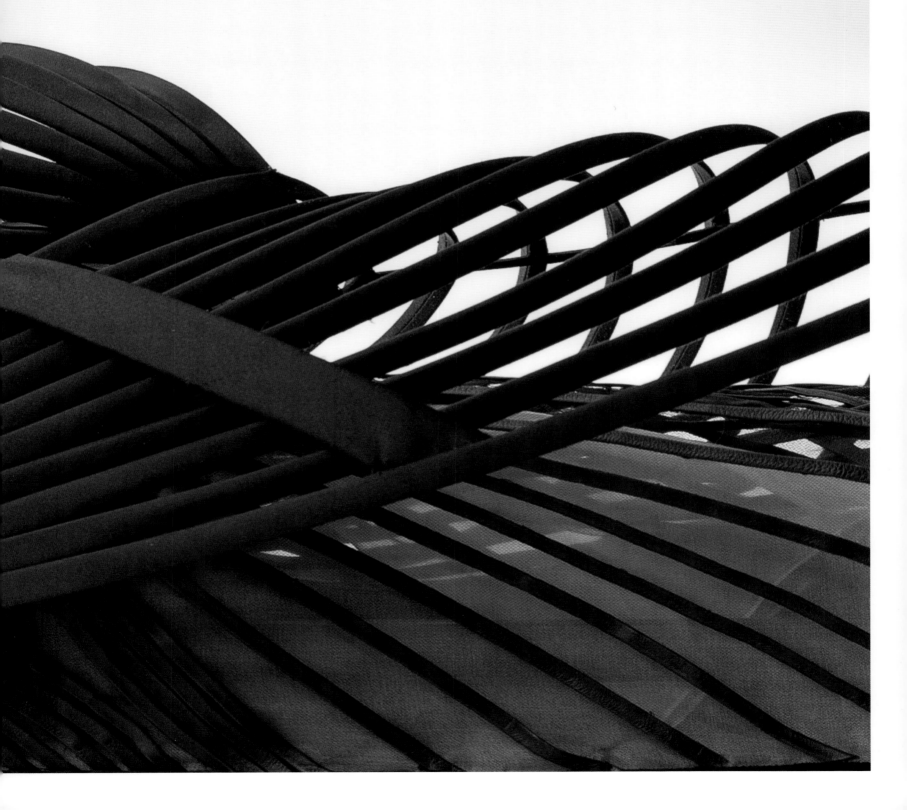

JEAN PAUL
GAULTIER

Jean Paul Gaultier

325, RUE SAINT-MARTIN

In Paris's third arrondissement, where whole-sale clothing manufacturers abound, is a temple to the eccentricity of Jean Paul Gaultier, the fashion world's enfant terrible. The building was once a gym, a swingers club, and the headquarters for the French Socialist Party before becoming home to team Gaultier. For every runway show, one climbs a grand staircase to the main hall, at the center of which is a stage. The seamstresses, stationed in their atelier halfway up, enjoy a plunging view of the collection they've spent hours and days sewing. At the very top hangs a huge chandelier, which is, much like the designer himself, offbeat and baroque, consisting of thousands of luminous ping-pong balls.

Since 2012, after spending twenty-eight years in haute couture at Yves Saint Laurent, Jacqueline Smeyers-Picot has headed the ateliers and reigned over the house of Gaultier, which employs forty people, some twenty full-time. She brings calm and a sense of order to Gaultier's creative fervor: "If the runway show were pushed back ten days, we'd redo the collection until the very last minute."[1] That would entail fifty silhouettes solidly built around the staples of the Gaultier style: the corset and the redingote.

Gaultier collections embody an inventive genius that combines humor and playfulness. Each runway show becomes an event, during which you can expect the conventions of fashion to be overturned: Gaultier dresses men in women's clothes and vice versa. In 1984, Gaultier was the first fashion designer to offer a skirt for men in his "Et Dieu créa l'homme" (And God created man) collection. The following year, he did it again with "Une garde-robe pour deux" (One wardrobe for two), which continued to explore the theme of androgyny through the women's tuxedo jacket.

The models who present his women's collections are often not stick thin and very young, some are even scouted on the streets. The highlight of each show is always a garment worn by a provocative star or a rebellious celebrity, such as singer Mylène Farmer in a black feather bridal gown called Libertine Swan, the reality television starlet Nabila in a feline dress, or the bearded drag queen Conchita Wurst in an embroidered gown with black tulle veil.

Nothing predisposed Gaultier as a child to become a fashion icon, and especially not to upend its norms. The only son of a mother who was a secretary and a father who was an accountant, he spent his childhood in Arcueil on the

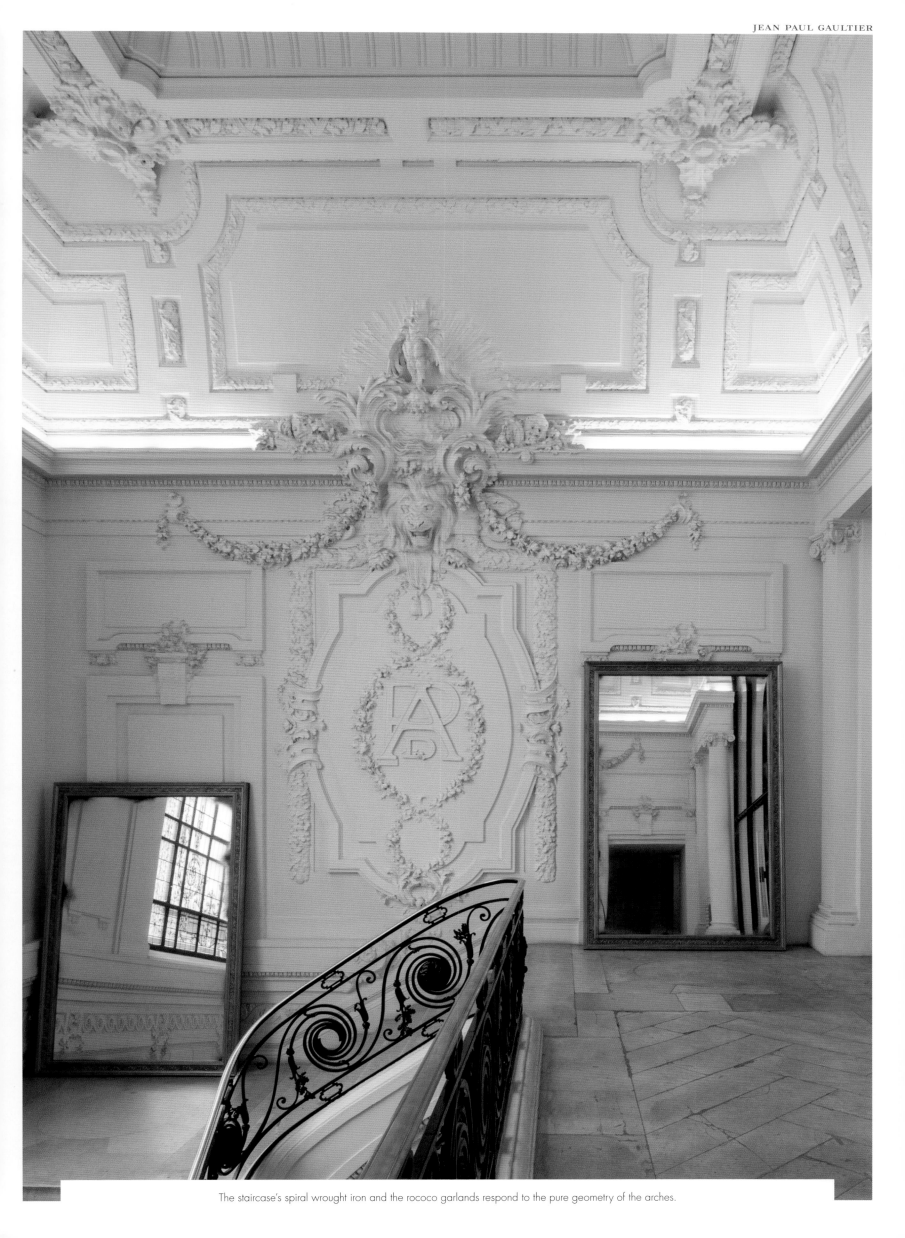

The staircase's spiral wrought iron and the rococo garlands respond to the pure geometry of the arches.

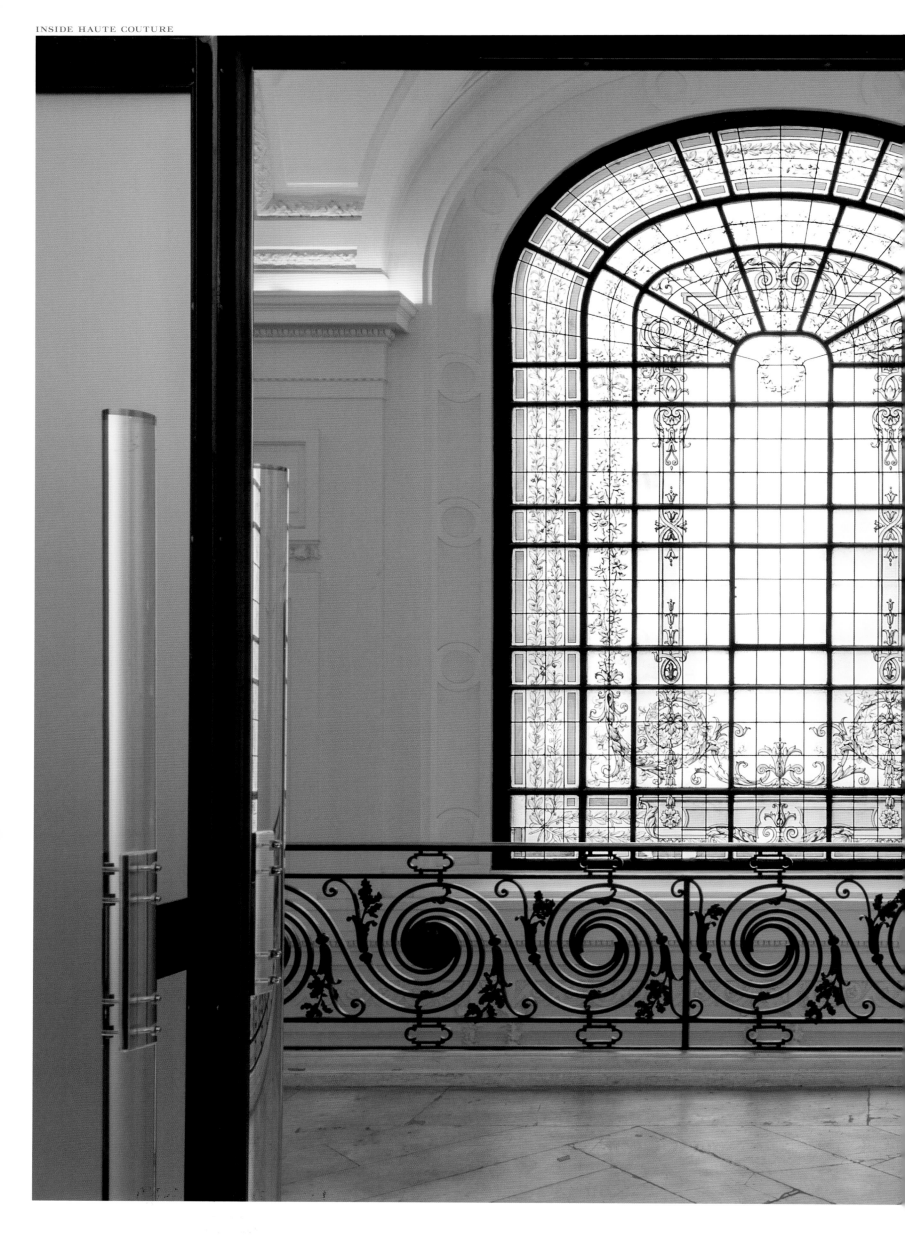

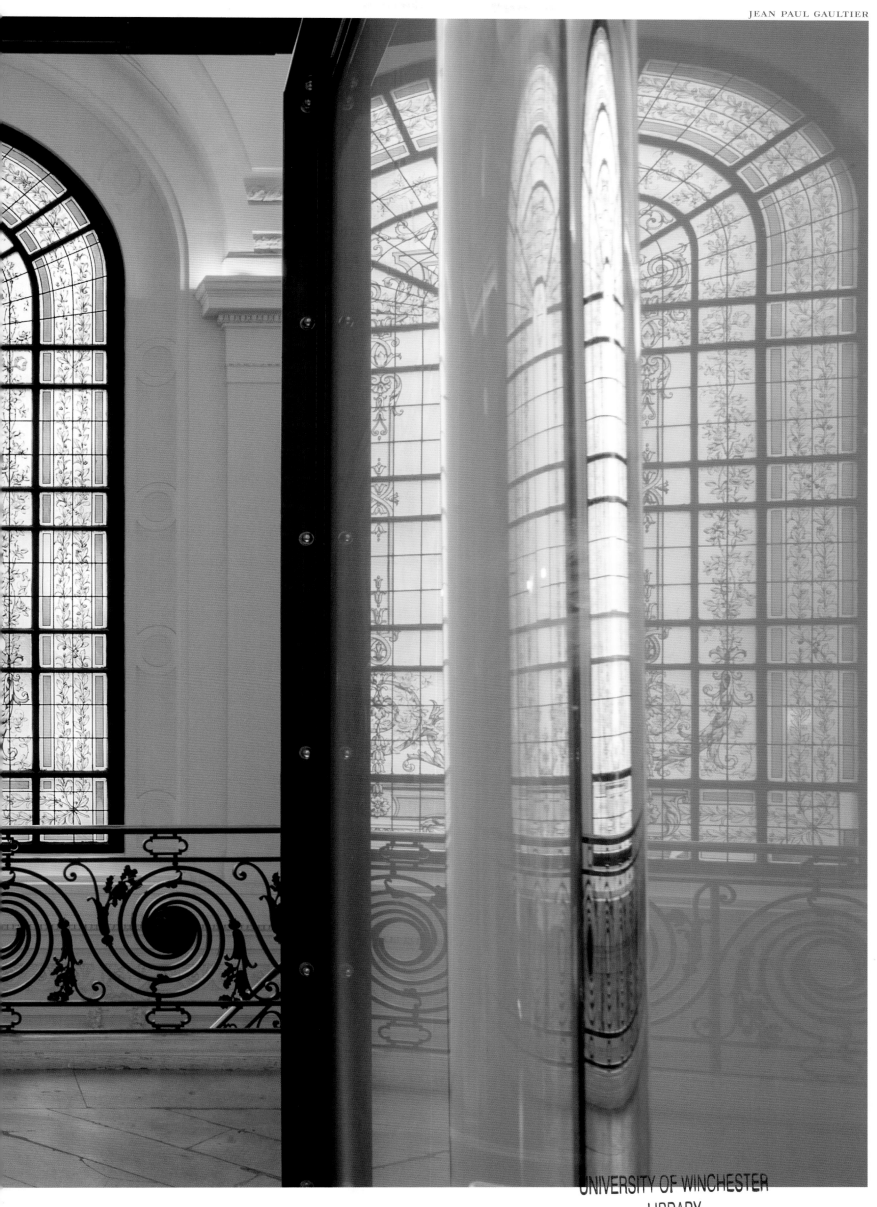

Architects Alain Moatti and Henri Rivière deftly retained the spirit of the space while making it contemporary.

outskirts of Paris. At age six, however, he found some corsets in his grandmother's chest and did a few "stylistic" experiments with his stuffed animal, a bear named Nana, whom he transformed into a drag queen with pointed breasts.

Corsets would become the staple of Gaultier's future label. About his grandmother, who taught him to sew, he says today, "She was a nurse, healer, and fortune-teller. After giving shots to her patients, she'd offer beauty advice to help the women hold on to their husbands. I've never forgotten her lessons. Seduce through provocation, but without alienating. A piece of clothing should be loquacious but not chatty. And it must always retain some mystery, the unspoken."[2]

In 1970, Gaultier had the good idea to send some of his design sketches to several Paris fashion houses. On the day of Jean Paul's eighteenth birthday, Pierre Cardin asked him to join his team; he stayed a year before joining Jacques Esterel, then Jean Patou. In 1974, he returned to Pierre Cardin, who sent him to the Philippines to manage his boutique there and to create patterns for the American market.

The first collection Gaultier launched under his own name in 1976 was a complete commercial flop. But the Japanese apparel company Onward Kashiyama came to his rescue by offering financial backing and by ordering a line of clothing. In 1978, he found success with his "Big-bang, chahut, et tohu-bohu" (Big Bang, ruckus, and commotion) collection—a star was born! In the 1980s, the label expanded and enjoyed tremendous acclaim. In 1990, Madonna performed wearing the famous cone bustier the designer had made for her, and the sailor shirt, intrinsic to Gaultier, became evening wear. That year was also a difficult one, however: Francis Menuge, his friend, lover, and business partner, died of AIDS-related causes.

In 1993, Gaultier launched the women's perfume Jean Paul Gaultier, which became Classique; the bottle, a female bust in a shell bodice, comes in a cylindrical metal box. Le Mâle, in the incarnation of the male torso, followed in 1995, and ever since has been a top seller. Markedly more profitable than fashion, perfumes today represent 40 percent of sales from the Gaultier label, whose majority shareholder is the Catalonian company Puig.

An offbeat chandelier made from thousands of luminous ping-pong balls.

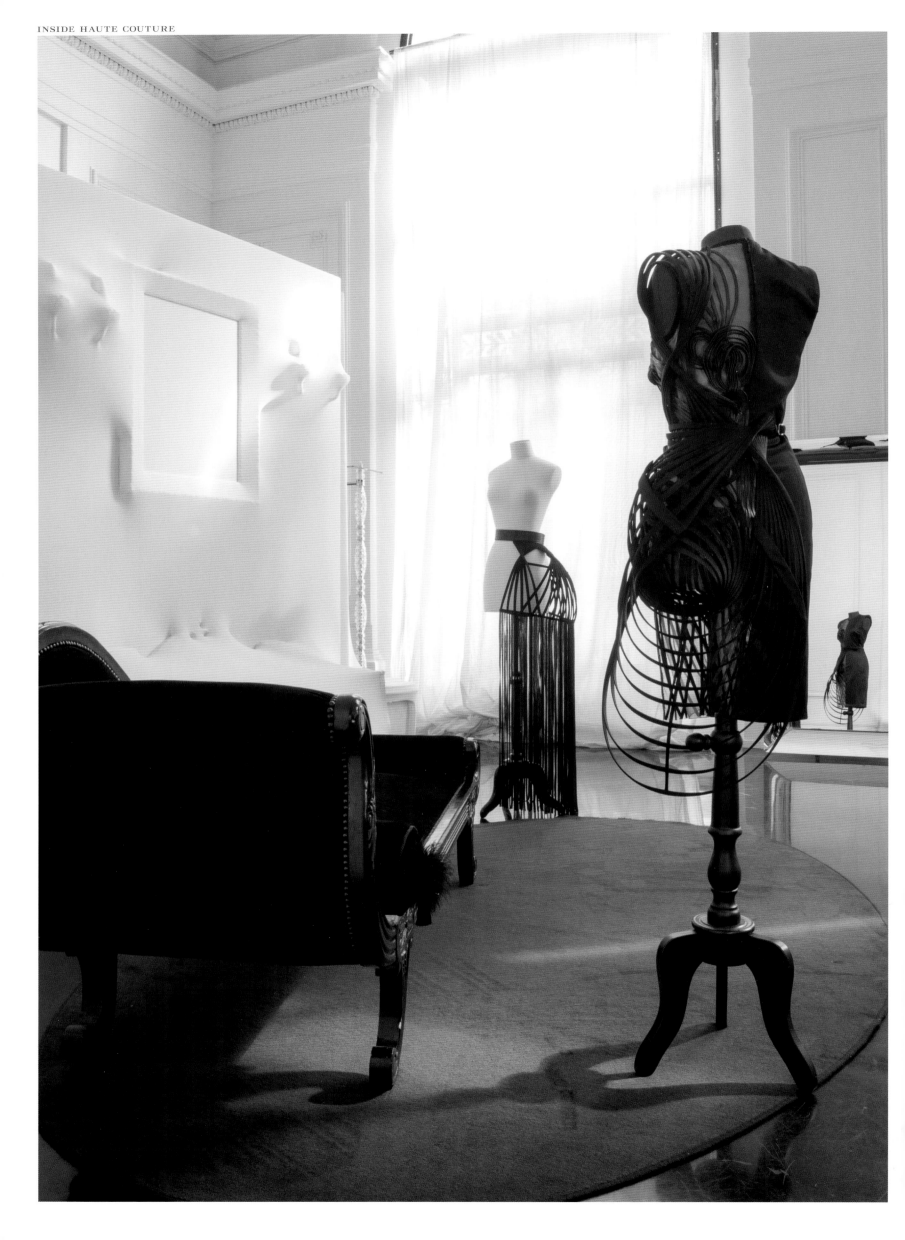

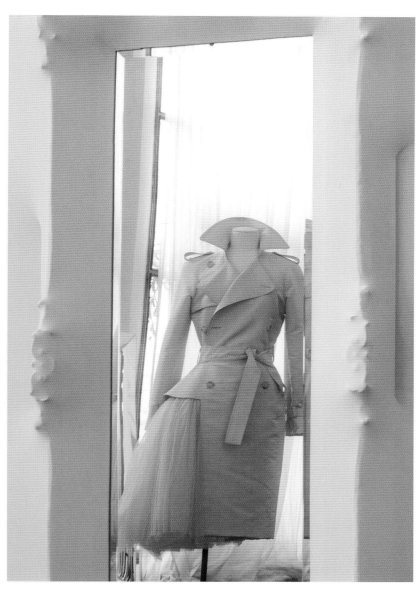

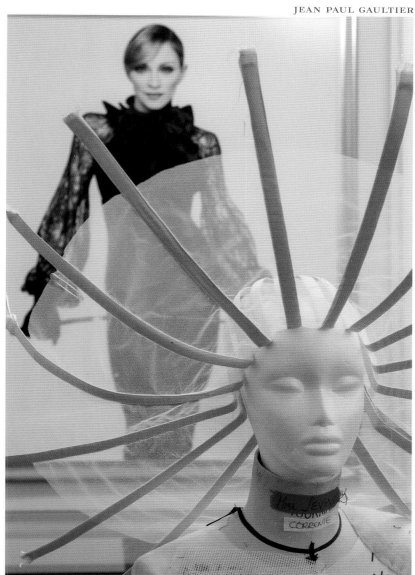

The shape of a hat in front of a photograph of Madonna, one of Gaultier's muses, and other iconic designs are scattered throughout the fitting rooms.

In 1997, Gaultier joined the Chambre Syndicale de la Haute Couture and presented his collection "Gaultier in Paris." On September 27, 2014, at Le Grand Rex movie theater, following his most recent prêt-à-porter runway show during Paris Fashion Week, Gaultier announced that he would now devote himself exclusively to haute couture: "For a few years now, it's haute couture that has been truly fulfilling. It allows me to give free rein to my creativity and love of exploration and experimentation." A decision that might seem to go against the commercial grain—but one that suits him so!

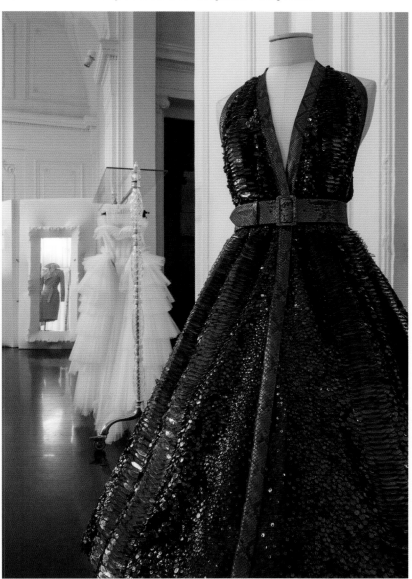

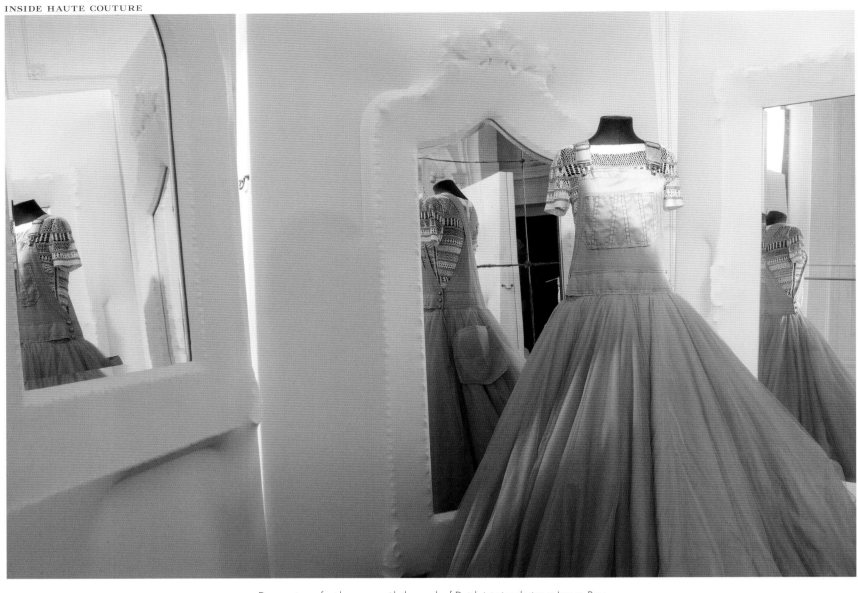

Dresses in perfect harmony with the work of Dutch interior designer Jurgen Bey.

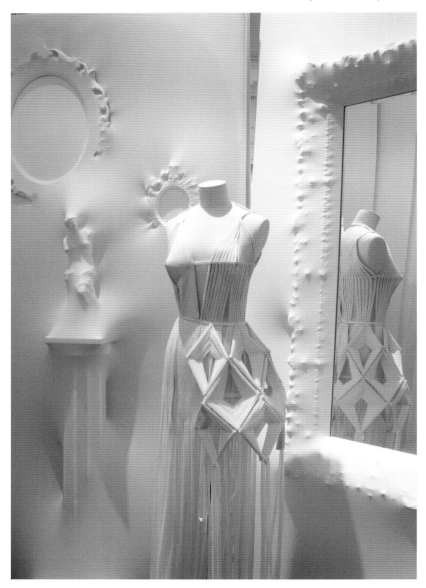

INSIDE THE COUTURE FITTING ROOM

Transfixed by Dutch designer Jurgen Bey's morphing installations, Jean Paul Gaultier asked him in 2003 to design the fitting room for his fashion house on rue Saint-Martin in Paris, located in a dramatic, sixty-five thousand–square-foot (six-thousand-square-meter) building. Originally designed to house the offices of the organization L'Avenir du Prolétariat (The Future of the Proletariat) and inaugurated in 1912 by the philanthropist Ferdinand Boire, the building was restored by the architects Alain Moatti and Henri Rivière, who brought in the Gaultier touch. They kept the ornate staircase, the spiral wrought ironwork, and the rococo garlands of the archways, which contrast with the otherwise purely geometric angles and a black resin floor.

In 2015, Jean Paul Gaultier again called on Bey to design his exhibition, "Jean Paul Gaultier: De la Rue aux Étoiles," at the Grand Palais in Paris. The retrospective tells the fashion designer's life story in more than 175 pieces—his inspirations, his interactions, his couture designs, and his costumes. The highlight is a fully reproduced runway, with commentary by Catherine Deneuve. At the heart of this fashion universe is Bey's installation, which perfectly communicates Gaultier's unbridled creativity.

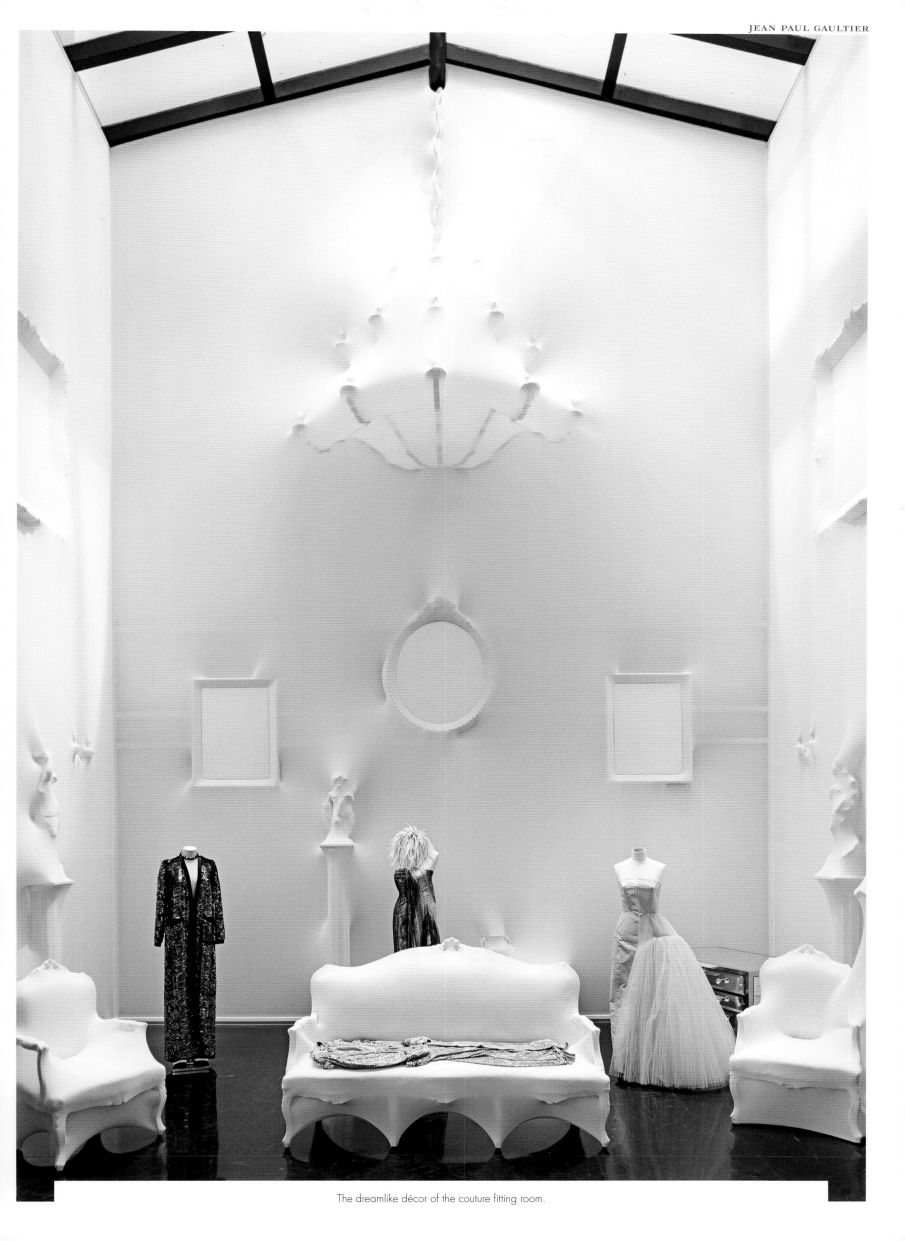

The dreamlike décor of the couture fitting room.

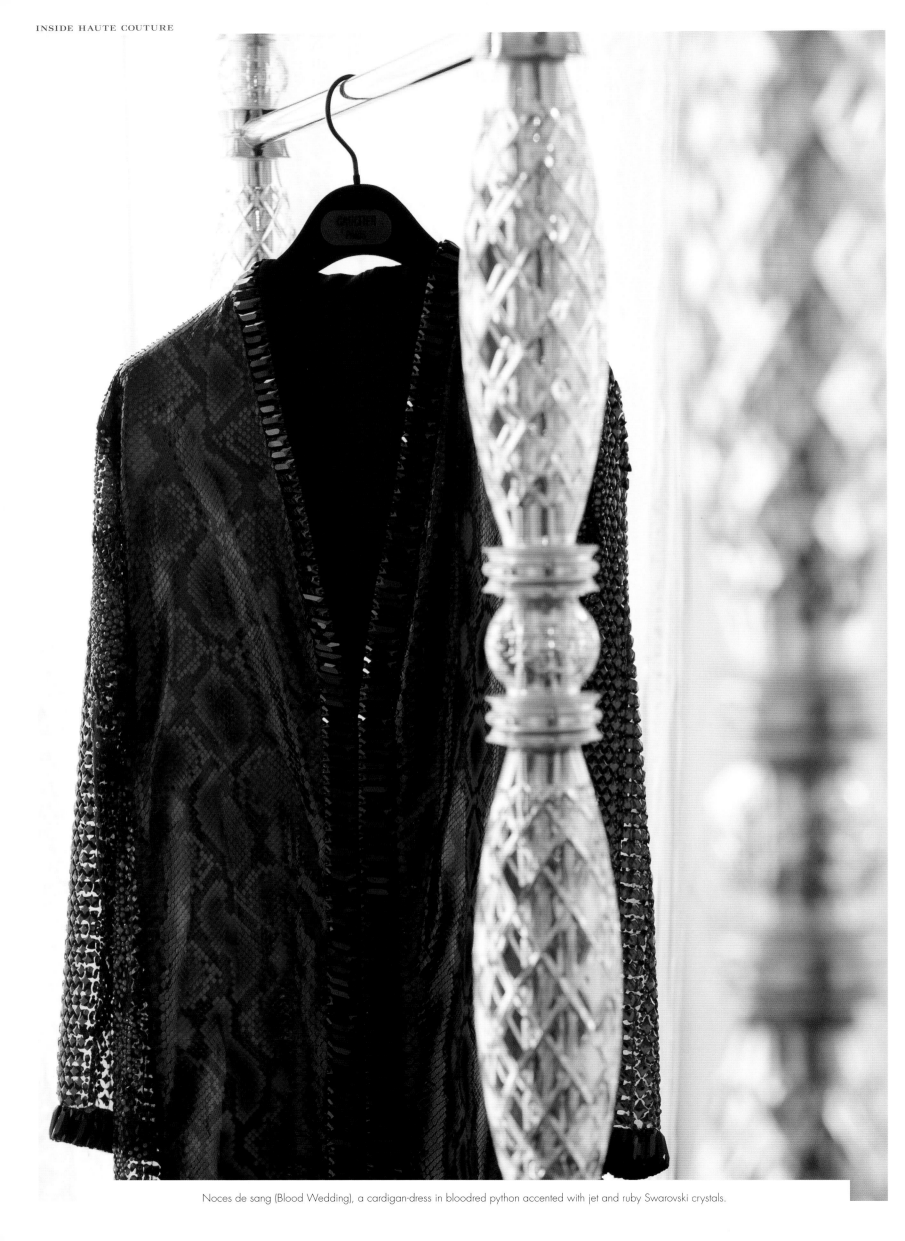

Noces de sang (Blood Wedding), a cardigan-dress in bloodred python accented with jet and ruby Swarovski crystals.

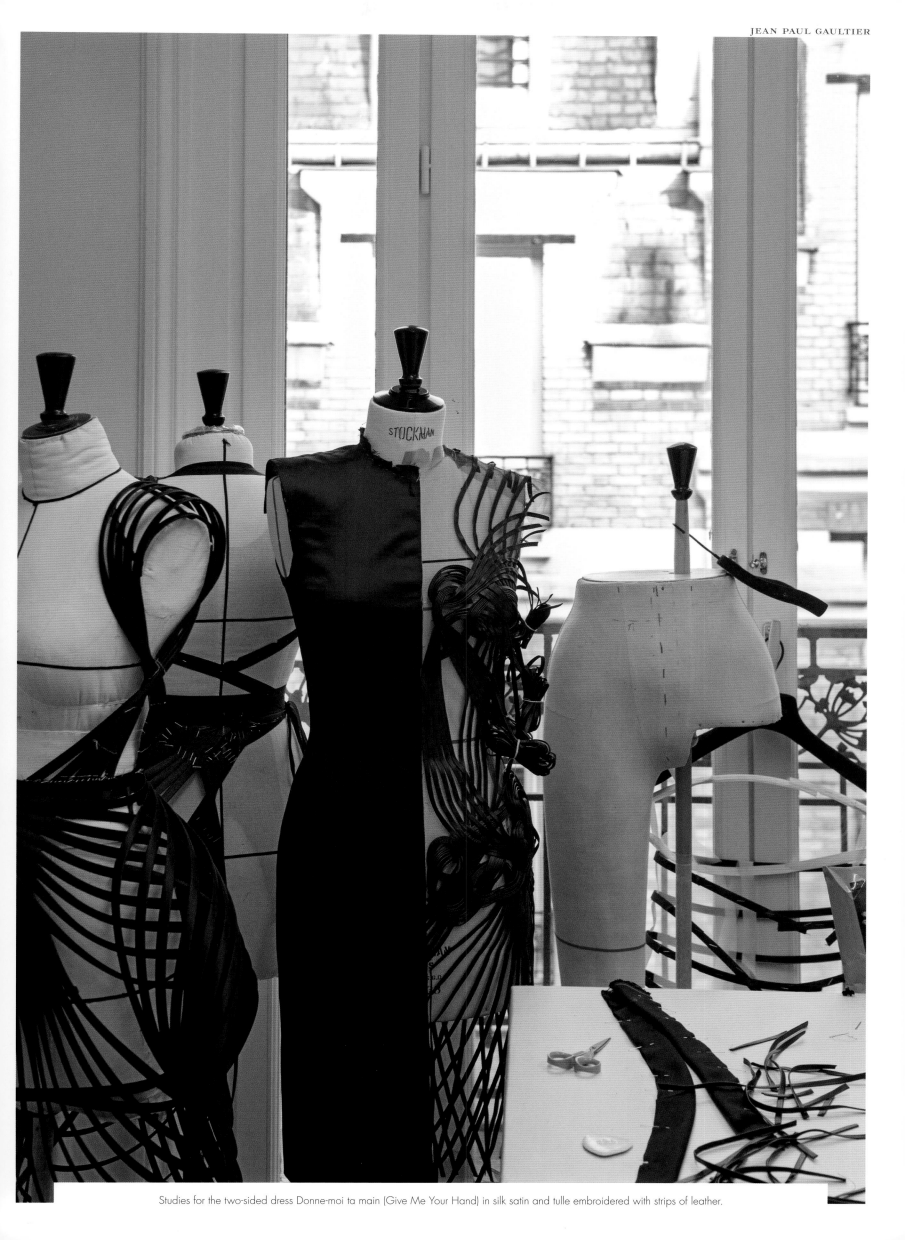

Studies for the two-sided dress Donne-moi ta main (Give Me Your Hand) in silk satin and tulle embroidered with strips of leather.

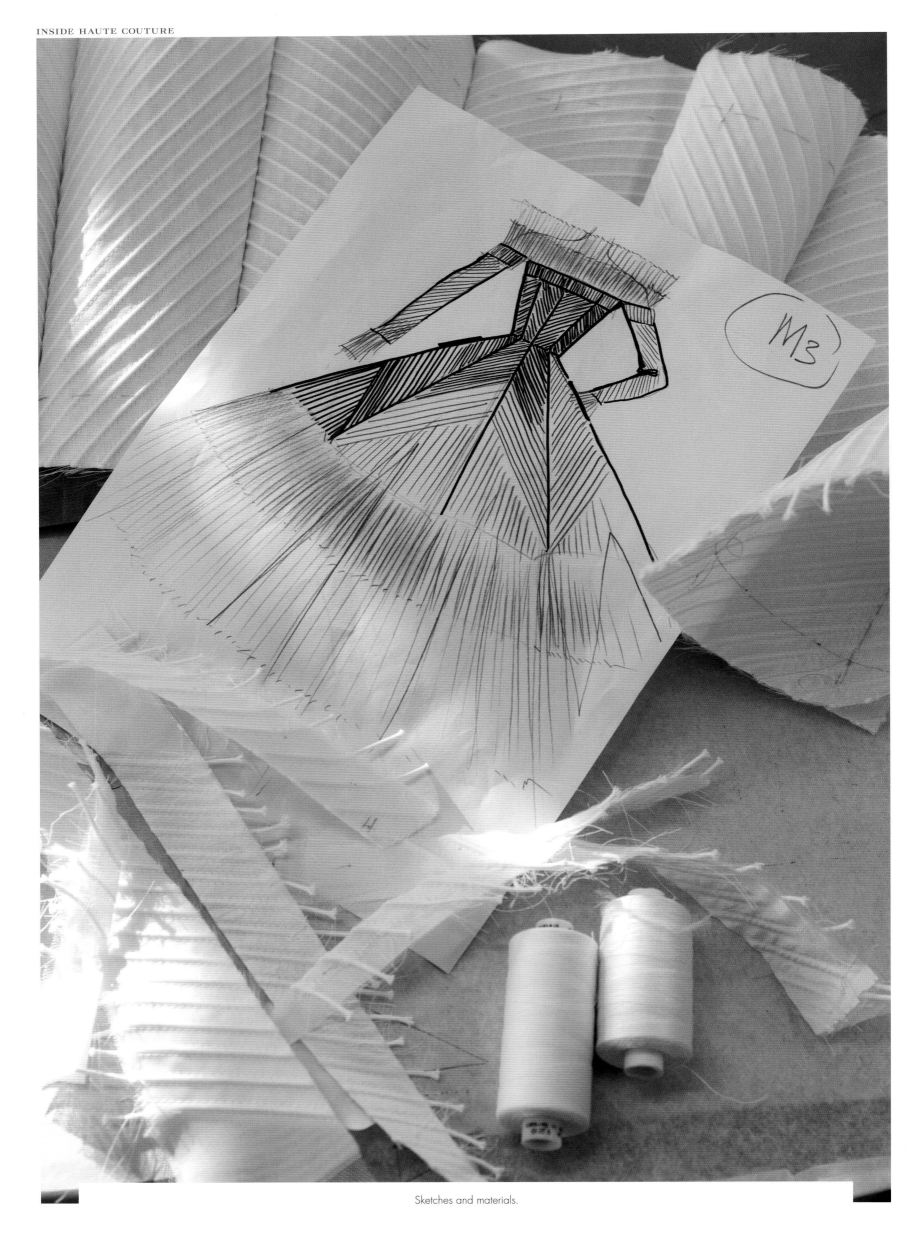

Sketches and materials.

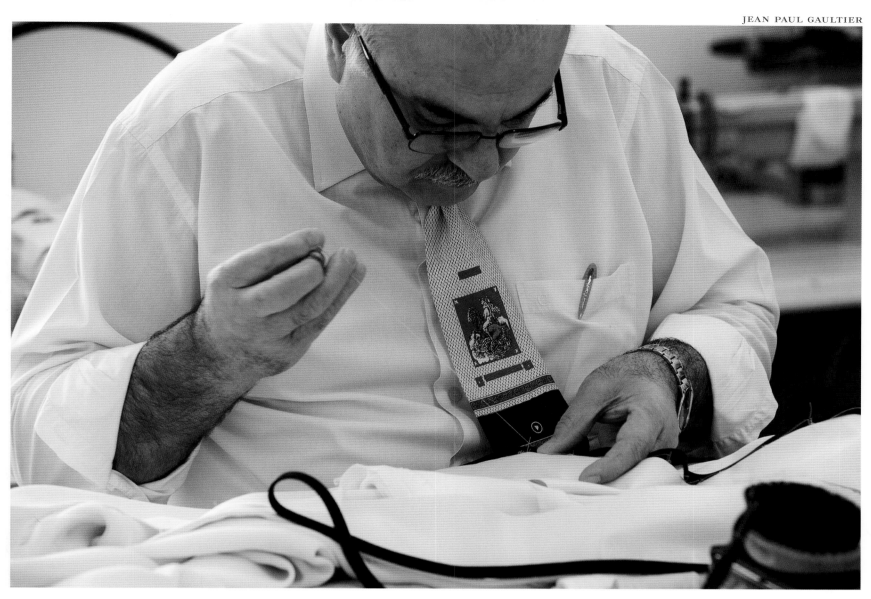

An atelier flooded with light and looking out over the roofs of Paris.

INSIDE THE ATELIERS

On the seventh floor of 325, rue Saint-Martin, a few days before a runway show, nothing, frankly, is ready, and yet serenity reigns as the windows overlooking the roofs of Paris drench the space in sunlight. Normally consisting of some twenty people, the team working there can grow to fifty when preparing a couture collection. Héloïse Mantel applies her talents to Nid d'amour (Love Nest), a duchess satin corset with a crazy nest of boning at the hips. Scattered about are a taffeta crocus, a blood-orange snakeskin, embroidered details made with tubes of colored crystal, and a full-body tutu in pleated tulle. This isn't something from the pages of Verlaine's *Fêtes galantes*; it's Gaultier's own poetry.

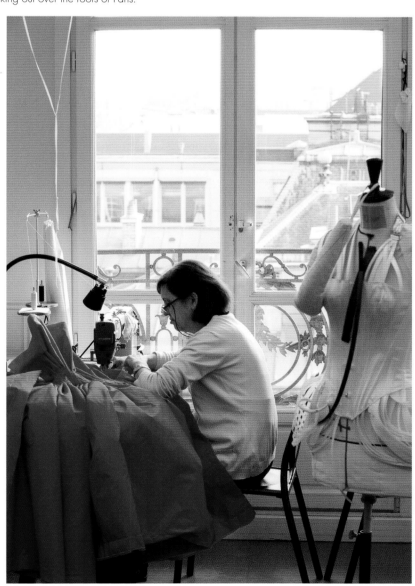

71

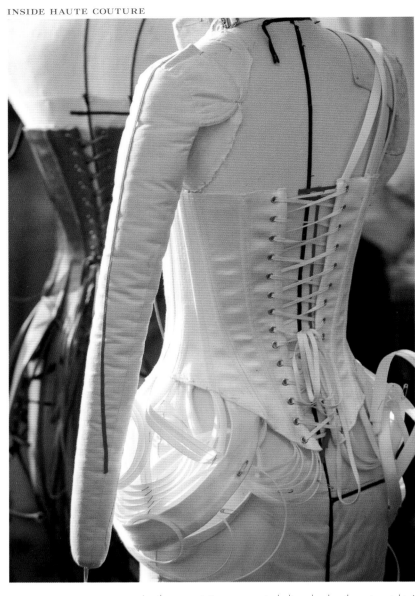

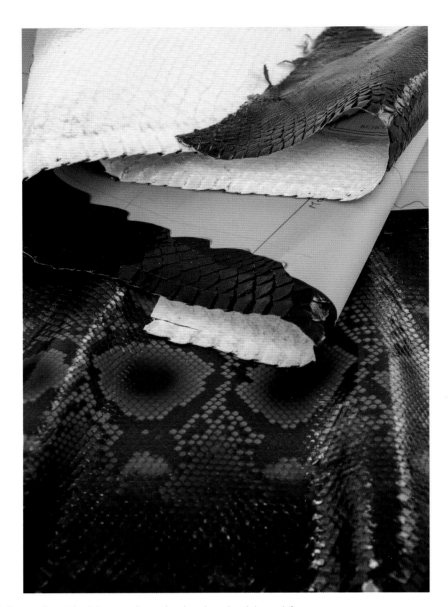

Leather corsets in progress, including dyed python, top right; Nid d'amour (Love Nest), lower right; and embroidery detail, lower left.

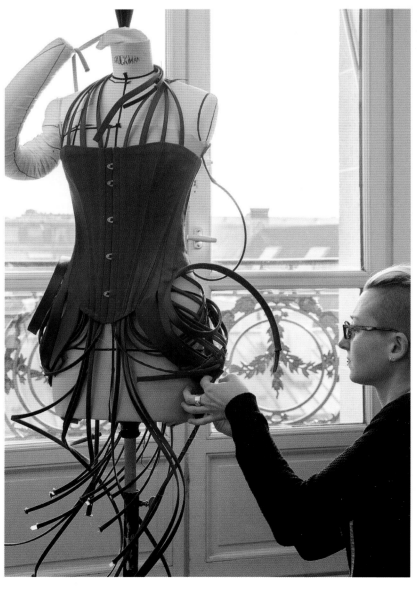

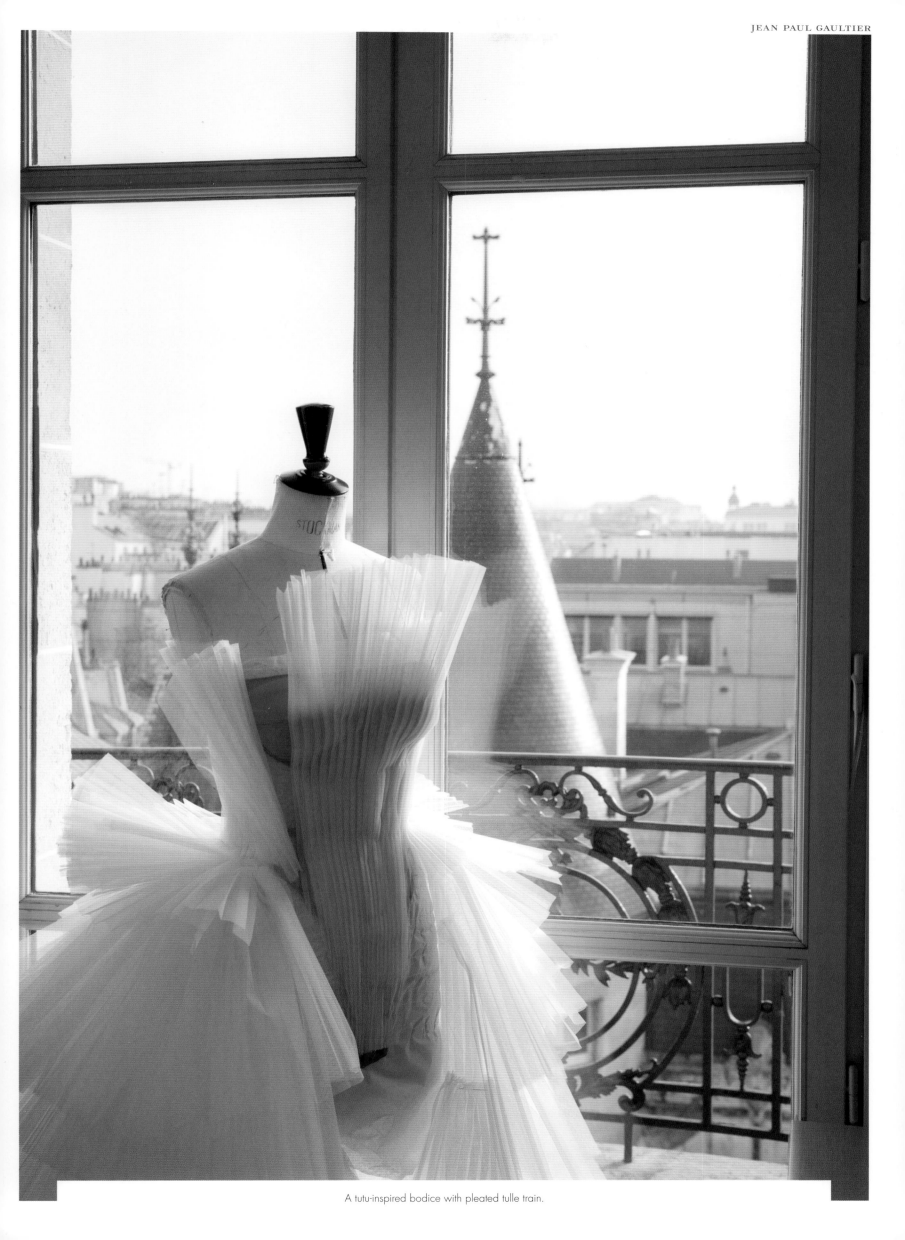

A tutu-inspired bodice with pleated tulle train.

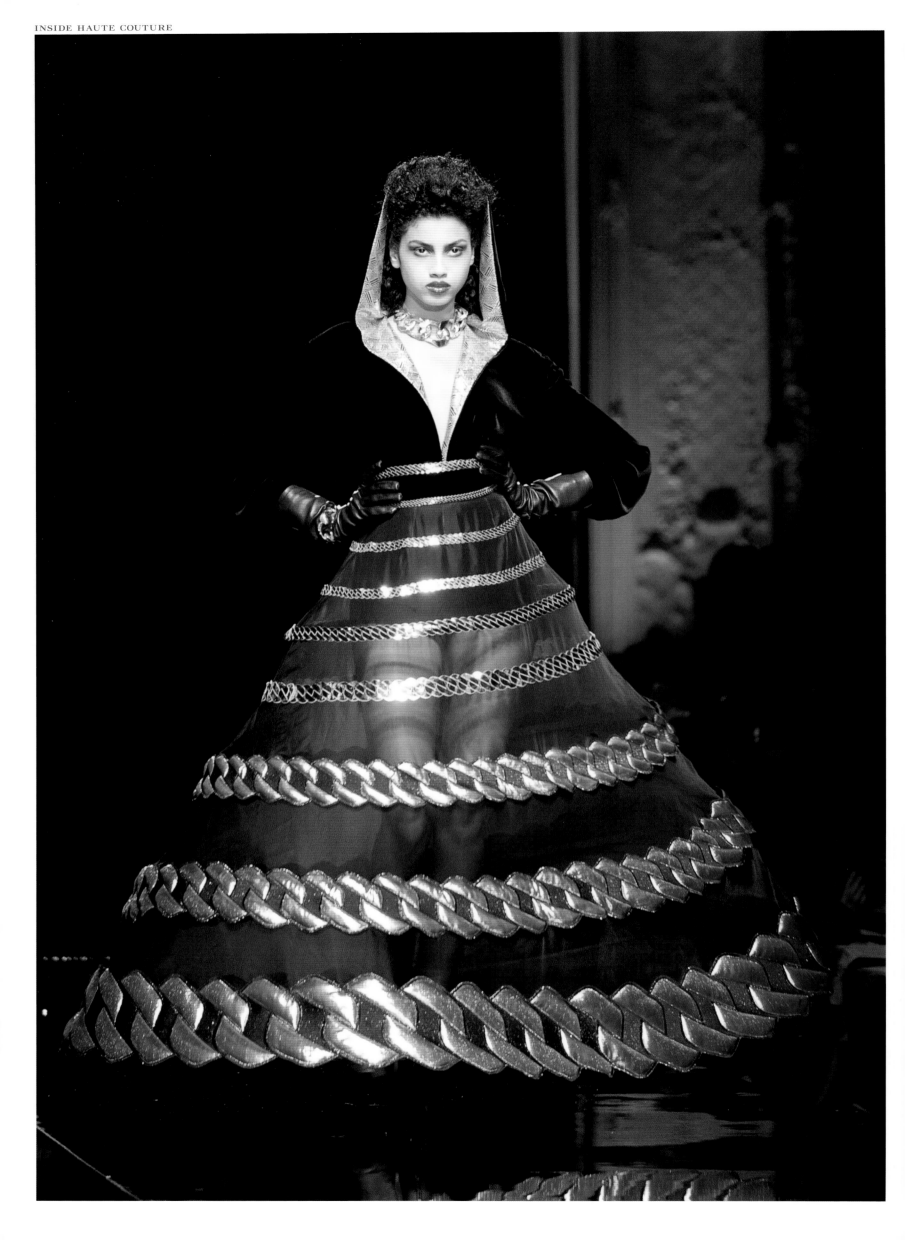

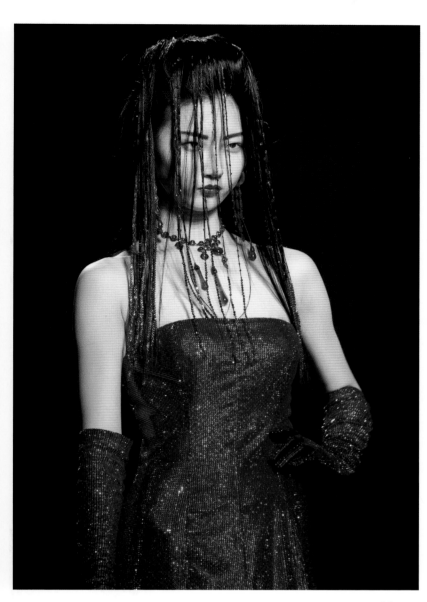

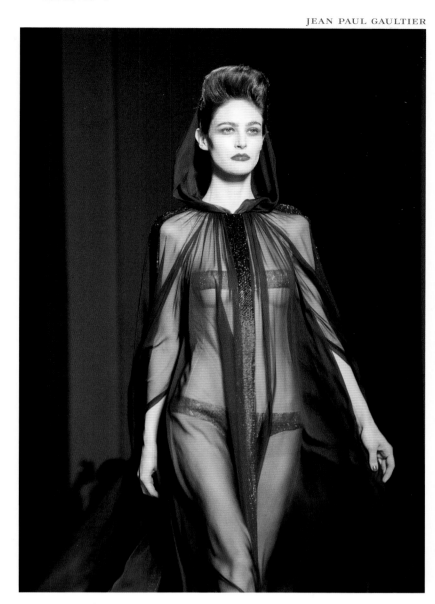

2014–2015 fall–winter haute couture runway show.

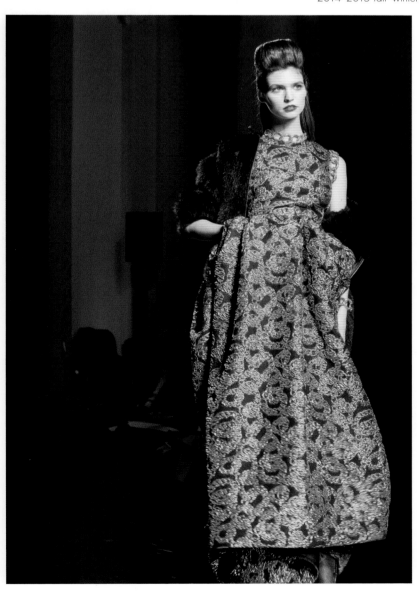

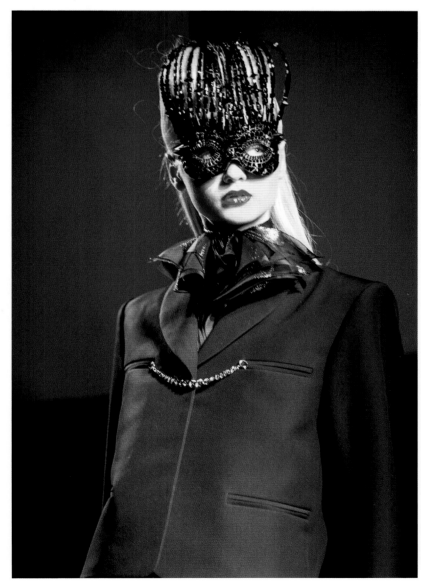

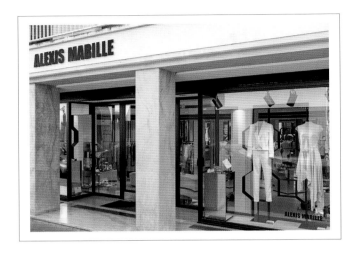

Alexis Mabille
11, RUE DE GRENELLE

His signature is the bow tie, his guiding principle, unisex. It was at 11, rue de Grenelle, in Paris's seventh arrondissement, that Alexis Mabille, the "flamboyant dandy," as he was dubbed by French *Vogue*, opened his first boutique in 2012—a jewel box with copious mirrors creating spectacular visual effects.

Mabille was born on November 30, 1976, in Lyon. As a child, he learned to sew and liked to cut up the slips and lace he found in the family attic to form new creations; as a teenager, he learned about fashion by visiting museums. His father was a printer, his mother, a stay-at-home mom with time to devote to her children: "[They were] cool parents who allowed me to develop my individuality. And so I didn't have to go through an adolescent crisis,"[1] he said in 2006.

After starting as a costume designer for the Lyon opera, Mabille moved to Paris and enrolled at the École de la Chambre Syndicale de la Couture Parisienne for a three-year course of study. Upon his graduation in 1997, he completed his training by working for Emanuel Ungaro, then with Nina Ricci, before joining the House of Dior. For nine years, he had the opportunity to work with John Galliano, Dior's creative director, in accessories, and then assisted Hedi Slimane in men's jewelry for Dior Homme.

In 2005, Mabille founded his own company, named Impasse 13—a sniff at a number said to be bad luck—and launched a prêt-à-porter label under his own name. His mother and sisters were at his side, and he pushed the creative envelope to reinvent pants, shirts, and jackets that suited both women and men. His cuts, however, are anything but androgynous: While the designer often draws inspiration from men's clothing, he revises that attire by introducing unexpected contrasts (for example, a smoking jacket paired with a romantic skirt with lace flounces). The result is a marriage of poetry and fantasy. Mabille gives free rein to an offbeat style that lends clothing panache, eccentricity, and sometimes even frivolity. His favorite fabrics are organza, Moroccan crepe, and tight-fitting materials that don't wrinkle.

When he launched the "Treizeor" bow-tie line in 2007 (the name is a phonetic reading of the French word for *treasure*), Mabille entered a new stage of extravagance. He radically updated the accessory for modern times, embroidering it, weaving it, redesigning it as a handbag, and even producing a bow-tie cookie for the renowned patisserie Ladurée. Both edgy and playful, these bow ties embody the designer's

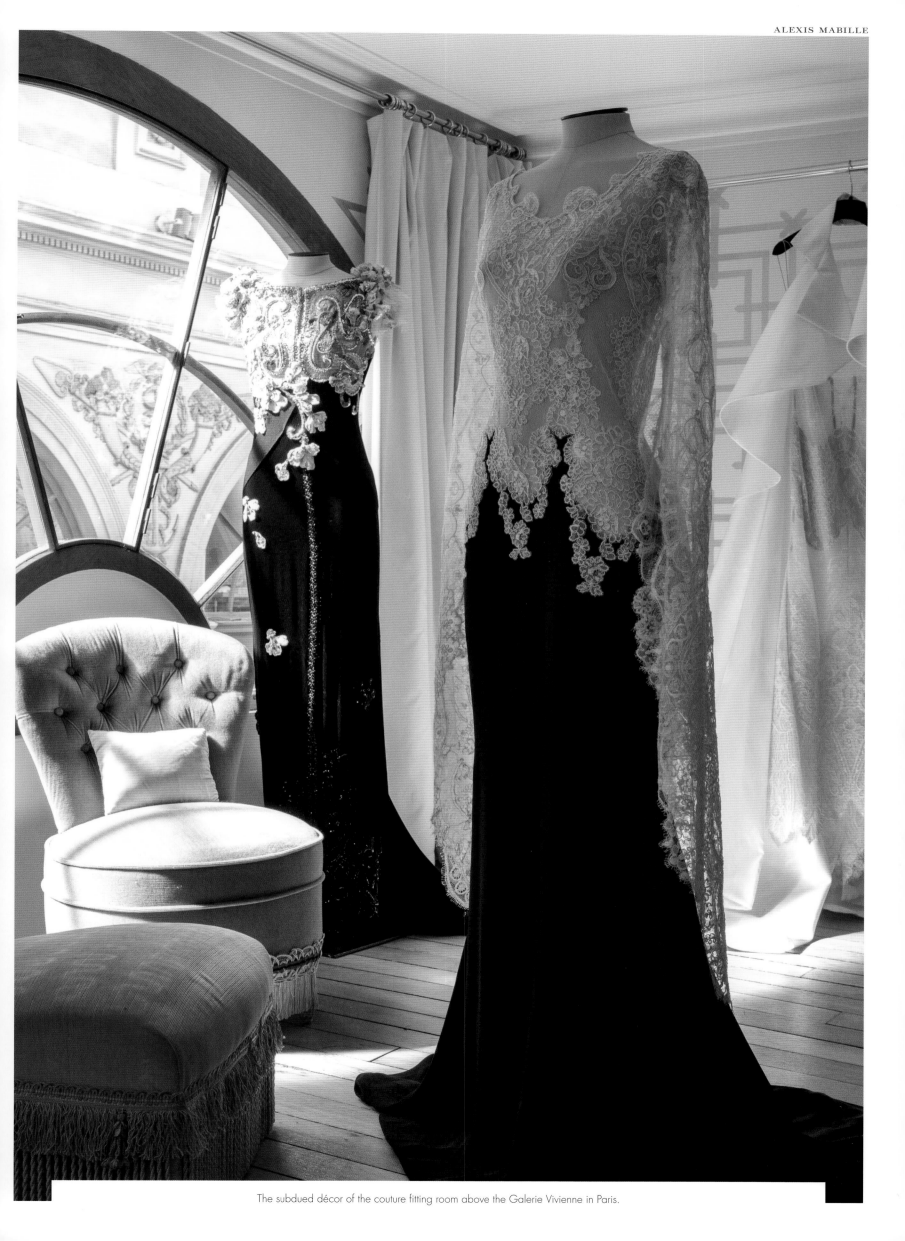

The subdued décor of the couture fitting room above the Galerie Vivienne in Paris.

The fitting rooms mix classical elements with modern pieces.

entire fashion philosophy: play with bourgeois rules, mix up types, take the inhibition out of elegance. The press was enthusiastic and made Alexis Mabille the "it" designer of the moment.

In December 2012, Mabille became a member of the small circle of French haute couturiers, and in January 2013, his first runway show under this status was historic. The walls of one of the rooms of Paris's fourth arrondissement *mairie* (town hall) were done in pink, and chandeliers like those in the Château de Versailles twinkled elegant light. Sitting in the front row? The queen of burlesque, Dita Von Teese. Following the first models dressed in powdery and pastel tones came clothes of explosive color: ruby red, purple, mauve, and mimosa yellow, all set to techno harpsichord beats! Each model sported a silver bun in a kind of multifaceted homage to Versailles, the Eiffel Tower, and the Moulin Rouge. Some viewers adored the spectacle, while others hated it, but no one was left feeling indifferent.

When Mabille was asked what might constitute bad taste, he answered, "That's a difficult question, because, depending on the person, the worst faux pas could become the ultimate in chic. But I'd say: going barefoot in leather shoes. I've always hated that. And then, of course, white socks with loafers. Unacceptable!"[2]

His 2014 spring–summer haute couture show was less controversial than that of the year before. The collection was like a pastry-shop window: "pleated organza layered like mille-feuille, silver nets sprinkled with crystals topped the flounces of an apricot dress, peach underwear over an almond radzimir short pant."[3]

His 2015 spring–summer prêt-à-porter collection highlighted sexy-chic sportiness. On the

A hallway adorned with statues and plaster reliefs.

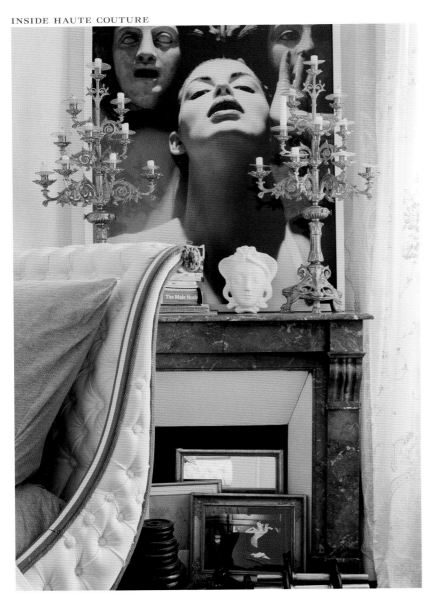

Evidence of Alexis Mabille's love of glamour can be seen in the details that decorate his atelier and his boutiques.

runway: dresses inspired by boxing robes, trench coats with hoods, sweatshirts paired with net skirts.

That same season's haute couture show, which took place at the Mona Bismarck American Center for Art and Culture, displayed a radical change in tone. The exuberant designer presented a show-length ode to giant flowers and sparkling colors: violet, blue, and fuchsia brightened the stage. The famous bow tie, his favorite accessory, took on extreme proportions, with elaborate pleats suggesting impossibly luxurious petals. Celebrating the tenth anniversary of his label in this way, Alexis Mabille stayed true to himself and fully affirmed his style with a mix of fantasy and individualism.

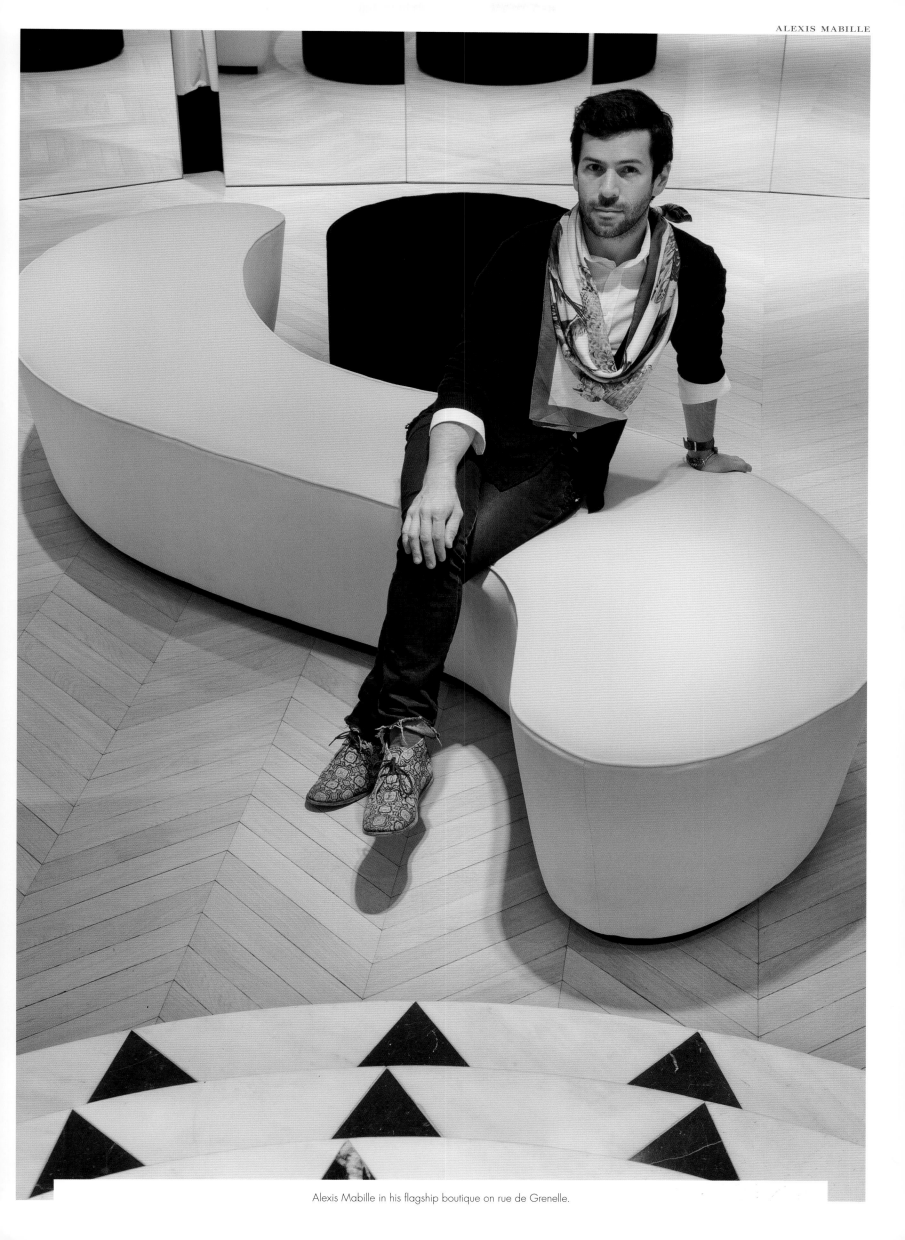

Alexis Mabille in his flagship boutique on rue de Grenelle.

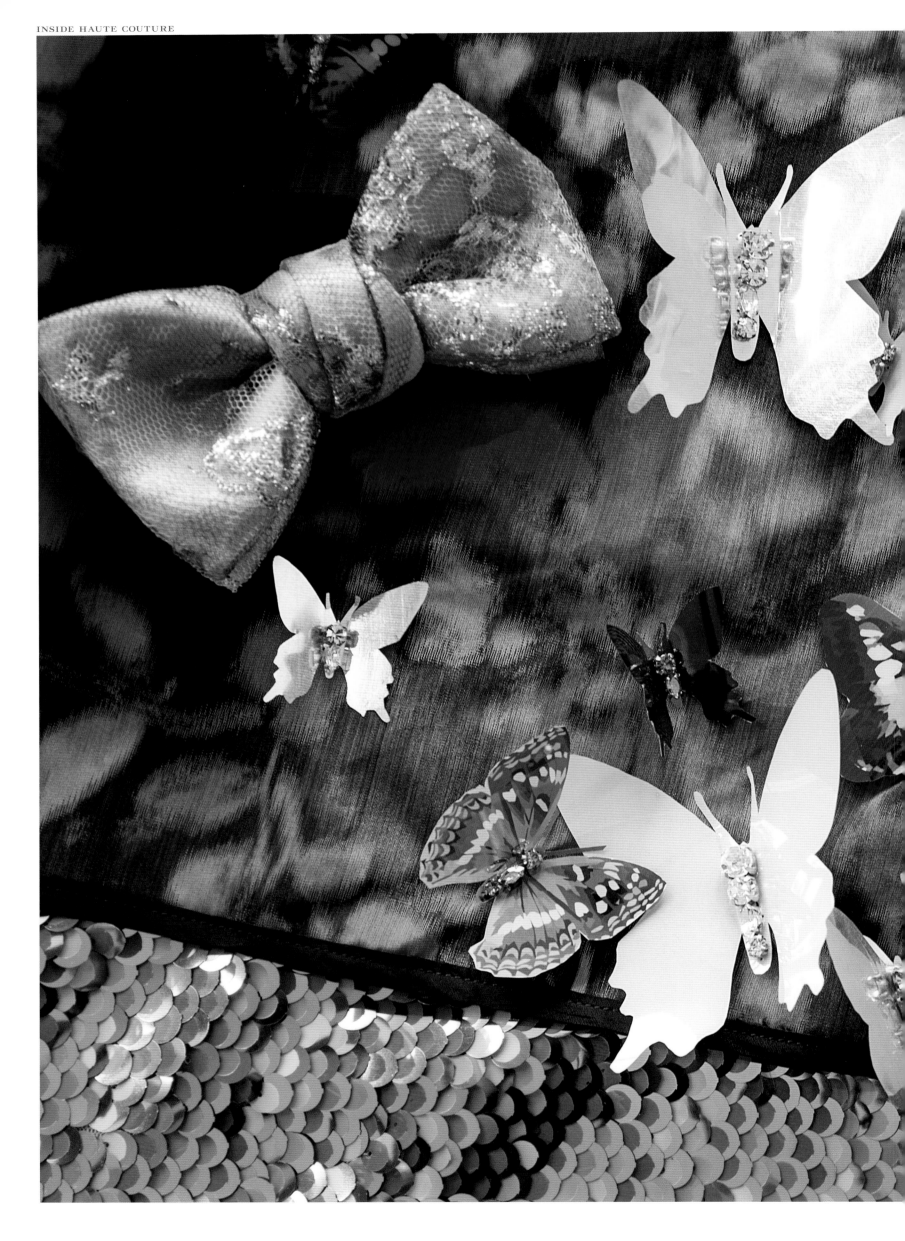

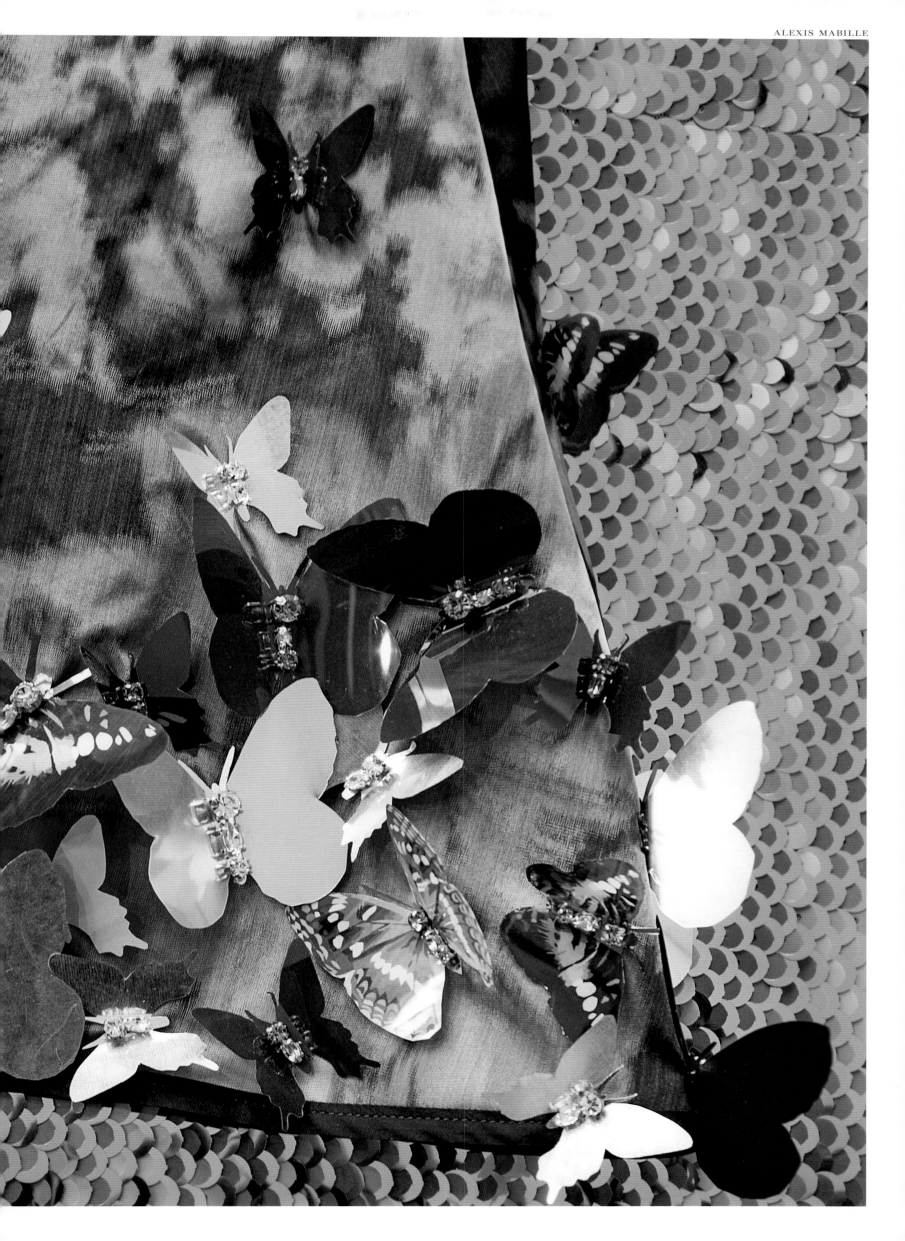

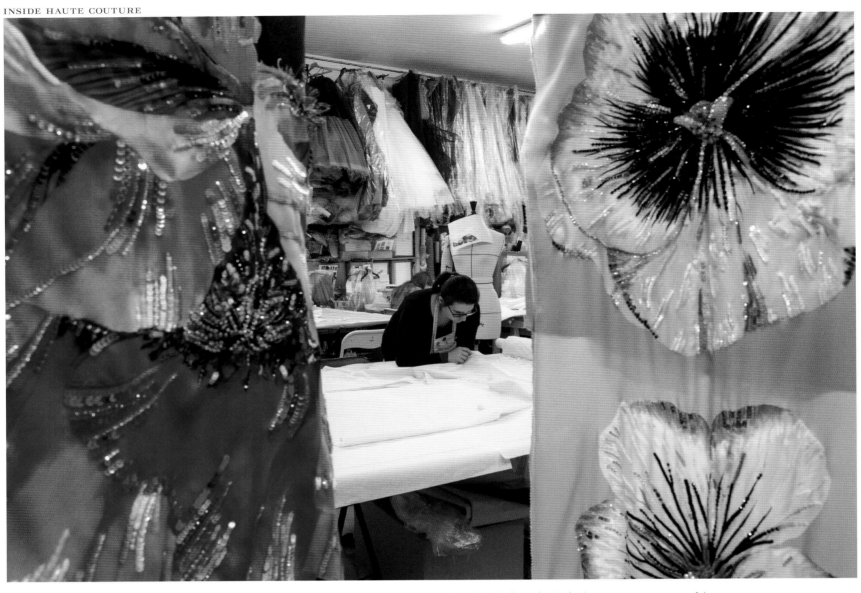

The artisans refine the design, making alterations on white muslin, which will be the basis for the final creation using exquisite fabric.

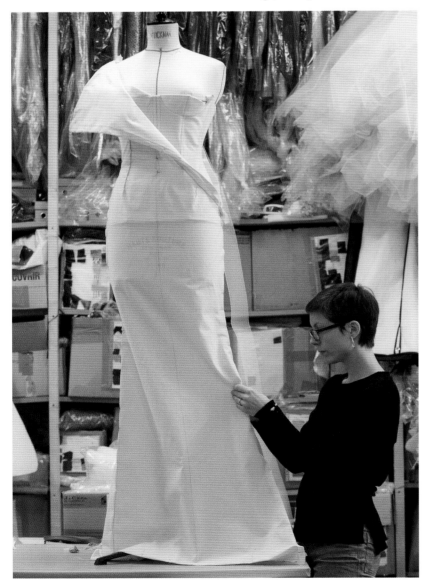

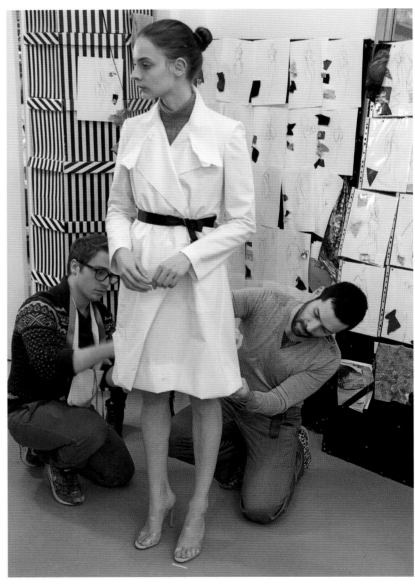

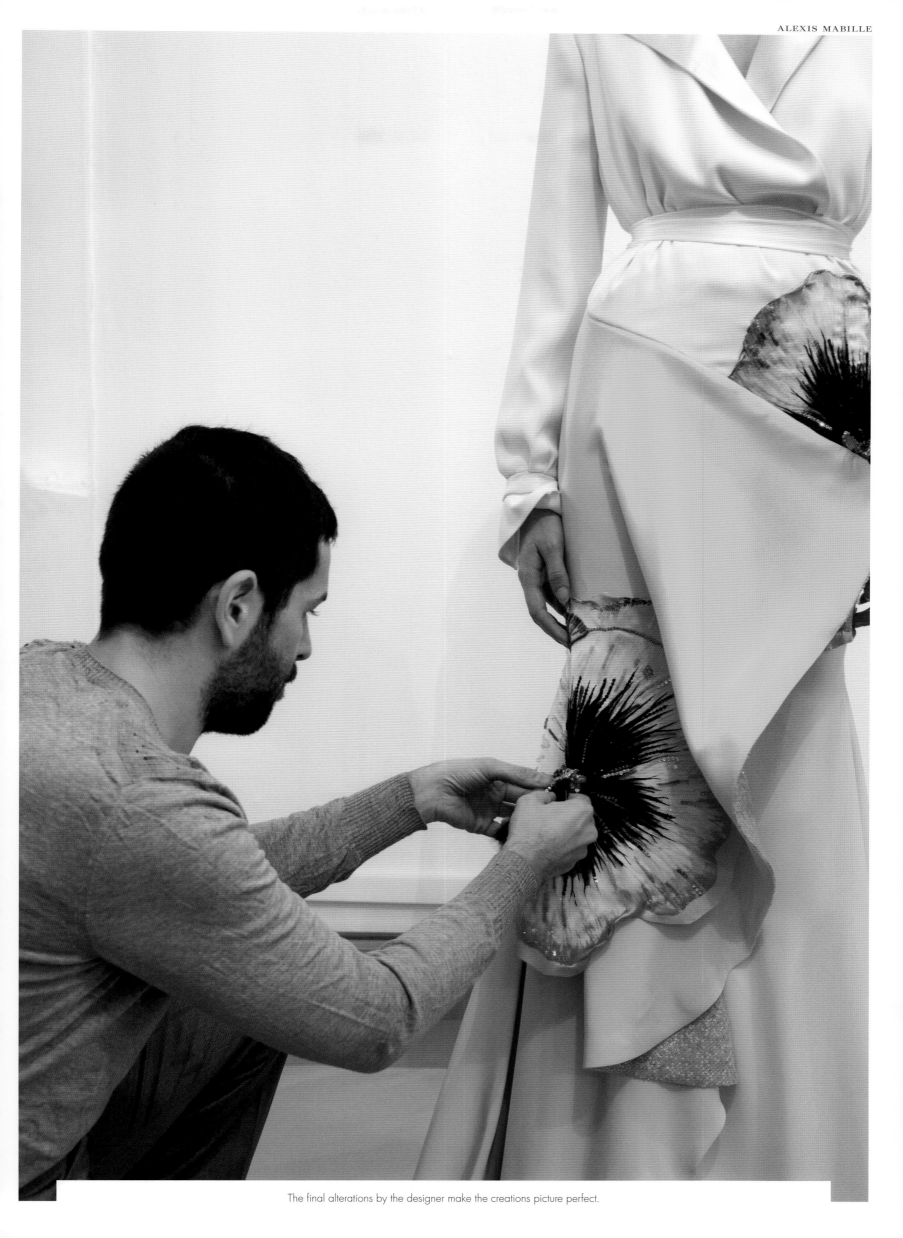

The final alterations by the designer make the creations picture perfect.

Style is the garb of thought.

SENECA
Letter to Lucilius, first century

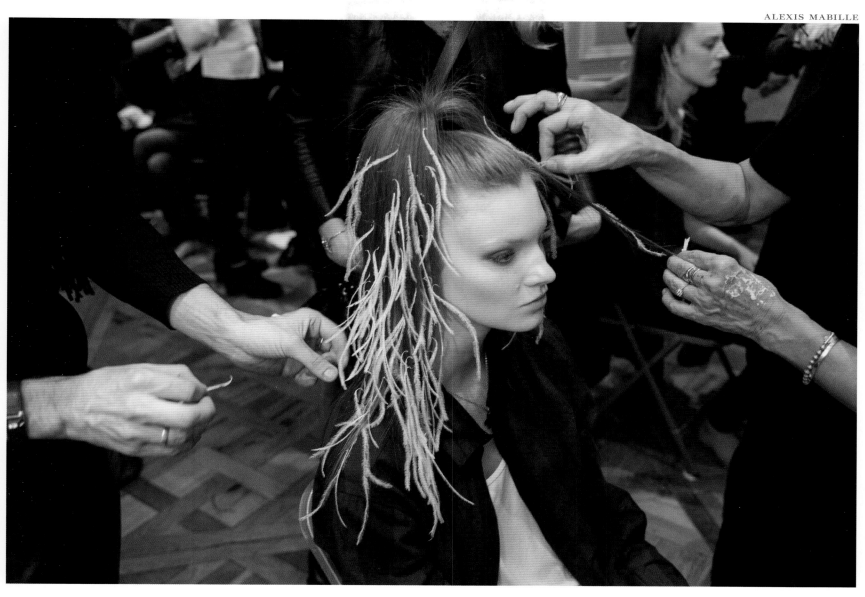

Final custom adjustments and hairstyles inspired by flowers.

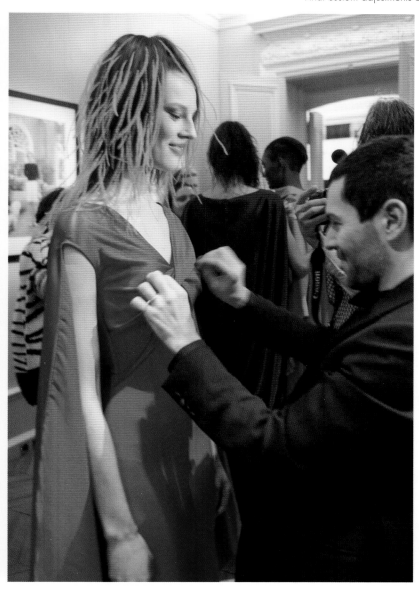

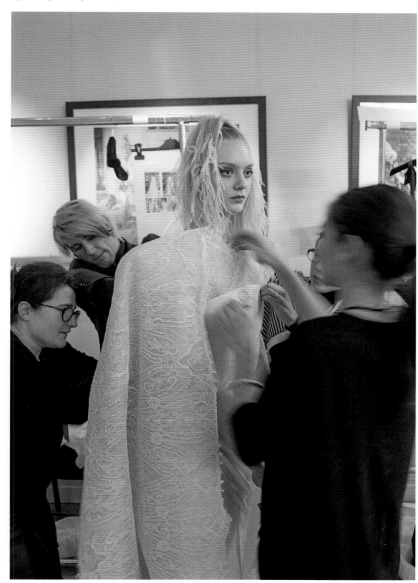

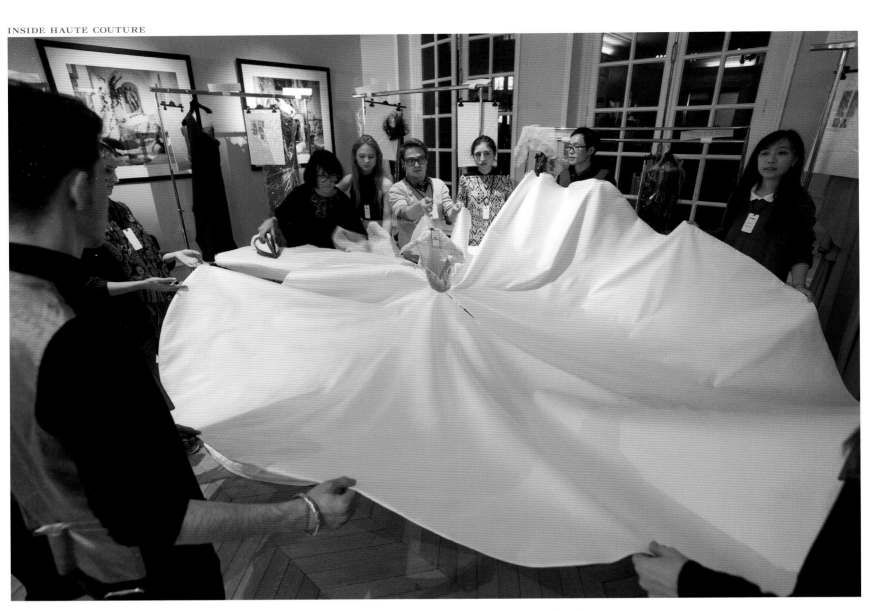

It takes eighteen hands to iron the wedding dress, the highlight of the show.

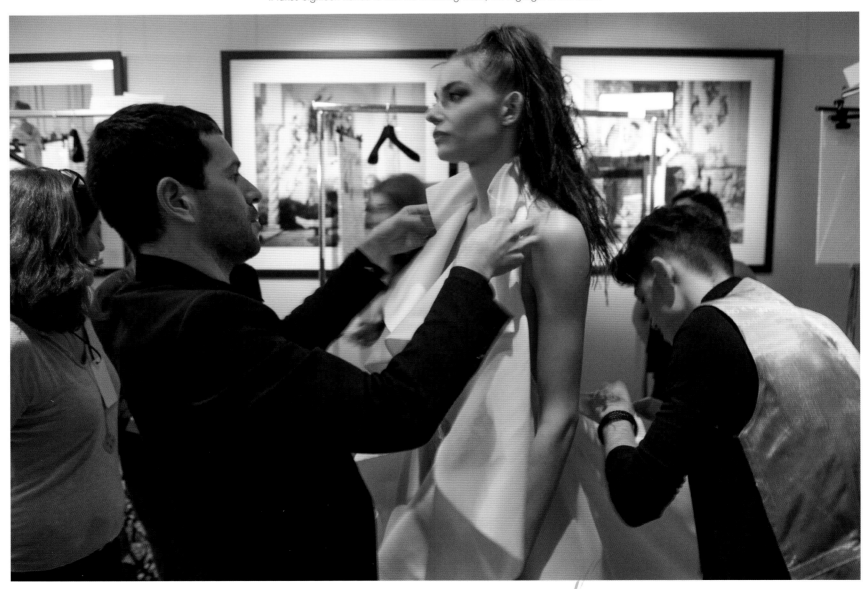

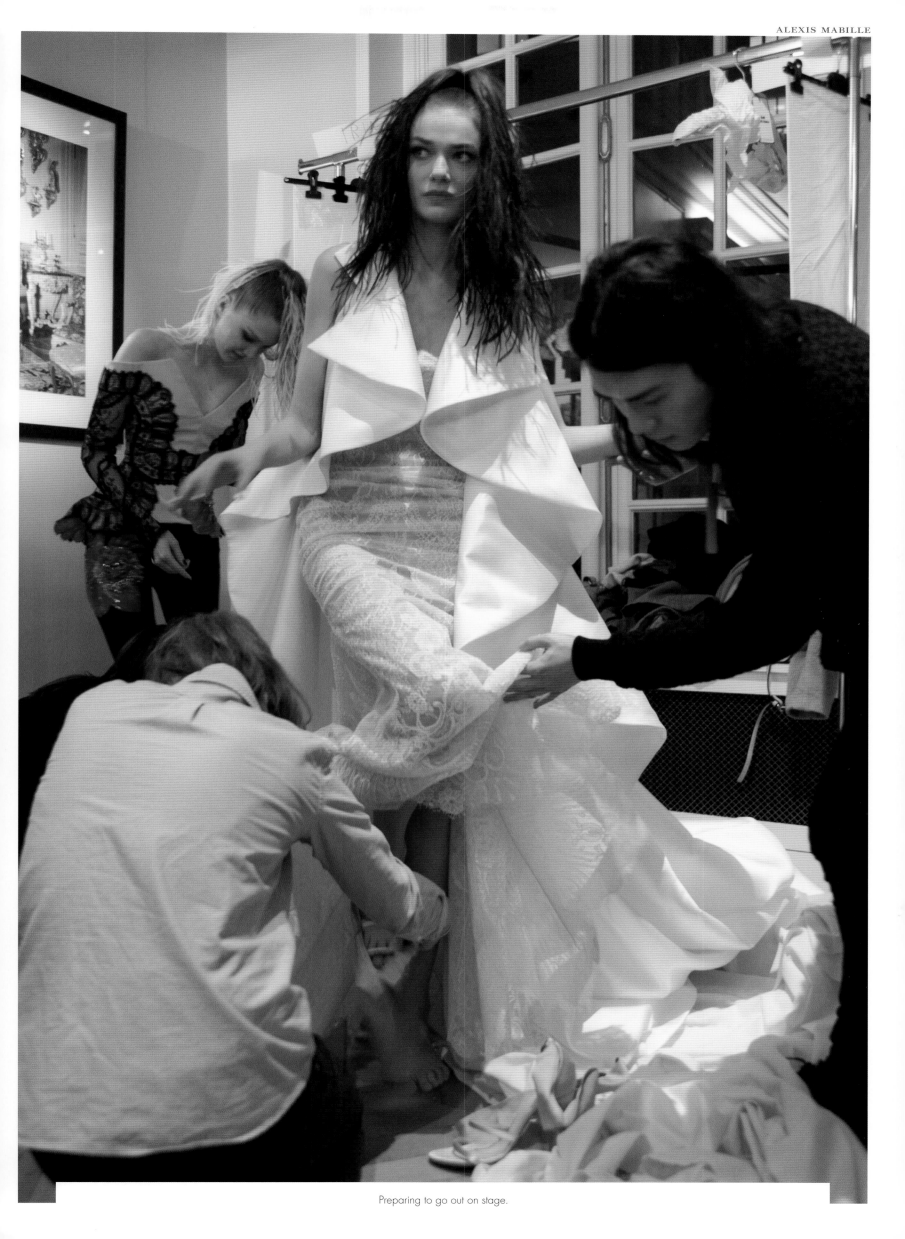

Preparing to go out on stage.

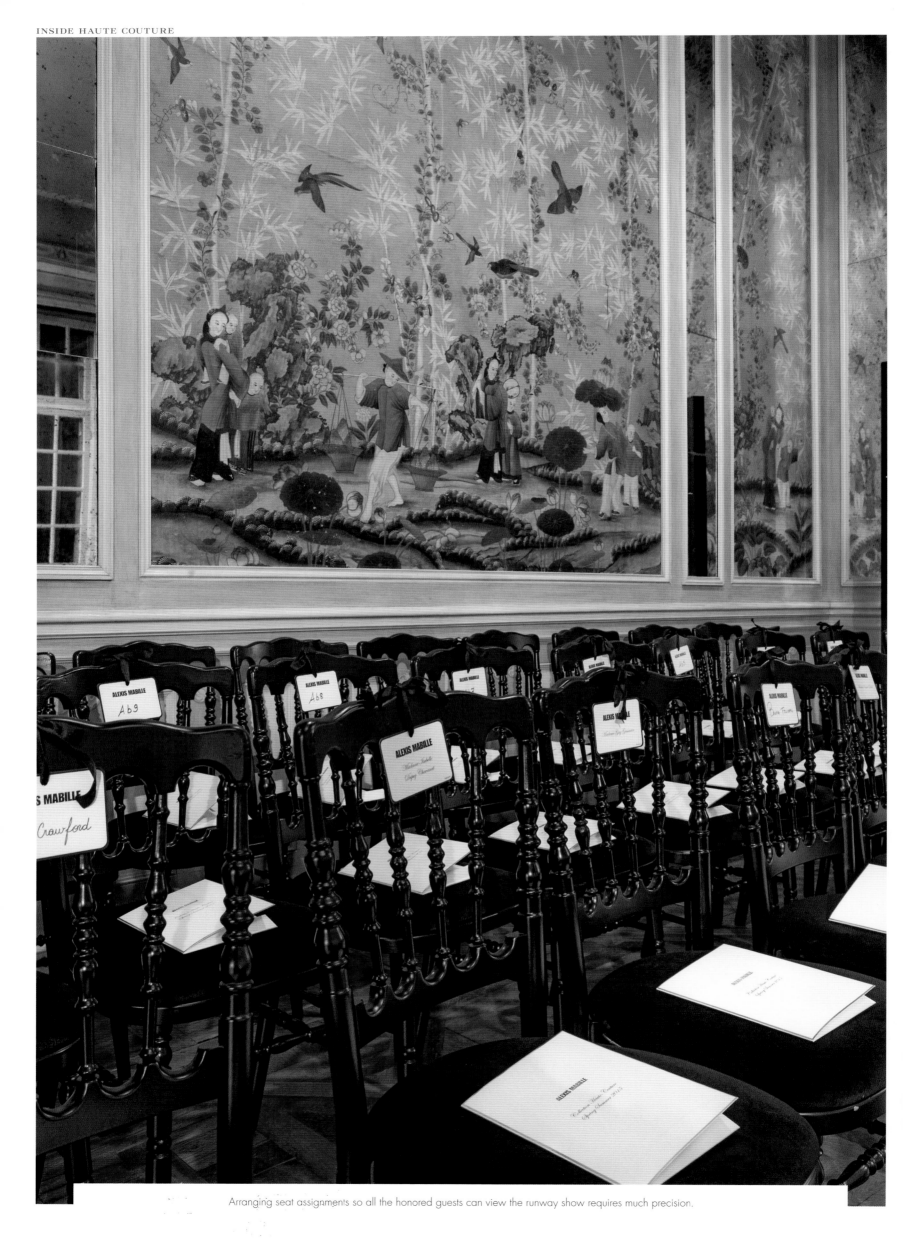

Arranging seat assignments so all the honored guests can view the runway show requires much precision.

ALEXIS MABILLE

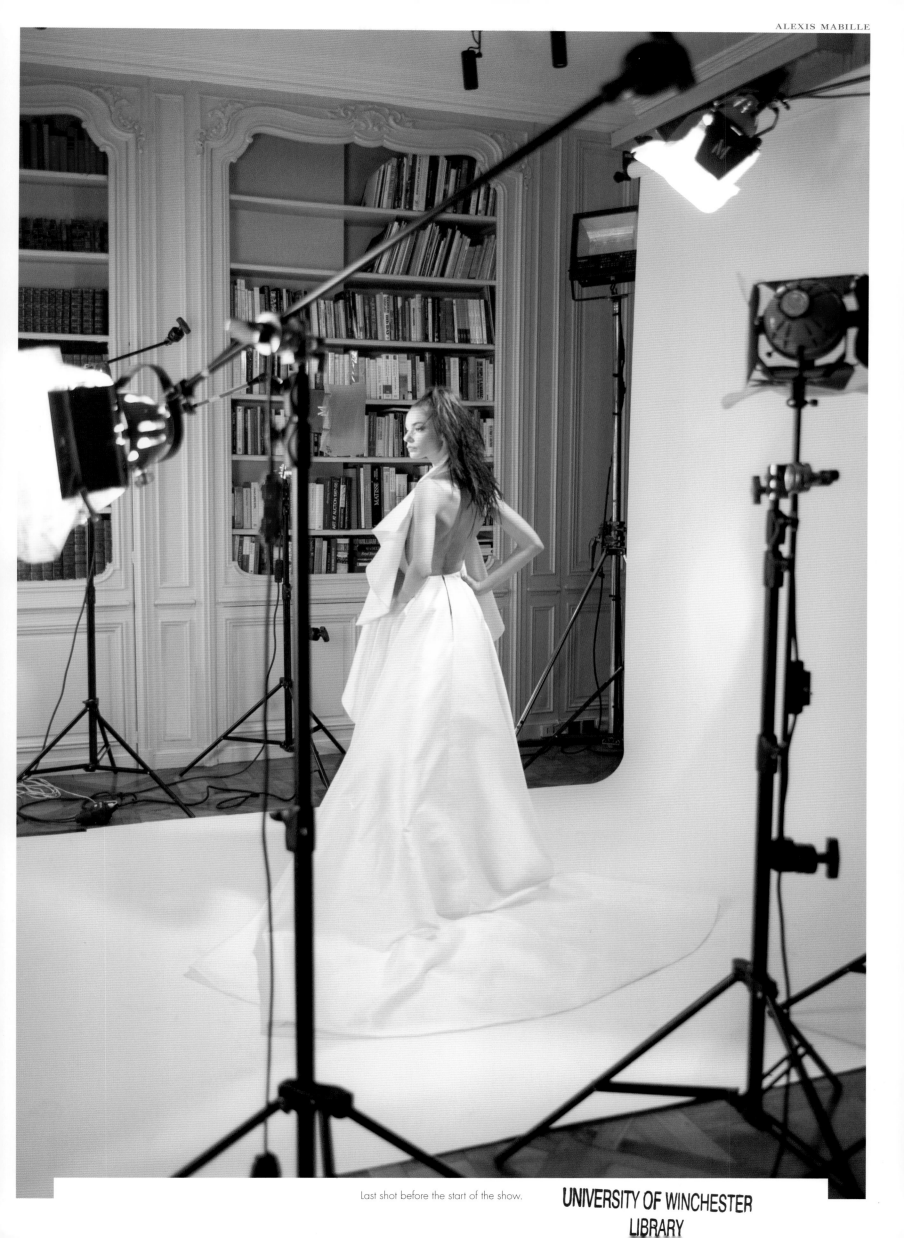

Last shot before the start of the show.

Ralph & Russo

29, RUE FRANÇOIS 1ᴱᴿ

Her great-grandmother, her grandmother, and her mother were all designers and couturiers, and so Tamara Ralph was born with fashion everywhere around her; clearly, it is part of her DNA. In her native Australia, she studied at the Whitehouse Institute of Design in Sydney and dreamed of one day creating her own fashion label in Europe. In the meantime, she quickly became a go-to designer for stylish women in her country.

As fate would have it, a trip to London in 2004 would make her dream come true. Upon her arrival, by chance she met Michael Russo in the street—a brilliant and talented businessman, also Australian. A short while later, charmed by Tamara's talent, Michael suggested becoming her partner in opening a fashion house in London. Tamara set out in search of the perfect seamstresses to bring her designs to life, while Michael looked for the ideal location. In 2007, they moved to Sloane Street in the heart of London. Then they opened a showroom on rue François 1ᵉʳ in Paris's eighth arrondissement. Michael became not only the CEO of their joint venture but also the love of Tamara's life.

In 2014, their fairy tale soared beyond even what they could have imagined. For the first time in more than one hundred years, England was admitted into the prestigious calendar of Paris's women's haute couture fashion shows, represented by Ralph & Russo.

On the day of their show, everyone was holding her or his breath: the press, the couple, and the audience. The result: a standing ovation! All agreed that the garments' cuts, embroidery, details, and inspiration perfectly embodied the spirit of true haute couture, the kind that is passed down from generation to generation. John Galliano and Christian Lacroix both noted that an incredible maturity emanated from the designs onstage, each example an astounding combination of glamour and freshness.

Ralph & Russo's 2015 spring–summer collection confirmed those first impressions. Tamara Ralph became even more confident; the dresses she presented evoked the exuberance of a ballet, with enormous petals of organza enveloping the models and gathering into magnificent blooms.

The Ralph & Russo company is, as of 2013, growing 400 percent per year, unheard of in

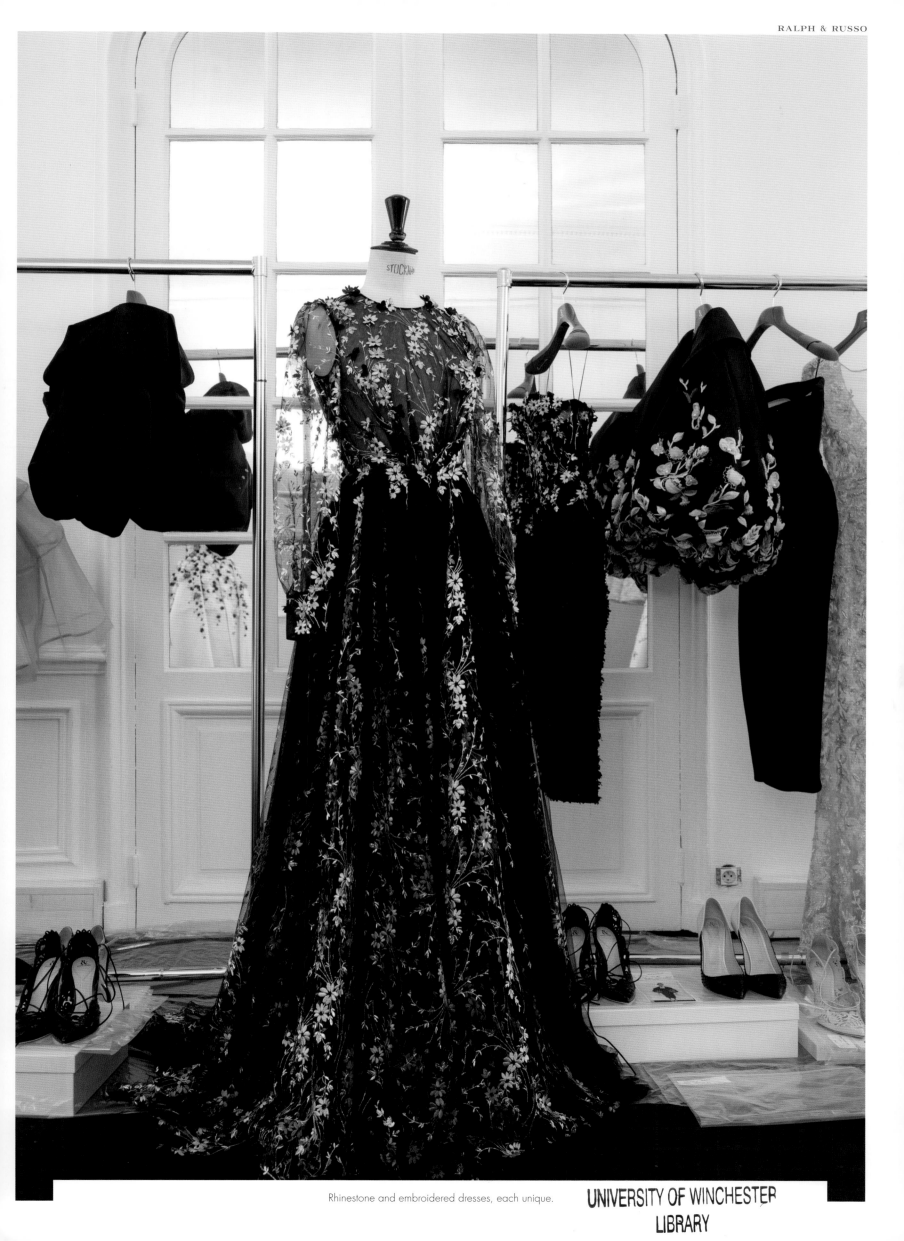

Rhinestone and embroidered dresses, each unique.

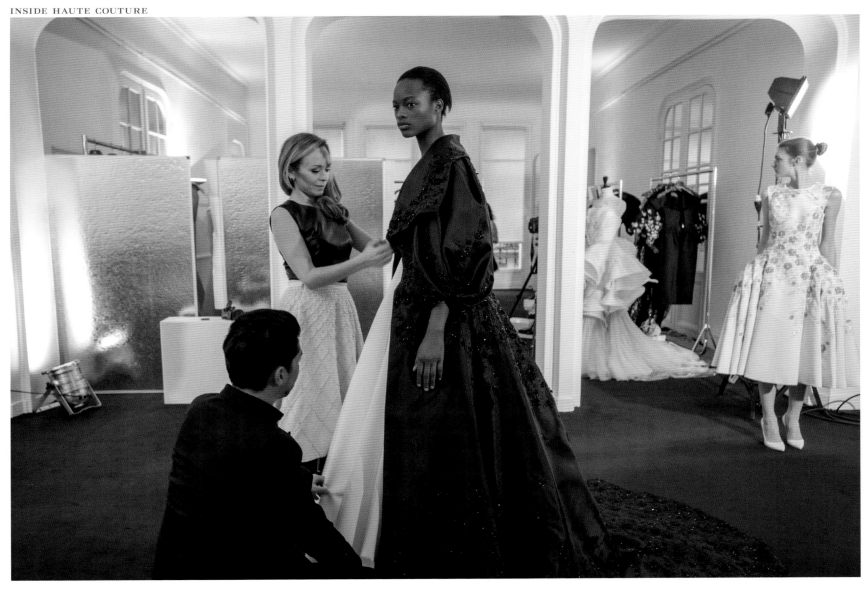

Tamara and Michael, a talented duo.

the world of fashion. In 2013 *Fortune* magazine included the couple on its prestigious list of "40 Under 40," which names the world's most influential young entrepreneurs. Beyoncé, Angelina Jolie, Eva Herzigová, and Sheikha Mozah of Qatar have championed their designs.

Ralph & Russo haute couture dresses each require between five hundred and seven hundred hours of work. Tamara herself performs miracles with her scissors and needle; she attends to every last detail, readjusting a sleeve's curve with precision. (She and Michael are equally impassioned, and the wonder they feel for every piece is palpable.) In the Paris ateliers they rented for their 2015 spring–summer show, there were sixty seamstresses at work, some coming from London especially for the event. On the hangers, the dresses looked like bouquets of flowers. Worn, they proved masterly: the cuts ever more inventive, the models shaped, sculpted, enhanced. The plentiful embroidery

is made by the prestigious Maison Lesage; such a level of professionalism has no room for approximation or useless details.

Cinched waists, elegant detail, and full-skirted gowns…Ava Gardner and Rita Hayworth would have melted in front of Ralph & Russo's haute couture. In addition to their refinement, the garments all share an extraordinary femininity, which comes to the fore with every movement of the torso, emphasizing the curves of the hips. The embroidery supplies cheerful enchanted gardens, the pleats, rivers of sensuality; nothing betrays the talent of the fashion designer as she expertly marries color and texture. Cinderella's fairy godmother appears to be close by, offering shimmering coats and dresses that spark one's instant desire to wear them. But with each one unique, which of these romantic yet contemporary pieces to choose? Ralph & Russo gives us haute couture full of pleasure and joy, which can be rare in fashion today.

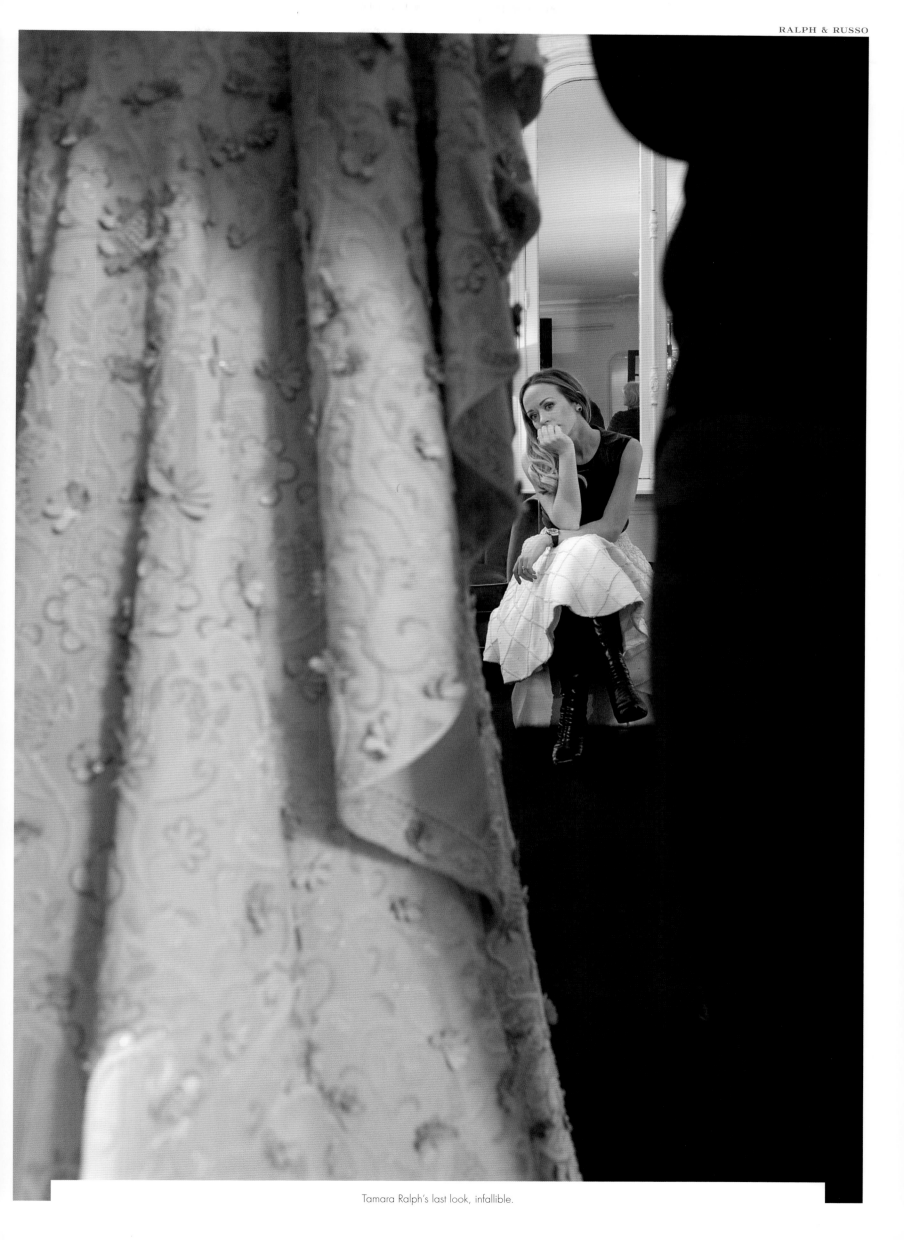

Tamara Ralph's last look, infallible.

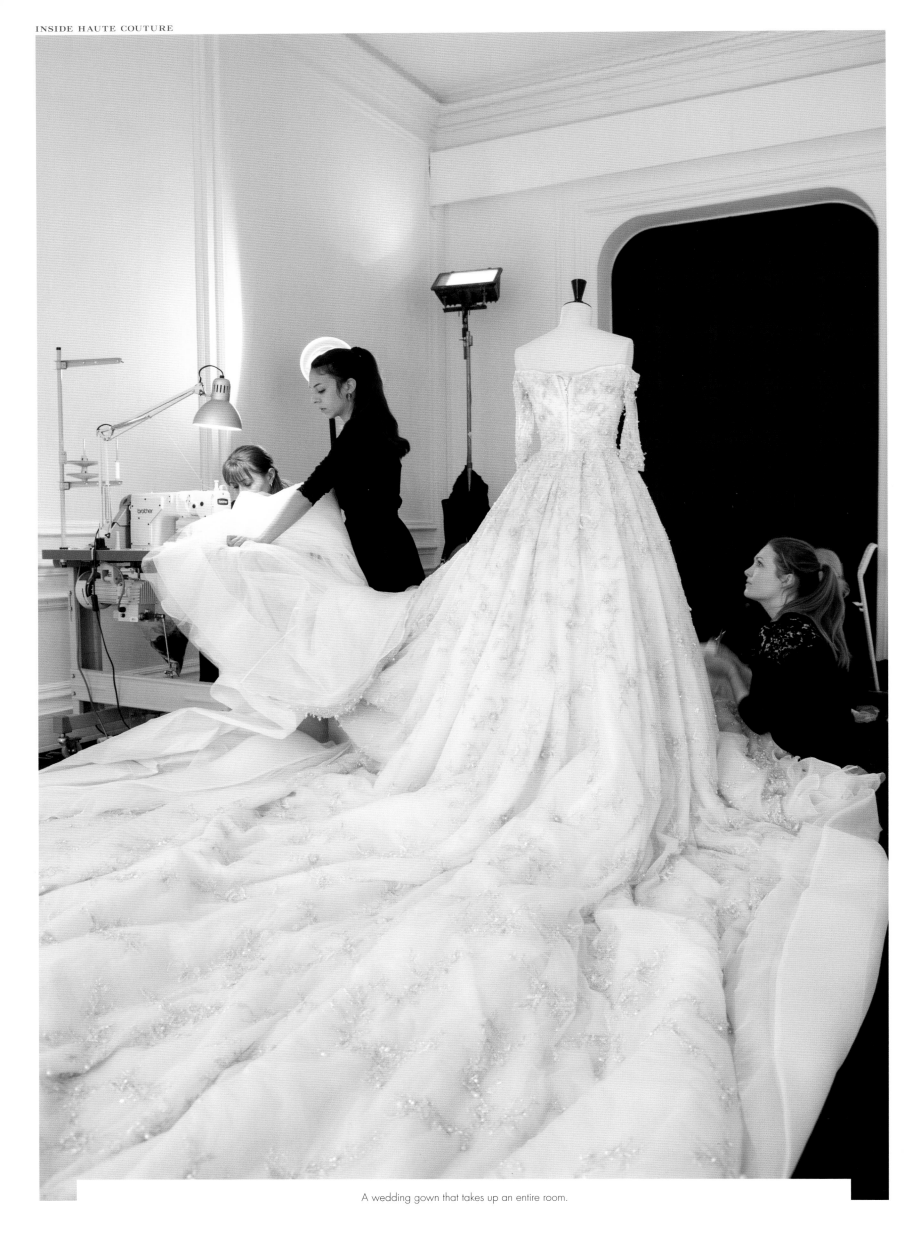

A wedding gown that takes up an entire room.

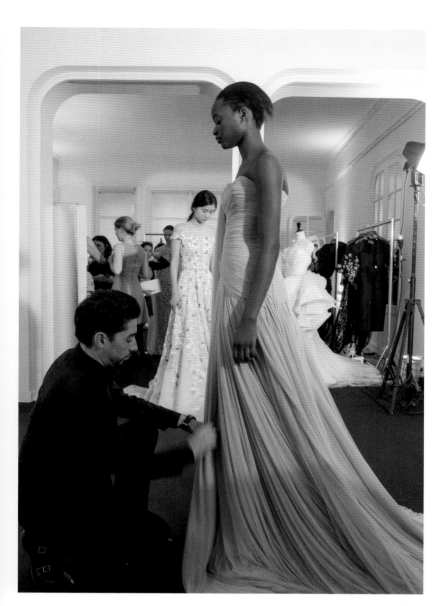

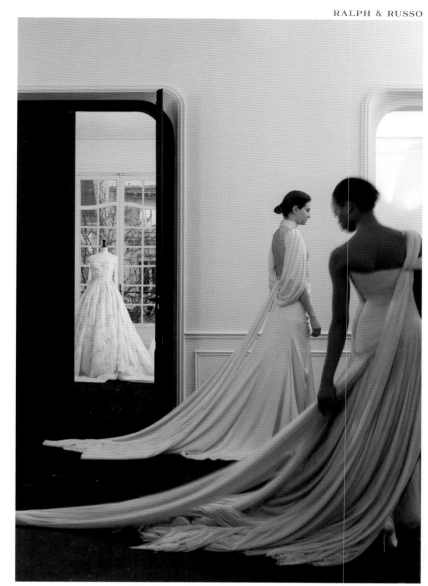

Fitting on models, a key moment in dressmaking.

THE WHIRLWIND OF FINAL PREPARATIONS

The bridal gown for Ralph & Russo's 2015 haute couture spring–summer runway show required 3,900 hours of work. At the time the final touches were being made, two thousand feet (six hundred meters) of silk tulle unfurled over the floor of their studio, and some dozen seamstresses were at work, like butterflies hovering over a flower.

"We deliver a huge number of bridal gowns throughout the world, and each one is obviously a unique piece. The same is true for all the collections our studios produce. We don't do prêt-à-porter, and the company rule is that each country has to receive a different collection," Michael Russo said the day before the Paris Haute Couture show on January 28, 2015.

In a mere seven years, the house of Ralph & Russo has gone from a shoebox-size office with only one sewing machine to a bustling company of more than one hundred people. It opened a boutique at Harrods, the luxury department store in London, and will soon have shops in New York City and Hong Kong. Work is never slow, especially since John Caudwell, founder of Phones 4u, invested in the brand's expansion. Indeed, orders are pouring in from all over the world, most recently from China. Their designers are so booked that appointments with Ralph & Russo are sometimes made two years in advance.

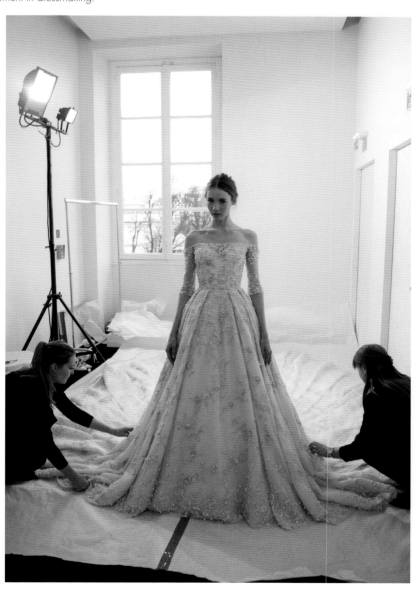

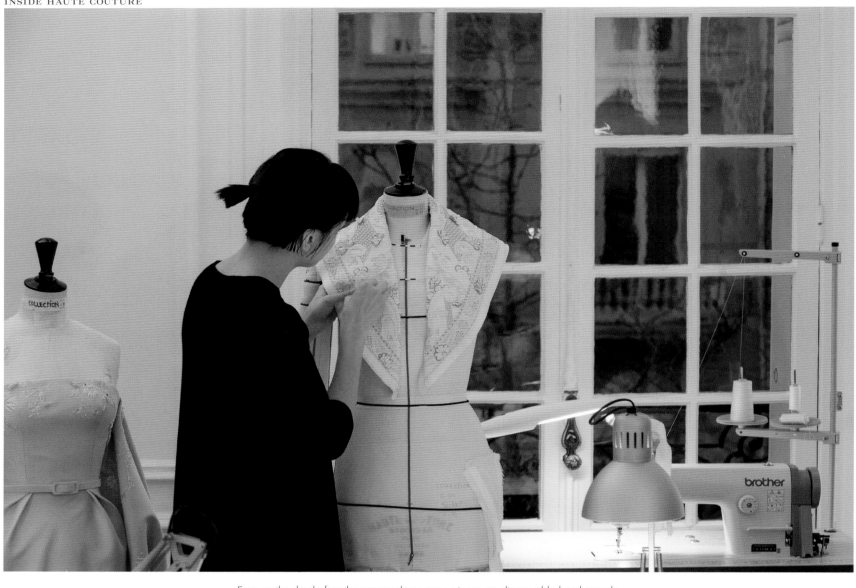

Even on the day before the runway show, some pieces are disassembled and remade.

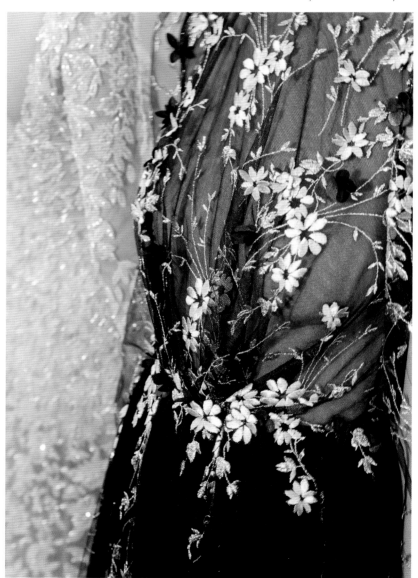

In 2013, when the couple was visiting Azerbaijan, invited by the architect Zaha Hadid, Michael received a call from the president of the Chambre Syndicale de la Haute Couture to inform him that Ralph & Russo would be included in the official schedule—wonderful news that opened the doors to fame for Michael Russo and creative director Tamara Ralph. Ever since, despite the success engulfing them, they've remained true to themselves—vivacious, puckish, and charming, completing each other's sentences or saying the same word at the same time.

In anticipation of their wedding, Tamara has decided to design four dresses so that Michael won't be able to guess which she's going wear on the actual day. Lots of work, true, but what wouldn't she do to surprise the love of her life?

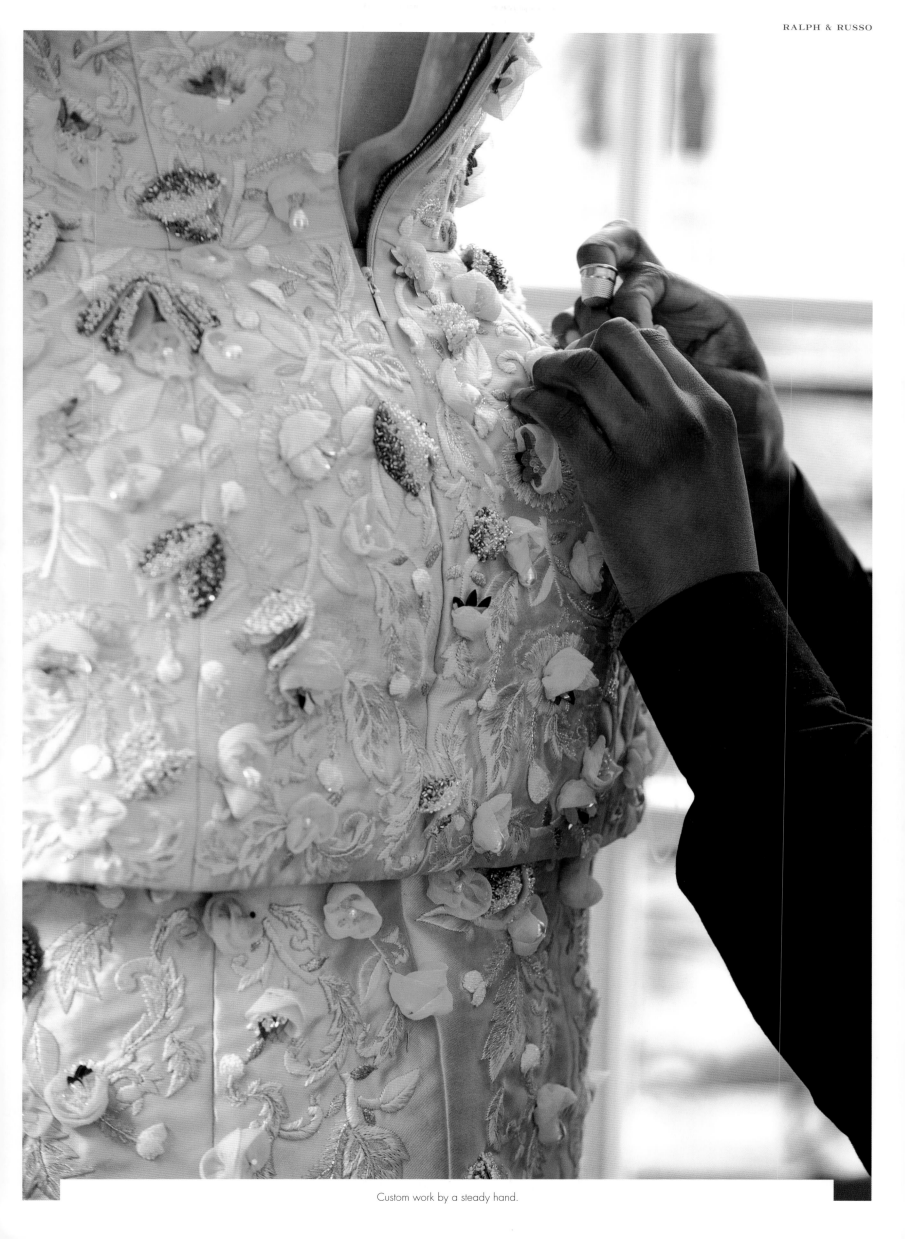

Custom work by a steady hand.

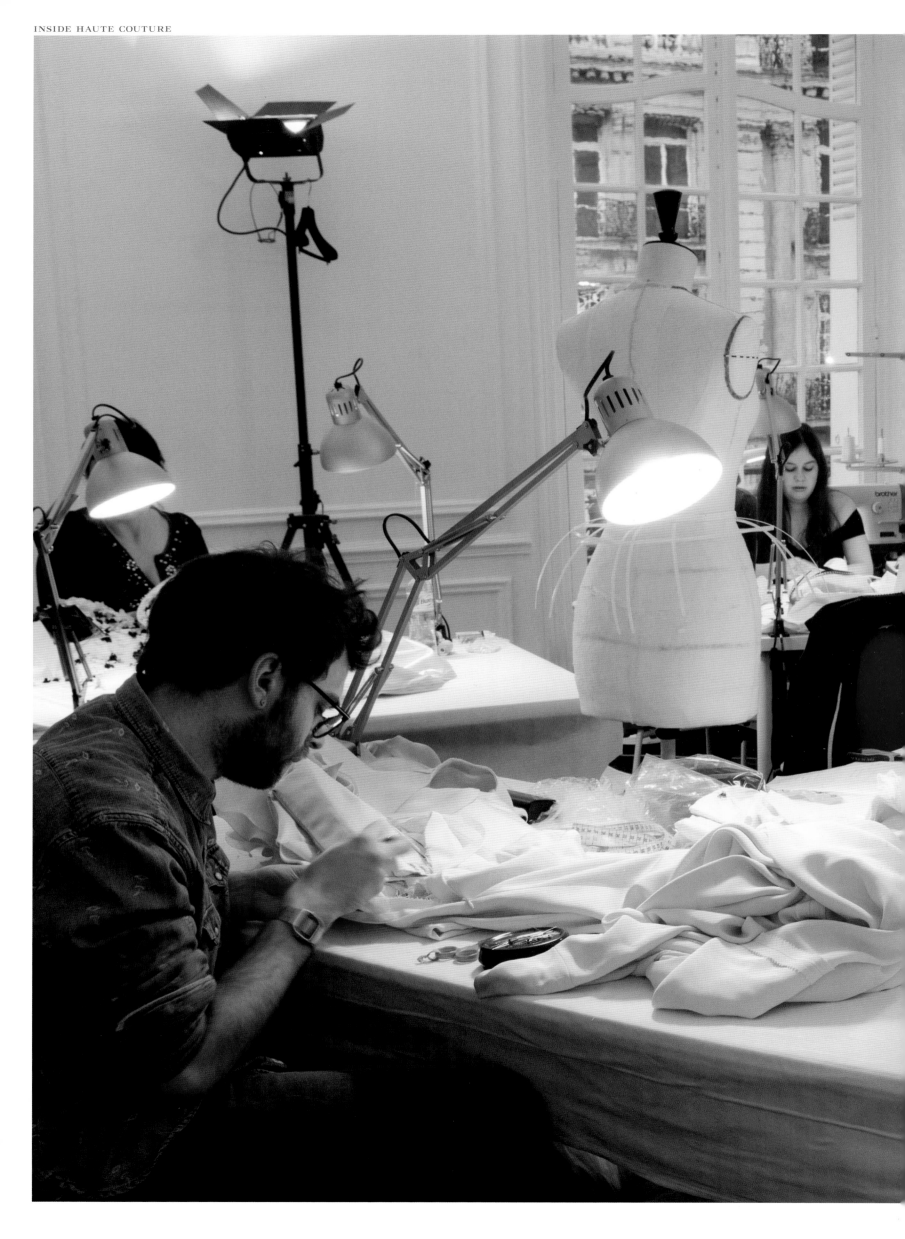

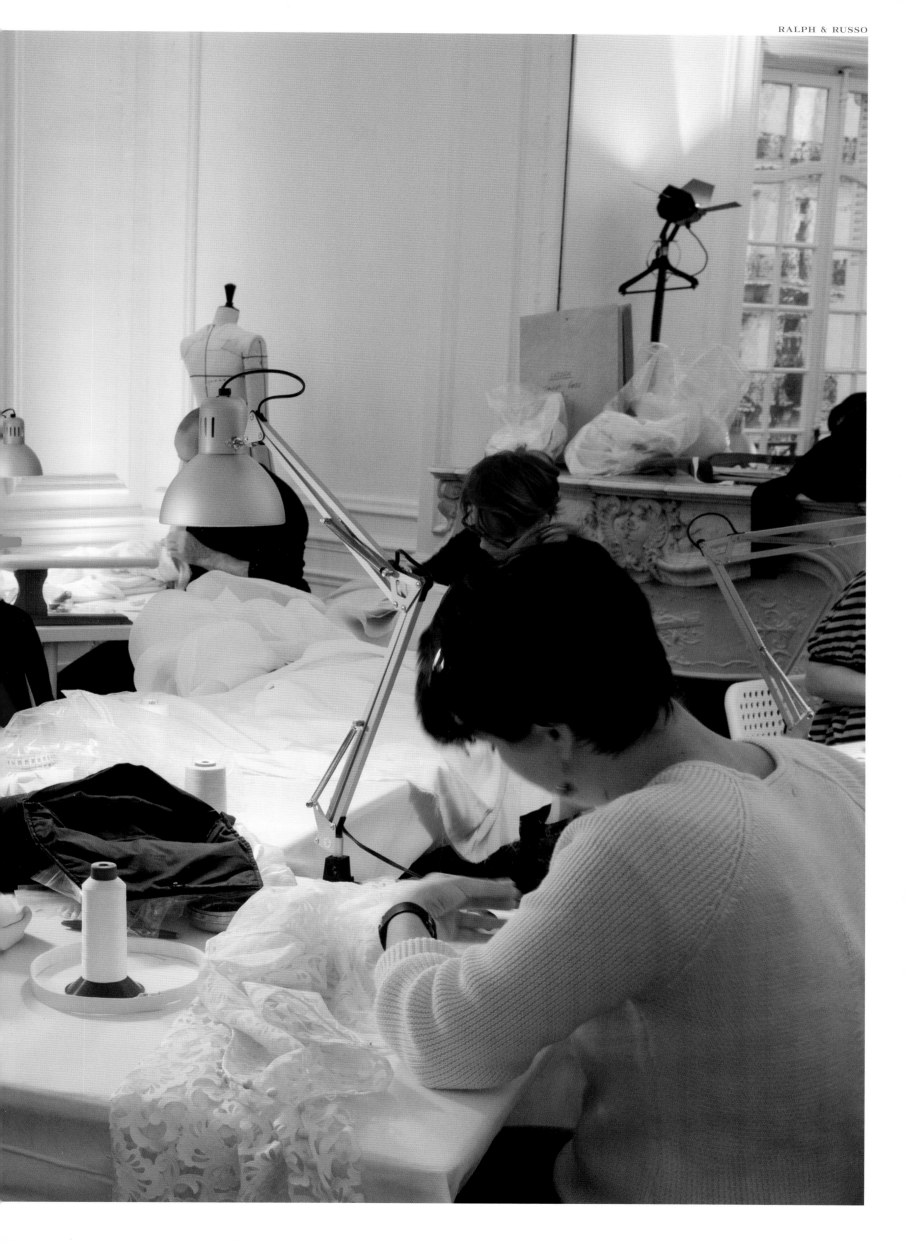

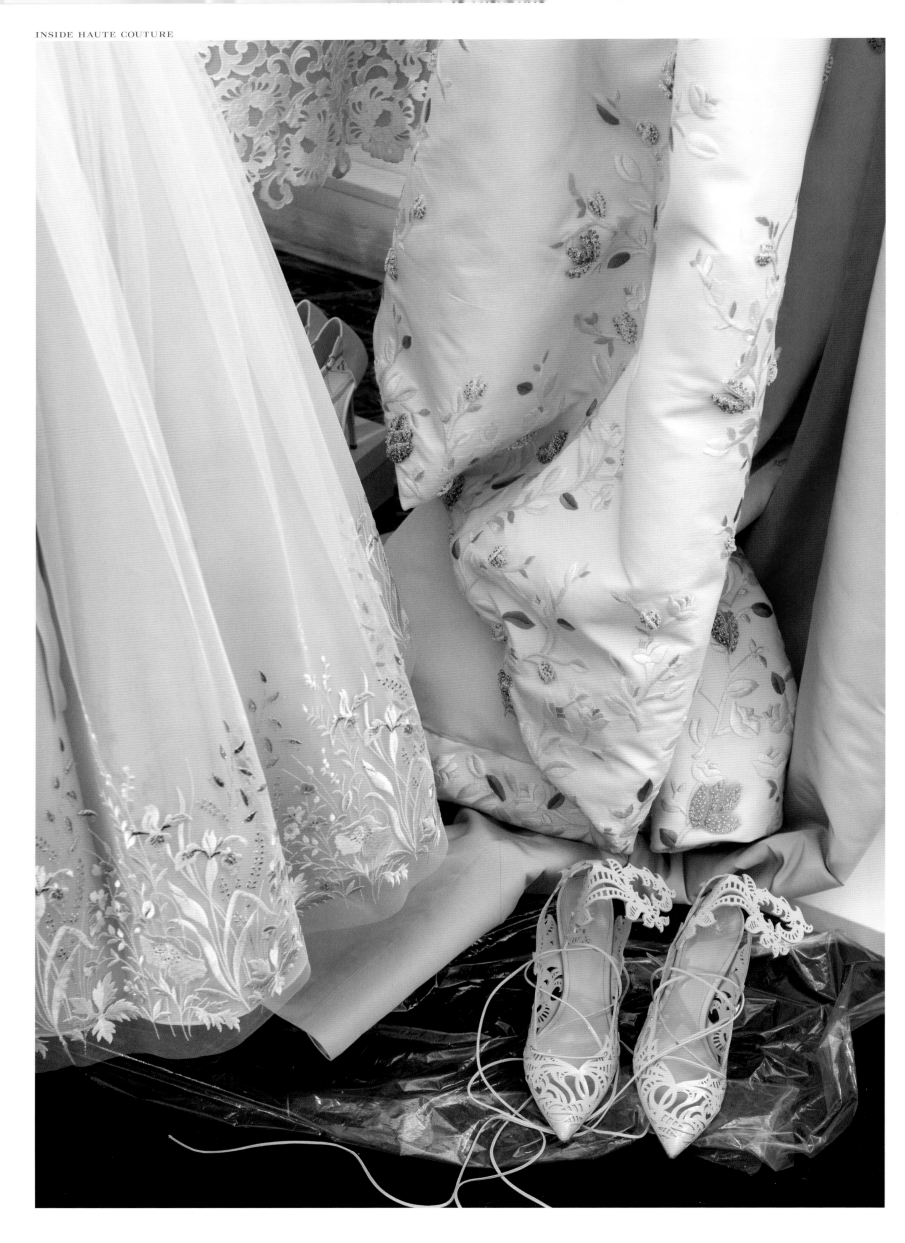

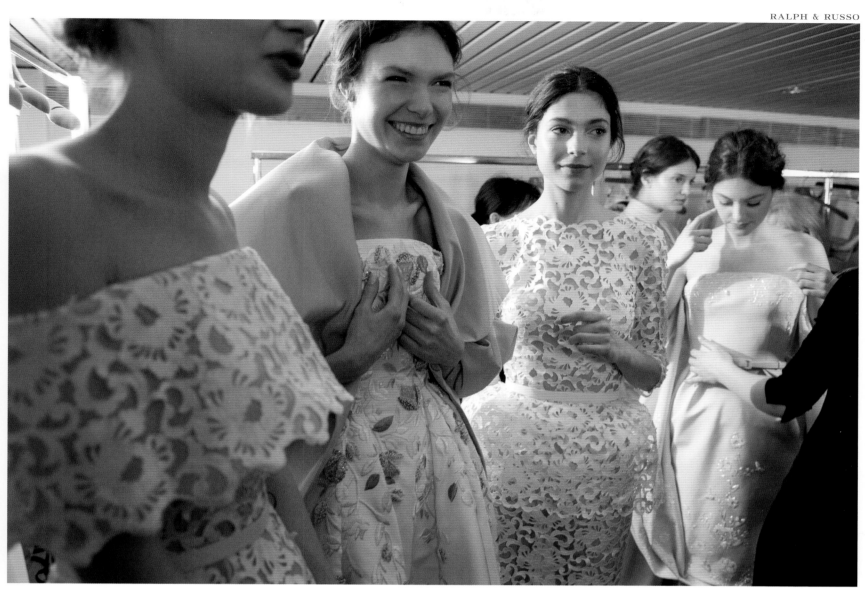

Buoyant mood and final checks before the show begins.

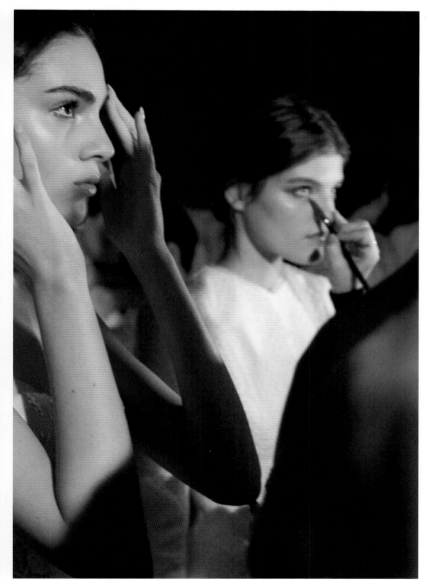

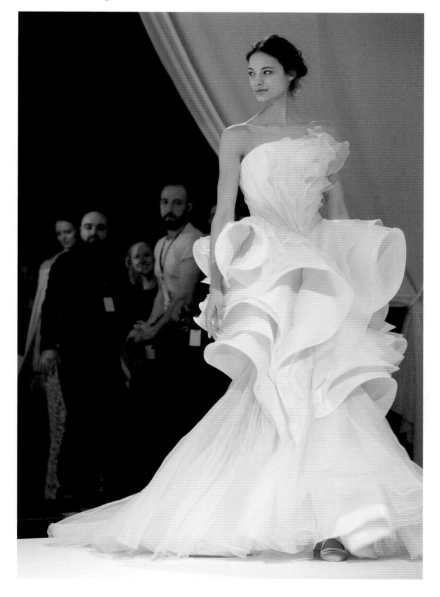

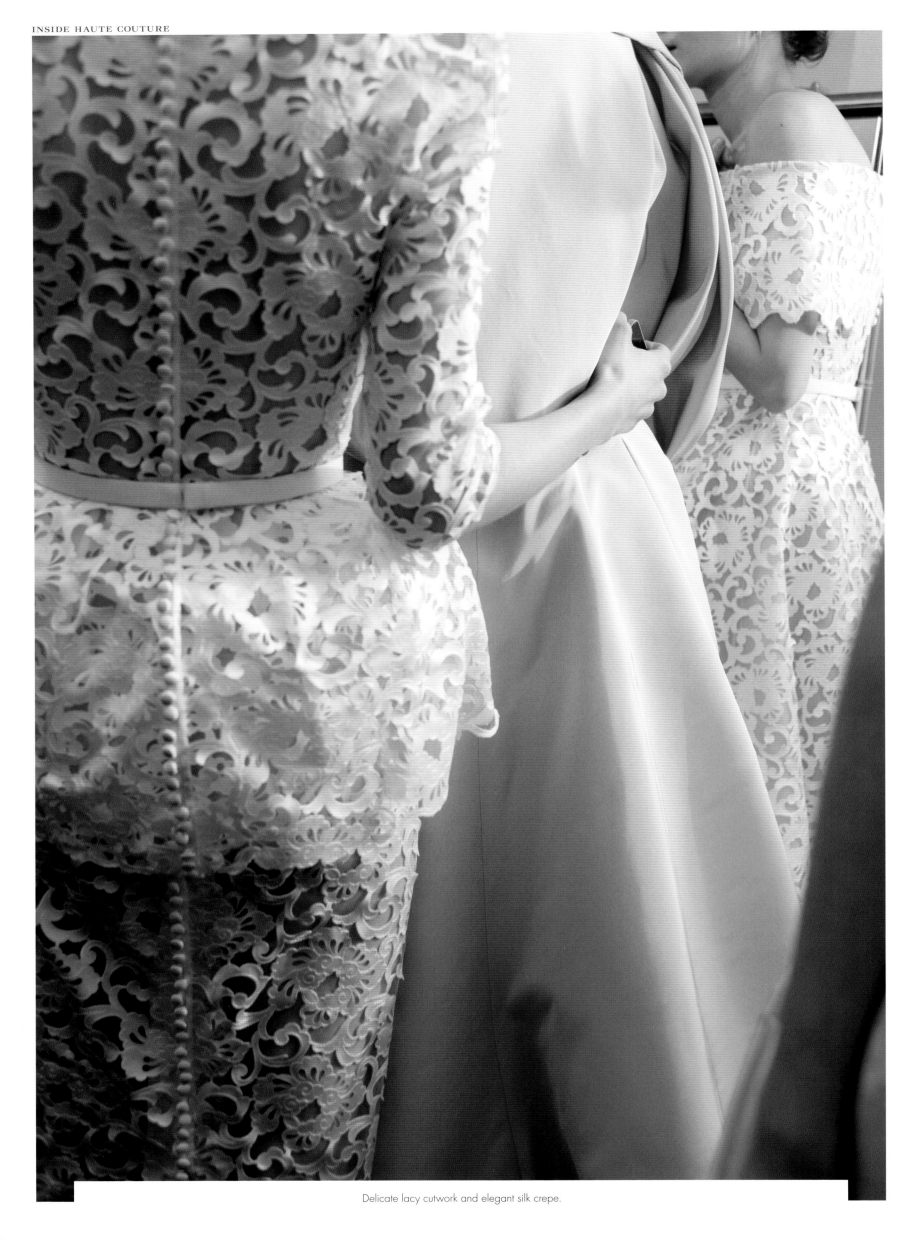

Delicate lacy cutwork and elegant silk crepe.

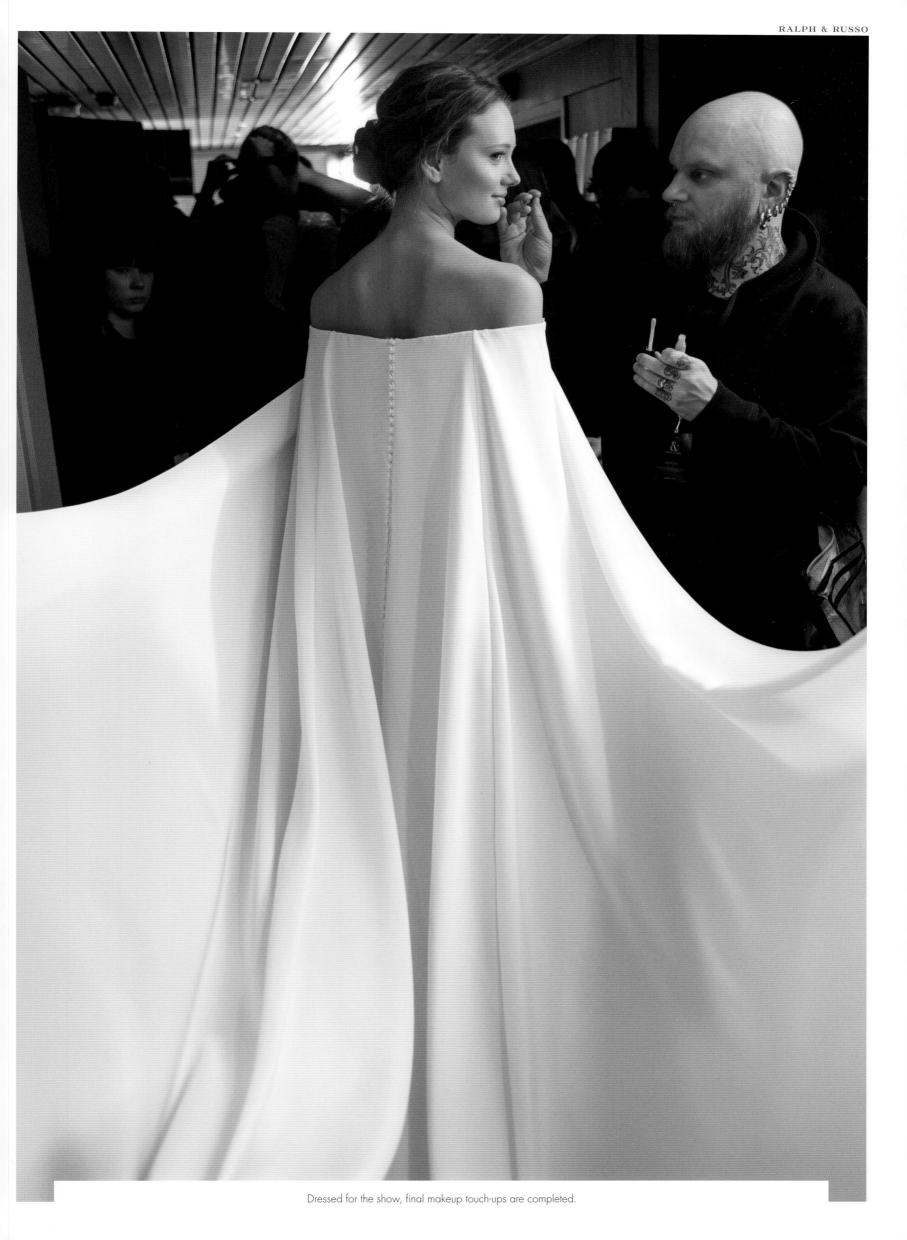

Dressed for the show, final makeup touch-ups are completed.

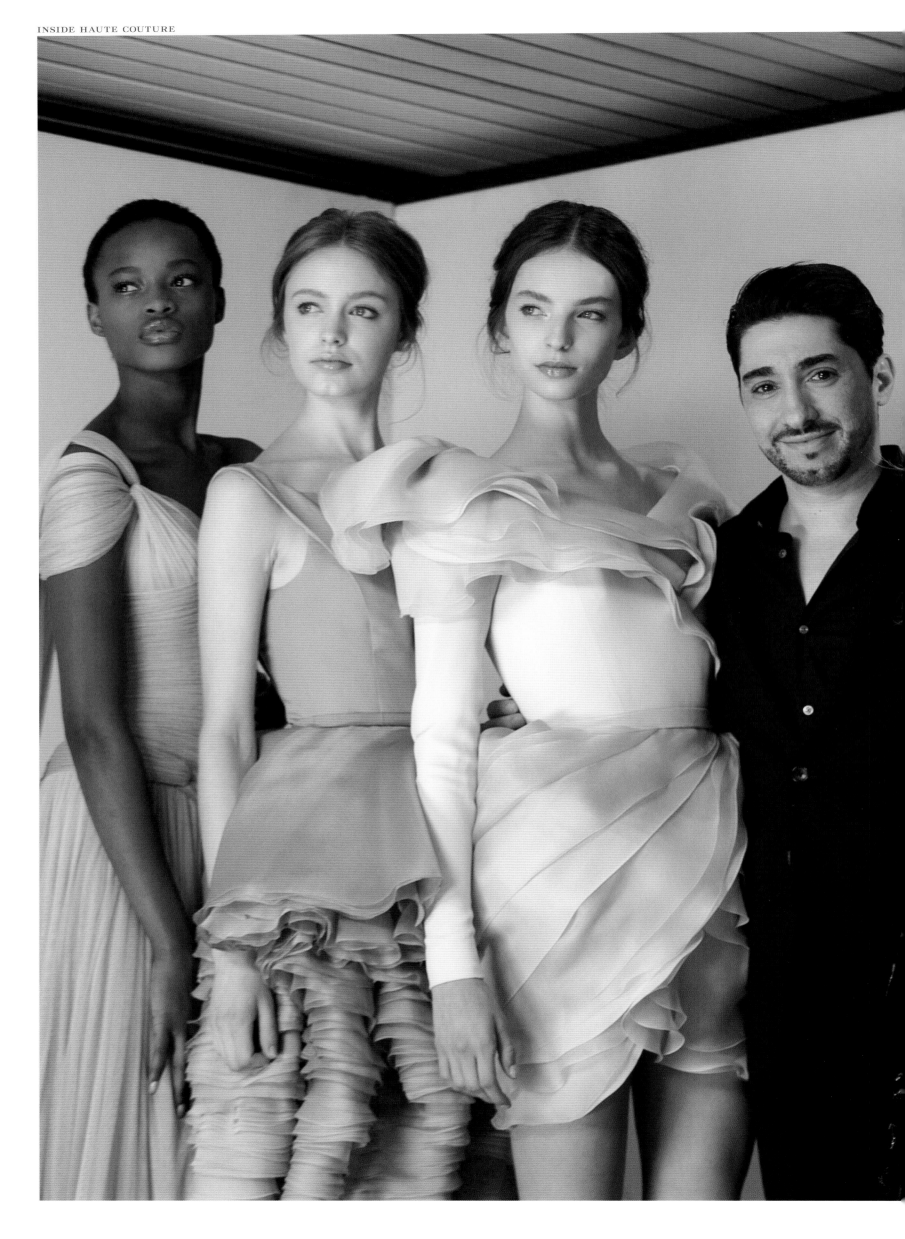

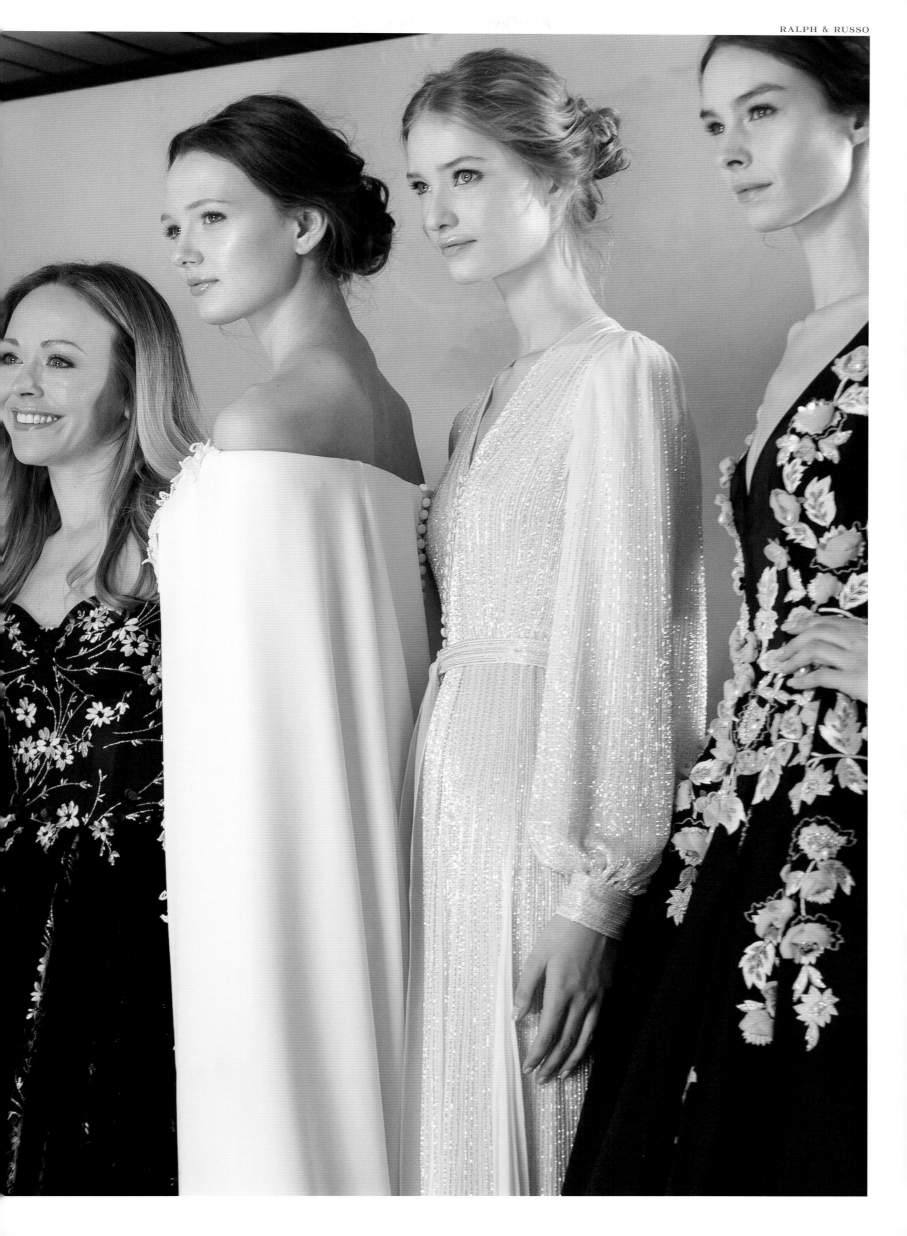

STÉPHANE
—
ROLLAND

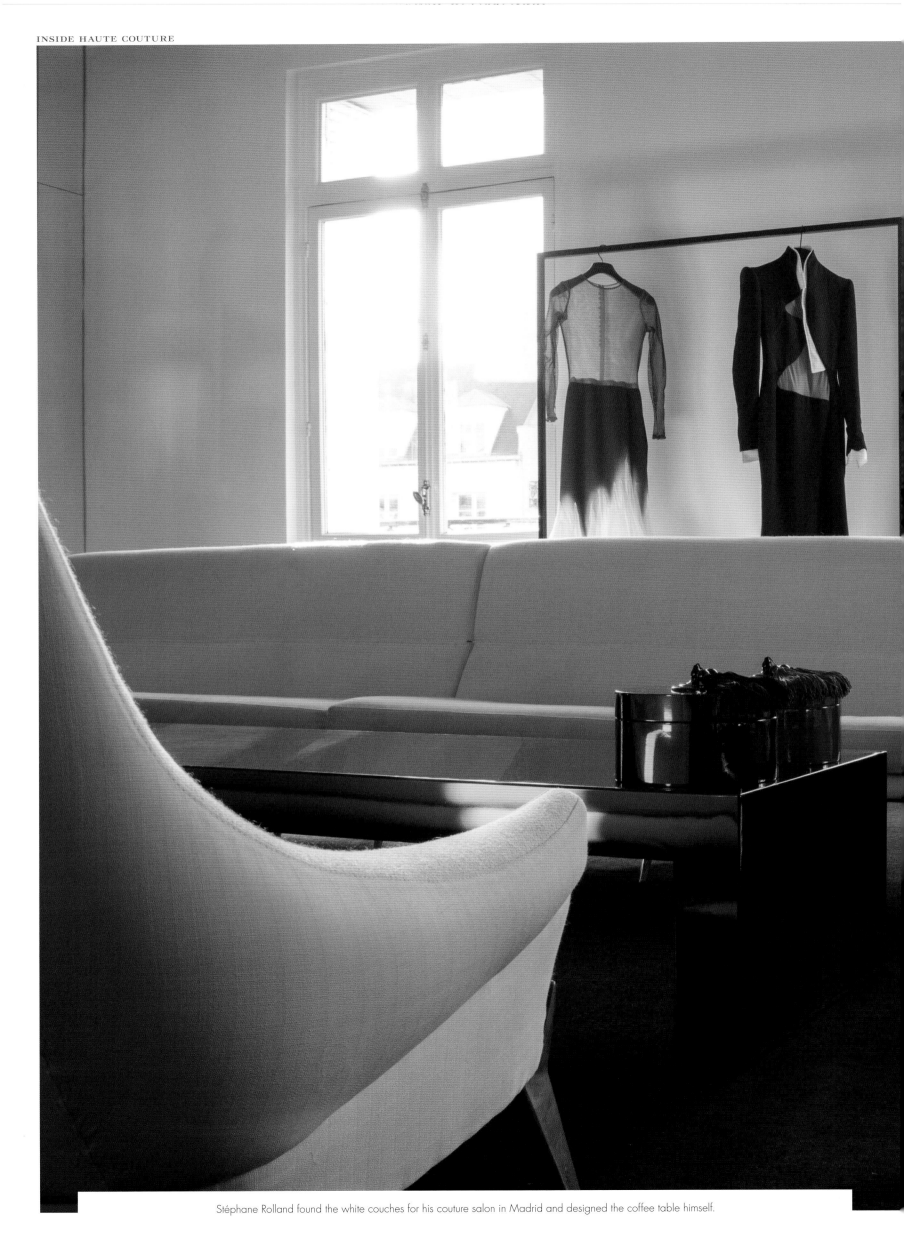

Stéphane Rolland found the white couches for his couture salon in Madrid and designed the coffee table himself.

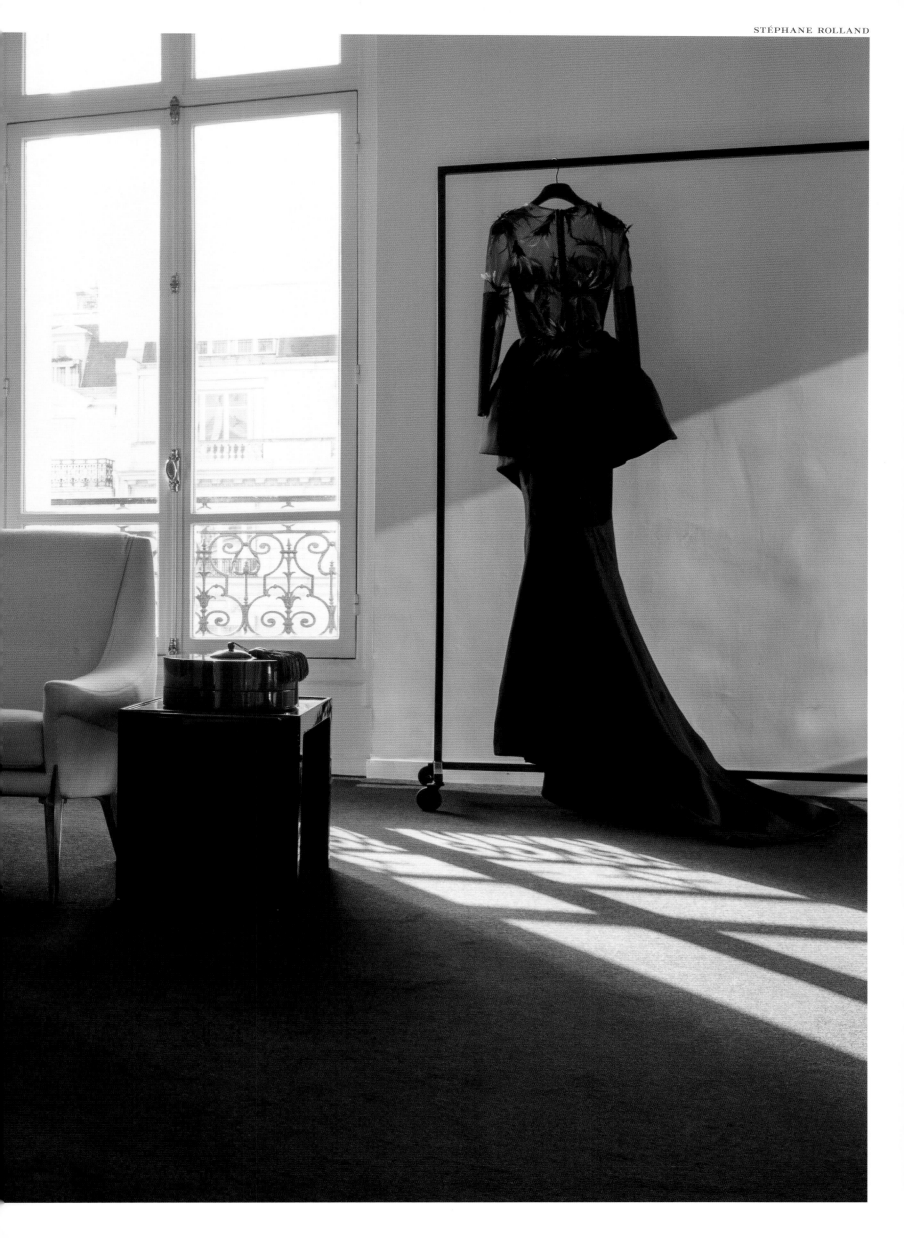

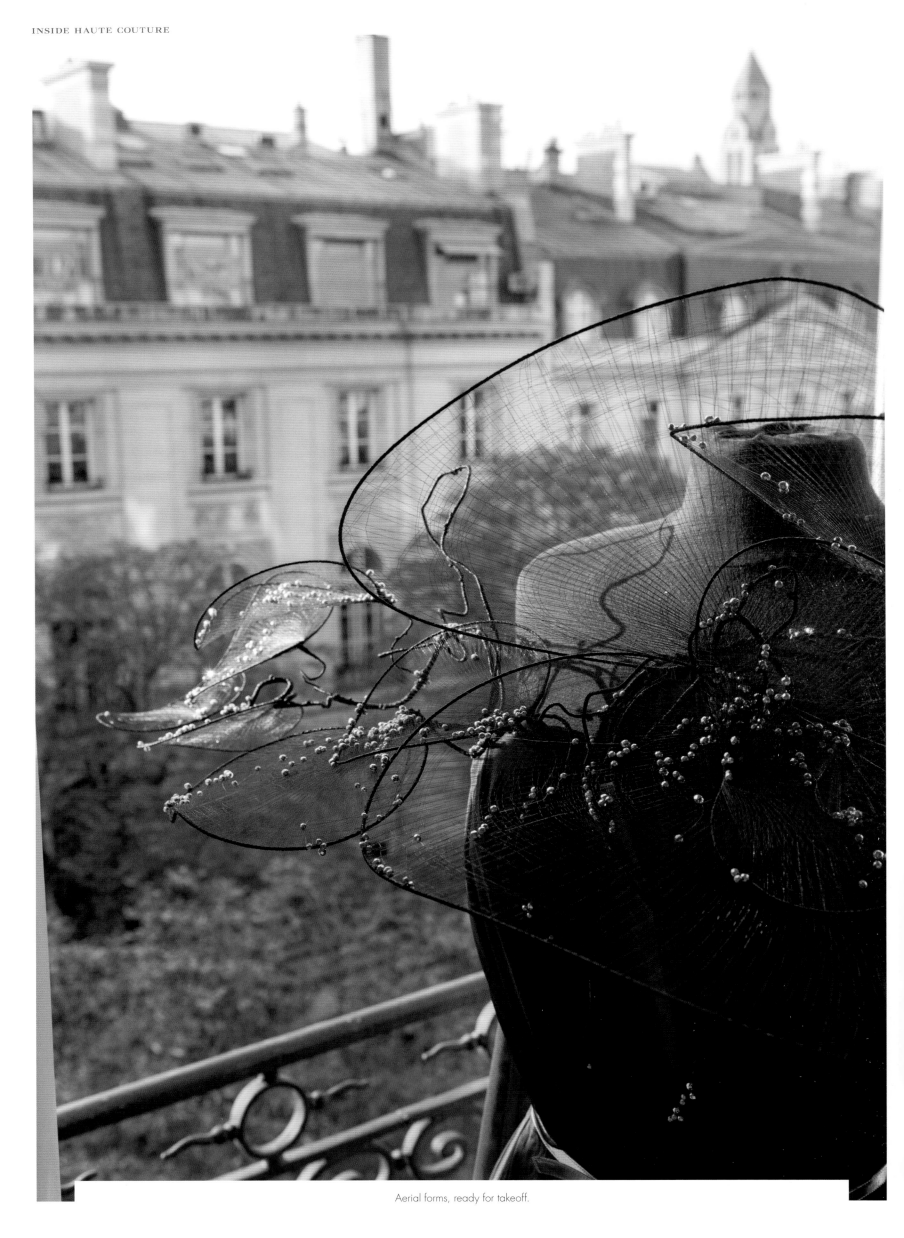

Aerial forms, ready for takeoff.

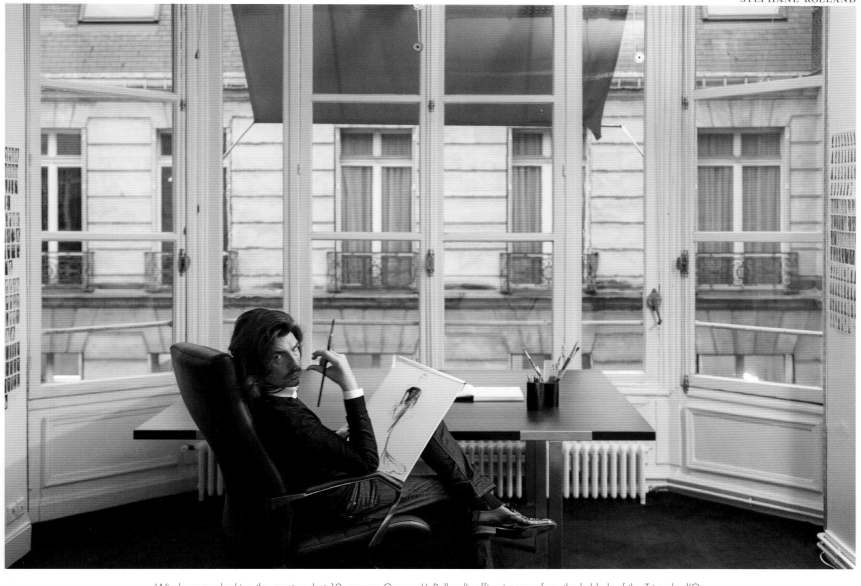

Windows overlooking the courtyard at 10, avenue George V. Rolland's office is away from the hubbub of the Triangle d'Or.

his prestigious firm on avenue Montaigne. He would stay ten years.

On July 2, 2007, he presented his first haute couture collection under his own name at his ateliers at 10, avenue George V, in Paris. By 2008, his company became a member of the very exclusive Paris haute couture circle. Floating capes and ultra-modern sheath dresses embody sensuality but also express the duality that brings such spirit to Rolland's work: the effervescence of an active life and the contemplation of time passing, simplicity and depth, minimalism and exuberance. In all his collections, fashion is expressed in black and white, interspersed with a few lively colors and earth tones. Structured shapes contrast with voluminous dresses; silk crepe and organza amplify the play of transparency in a genuine ode to elegance.

Rolland loves women with character, and they love him back. He notably dresses the model Petra Němcová, the Spanish actress Paz Vega, and singers Lady Gaga and Rihanna. Her Highness Sheikha Moza of Qatar and Queen Rania of Jordan are sculptural visions in his gowns.

In his ateliers, which are divided between *flou* (draping) and *tailleur* (fitted), some thirty people work diligently, as if in a beehive. Josette, head of the *flou* atelier, sets the tone, deftly folding fabric and precisely positioning her needle; watching her work is a true pleasure. All the employees know exactly what they have to do, and no one is bothered when the artist arrives unannounced.

Quite the opposite. Even the hands of this charismatic man—who can spin words into beautiful tales—move in a constant ballet reminiscent of his dresses in motion.

When one speaks of haute couture, one is speaking, of course, of luxury. As Rolland says: "And real luxury means taking one's time in order to attain perfection. Another constant that always accompanies time is the unpredictable. You can't fold [time] and put it away in a closet and take it out as you please. Time is chaos. It's like Cairo. [But] I love the feeling of [that city's] chaotic disorder, of honking, dust, people, and song mixing together to create an authentic and particular charm." Rolland considers time a

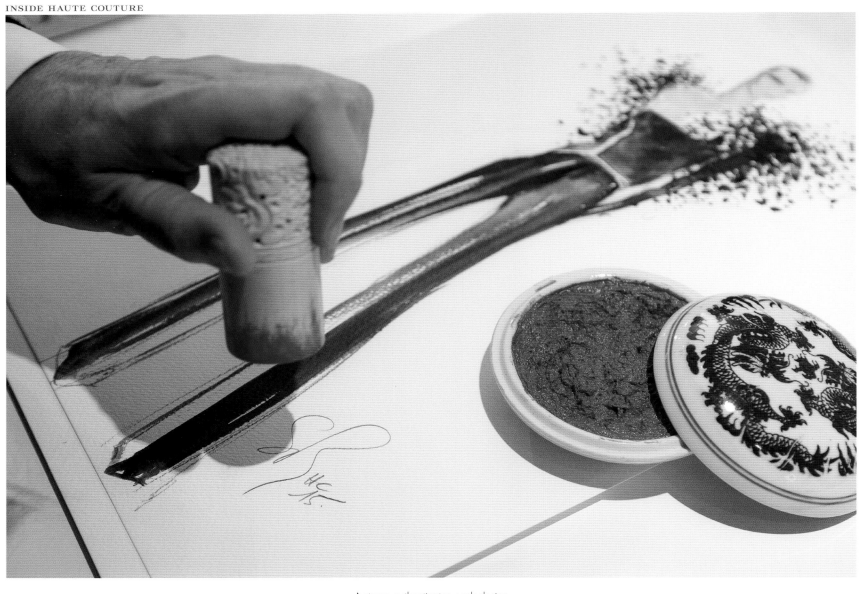

A stamp authenticates each design.

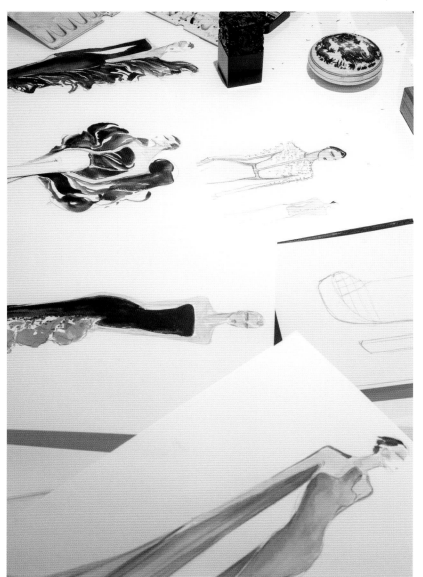

treasure; he has always known how to master and transform it into savoir faire and *savoir vivre*.

If he hadn't become a designer, he says he would have found a career in film: "I would have been an actor. I love the movies. The cameramen, the technical crew, the world of the image. The movies took hold of me. They inspire what I do. My nights are haunted by Marlene Dietrich, Ava Gardner, and the myth of the blonde embodied by Charlize Theron, who can juxtapose the art of seduction with the spirit of spontaneity."[1]

In 2013, he chose Abu Dhabi for his first prêt-à-porter and luxury-accessories boutique. There, Rolland continues to write his life story, his imagination never ceasing, however, to confront economic reality. Even as he woos the mythical East of *One Thousand and One Nights*, it flirts back in return, attentive to his every collection. For his 2015 spring–summer haute couture runway show, black *abayas* in flowing, pure cuts breathed new life into the sometimes strict women's attire of the region—kind of a couture "hyphen" between the traditions of the Middle East and the West.

Surrounded by his favorite pictures, the couturier draws elegance.

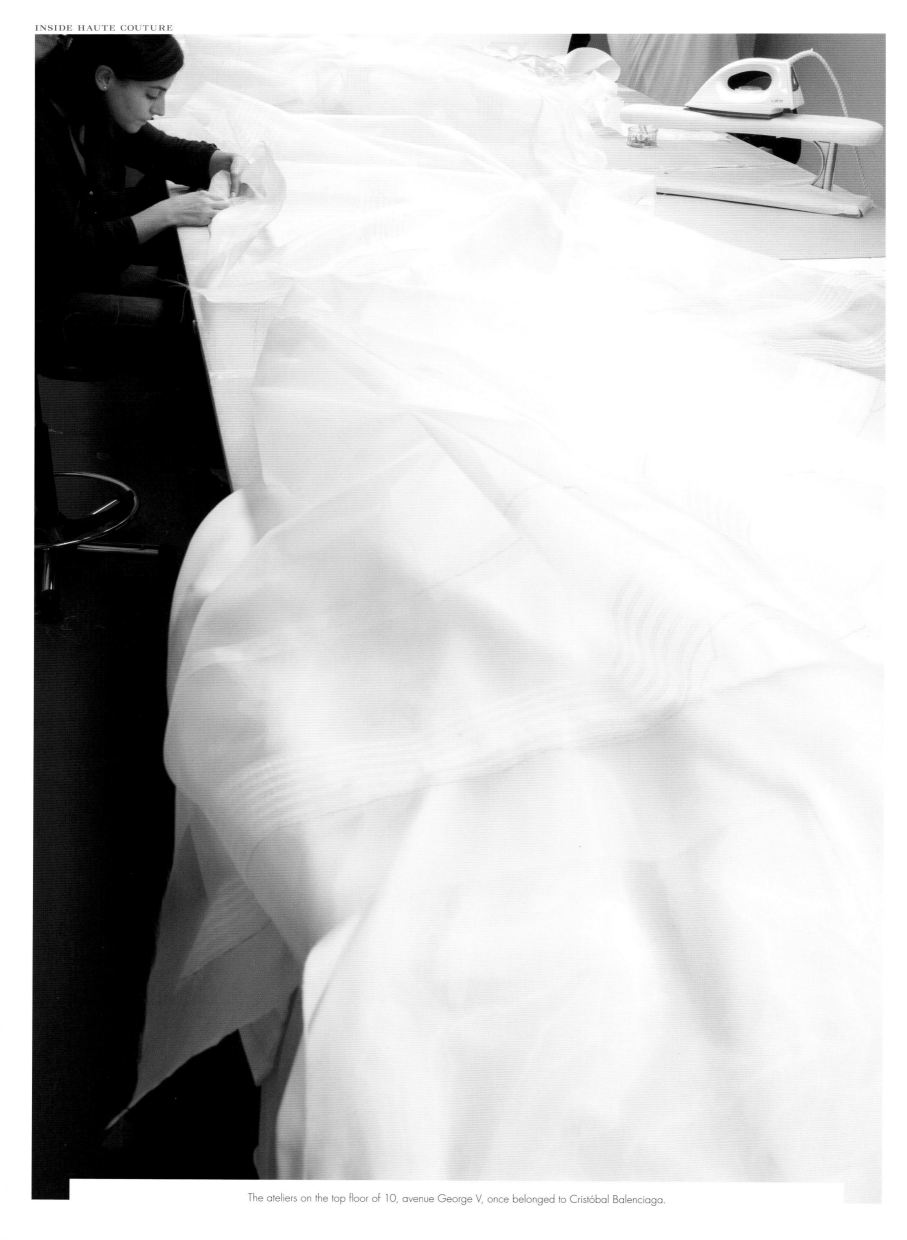

The ateliers on the top floor of 10, avenue George V, once belonged to Cristóbal Balenciaga.

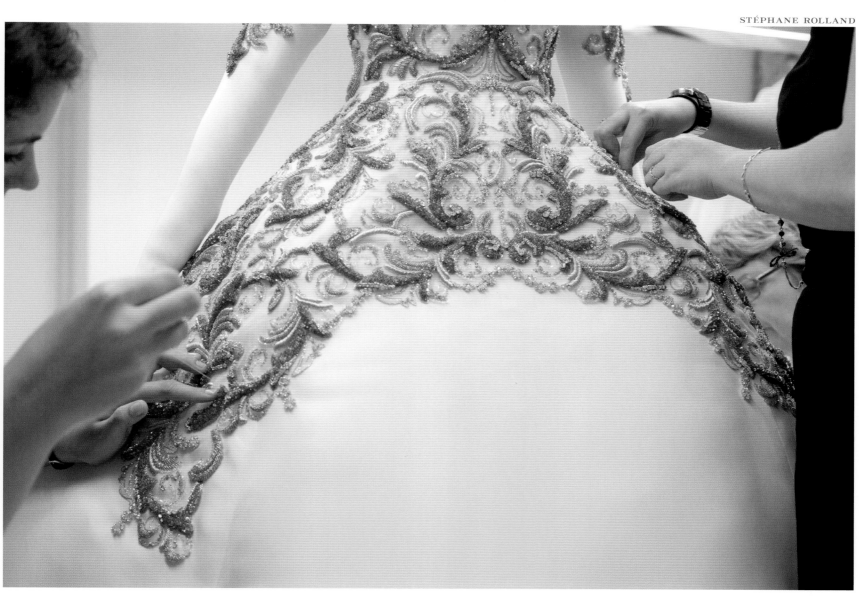

Princess dresses demand careful attention.

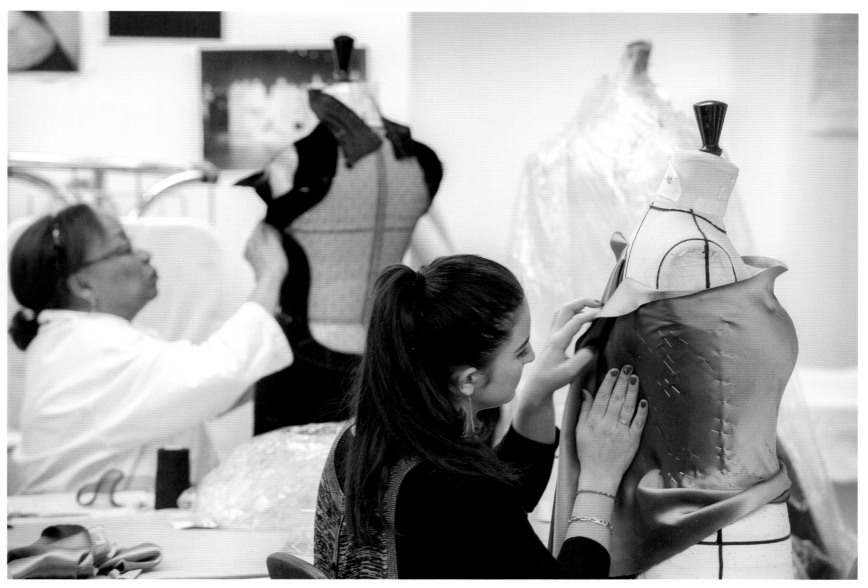

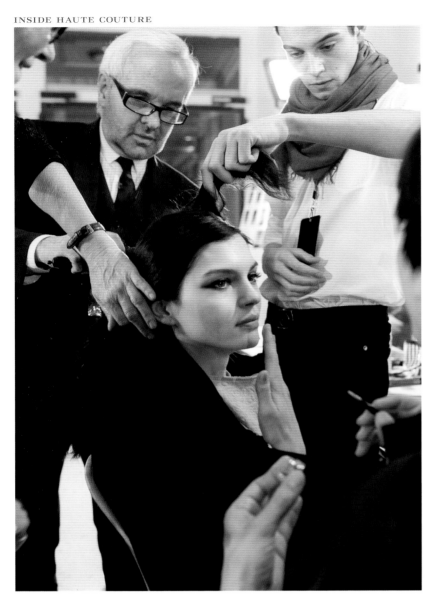

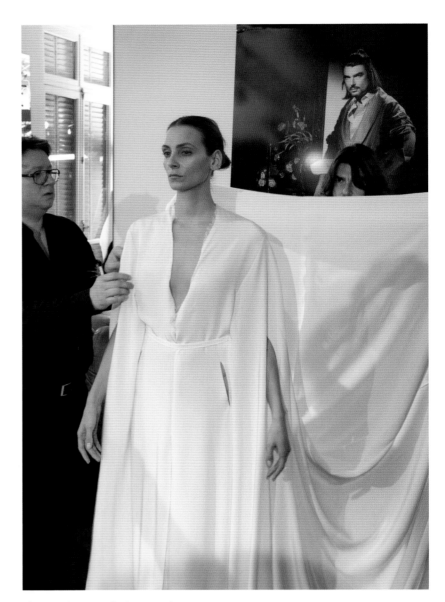

Hair stylists and makeup artists take over before the designer's final approval.

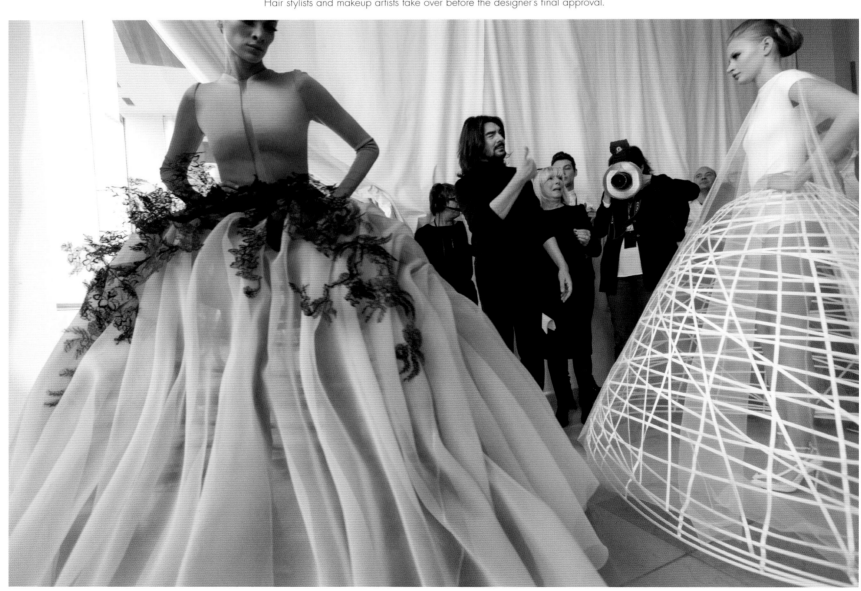

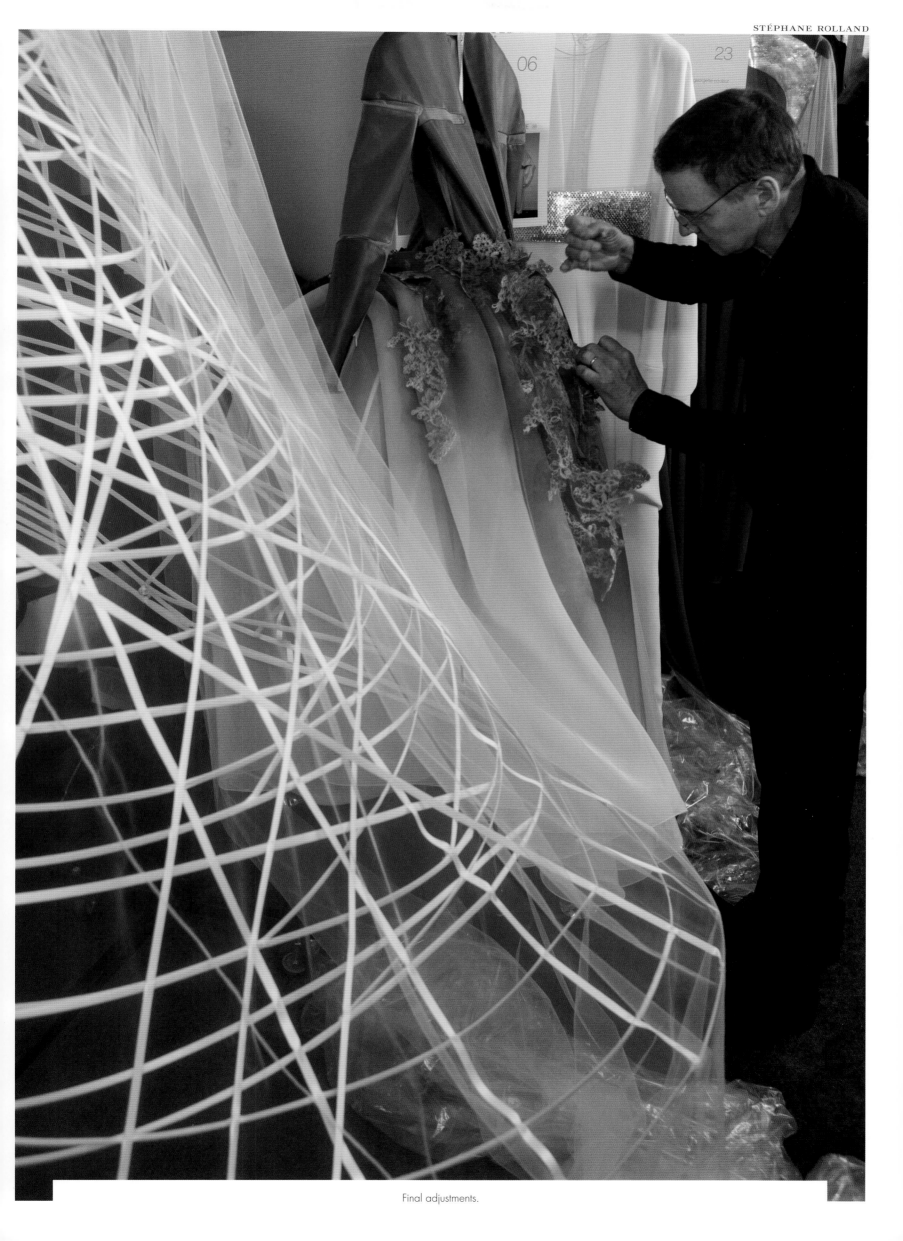

Final adjustments.

I suddenly realize that
I cannot in actual fact
remember a single detail
of your face. Only your
silhouette, your clothing . . .
that, yes, I remember.

FRANZ KAFKA
letter to Milena Jesenská, in *Lettres à Milena* (*Letters to Milena*), Paris, Gallimard, 1983

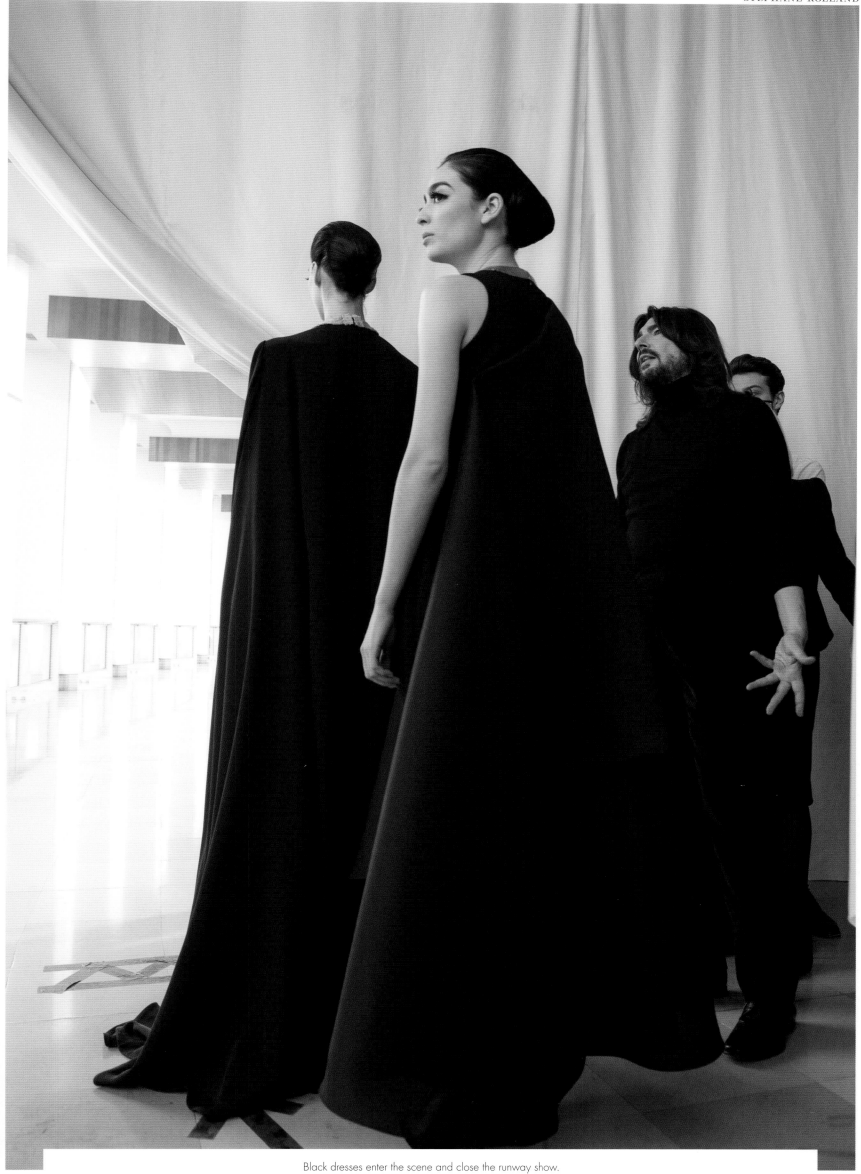

Black dresses enter the scene and close the runway show.

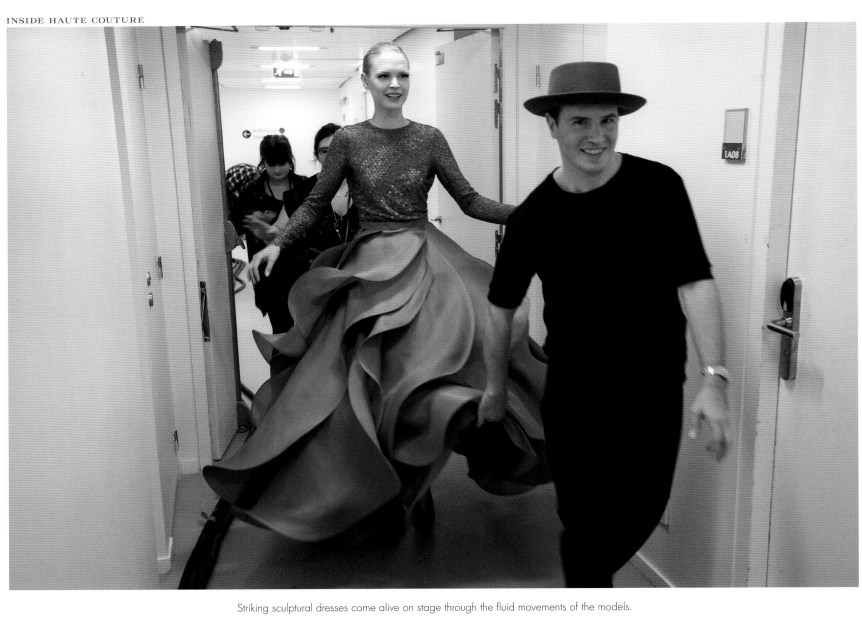

Striking sculptural dresses come alive on stage through the fluid movements of the models.

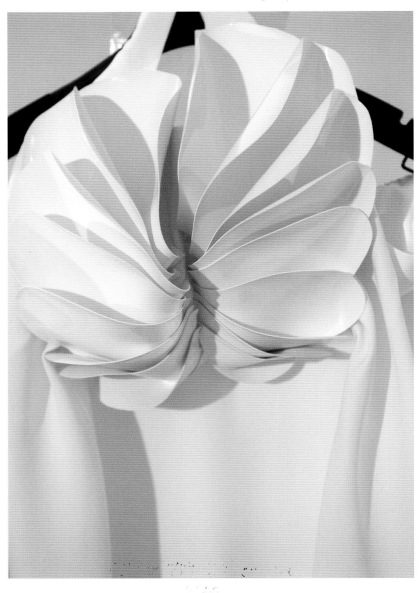

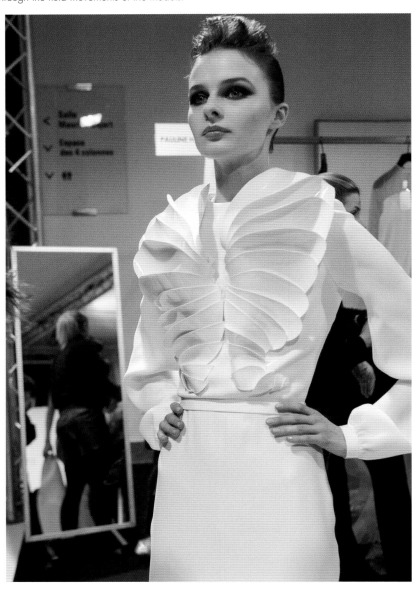

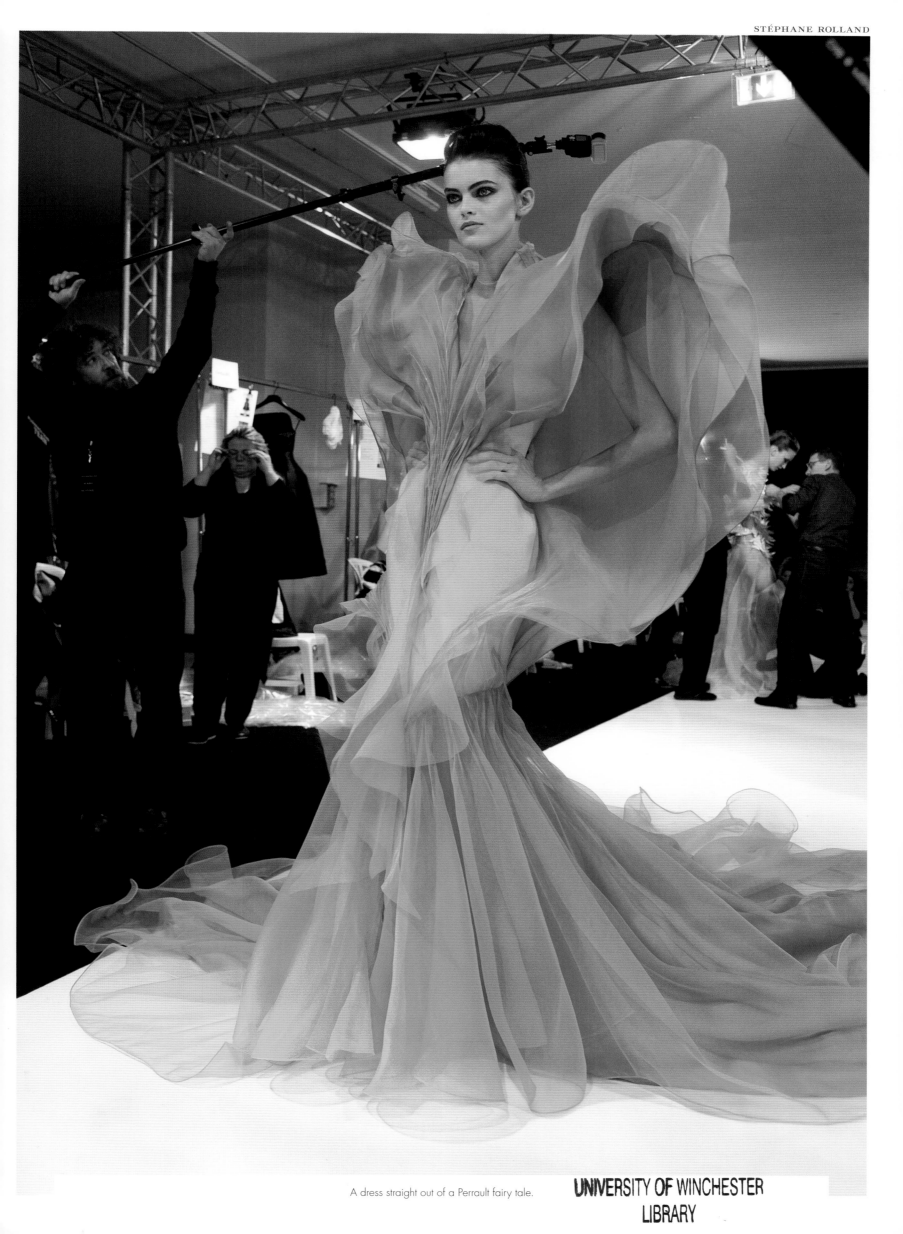

A dress straight out of a Perrault fairy tale.

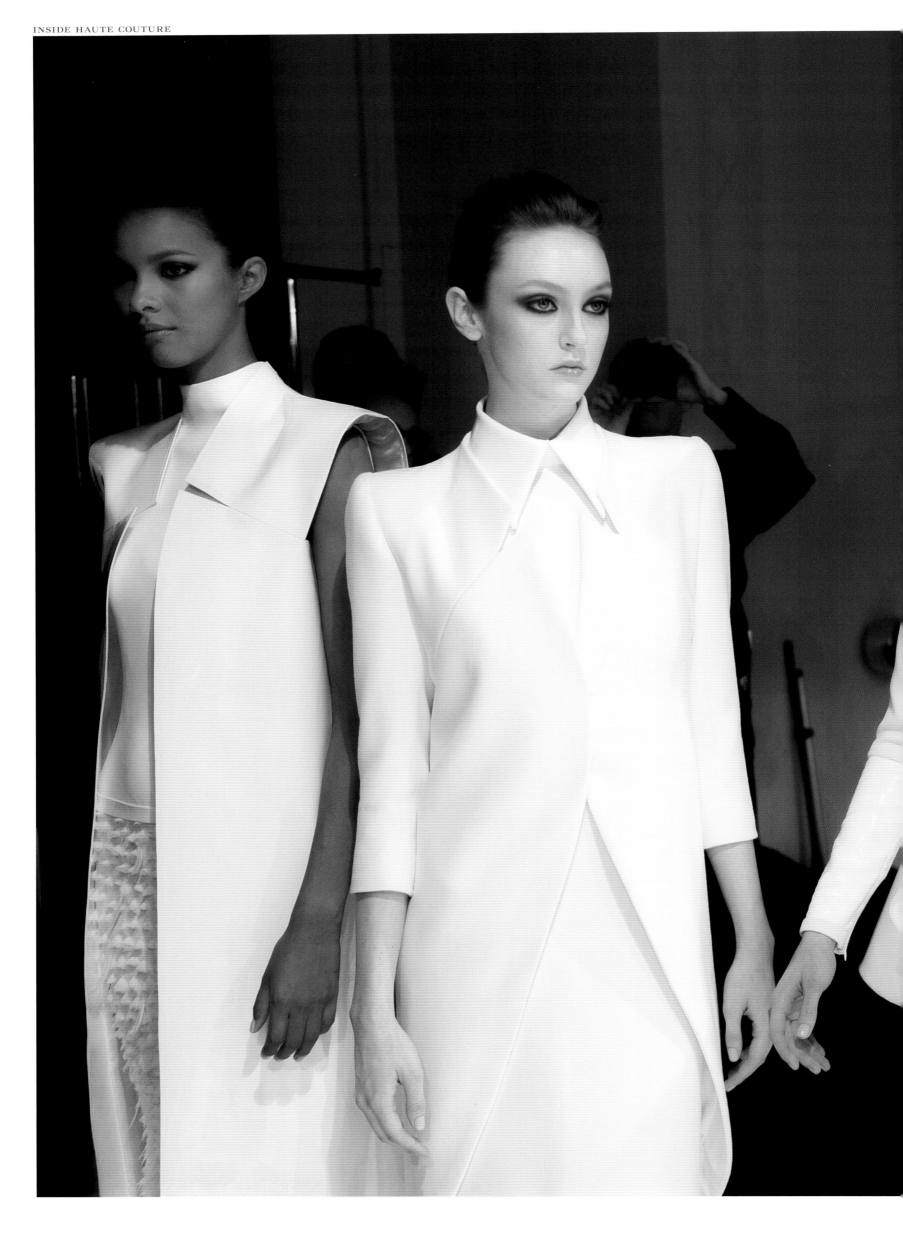

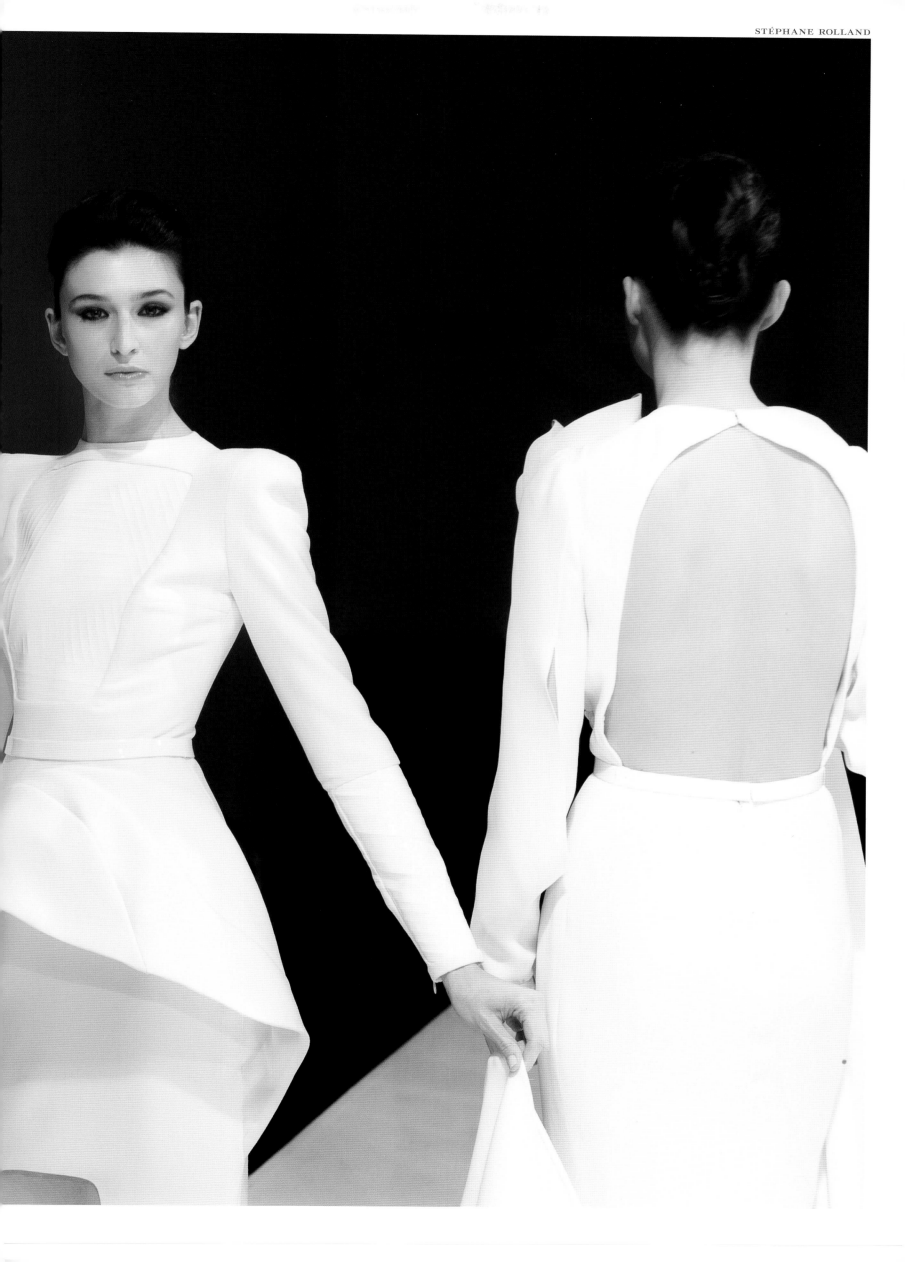

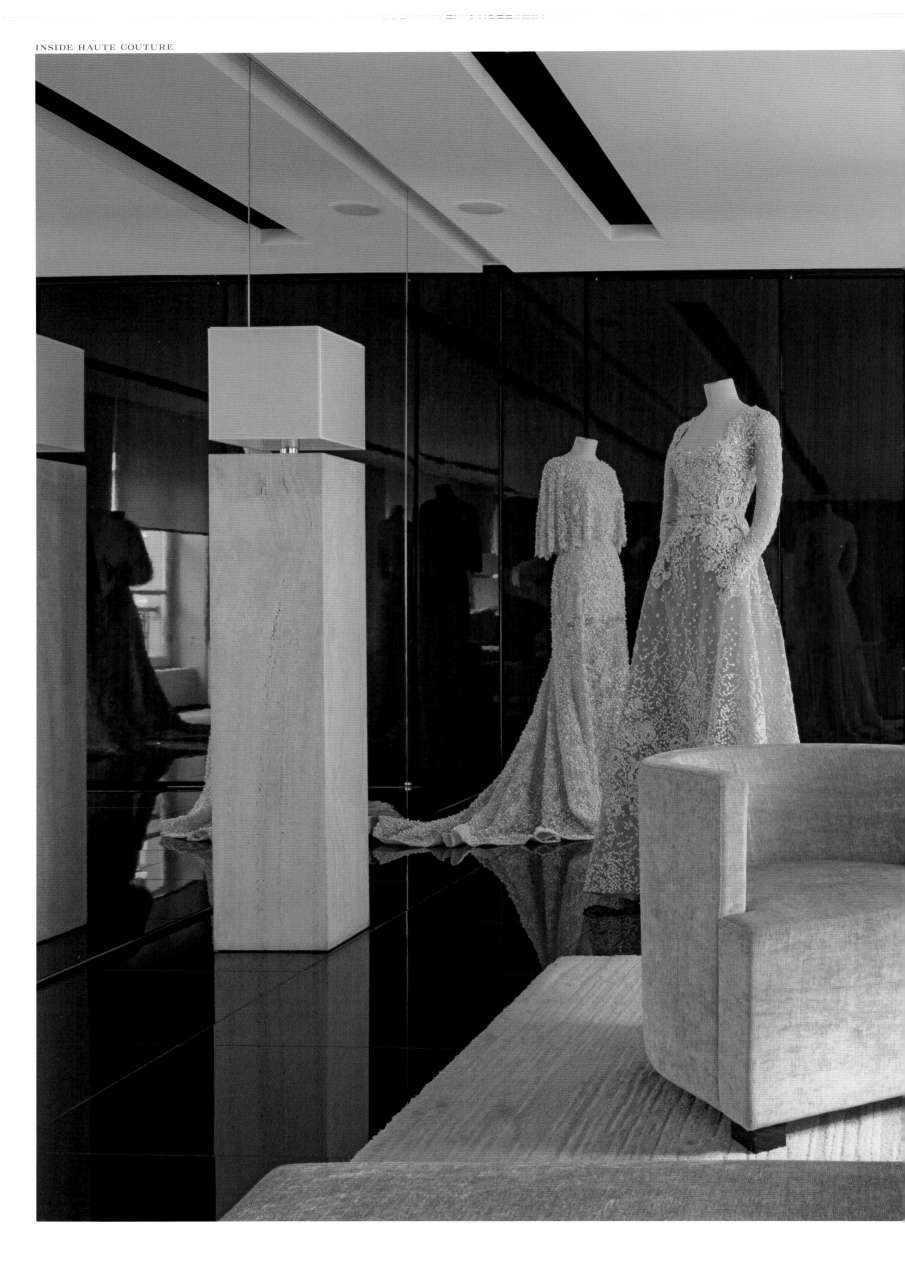

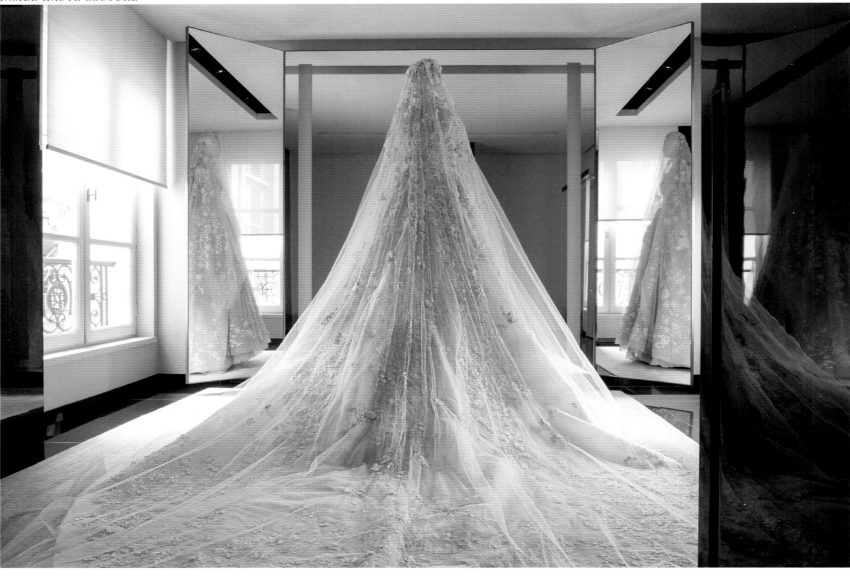

In the fitting rooms, the wedding gown reigns, every princess's dream.

likes to repeat to young designers seeking his advice. And so that Lebanese students wouldn't have to travel to Europe for their training, Saab launched a university curriculum in fashion design at the Lebanese American University in 2014, in collaboration with the London College of Fashion.

The top seller of haute couture dresses worldwide (according to trade press), Saab has also presented two prêt-à-porter lines per year since 2000. He continually reinvents himself without straying from his singular vision. "What's important is remaining faithful to yourself," he said the day before his runway show in January 2015. Making women ever more beautiful—that's the goal that inspires him. Scorning wildly experimental couture, the Lebanese designer's priority is enhancing a woman's shapeliness with a light touch, revealing her sensuality with elegance, seeking neither to erase nor exaggerate it—a key to his success. Each of his collections includes formfitting dresses, sparkling

and as light as a breeze, allowing the women who wear them to enter a room or walk a red carpet in triumph.

Even though his collections celebrate curves and come in infinite colors—powder pink, emerald, cobalt blue, ruby red, aged gold, mouse gray, and more—everywhere Saab works and lives is purely linear and dominated by black and white. Of the colors of his fashion designs, he said, "Red is essential, but how intense, how much? White, a color hard to wear, despite the fact that it comes back every ten years. Black? My favorite color, it makes you excel. Besides, every elegant woman owes it to herself to have a black dress!"[2] Though perhaps not in his favorite color, his bridal gowns, in every shade of white, constitute the highlight of each runway show.

Equally striking—with warm and luminous tones, like embroidery embellished with semi-precious stones, a combination of indolence and refinement, where East meets West in the best of both worlds, the scents of cedar, orange

Beads and cabochons are embroidery's marks of distinction.

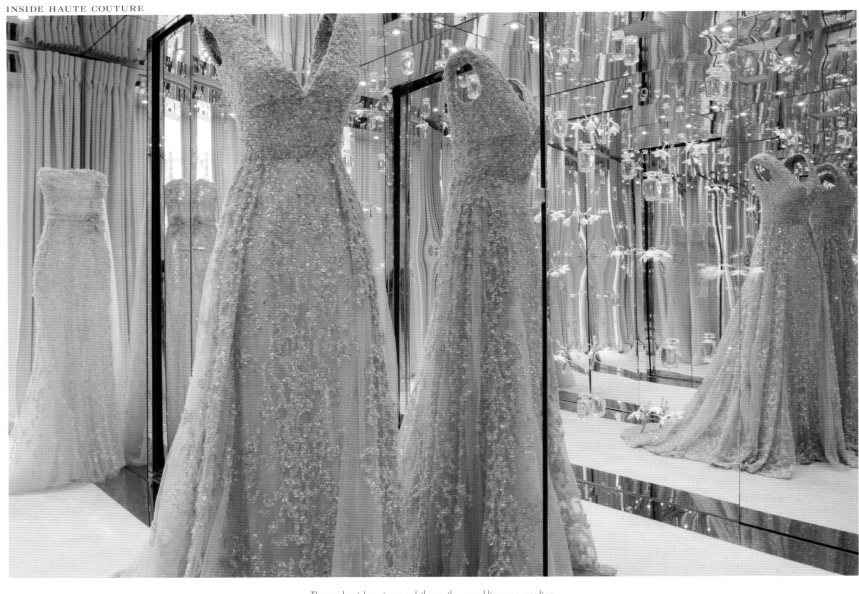

The embroidery is as subtle as the sparkling mousseline.

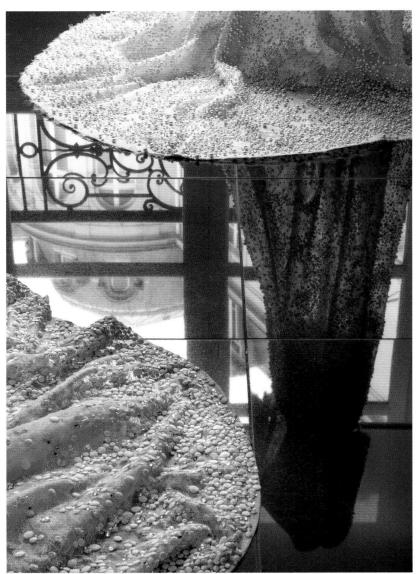

blossom, and jasmine floating through the air—is the fragrance of Elie Saab Le Parfum, which was launched along with his 2011–2012 fall–winter haute couture collection, and at the French Fifi Awards in June 2012.

Elie Saab has achieved his amazing career trajectory seemingly without errors in taste or strategy. "I have a vision. I know where I want to go and how to do it," he says.[3] His company's only shareholder, the fashion designer is a true businessman, recognized as such by HEC Lebanon, which named him manager of the year in both 2003 and 2014. Who said you couldn't be no-nonsense and glamorous at the same time?

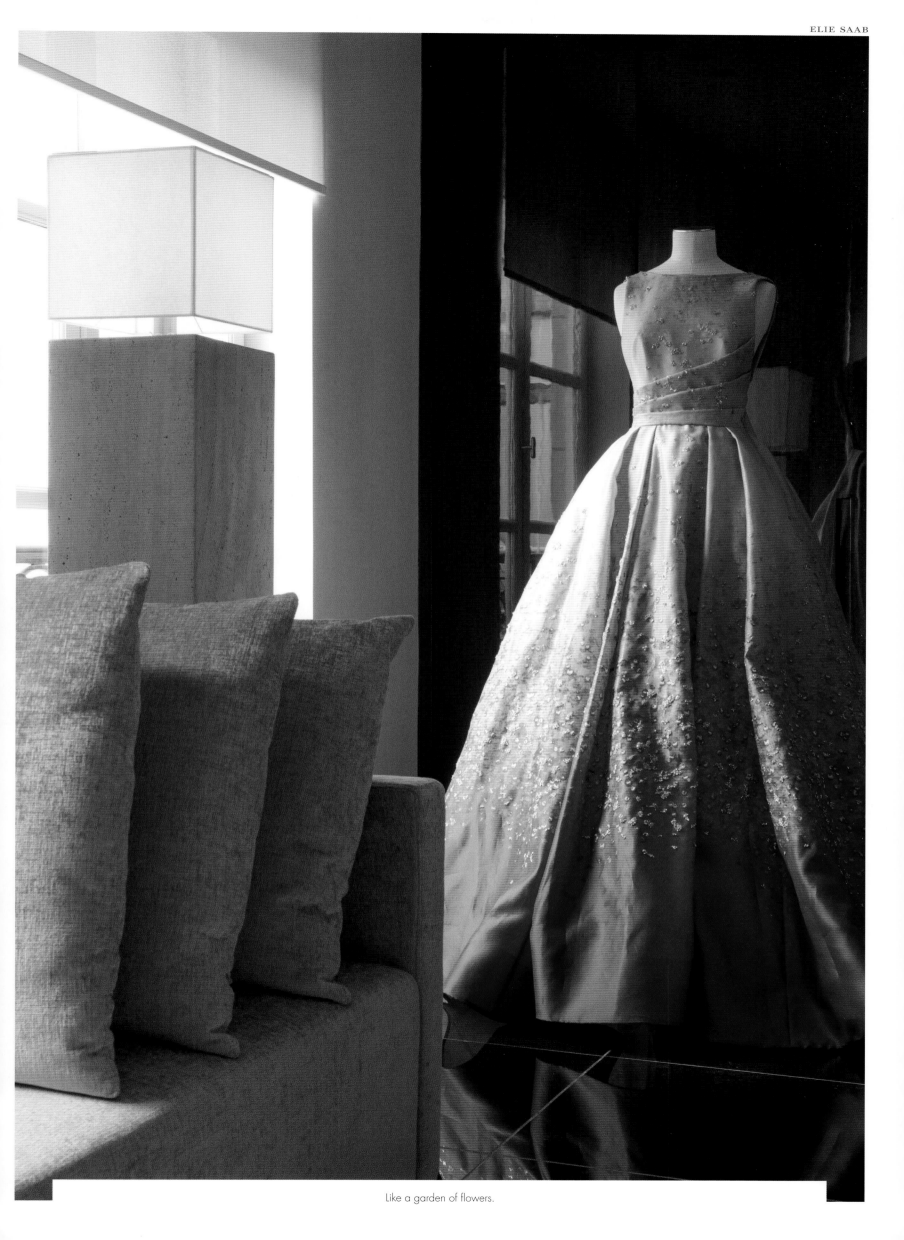

Like a garden of flowers.

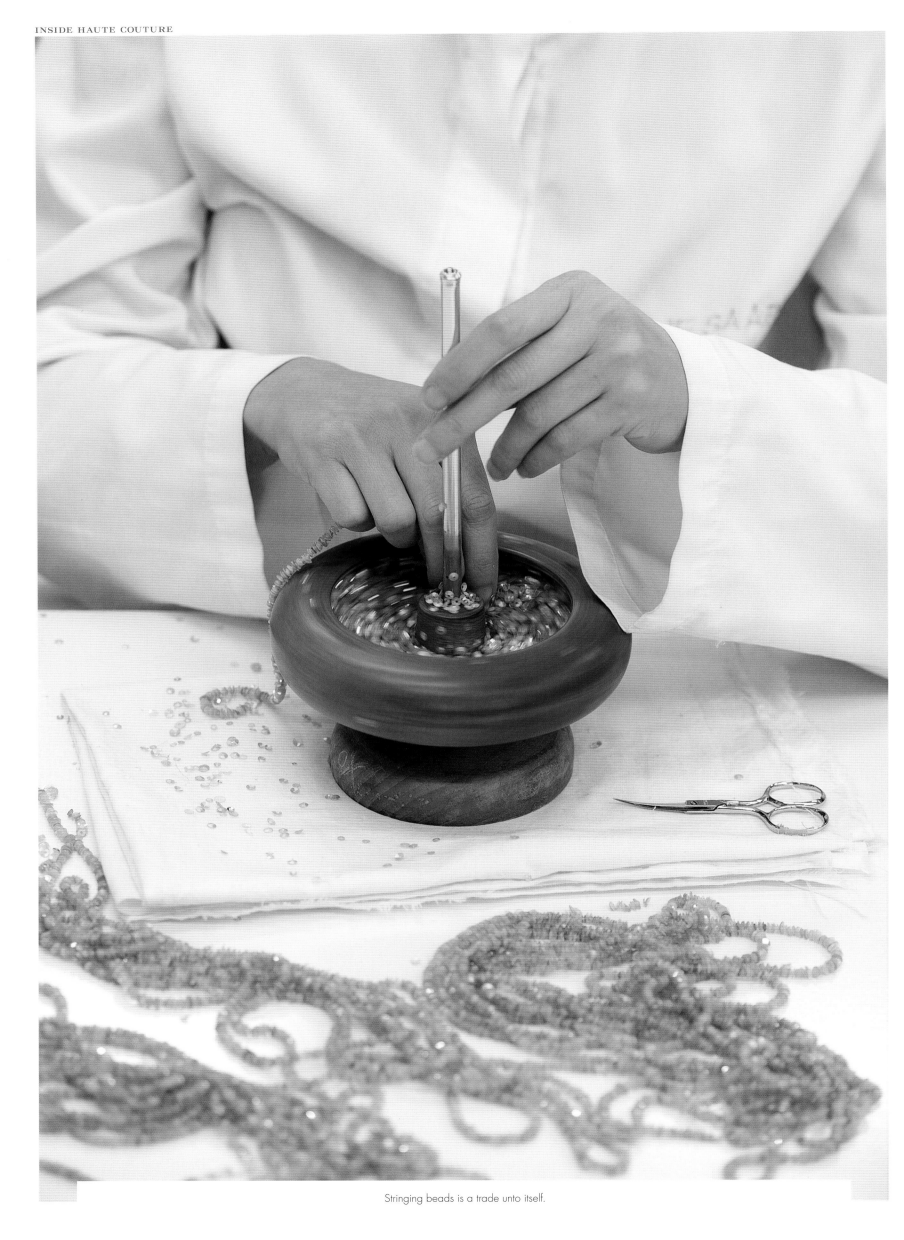

Stringing beads is a trade unto itself.

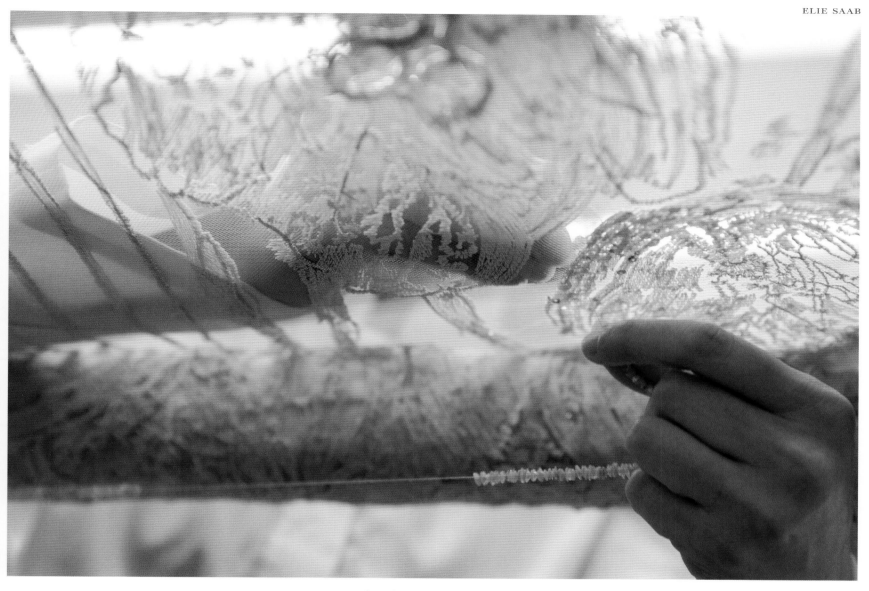

Needlework requires the utmost dexterity.

INSIDE THE ATELIERS

In central Beirut, a grand building, inaugurated in 2005, is home to the boutique, offices, and the haute couture workshops of Elie Saab. The ambiance there is at once industrious and easygoing; sheltered from the brouhaha of the Lebanese capital, seamstresses are at work. Entering the premises, one is immediately impressed by the number of Stockman mannequins of all sizes, each an exact replica of a loyal client. Then comes a giant stand of bobbins (more than a hundred) in every color of the rainbow. The array provides a real treat for the eyes. The fingers of the embroiderers dance an impressive ballet; each worker maintains total concentration, aware of the master's standards of perfection. Saab is known to have taken apart a finished dress to move its embroidery over by one or two millimeters.

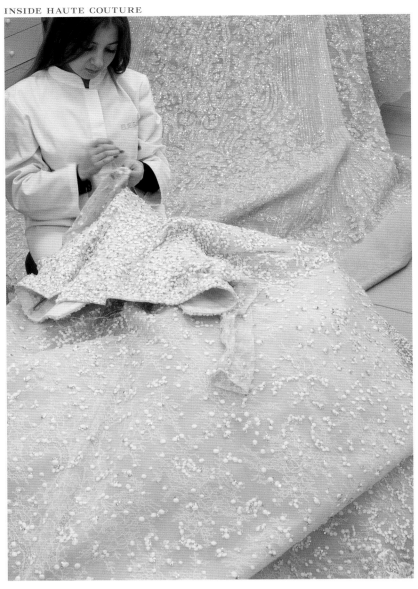

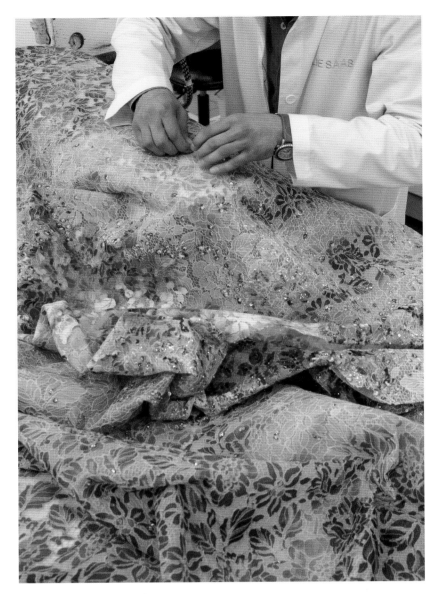

In the Beirut ateliers, all the crafts of haute couture are under a single roof.

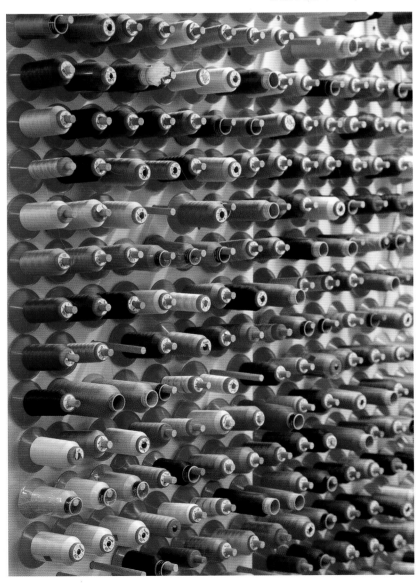

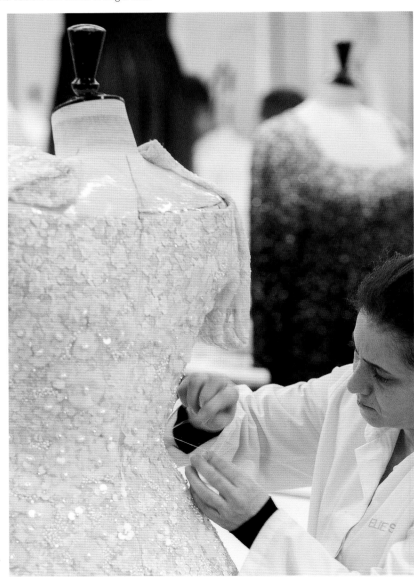

Many hands are needed to spin a spider's arabesque of lace.

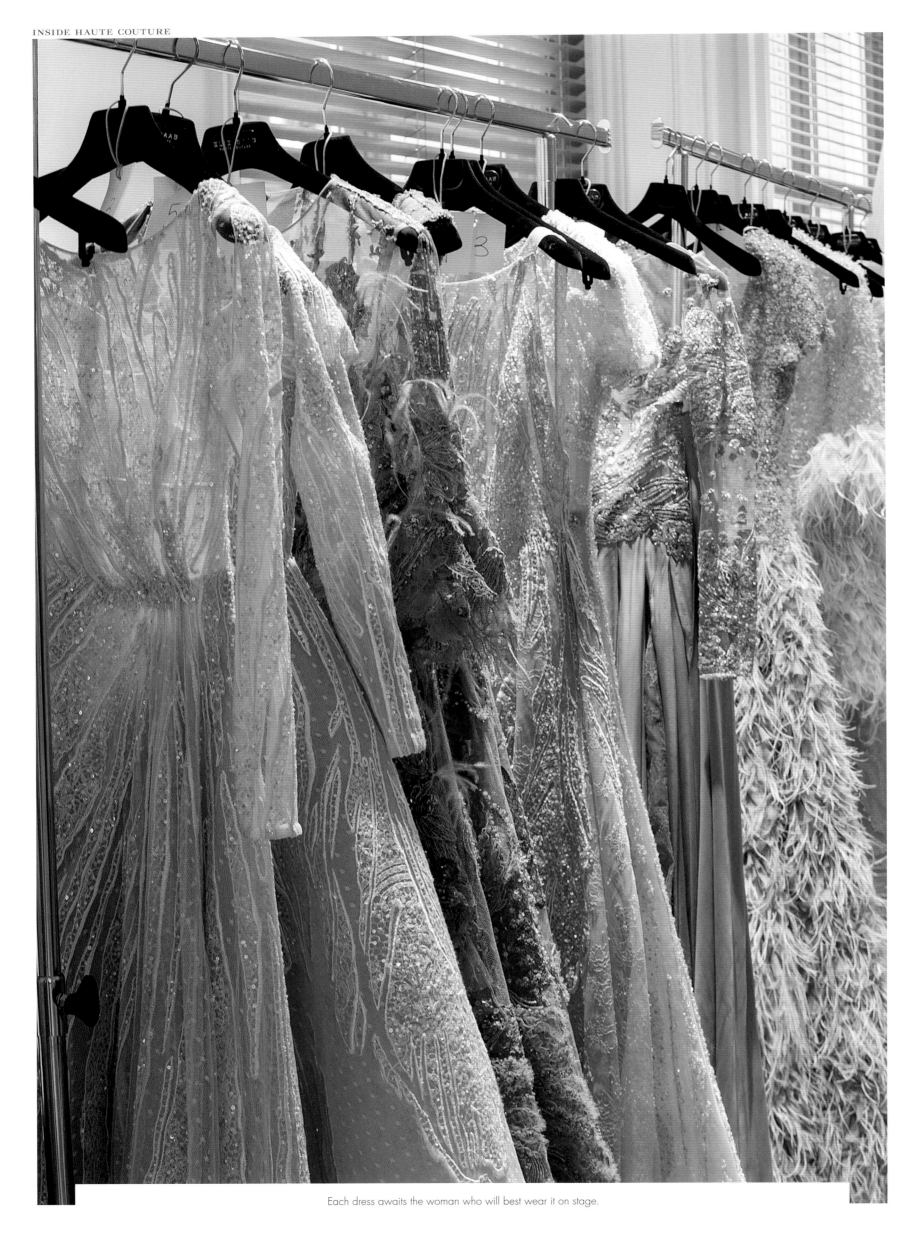

Each dress awaits the woman who will best wear it on stage.

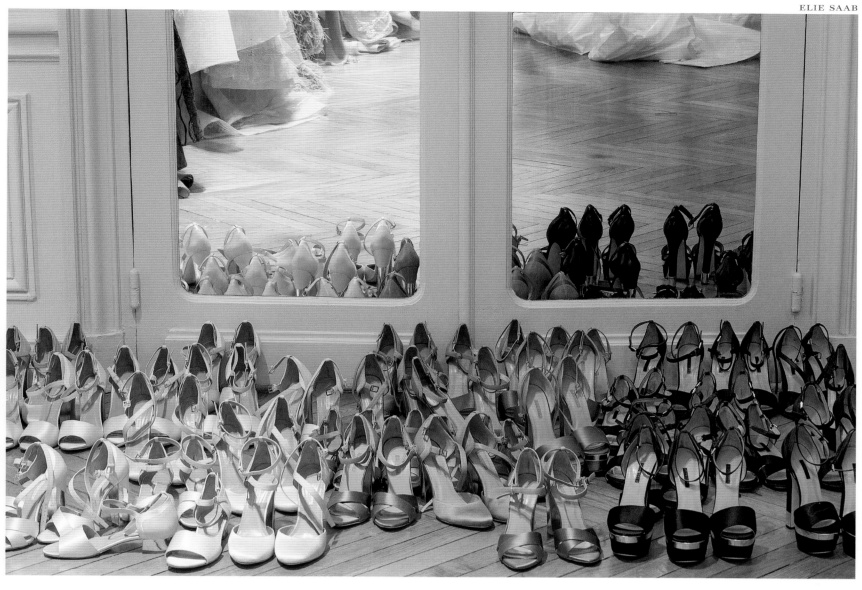

An impressive collection of shoes in several sizes.

THE WHIRLWIND
OF FINAL PREPARATIONS

As the day of the haute couture show approaches, the Paris ateliers become a real beehive. Stylist, assistants, PR: the whole team stands ready around the artist. His dark eyes follow the stream of models during the final rehearsal. In carefully planned minutes, attention is paid to every detail. It's the last chance to fix a shoulder strap, accentuate a dart, or replace a belt. To best display the designs, everything must be precisely adjusted to the measurements of the selected models. In the ateliers, work is constant; before a runway show, it's always an all-nighter.

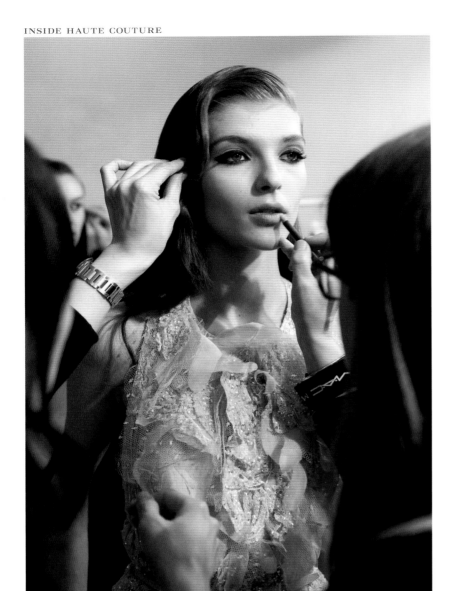

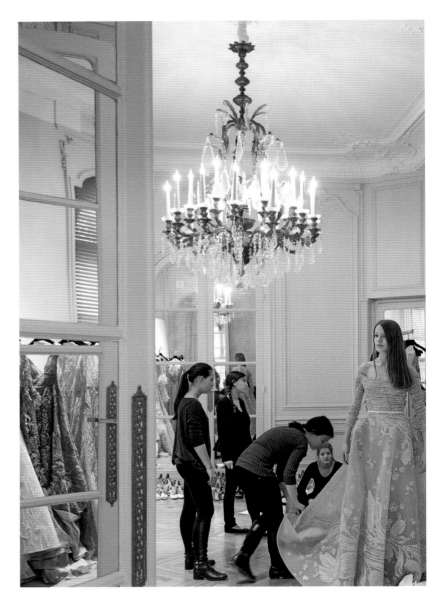

Fitting and primping right before the runway show.

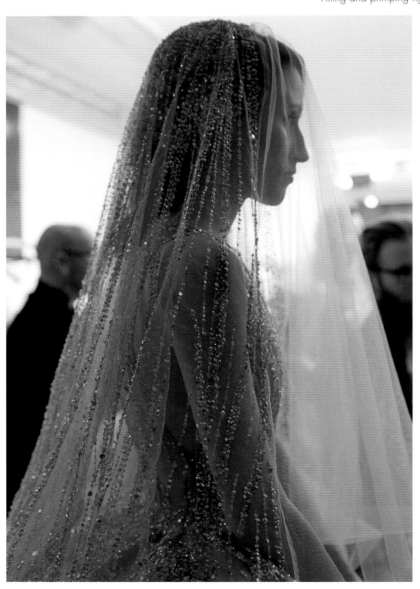

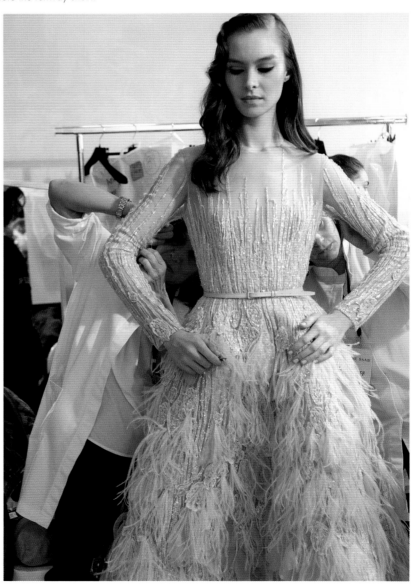

A final brush of the hair and the queen of the moment is ready for her show.

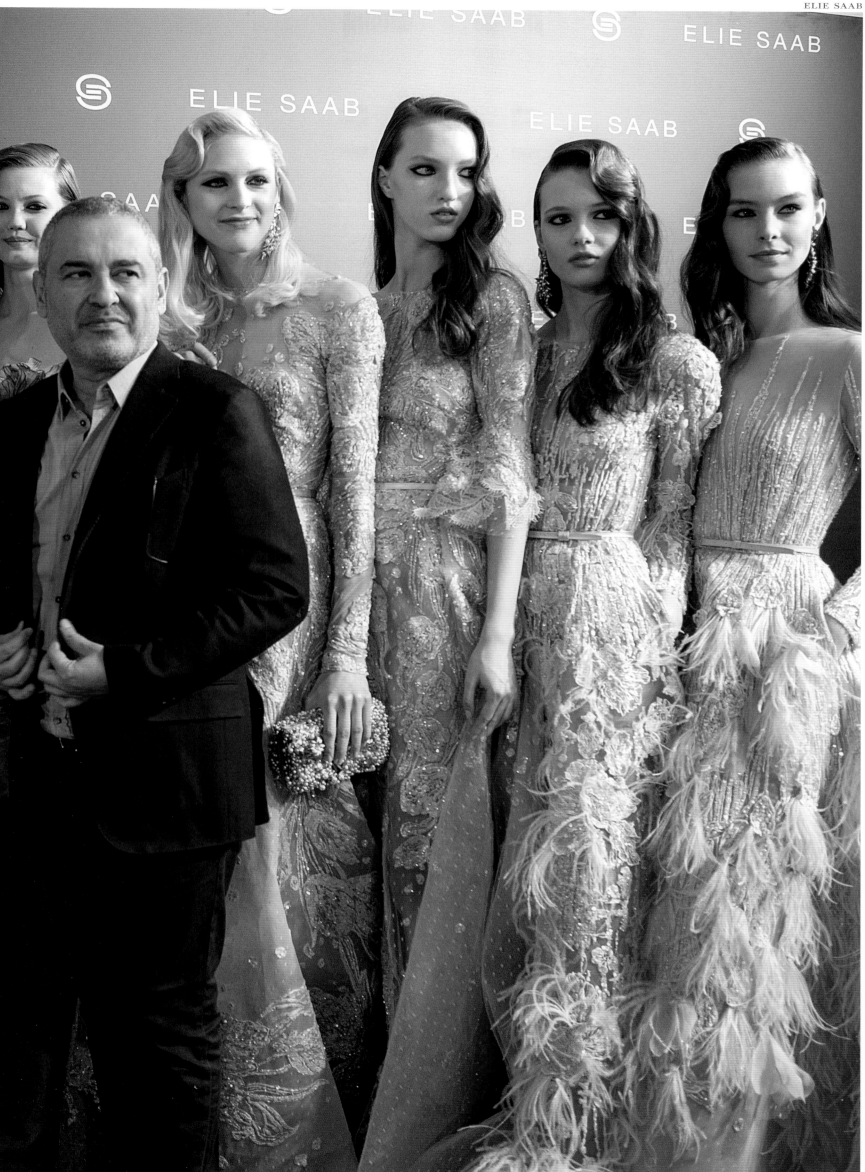

YVES
—
SAINT LAURENT

Yves Saint Laurent

5, AVENUE MARCEAU

On Monday, January 7, 2002, Yves Saint Laurent called together a press conference at his *maison de couture* at 5, avenue Marceau, in Paris's eighth arrondissement. Seemingly every trade journalist was there, as were his loyal supporters Anne-Marie Muñoz, Loulou de la Falaise, and Betty Catroux. In a voice filled with emotion, his eyes on his prepared statement, Saint Laurent announced that he was ending his career in haute couture, exactly forty-four years after his first collection, "Trapèze," for Dior, in 1958 had catapulted him to the summit of fashion.

He paid homage to all the designers who had inspired him—his teachers, Christian Dior, Elsa Schiaparelli, and Gabrielle Chanel—and then said, "I am extremely proud that women across the world wear pantsuits, pea jackets, and trench coats," styles he had made ubiquitous. He had not forgotten difficult times, and in an aside he mentioned his demons: "I've been through much anxiety, many hells. I've encountered fear and terrible solitude. The untrue friends, the tranquilizers and narcotics. The prison of depression and rehabilitation centers. From all that, one day, I escaped, dazed but sober."[1] The master was leaving, but his work was already legendary.

Five thousand examples of haute couture and fifteen thousand accessories, sketches, and various related objects are housed at the Fondation Pierre Bergé–Yves Saint Laurent. Recognized as a French nonprofit organization on December 5, 2002, its mission is to organize thematic exhibitions around fashion, painting, photography, and the decorative arts and to support cultural and educational initiatives.

On March 10, 2004, the Fondation opened its doors to the public in Paris's sixteenth arrondissement with the exhibition "Yves Saint Laurent: Dialogue avec l'art," which would travel in 2008 to the Fundación Caixa Galicia in A Coruña, Spain. Then, in 2010, came a comprehensive retrospective of Yves Saint Laurent's life's work at the Petit Palais in Paris, while the Journées de la Mode d'Oran, in Saint Laurent's city of birth in Algeria, honored him in May 2013 at the Le Méridien Oran hotel and convention center.

Flashing back to 1958, we come to an important year in the fashion designer's career, when Saint Laurent met the man who would forever change his life's trajectory: Pierre Bergé. Having become his mentor, Bergé encouraged Saint Laurent to open his own fashion house after he

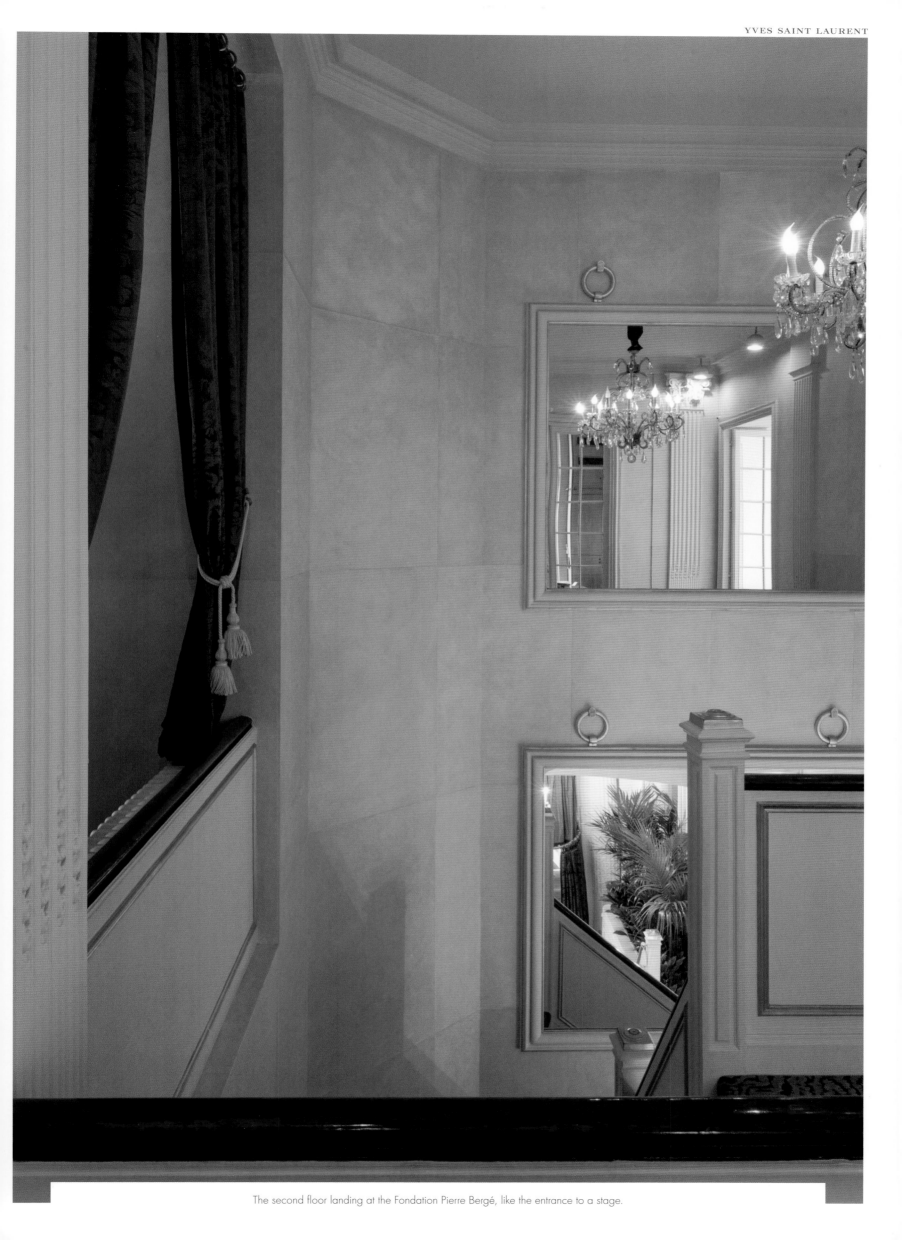

The second floor landing at the Fondation Pierre Bergé, like the entrance to a stage.

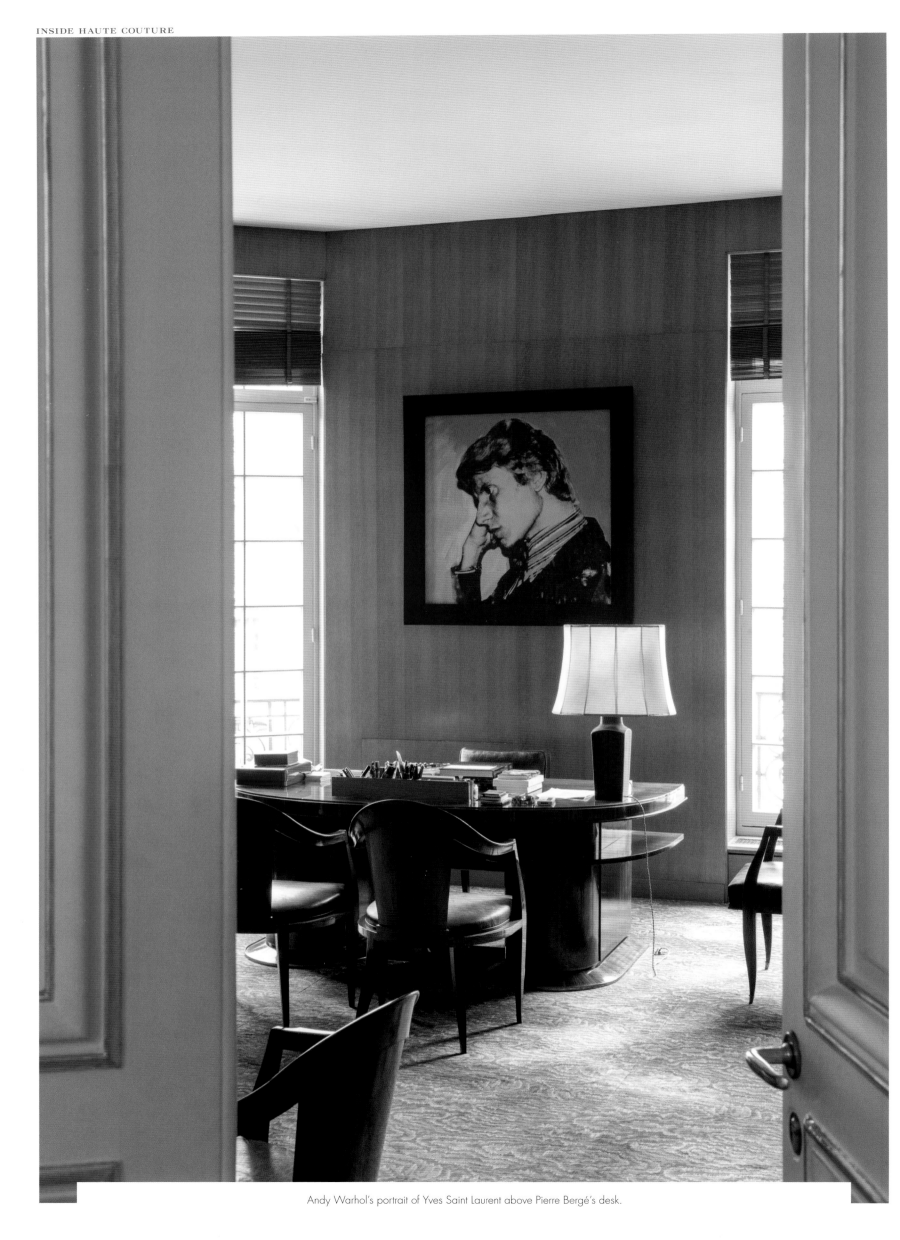

Andy Warhol's portrait of Yves Saint Laurent above Pierre Bergé's desk.

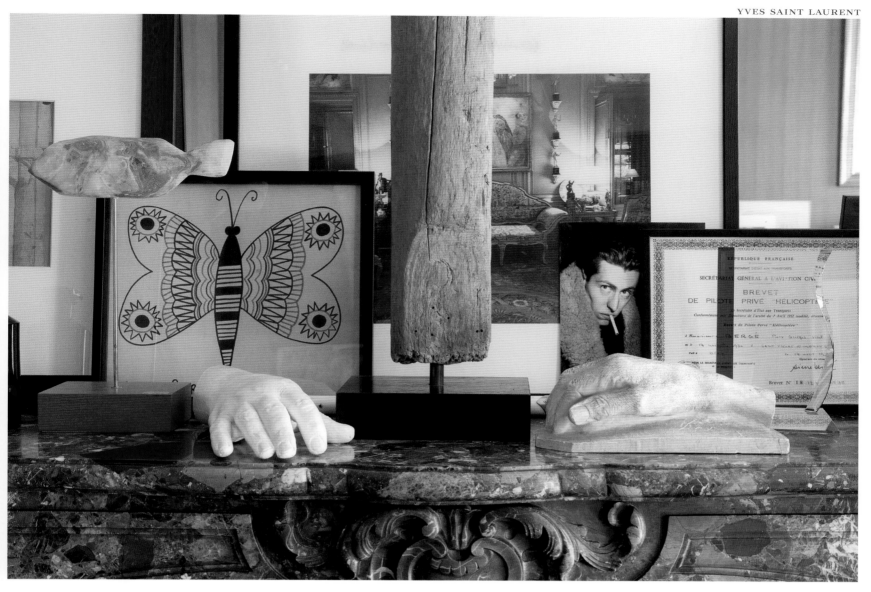

Personal mementos on the fireplace mantel.

was dismissed from Dior in 1960. The American billionaire J. Mack Robinson backed him, and the famous typeface designer Cassandre created the brand's *YSL* logo in 1961.

The first collection was presented on January 29, 1962, at 30 bis, rue Spontini, in Paris's sixteenth arrondissement, where the company was founded and would remain for twelve years. There, Yves Saint Laurent designed the modern woman's wardrobe, reinventing the pea jacket and trench coat in 1962, launching the first women's tuxedo blazer in 1966, the first pantsuit and safari jacket in 1967, the jumpsuit in 1968. By adapting masculine codes, Saint Laurent gave women confidence, boldness, and power, all while maintaining their femininity.

The designer also innovated and brought design to the streets by launching a pioneering luxury prêt-à-porter line called "Saint Laurent Rive Gauche."

In 1974, Saint Laurent and Bergé moved the fashion house to 5, avenue Marceau. There, the master's style became more defined and mature, translating social upheavals into haute couture. He replaced the usual dictates of fashion with freedom, creating clothing that enhanced life and movement.

Through his collections, Saint Laurent also paid tribute to visual artists: in 1965, with his Mondrian dresses; in 1966, with his Pop Art dresses; in 1979, he focused on Picasso and Diaghilev, then later, in the 1980s, on Matisse, Cocteau, Braque, van Gogh, and Apollinaire. He explored exotic themes inspired by Africa (1967), Russia (1976), China (1977), and Spain (1977).

Morocco, too, would considerably influence Saint Laurent's work and color palette. Every year, in December and June, he would spend two weeks in Marrakesh designing his haute couture collections. In 1980, he and Bergé

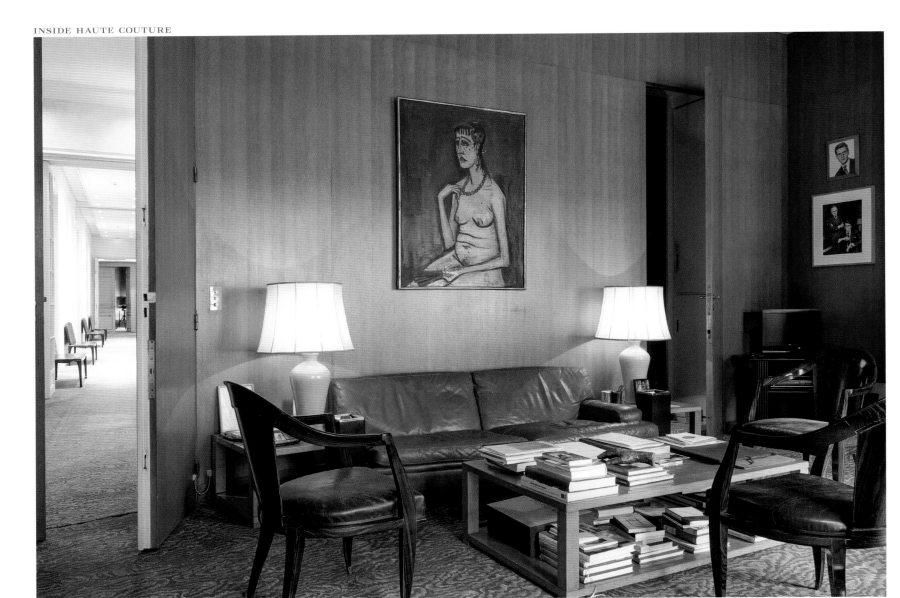

In Pierre Bergé's office, shown here and opposite, a Bernard Buffet painting and André Ostier's portrait of Yves Saint Laurent.

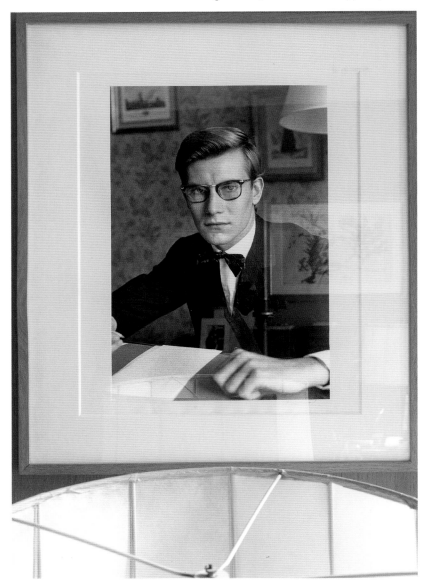

purchased the former property of French painter Jacques Majorelle and revived its astounding botanical garden, which is now open to the public.

In 1999, the Yves Saint Laurent group was transferred to PPR (now Kering). Saint Laurent and Bergé continued to oversee its haute couture, but in 2002, when Saint Laurent decided to retire, the *maison de haute couture* closed its doors. No other designer would replace him. A retrospective runway show in January of that year at the Centre Pompidou marked the end of what he referred to in his retirement speech as a "marvelous adventure."

On June 1, 2008, Yves Saint Laurent died in his seventy-second year of a brain tumor, and his ashes were later scattered in the Jardin Majorelle in Marrakesh. Today, 5, avenue Marceau, is no longer the home of a fashion atelier, but the Fondation Pierre Bergé–Yves Saint Laurent keeps a precious legacy alive.

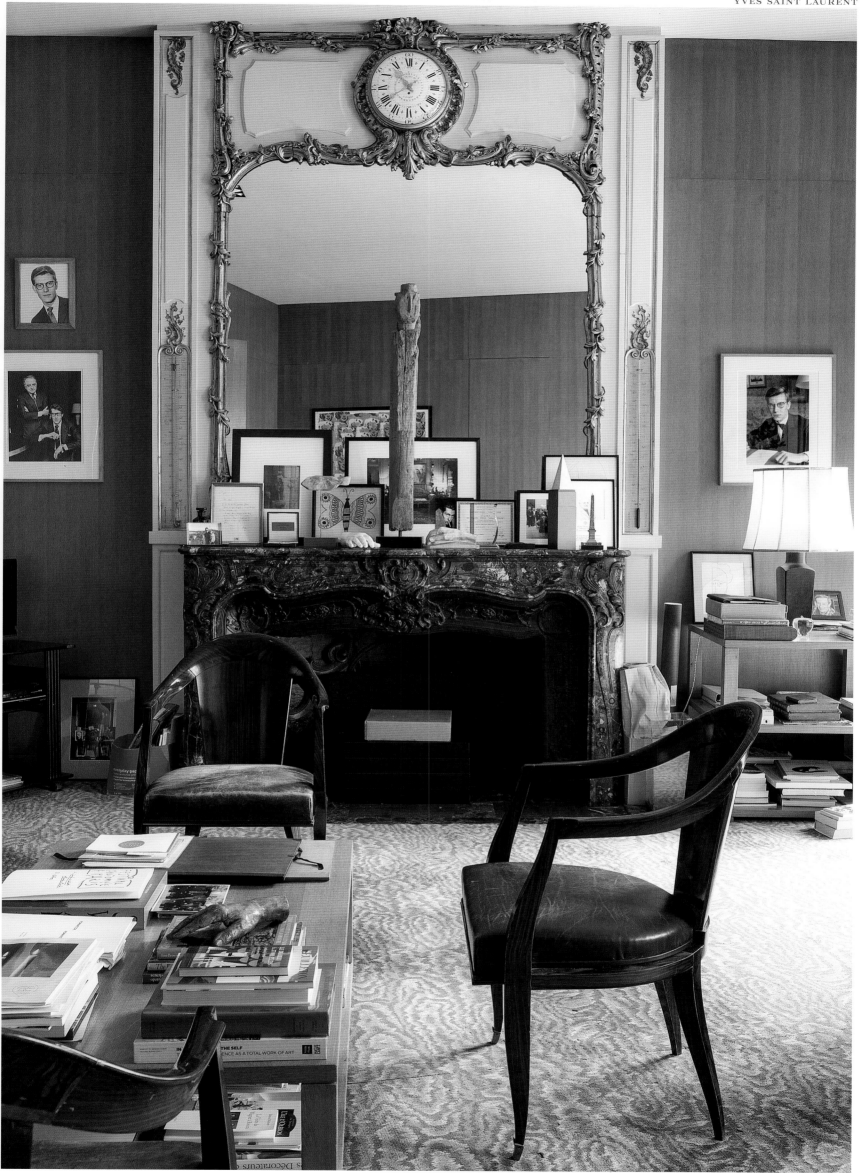

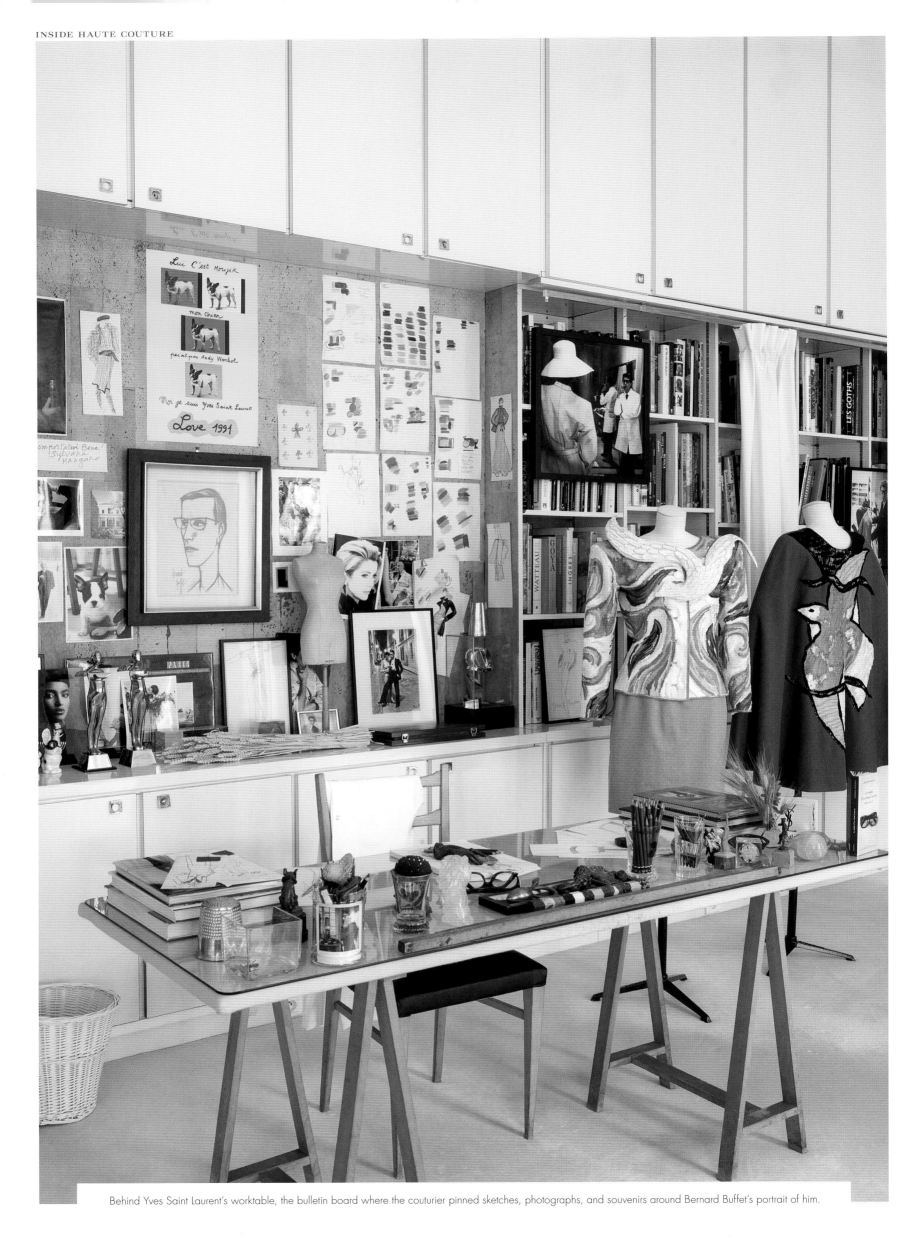

Behind Yves Saint Laurent's worktable, the bulletin board where the couturier pinned sketches, photographs, and souvenirs around Bernard Buffet's portrait of him.

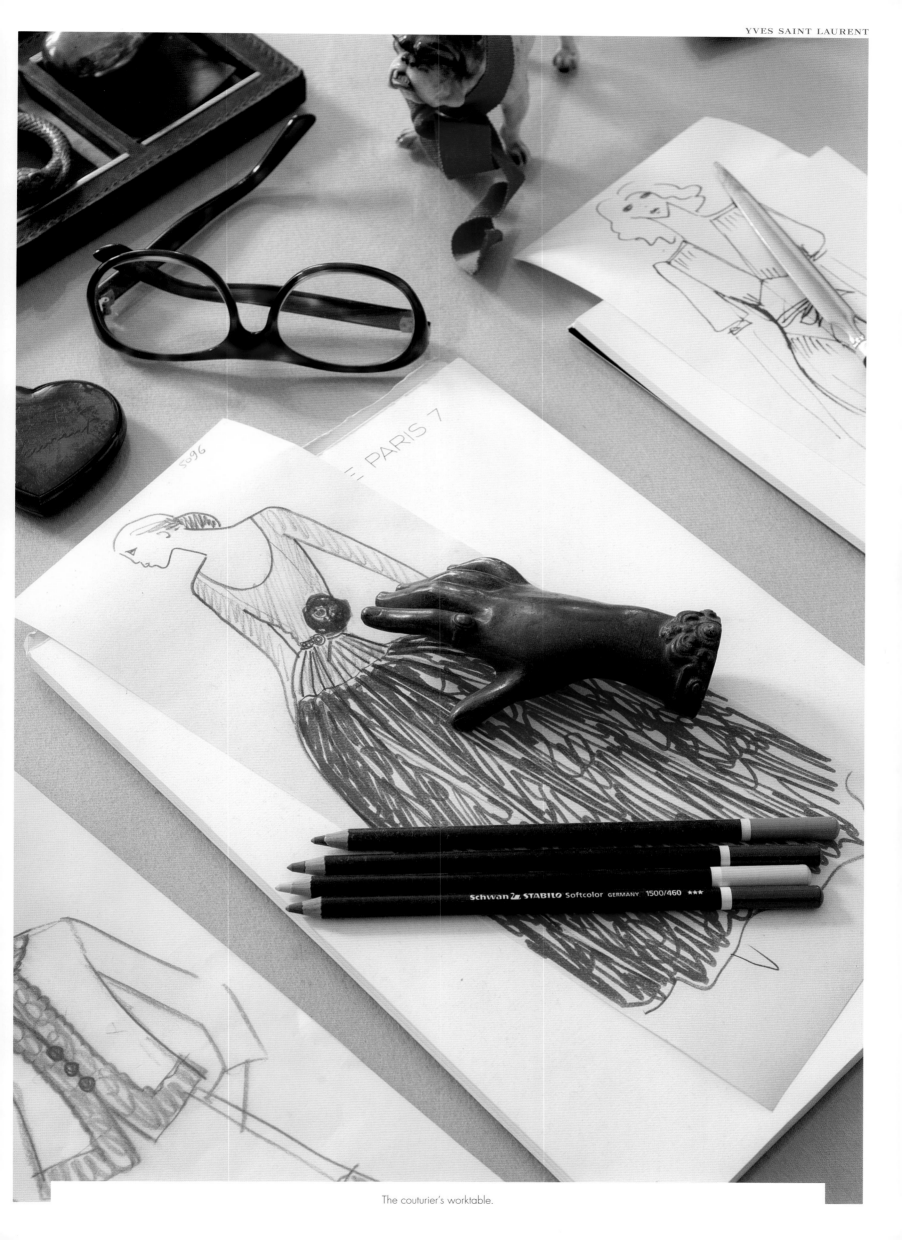

The couturier's worktable.

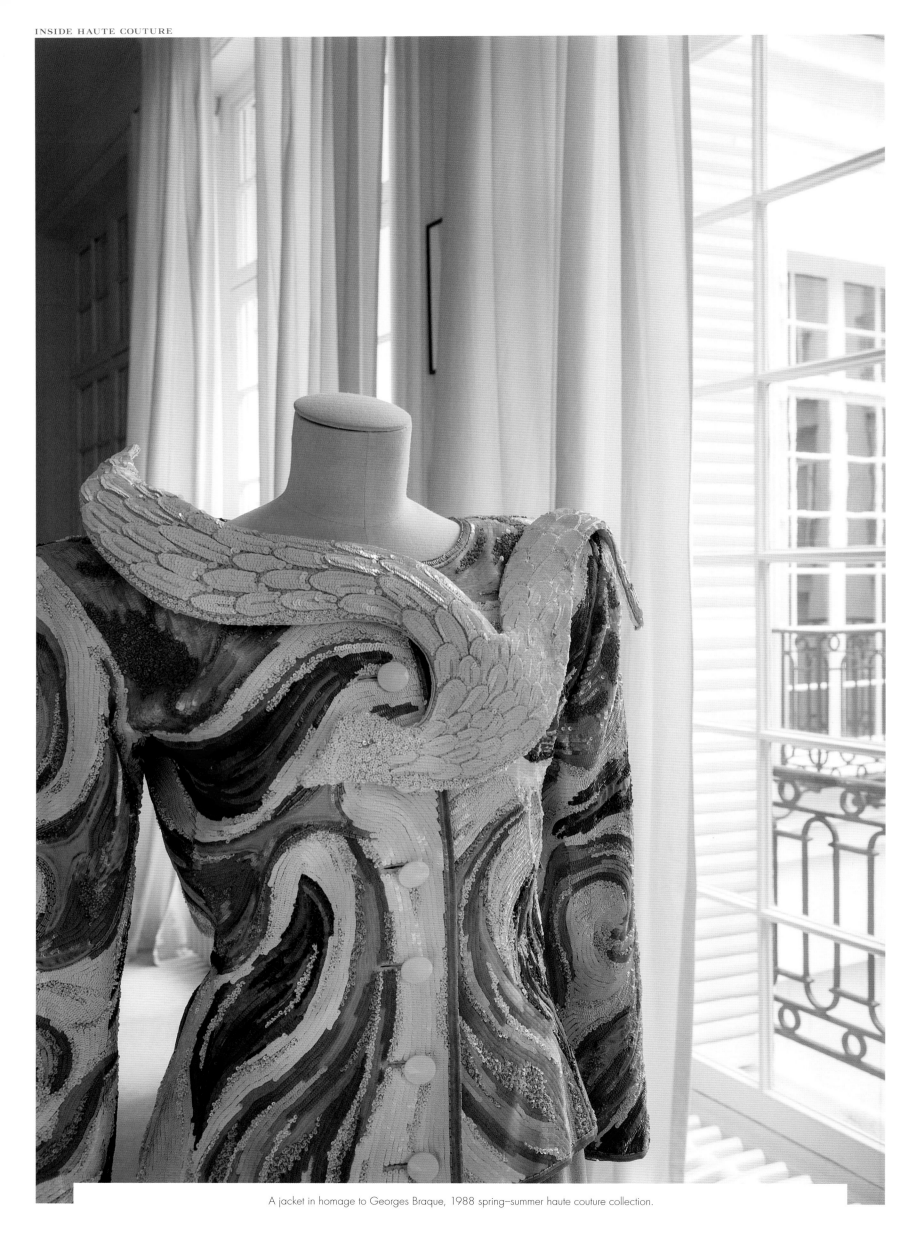

A jacket in homage to Georges Braque, 1988 spring–summer haute couture collection.

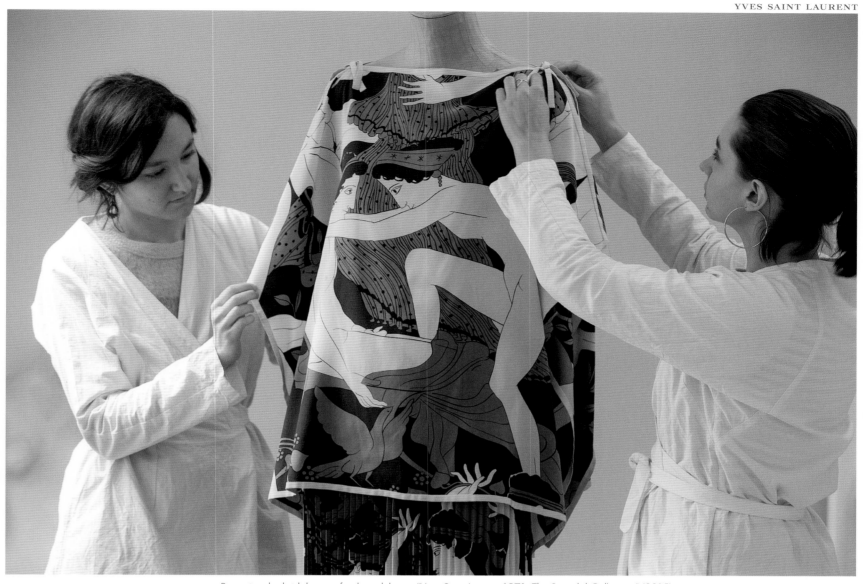

ABOVE: Preparing the bridal gown for the exhibition "Yves Saint Laurent 1971: The Scandal Collection" (2015).
BELOW: Mondrian dresses from the 1965 fall–winter collection.

A PLACE WHERE MEMORY LIVES

"I would like for my dresses and drawings to be studied in a hundred years," Yves Saint Laurent told *Elle* magazine on January 27, 1992. At present, the retrospectives planned by the Fondation Pierre Bergé–Yves Saint Laurent make his dream come true, allowing for the study of a body of work whose creative vibrancy and influence on contemporary fashion is being appreciated every day.

Unique of its kind, this institution, which is housed at 5, avenue Marceau, brings together a selection of pieces from eighty-one haute couture collections. What's more, two thousand square feet (two hundred square meters) of event and exhibition space were built according to strict museum standards. But the true treasures on-site are the collection archives (which are not accessible to the public). An entire heritage composed of clothing, drawings, and sketches is conserved at a constant temperature of 65 degrees Fahrenheit (18 degrees Celsius), a 50 percent hydrometric standard, in no-dust closets and acid-free archival boxes.

"Fashions fade, [but] style is eternal," Yves Saint Laurent liked to say. Today, his collections continue to impress and prove that clothing mustn't merely appease a fantasy, but also dress the modern, emancipated woman.

In 2017, the Fondation will become the Yves Saint Laurent Museum, Paris, entirely dedicated to the work of the creator. Another Yves Saint Laurent Museum will also be built in Marrakesh next to the Jardin Majorelle.

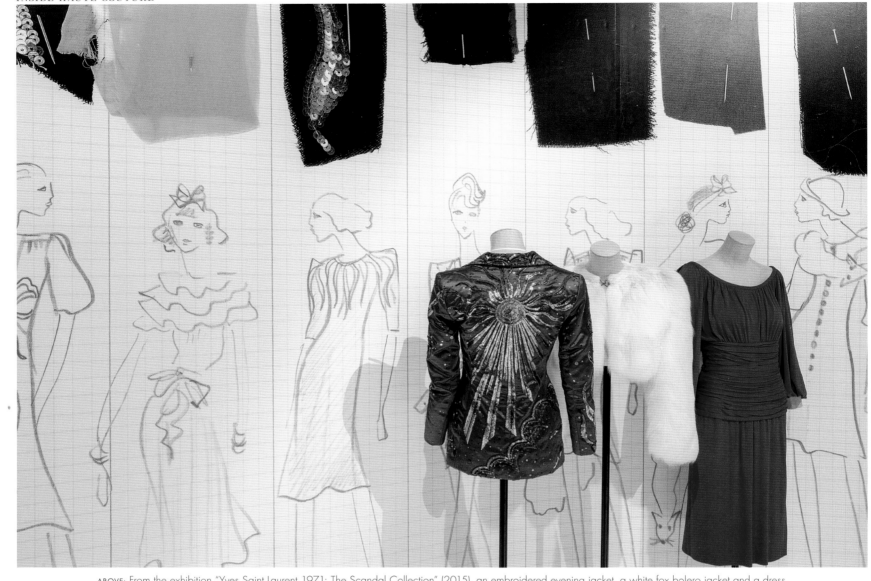

ABOVE: From the exhibition "Yves Saint Laurent 1971: The Scandal Collection" (2015), an embroidered evening jacket, a white fox bolero jacket and a dress.
BELOW: "Bougainvillea" capes from the 1989 spring–summer collection and pieces from the 1994 fall–winter collection.

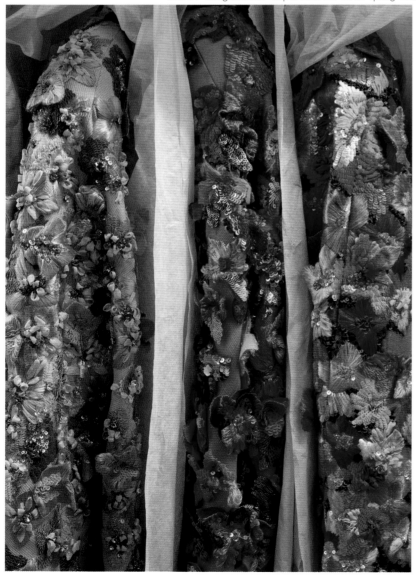

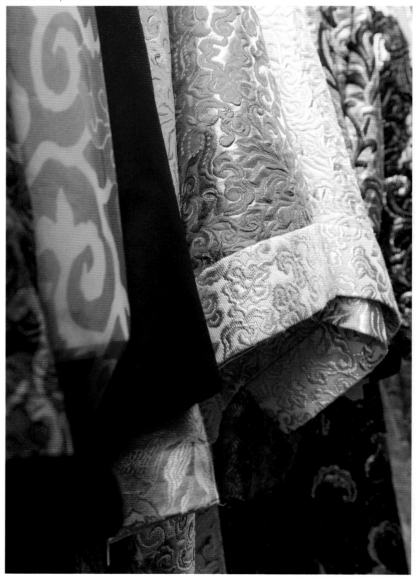

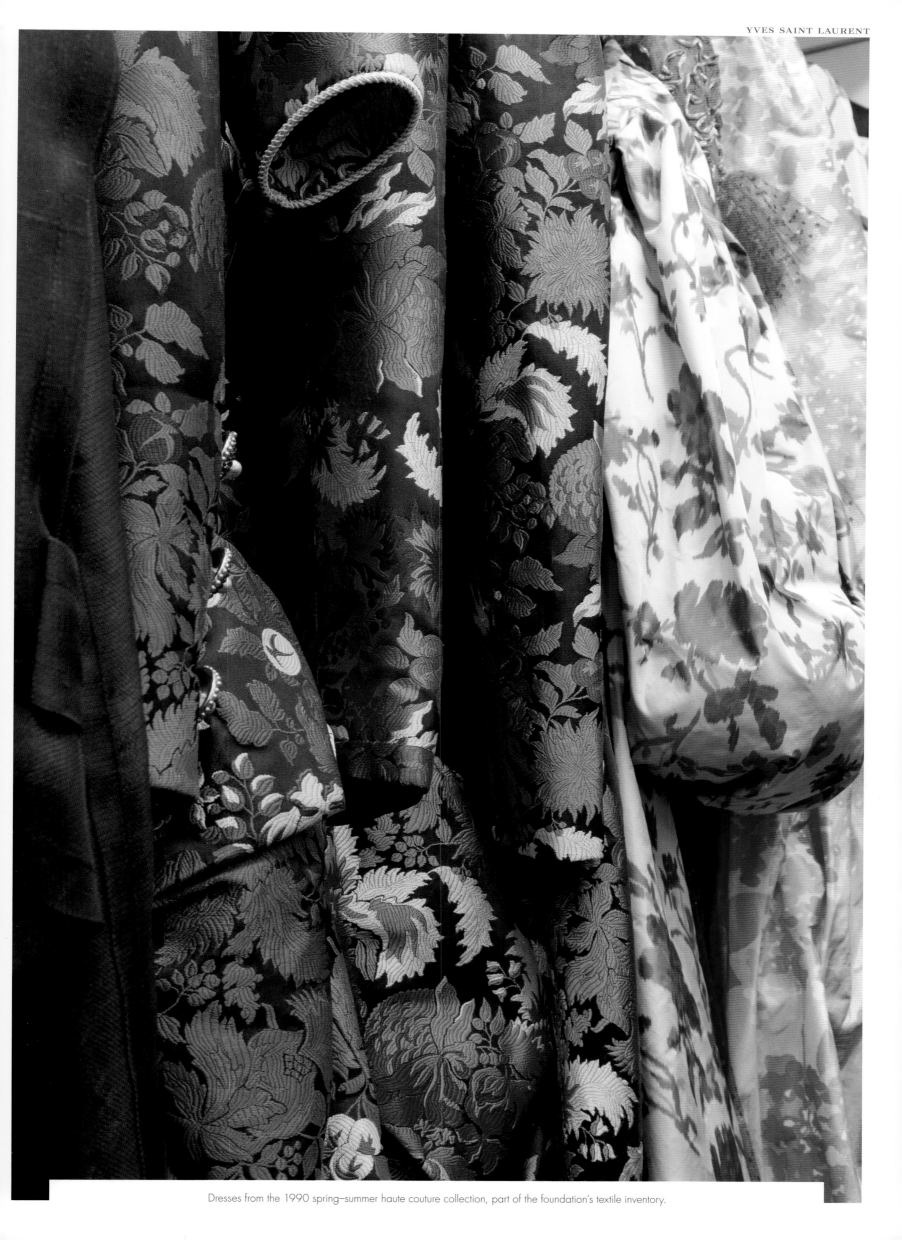

Dresses from the 1990 spring–summer haute couture collection, part of the foundation's textile inventory.

A difficult reign to uphold,
elegance is. You are
toppled as quickly as
you were placed.
Paris is a city of fashions.
Surviving there is a true feat.

JEAN COCTEAU
Reines de la France, Paris, Grasset & Fasquelle, 1952

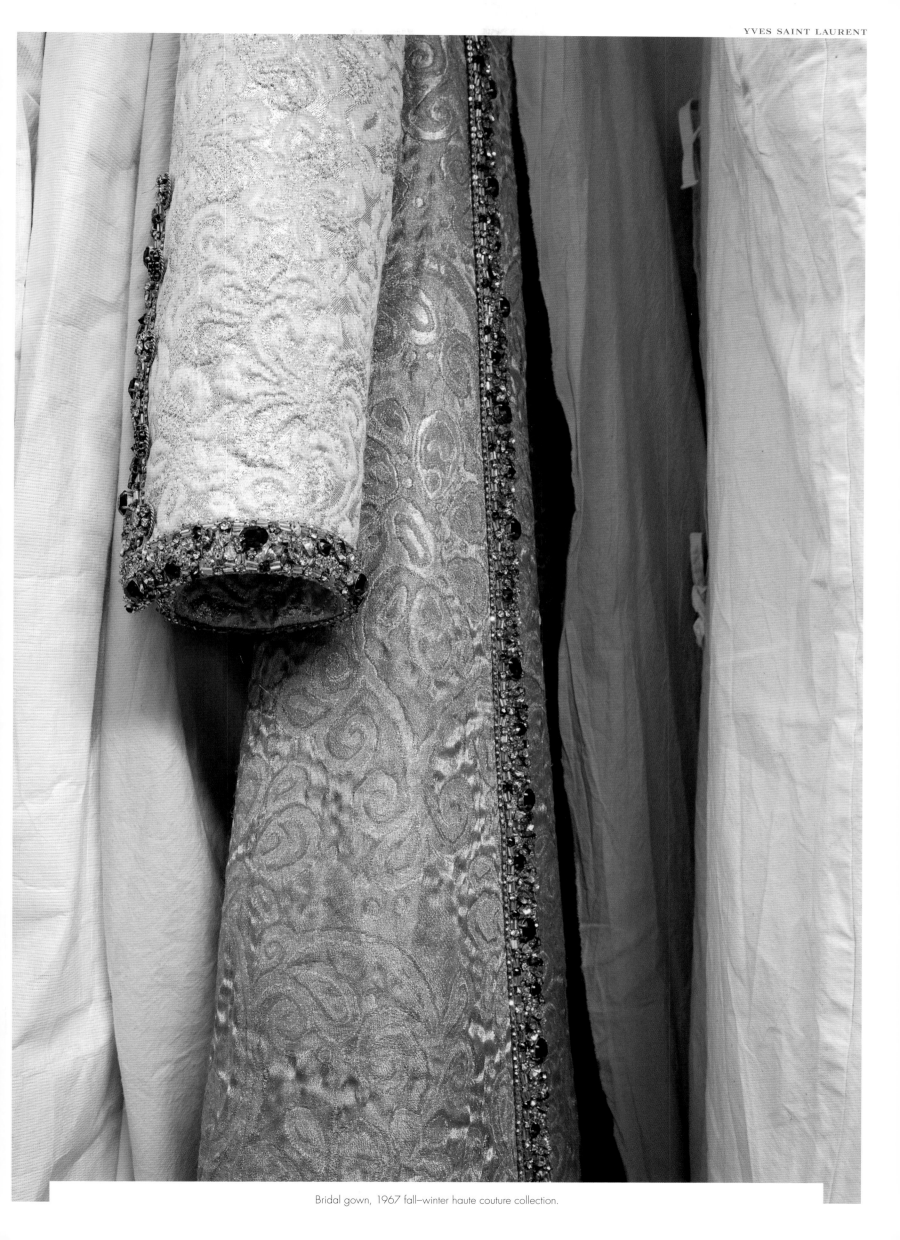

Bridal gown, 1967 fall–winter haute couture collection.

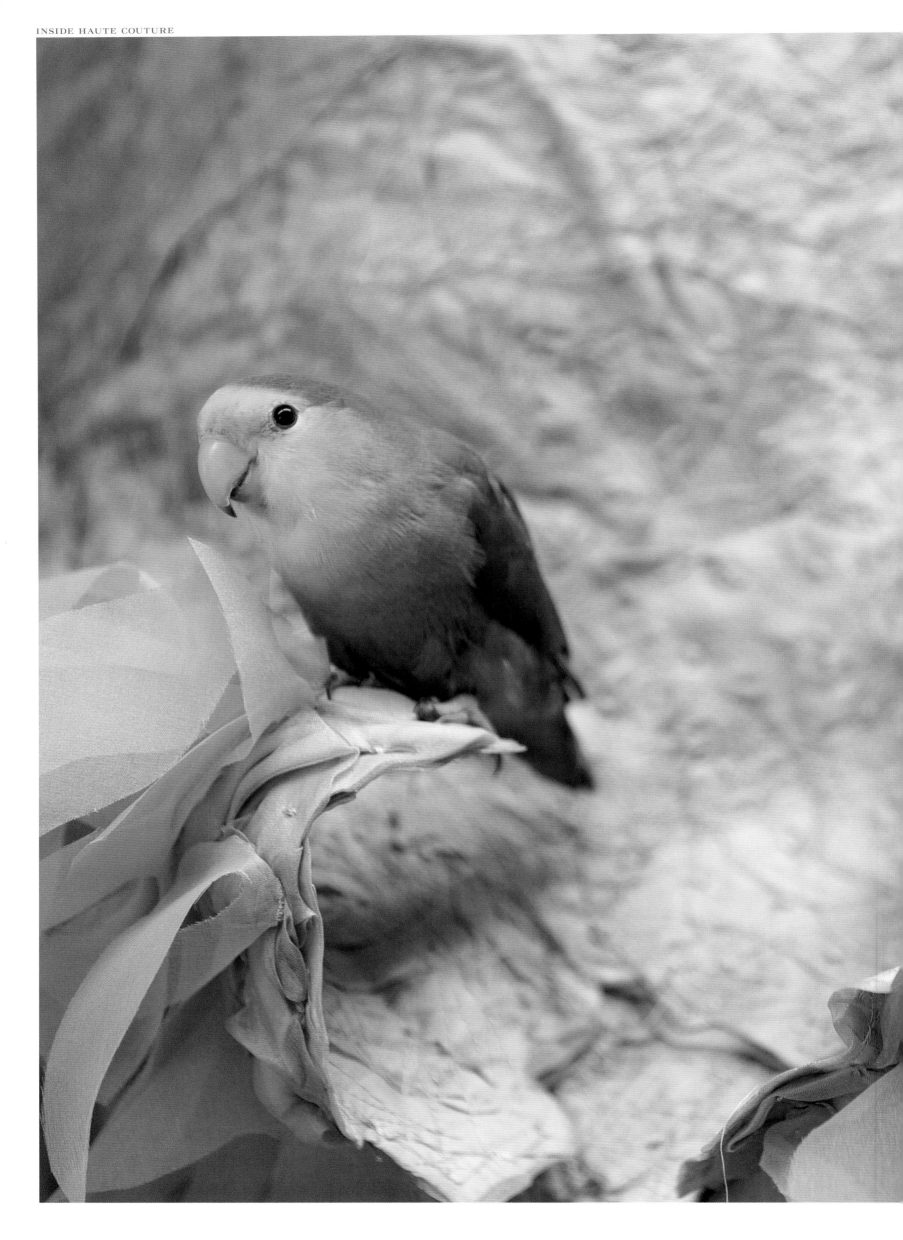

FRANCK
—
SORBIER

Franck Sorbier

106, BOULEVARD DE SÉBASTOPOL

Inspired by lovebirds—in French, better known as *les inséparables*—that he adores and keeps as pets, the poetic couturier Franck Sorbier can design masterpieces from next to nothing. His 2015 spring–summer collection was called "Pirate" and paid homage to his nest-building friends: The models were coiffed with fascinators made of twigs and wore colorful, floaty dresses made from lace and silk organza, heralding bright days ahead.

Born in Fréjus in southeastern France in 1961, Sorbier spent his childhood in French Basque country. Having a knack for foreign languages (he speaks English, German, and Russian), he once imagined becoming an interpreter. Instead, he would become a designer of haute couture.

For this young man who discovered the world of fashion through magazines, Thierry Mugler and Kenzo Takada were gods, as was Serge Lutens—"the great designer of beauty," according to Sorbier. Upon seeing a Lutens fashion photo that, for him, was a vision of rigor, timeless elegance, and the dream and mystery he had always sought, he hesitated no more: He would turn fashion into a means of expression as powerful as painting or sculpture. "I felt that

by pursuing this career, I'd be free, and I'd be able to enter the enchanted realm of dream images that have never stopped haunting me."[1]

In the 1970s, he designed his first pieces solely by instinct, cutting his patterns straight from the fabric. Working freelance for many years, he joined the haute couture circle in 1999 as an invited member of the Chambre Syndicale de la Couture Parisienne, then as a permanent member in 2005.

Behind his sewing machine, in the simplicity of his atelier in Paris's third arrondissement, Sorbier "rewrites" dresses like poems by Jacques Prévert as his birds whirl freely about. Everyone around him and everyone assisting him constitute his "family." First, there's Isabelle Tartière, his "other half," his longtime, inseparable companion and associate, with whom he works, thinks, and wrestles each runway show into being. Then there's Bruno Lepage, his communications manager, along with the famous godparents Sorbier honors at his shows and the seamstresses who come to assist him during rush periods.

What Sorbier likes best is designing from (almost) nothing, recycling fabrics, even scraps; he hates throwing anything out. "One day, as

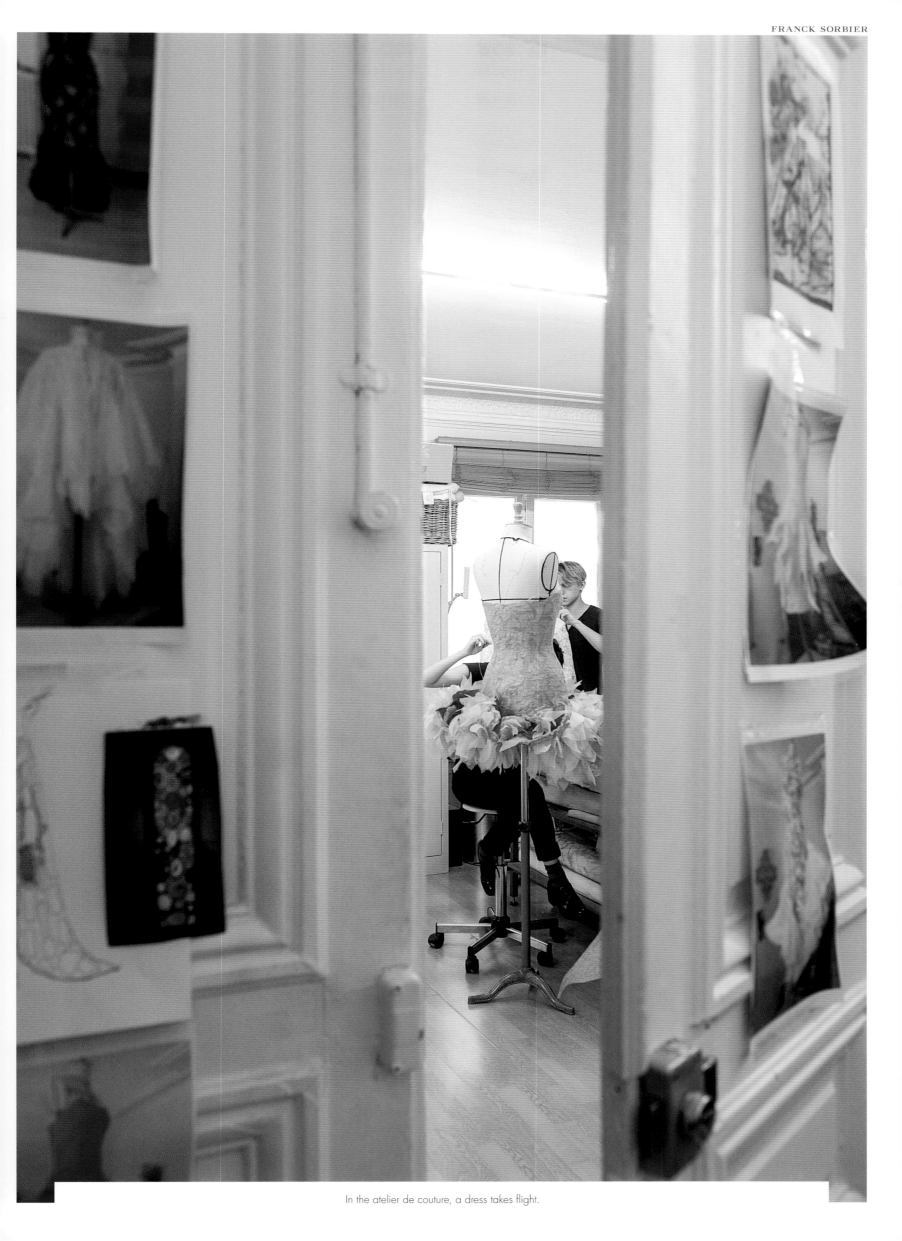

In the atelier de couture, a dress takes flight.

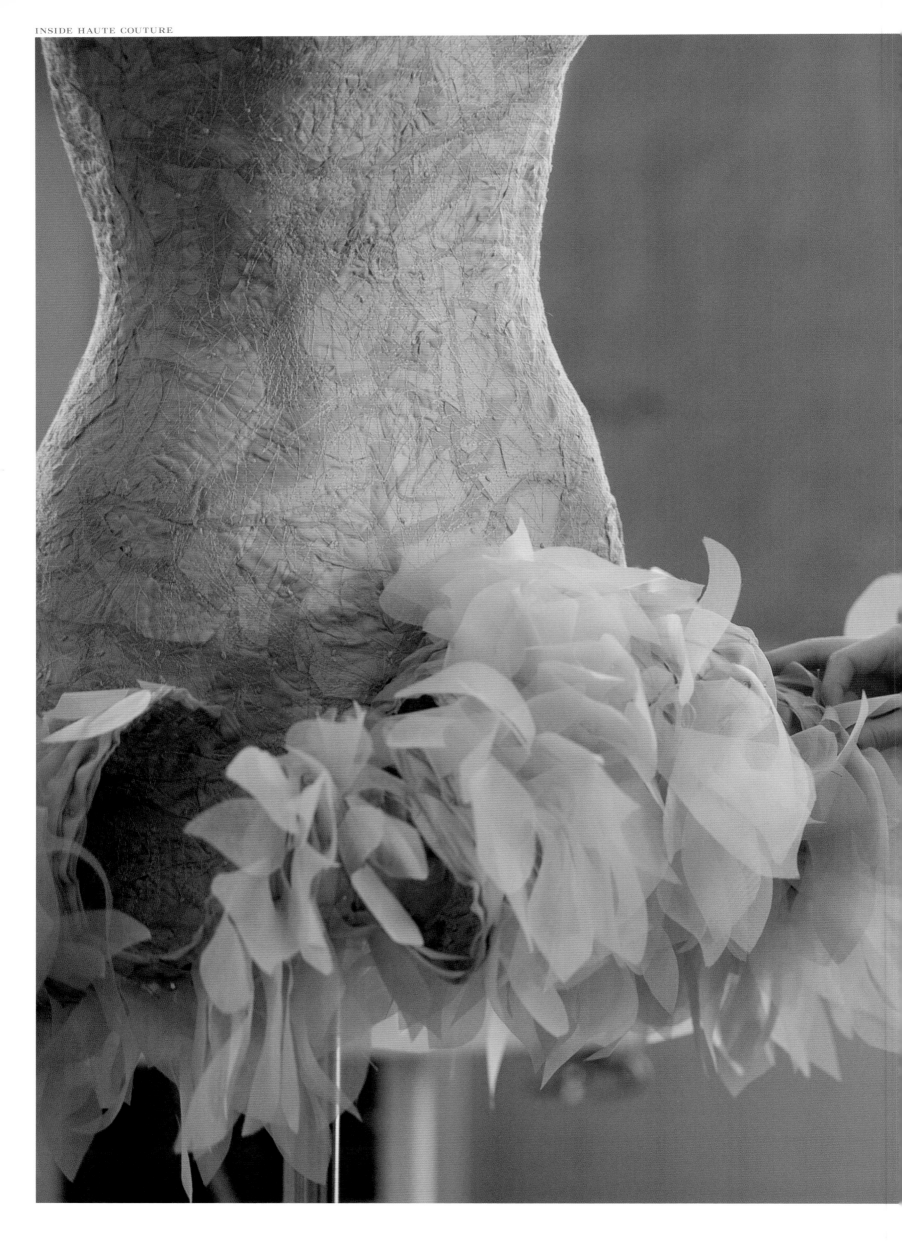

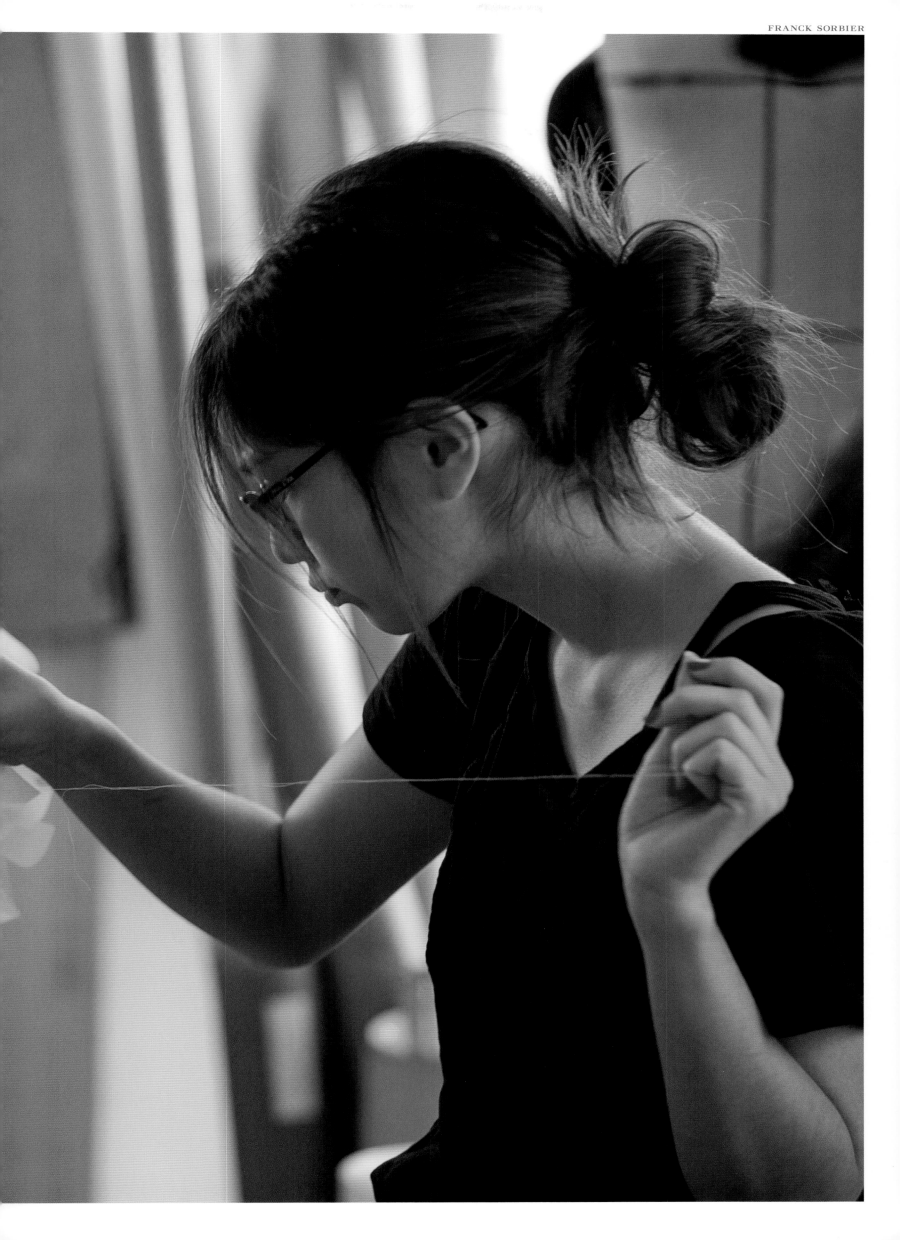

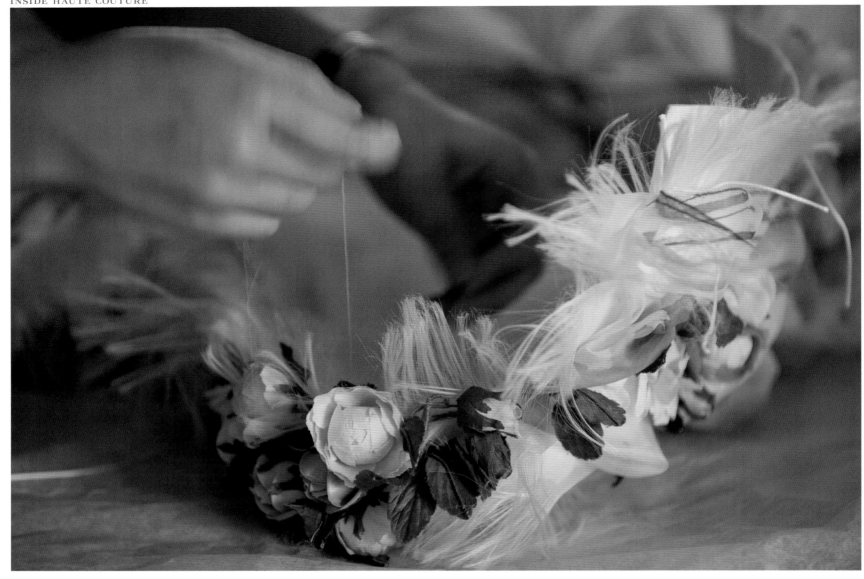

Frayed tulle and fabric flowers for the lightest of bustiers.

I was finishing a skirt, I realized there was a whole pile of cut-off bits in the garbage. I put the pieces under the [sewing] machine, and I stitched and creased, and re-stitched and re-creased...I worked the fabric the way a sculptor works clay. That's how my idea of compression was born. The incredible pleasure of inventing my own fabric, my own material. An amazing freedom and such a beautiful result,"[2] he reports, exultant.

As early as 1991, Sorbier reinvented the suit jacket and made it an immediate success. What was so extraordinary about it? Both nothing and everything. The cut was extremely simple, the fabric top quality, of course, but what was unique was the way the garment was covered with words such as *manche* (some), *hanche* (hip), *galbée* (rounded), and *poche* (pocket). He would make many other such revolutionary, deconstructed garments—one covered in old cigarette butts, another sewn from wrapping paper—all addressing society's ills with insolence and modernity.

In July 2008, Sorbier launched a new type of runway show; it was on the Internet and was immediately distinguished by a Webmaster Award, the Grand Prix du Luxe by Stratégies / Condé Nast, and an honorable mention for fashion website at the Festival de la Publicité de Méribel. And yet, this collection had a difficult start. The designer had chosen twenty-five women from history to illustrate the theme of radical activism. He created twenty-five corresponding costumes but only had the means to manufacture two. Then came a stroke of genius: presenting his costly designs in drawings and descriptions on the Internet.

Transforming difficulty into triumph is always a challenge, and that concept could encapsulate Sorbier's entire attitude. He takes risks as a way of adapting to the unexpected, and he seems to rebound from every tricky circumstance. In 2009, he created the concept, screenplay, and sets of the film-fashion show *La haute couture n'est plus ce qu'elle était...So what!* (Haute couture is not what it was...So what!). At

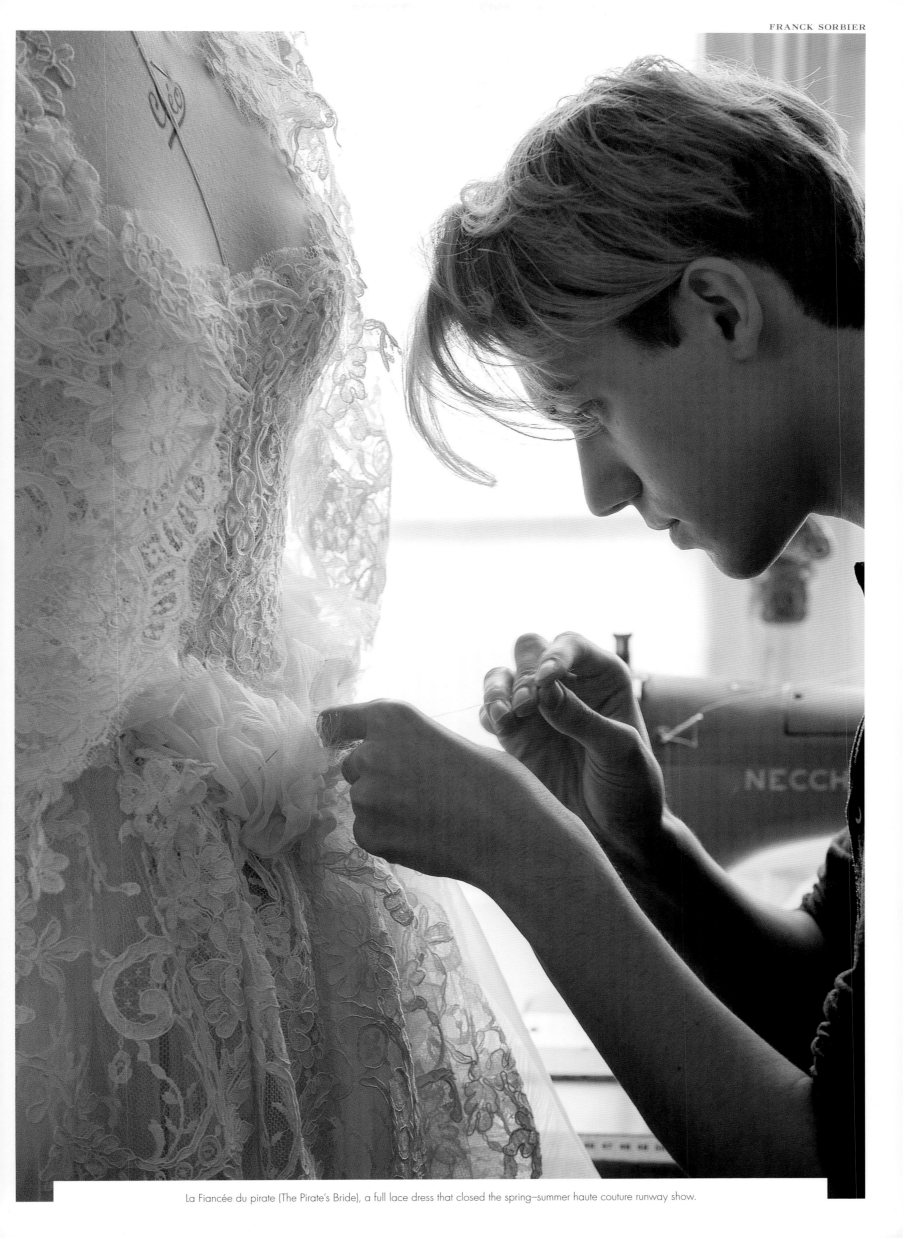

La Fiancée du pirate (The Pirate's Bride), a full lace dress that closed the spring–summer haute couture runway show.

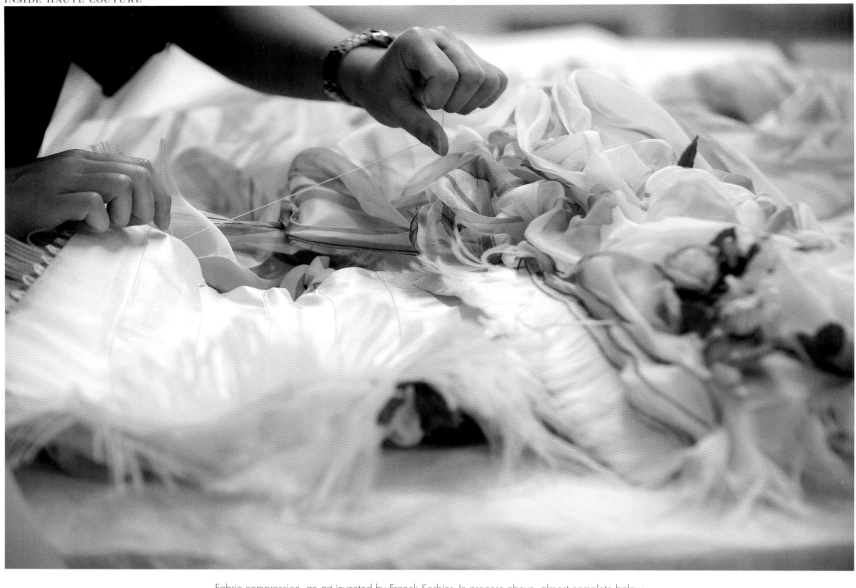

Fabric compression, an art invented by Franck Sorbier. In process above, almost complete below.

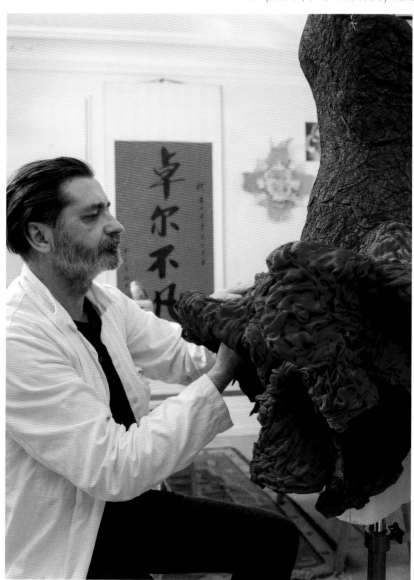

the same time, he was asked to mount an exhibition of his ten years in haute couture at the Musée des Tissus et des Arts Décoratifs in Lyon. He was the first fashion designer to be named "Maître d'art" by France's Ministry of Culture and Communication in 2010.

Franck Sorbier Couture also does costume designs for the stage. The first was for the Chinese-French painter Zao Wou-Ki for his admission into the Académie des Beaux-Arts. Then came costumes for outdoor operas and for Mylène Farmer and Johnny Hallyday concerts. "Each show is an adventure, an encounter. The costume designer is part of the puzzle. He works in service of the success of the director, the star, the soloist, the piece itself. Creating haute couture for shows is a trip," Sorbier says.

Every season, Sorbier's runway shows bring enchantment to the world of couture: astounding twenty-five-minute journeys through space and time. Never short of ideas, he goes with every folly and succeeds in astounding us.

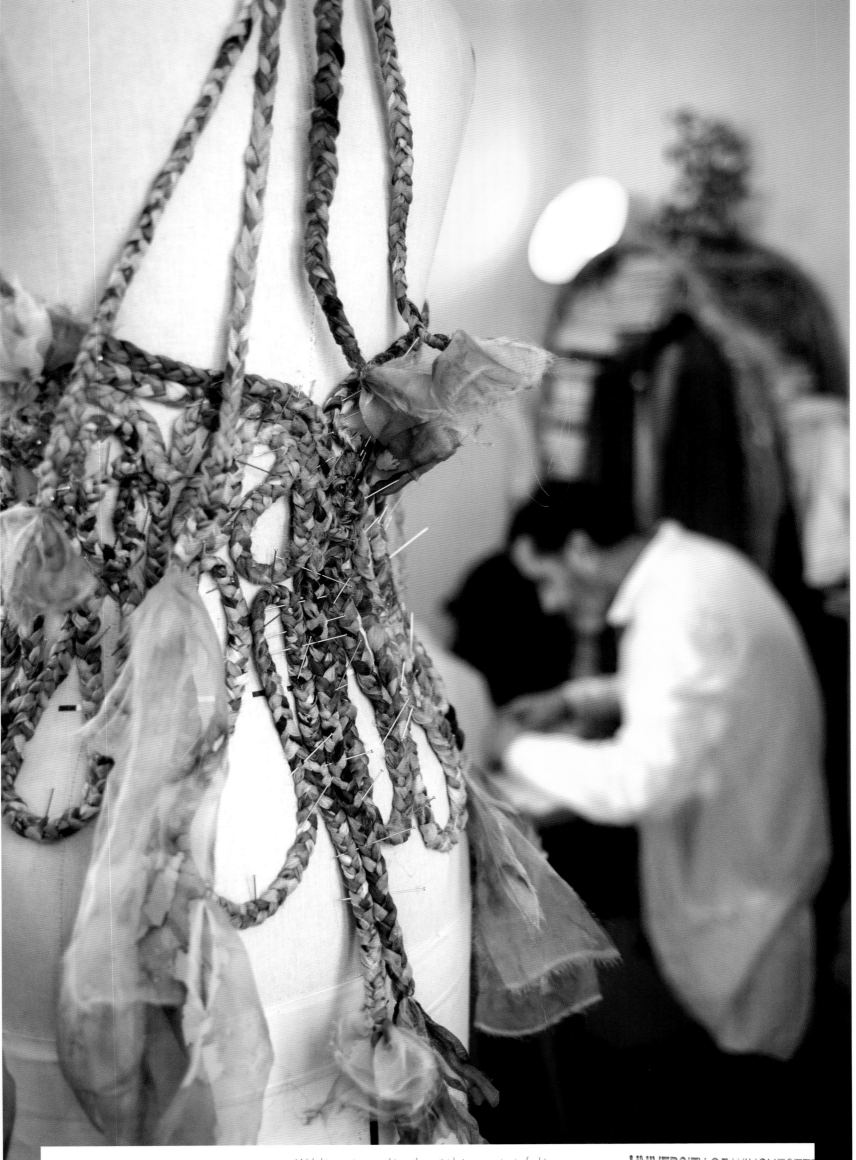

With his sewing machine, the artist brings poetry to fashion.

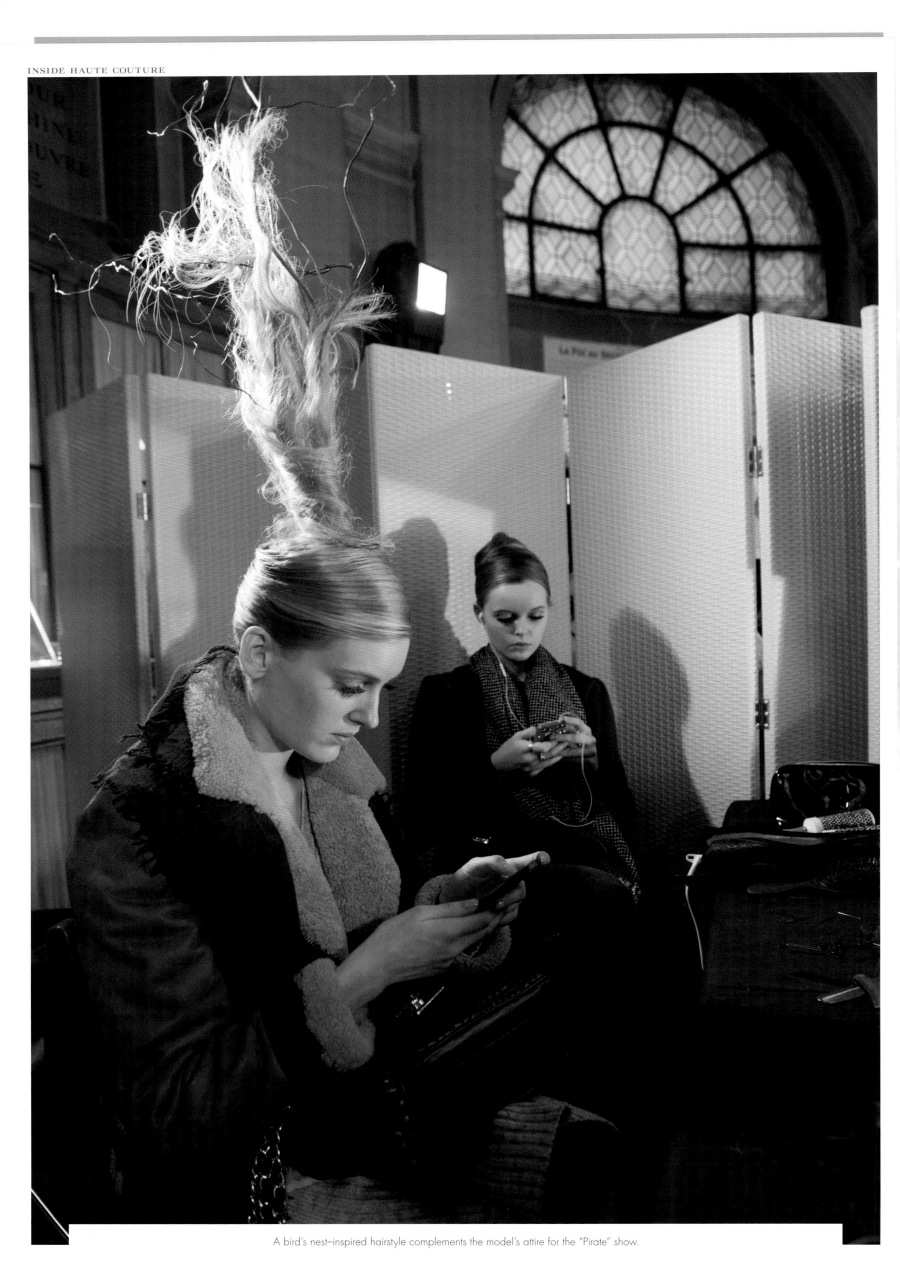

A bird's nest–inspired hairstyle complements the model's attire for the "Pirate" show.

Alexandre Vauthier

3, RUE CHRISTOPHE-COLOMB

Lauded by elite celebrities who love his chic bling, Alexandre Vauthier was granted the status of "haute couture" on December 16, 2014, only five years after his label was created. Joining that very exclusive circle was a true honor for the forty-three-year-old who speaks in the flowery accent of southwestern France.

Born in Agen in 1971, Vauthier was raised by a father who was once a soccer player for the Girondins de Bordeaux and then became a business developer, and by a mother who also worked in finance. Superbly elegant, she passed down to Alexandre her taste for designer clothes. After obtaining a baccalaureate in literature, Alexandre started law school but didn't complete his degree. With his father agreeing to finance yet another course of study, Vauthier pursued his passion for clothing. A fashion school, ESMOD, had just opened a campus in Bordeaux; Alexandre studied there for two years before leaving for Paris.

After that, things moved very quickly. In 1993, Vauthier joined Thierry Mugler Couture as a trainee, which turned into a position as an assistant to the designer for four years. In 1997, he joined the fashion house of Jean Paul Gaultier, where he was head of couture collections. During his eight years there, he learned from luxury master craftsmen such as François Lesage, Christian Louboutin, designers at Saga Furs, and many others. Then Vauthier took a break for four years to think and travel to Asia and California, which opened up new creative horizons for him.

In 2009, he decided to take off on his own and opened a fashion house under his name. His first runway show proved a success. His sensual designs gave a starring role to black and gold and to slit dresses with sheer portions and audacious necklines. The garments' smooth lines, revolving around a V-shaped geometry, are created by a sophisticated cut. Draping and defined shoulders enhance the femininity of the wearer. Rihanna, Amber Heard, Vanessa Paradis, Beyoncé, Rita Ora, and Heidi Klum, among others, go mad for his unique and recognizable style.

His atelier at 3, rue Christophe-Colomb, in Paris's eighth arrondissement, boasts eight employees and is always bustling. Couture prototypes rub shoulders with leather motorcycle jackets lined in lynx. (Vauthier loves big engines.)

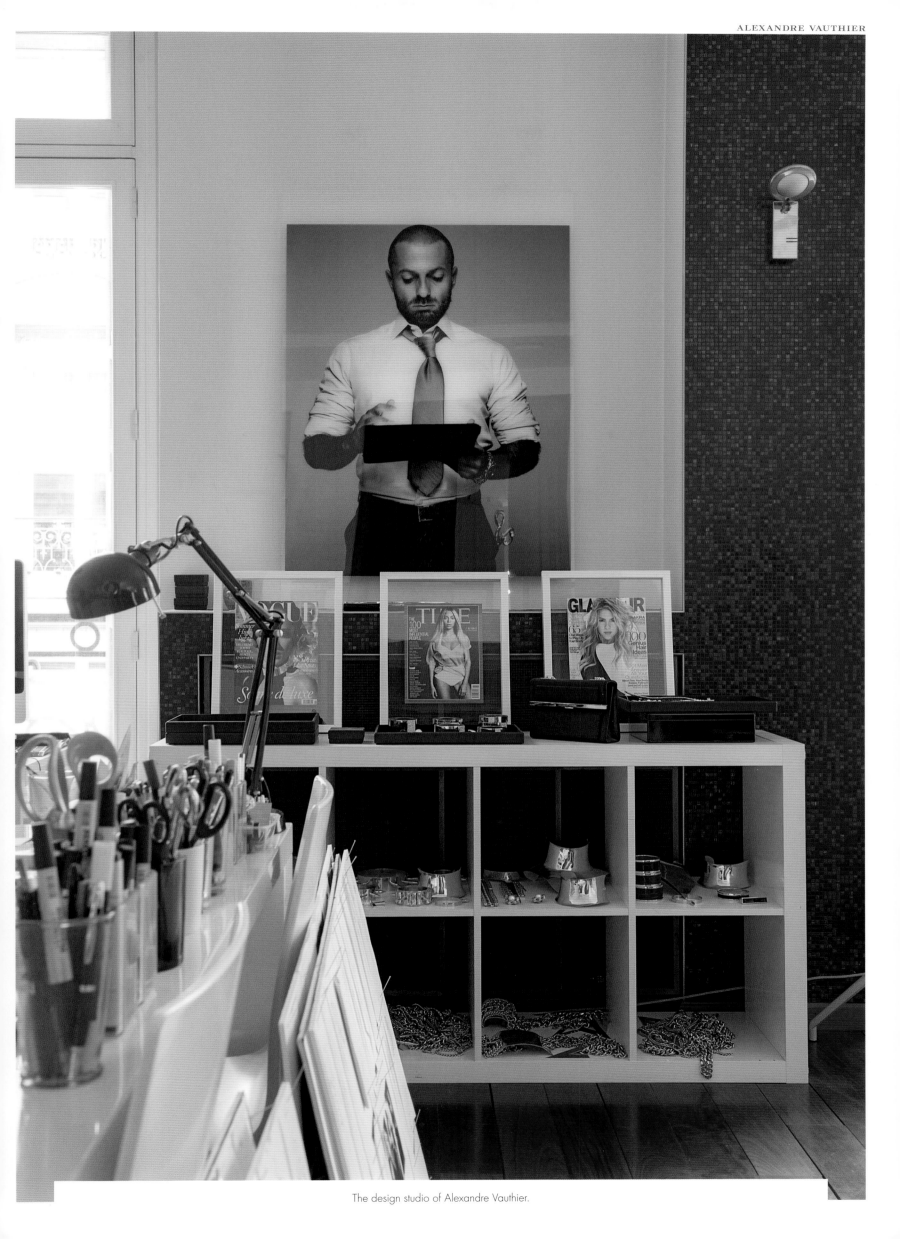

The design studio of Alexandre Vauthier.

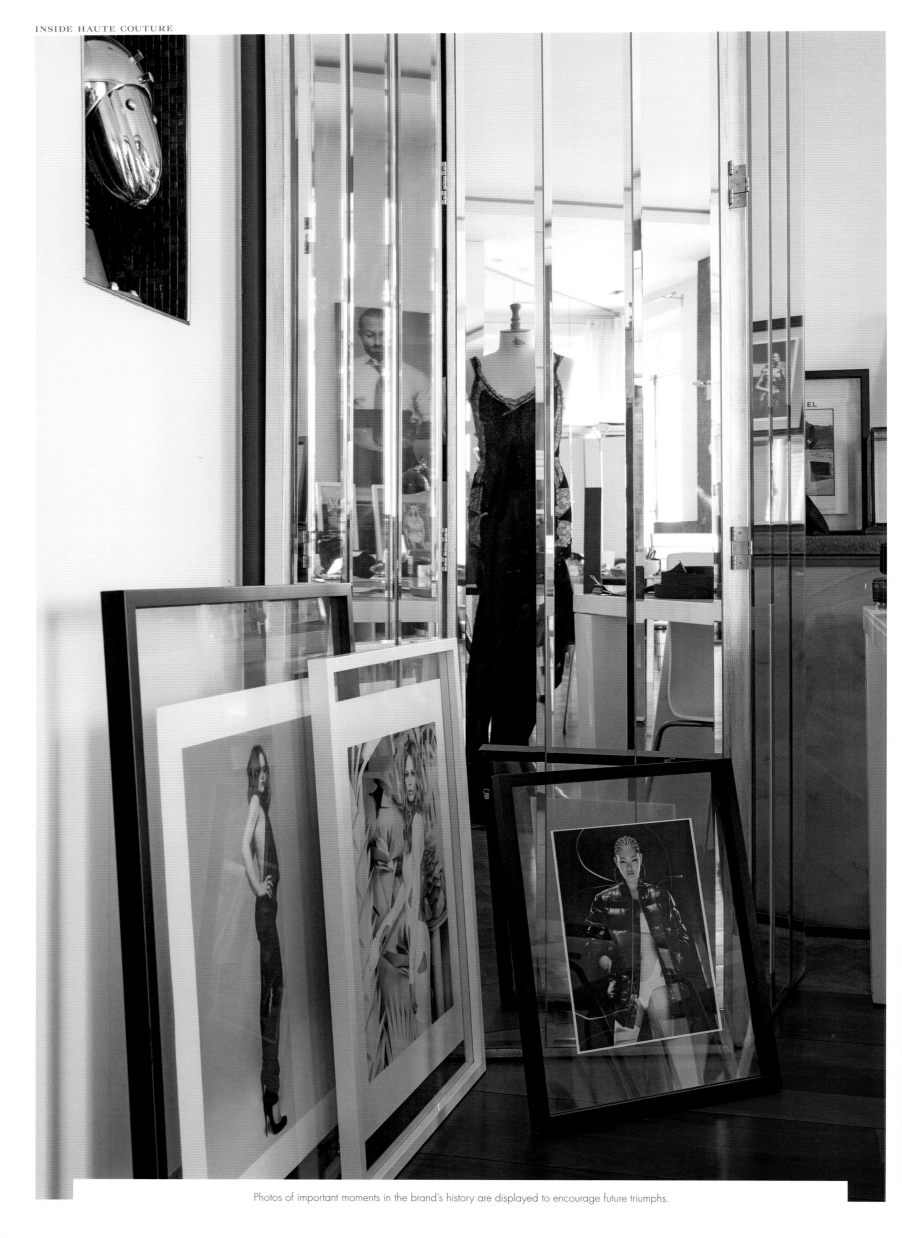

Photos of important moments in the brand's history are displayed to encourage future triumphs.

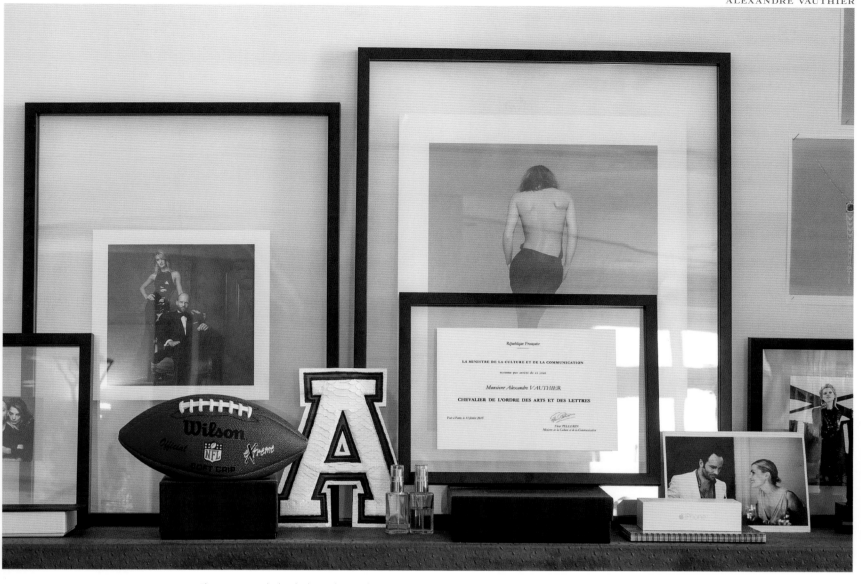

The inspiration behind Alexandre Vauthier's chic sport collections can be seen among the photographs.

"It's my job to listen to women. From the time they wake to the time they go to sleep, they change, experiencing moments of fragility, of self-doubt, of recovery. They tell me about their daily lives, about whom they love and why. I enter their private lives in order to be able to cover the range of their wardrobe [needs]. That's why there are clothes that are long, short, tight, and less formfitting. But the common denominator is luxury. [And] every woman wants to be unique,"[1] he said in January 2013.

In terms of prêt-à-porter, Vauthier stays true to himself. For example, his 2015 spring–summer collection presented aviator jumpsuits in black leather and sports T-shirts transformed into dresses; his 2015–2016 fall–winter collection adapted his famous sexy cuts and graphics for everyday life. And somehow the style remained fully in line with his haute couture.

The 2015 spring–summer runway show of this newcomer to the Chambre Syndicale de la Haute Couture was much anticipated. Brazilian top model Izabel Goulart opened the parade in a shiny black python jumpsuit; then came models wearing mermaid dresses and pirate pants embellished with sequins. Amid stylistic nods to lingerie—flattering sheer inserts enhancing the waist, hips, and curves of the legs—the music accompanying the show accentuated its libertine spirit. Rich in technical feats, the collection ended with an iconic dress bright with twenty-five thousand crystals hand-sewn, one by one, onto the fabric—highly intricate embroidery that required more than three hundred hours of work.

"This is my vision of fashion today: modernity paired with tradition," said Vauthier.[2] Sometimes, more than two months are needed to

Known for a modern, sensual style, Vauthier's designs have many advocates in Hollywood.

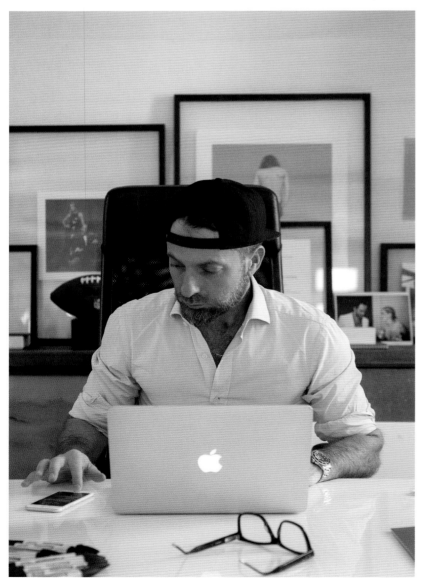

develop a sketch into a final Vauthier dress. Prices start at twelve thousand euros, and a gown embroidered with rare feathers or diamonds can reach enormous sums. This kind of dress—true ceremonial attire on the cutting edge of fashion technology—constitutes the apotheosis of each runway show, a way to reinvent the traditional bridal gown.

For a company that still can't afford advertising campaigns, the runway show remains the only window to Vauthier's couture. But its mission is clearly accomplished, since Vauthier continues to attract more and more champions of his sensual, refined clothing, especially movie stars in search of fashion that can make them look sublime.

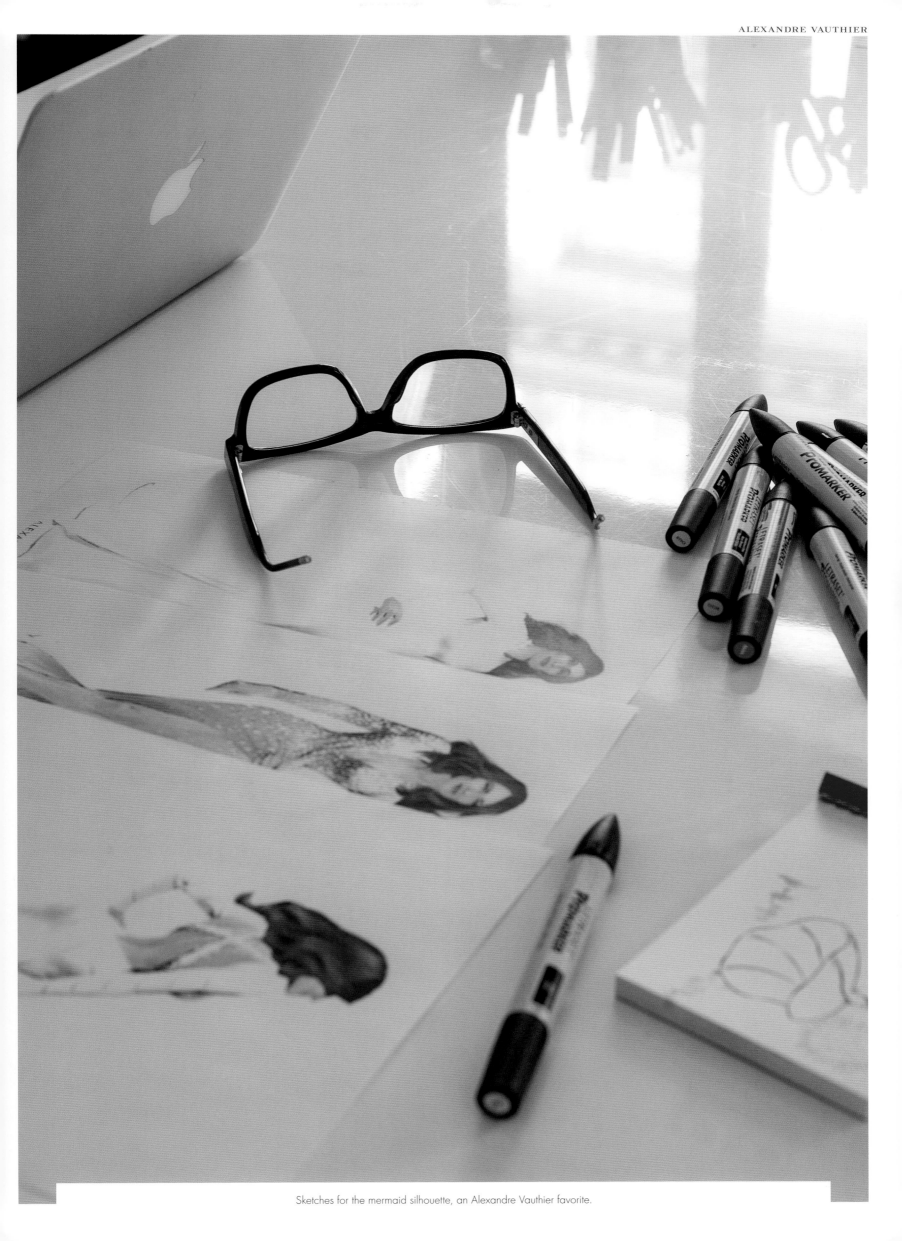

Sketches for the mermaid silhouette, an Alexandre Vauthier favorite.

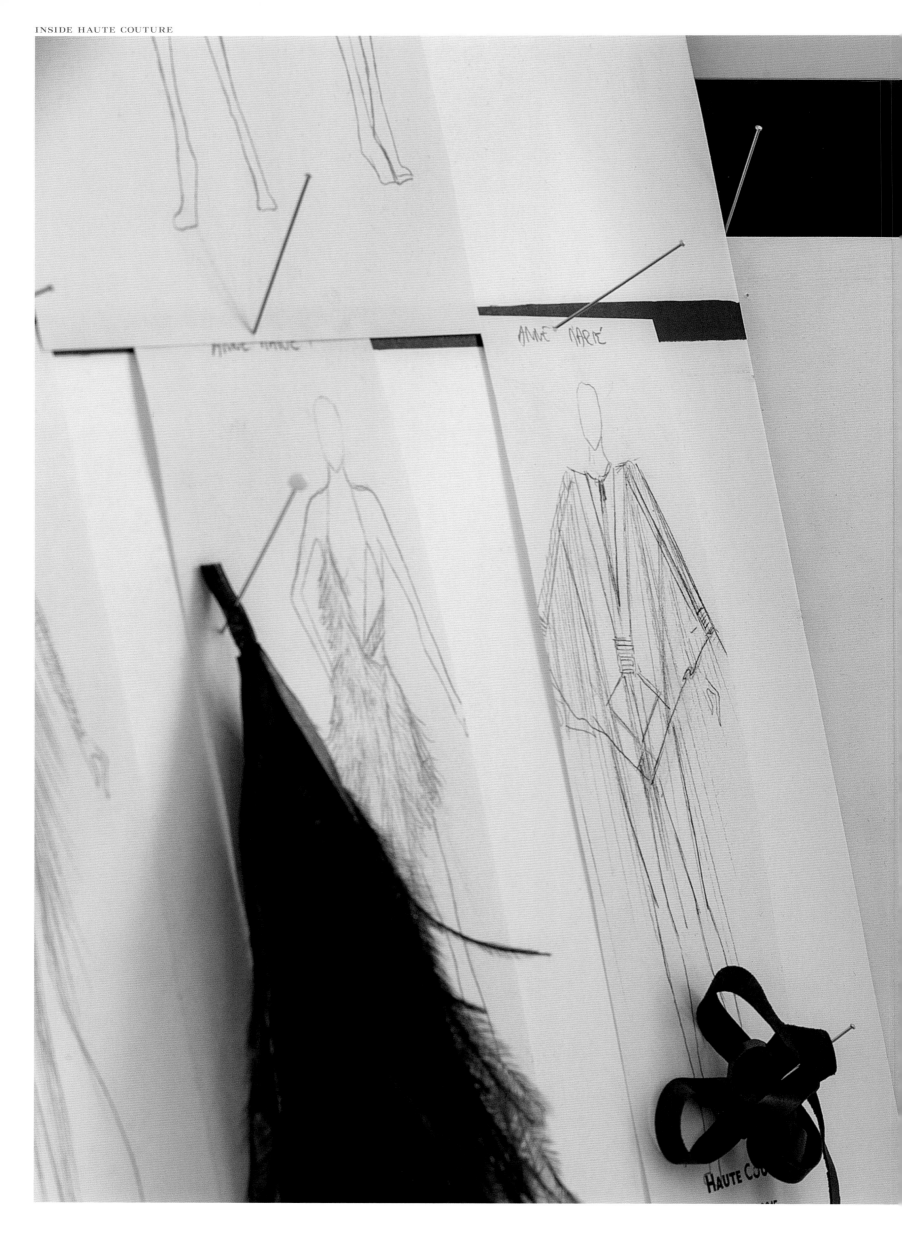

ANNE MARIE

HAUTE COU

PERF —D JOJO

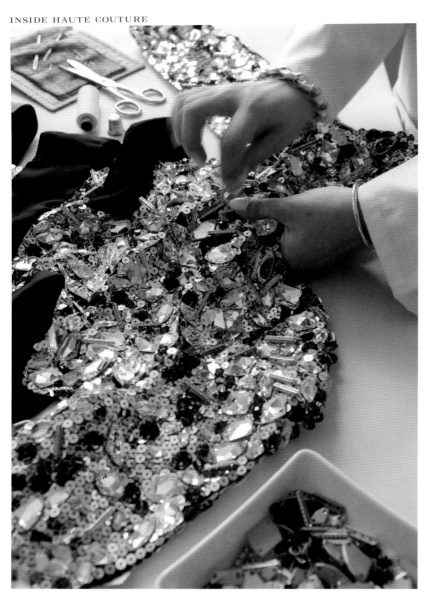

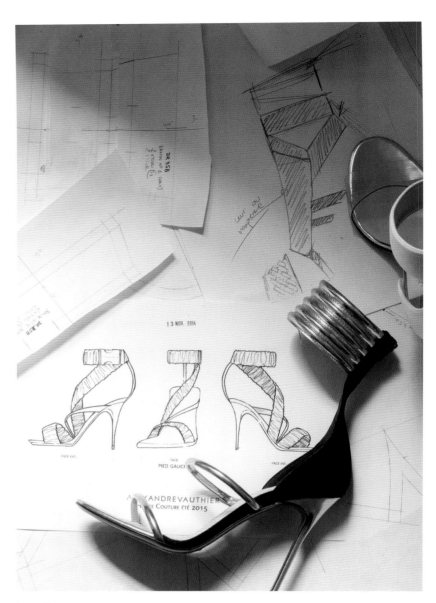

Crystals sewn one at a time and sparkling accessories.

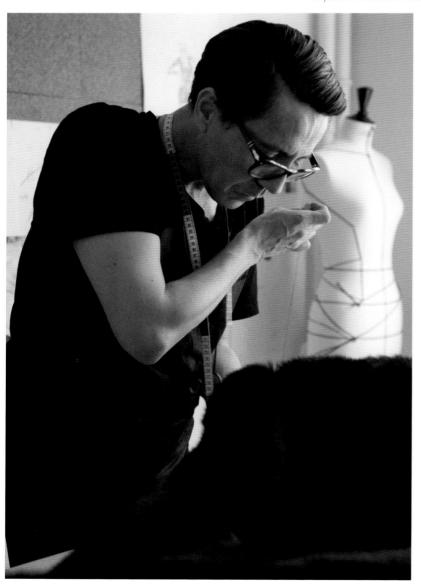

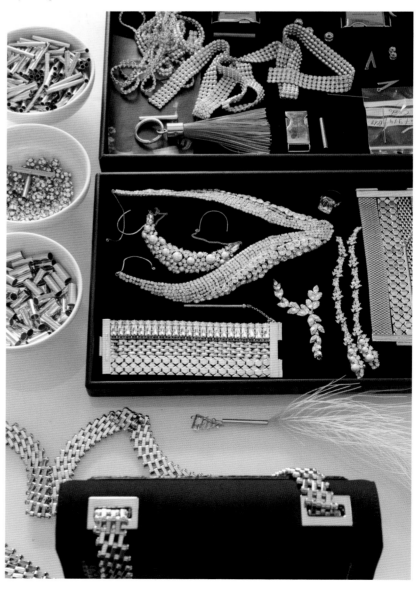

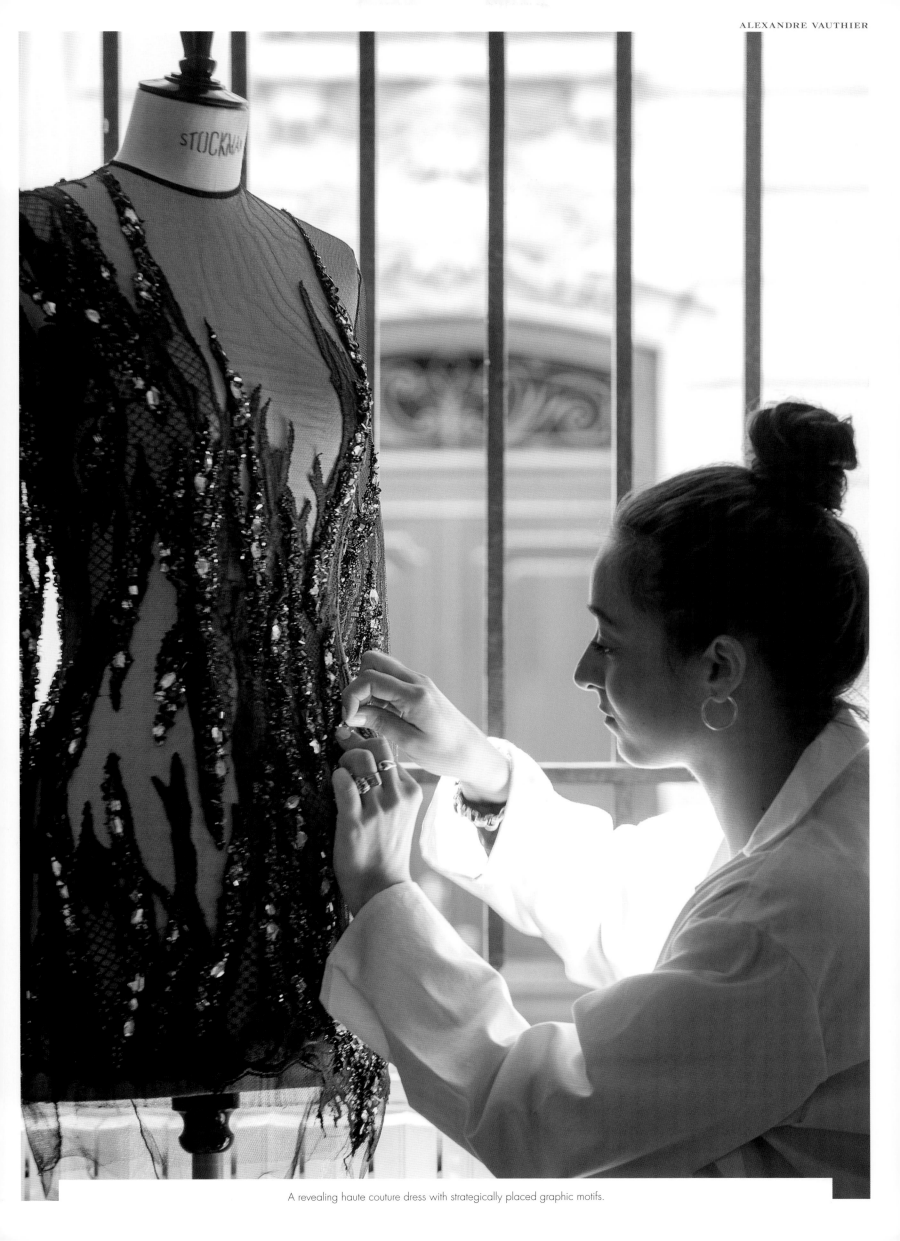

A revealing haute couture dress with strategically placed graphic motifs.

ALEXANDREVAUTHIER

ALEXANDREVAUTHIER

Precious details are given even to the haute couture packing box.

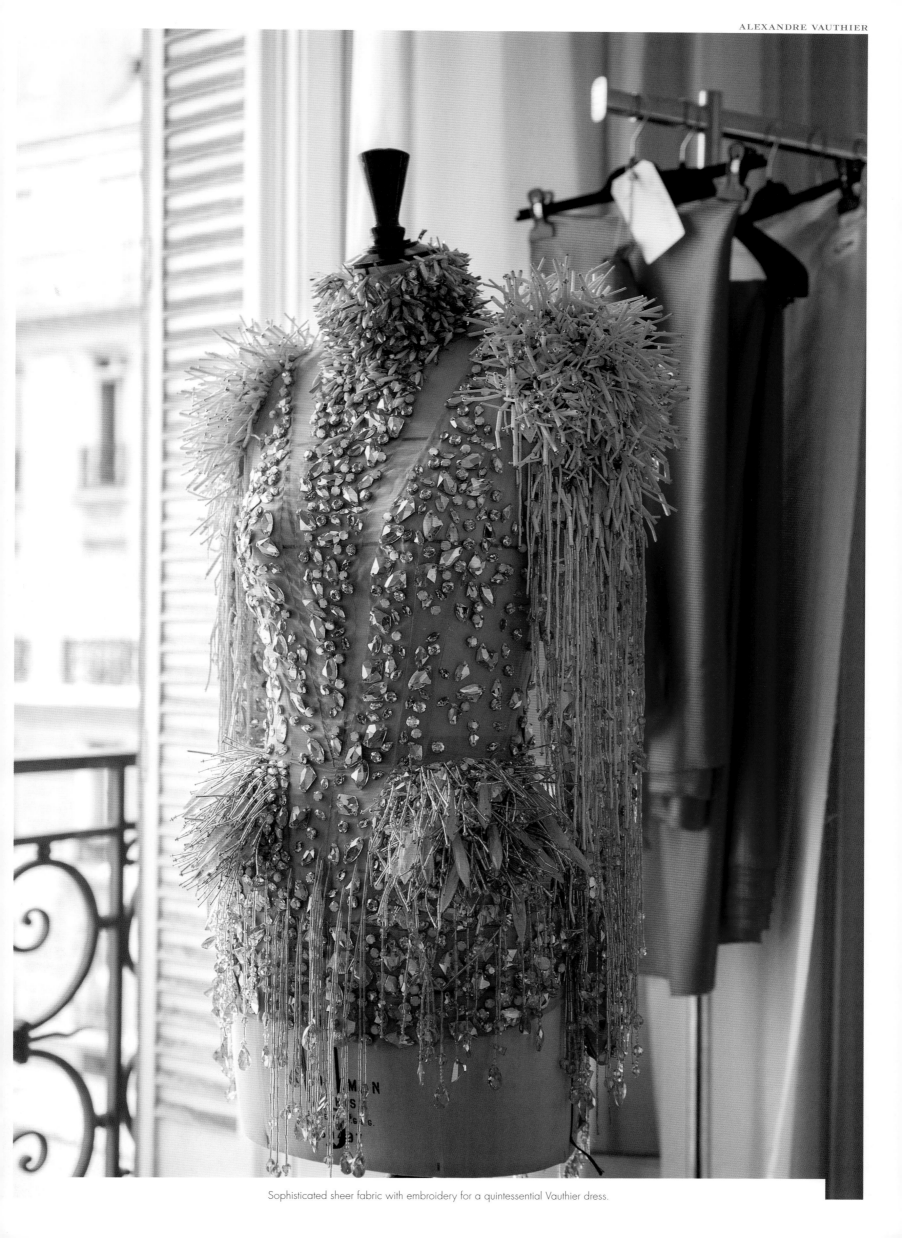

Sophisticated sheer fabric with embroidery for a quintessential Vauthier dress.

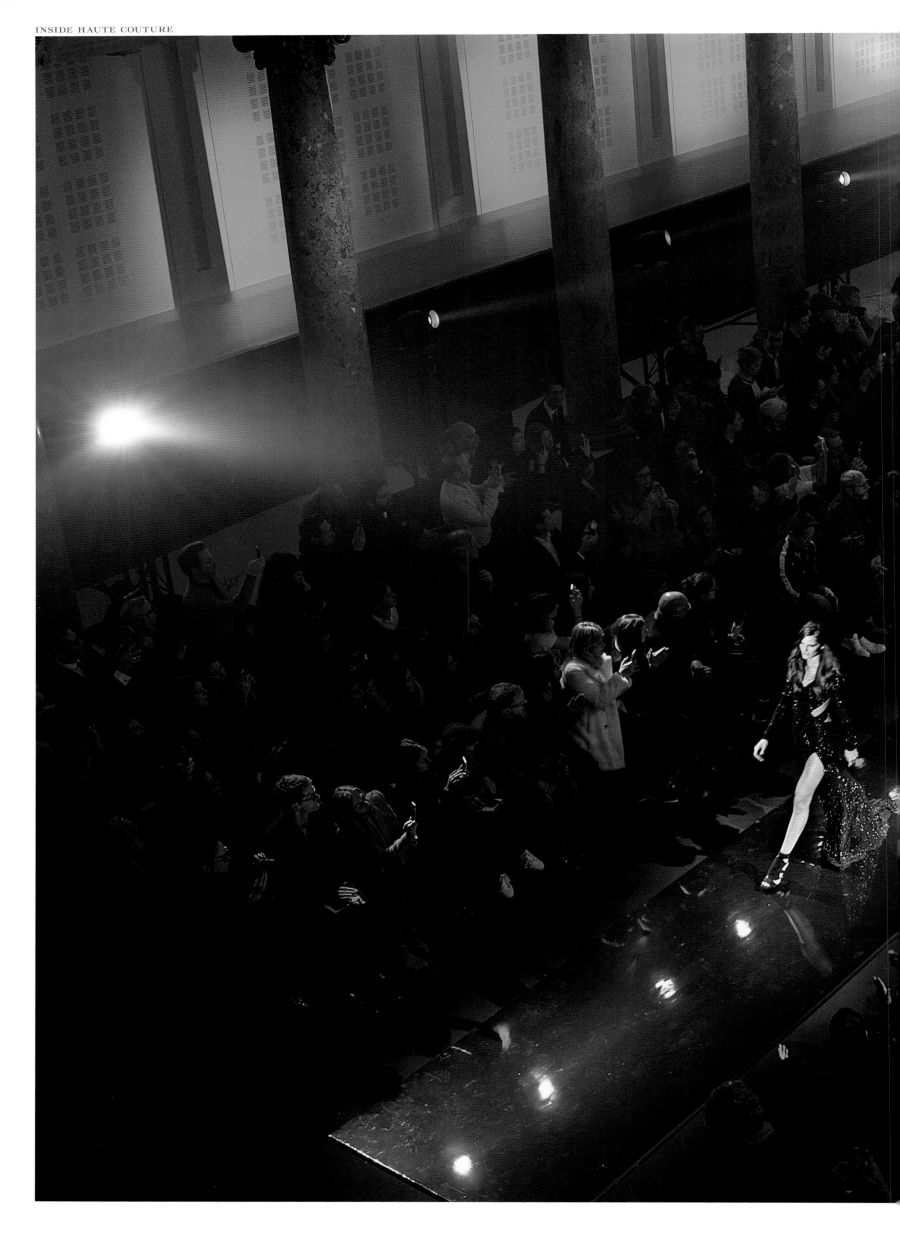

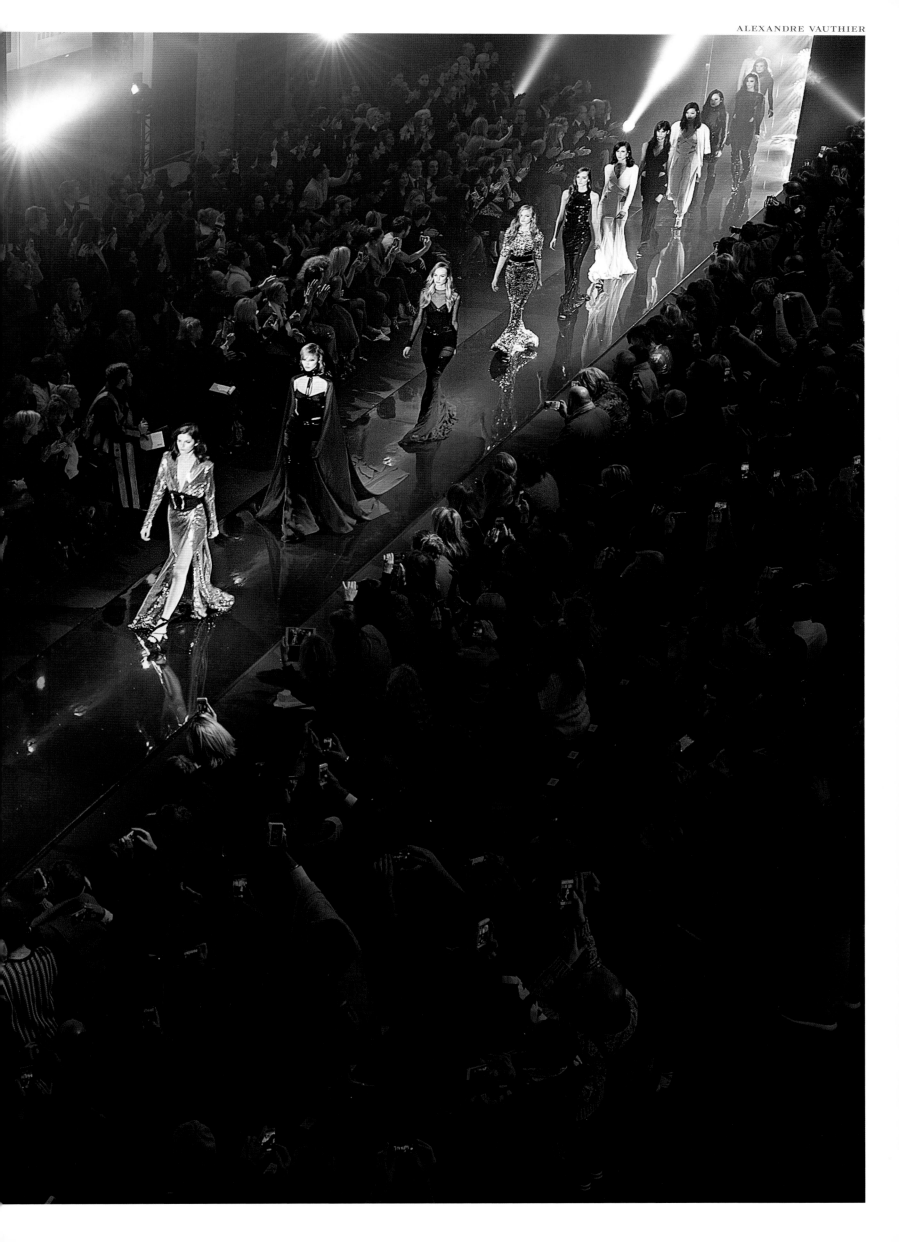

Notes

CHANEL

1 See *Mademoiselle "Coco," la solitude*, short film, 1975, available at http://www.ina.fr.

2 Thiébault Dromard, "Les Wertheimer aussi riches qu'invisibles," *Challenges*, no. 397, July 10, 2014.

CHRISTIAN DIOR

1 Christian Dior, *Christian Dior et moi*, Paris, Amiot-Dumont, 1956; new edition, Paris, Vuibert, 2011.

JEAN PAUL GAULTIER

1 Gentiane Lenhard, "Un parfum d'interdit," *Le Parisien*, August 29, 2014.

2 *Montréal Gazette*, 2011.

ALEXIS MABILLE

1 Florence Julienne de Sourdis, "Alexis Mabille: Ça roule pour lui!," http://www.luxe-magazine.com, July 2006.

2 Peggy Frey, "Mon idée de la mode Alexis Mabille," http://madame.lefigaro.fr, October 20, 2008.

3 Godfrey Deeny and Hélène Guillaume, "La forêt enchantée de Chanel," *Madame Figaro*, January 23, 2013.

STÉPHANE ROLLAND

1 Désirée Sadek, "Stéphane Rolland: Iconic Designer," *Elle Oriental*, no. 86, March 2014.

ELIE SAAB

1 Interview with the author, January 27, 2015.

2 Antoine Daher, "L'architecte de la haute couture," *Elle Oriental*, no. 1, July 2006.

3 Elsa Yazbek Charabati, "Deux semaines avec le maître," *Elle Oriental*, no. 92, September 2014.

YVES SAINT LAURENT

1 *Les Adieux d'Yves Saint Laurent*, France 3, January 7, 2002, available at http://www.ina.fr.

FRANCK SORBIER

1 *Franck Sorbier: La couture corps et âme*, Paris, Éditions Xavier Barral, 2009.

2 Justine Baldin, "Franck Sorbier, la mode à la confluence des arts," *Femmes Magazine Luxembourg*, no. 127, June 2012.

ALEXANDRE VAUTHIER

1 "Alexandre Vauthier, Hyperluxe made in France," *Le Journal du Dimanche*, January 14, 2013.

2 "Avec Alexandre Vauthier en coulisses," http://www.elle.fr, February 3, 2011.

Copyright © 2015 Éditions de la Martinière, La Martinière Groupe, Paris
English translation copyright © 2016 Abrams, New York

Published simultaneously in French as *Maisons de Haute Couture* by Éditions de La Martinière

FRENCH EDITION

Styles editorial team
Graphic design and layout: Laurence Salaün
Proofreading: Julie Houis
Photo separation: IGS

ABRAMS EDITION

Translation from the French by Molly Stevens

Editor: Laura Dozier
Designer: Shawn Dahl, dahlimama inc
Production Manager: Denise LaCongo

Library of Congress Control Number: 2015948409

ISBN: 978-1-4197-2020-8

Printed and bound in France
10 9 8 7 6 5 4 3 2 1

Abrams books are available at special discounts when purchased in quantity for premiums
and promotions as well as fundraising or educational use. Special editions can also be created
to specification. For details, contact specialsales@abramsbooks.com or the address below.

ABRAMS
THE ART OF BOOKS SINCE 1949

115 West 18th Street
New York, NY 10011
www.abramsbooks.com